AI WEIWEI'S BLOG

The MIT Press Writing Art series, edited by Roger Conover

THE MIT PRESS CAMBRIDGE, MASSACHUSETTS LONDON, ENGLAND

AI WEIWEI'S BLOG

Writings, Interviews, and Digital Rants, 2006–2009

AI WEIWEI

EDITED AND TRANSLATED BY LEE AMBROZY

WRITING**ART** SERIES

MIT Press books may be purchased at special quantity discounts for business or sales promotional use. For information, please email special_sales@mitpress.mit.edu or write to Special Sales Department, The MIT Press, 55 Hayward Street, Cambridge, MA 02142.

This book was set in Bembo and Gotham by the MIT Press. Printed and bound in Spain.

Library of Congress Cataloging-in-Publication Data

Ai, Weiwei.
 Ai Weiwei's blog : writings, interviews, and digital rants, 2006–2009 / Ai Weiwei ; edited and translated by Lee Ambrozy.
 p. cm. — (Writing art)
 Includes bibliographical references and index.
 ISBN 978-0-262-01521-9 (pbk. : alk. paper)
1. Ai, Weiwei—Blogs. 2. Dissenters, Artistic—China—Blogs. I. Ambrozy, Lee, 1978– II. Title.
N7349.A5A35 2011
709.51 090511—dc22

 2010024293

10 9 8 7 6 5 4 3

FOR THE GRASS MUD HORSE

CONTENTS

PREFACE

This book is a collection of texts representing the online presence of the artist / architect / activist Ai Weiwei. He would rather not be called a dissident, so I've omitted that word here. The texts have been culled from his blog (hosted on sina.com.cn), and date from 2006 to May 28, 2009, when the blog was censored and its entire contents deleted from cyberspace. Thus, the last five texts included here appeared on alternative blogging platforms, and one article, "140 Characters," is a compilation of microblogged tweets that were composed in July 2009 as the news of the Xinjiang riots broke to the public.

The more than one hundred short essays presented here are just a fraction of the total posts, and although a handful were previously printed in catalogs or press releases, the vast majority have never been seen in English. As Ai Weiwei posted on his blog every day for almost four years, the accumulating texts became a monumental undertaking to compile, as well as an incredible challenge to translate. The arduous and time-consuming task of downloading, organizing, editing, and archiving hundreds of files, both textual and visual, continues to occupy many hands and eyes in Ai's FAKE Design office in Caochangdi.

Thanks to Philip Tinari and Jeff Kelly, who instigated this book project, translations began in late 2008, as the blog was still growing every day. The process was well under way when a mainland publisher expressed interest in a Chinese edition in book form. All the original texts were then reedited for inclusion in a proposed Chinese-language edition; a team of editors, including Ai Weiwei's brother Ai Dan, cleaned up typos and mistakes, polished the language, and in some cases added or deleted significant amounts of content, for greater readability and clarity. All of the original English translations were reworked to reflect these changes; but in the end, a Chinese version was never published. The "political incorrectness" of Ai's viewpoints and the sensitivity of his subject matter proved too daunting, and too great a risk for any mainland publisher or distributor. To date, this volume is the most complete, public documentation of Ai's blog to date, in any language.

The opinions expressed in this book are all those of the author. Often they are in direct response to current affairs and include numerous sociocultural allusions, necessitating annotations. The Internet became the primary source for such annotations, and as this book was assembled in China, fact checking necessitated "leaping over the Great Firewall," which in 2008–2009 was constantly updating its Internet-monitoring software and methods. At last, using a VPN allowed access to almost all websites otherwise unavailable to the average mainland browser (including Twitter, YouTube, Facebook, Vimeo, and occasionally Flickr). But once over the firewall, a more serious challenge was posed in reconciling the often extreme differences between Western and Chinese sources. These discrepancies are perhaps the last vestiges of the Cold War. I hope that through more translations like this one, our two civilizations can reconcile the "facts." At the least, I am thrilled that an artist has generated enough

interest to warrant offering the English-speaking world a chance to read in translation what the Chinese are saying to each other, instead of merely what Western China "experts" are saying about them.

The sensitive and political nature of many of the events annotated here make the texts relevant to many disciplines. The information in the annotations was checked in multiple sources. I would like to express my gratitude to the following online media and indefatigable China watchers who have been especially helpful: Asianews.it, *China Elections and Governance* online, *China Digital Times*, danwei.com, the *EastSouthWestNorth* blog, *Global Voices* online, the *Guardian* online, the *Wall Street Journal's* "China Real Time Report," and both the Chinese and English versions of Wikipedia. The Chinese search engine Baidu and its encyclopedia Baidu Baike, as well as Hudong, China's largest wiki, were invaluable sources in the Chinese language; and for their indispensably "accurate" perspective, I must also acknowledge Xinhuanet.com and various online mouthpieces of the Communist Party of China.

Ai Weiwei would like to give special thanks to Lu Qing, for tolerating his spending so much time on the computer, and to the Chinese editors who did excellent work on the Chinese originals: Ai Dan, Luo Li, and Xiao Xi. And at request and on behalf of Weiwei, Lee thanks herself. He also thanks the FAKE office, especially Zhang Yiyan, for help in preparing the Chinese texts and for offering perspectives on citations; much appreciation to Nadine Stenke and Ragna van Doorn, for archival support; and also to Gao Yuan, photographer Zhao Zhao, and Xu Ye, the technical wizard for all matters blog. Roger Conover at the MIT Press was steadfast in his faith and patience in seeing this blog become a book, and we are thankful for his support. Finally, and most significantly, thanks to the citizen volunteers who helped with the collection of information in Sichuan, and applause for their resilience. We must mention all the cyberactivists and guerrillas who continue to fight for freedom of speech and the freedom to connect; many are staunch online supporters of Ai Weiwei, and we will never forget those who were willing to make their voices heard and are now behind bars. General thanks for the infinite enthusiasm of Ai's readers, subscribers, and Twitter followers. Last, and least (in height, anyhow), Ai Weiwei would like to give special mention to his son, Ai Lao, who gives him courage every other day.

INTRODUCTION

Some people find distraction online; Ai Weiwei finds a powerful medium for social change. In what has become a daily ritual, he devotes hours to his computer each day, simultaneously sifting through news, pouring over tweets, and purging his mind into cyberspace. "I spend ninety percent of my energy on blogging," he said in one interview just before his blog was closed. After the authorities shut down Ai Weiwei's blog, more than 2,700 posts, including thousands of photos and millions of reader comments, disappeared. The address blog.sina.com.cn/aiweiwei, from whence had poured scathing social criticism, condemnation of political policy, and finally a sensitive list of the names of students who were missing or killed in the Wenchuan earthquake, was closed indefinitely; in its place was the following message: "This blog has already been closed. If you have queries, please dial 95105670; click on 'have a look' in the left-hand sidebar to browse other excellent blog texts." The message is still there today.

The somewhat unusual event of translating a Chinese blog for an English print publication has been enabled by the far-reaching definition of contemporary art. As Walter Benjamin wrote in the 1923 preface to his own translation of Baudelaire, "Translations that are more than transmissions of subject matter come into being when in the course of its survival a work has reached the age of its fame."[1] Already legendary as a repository of the artist's thoughts and ideas, Ai's blog has seen more fame and reproduction via the digital revolution than Benjamin could ever have imagined. For Chinese readers, the blog was provocative and controversial; until now, non-Chinese readers could only partially grasp the depth of its content; nonetheless, Hans Ulrich Obrist called it "one of the greatest social sculptures of our time."[2]

The term "artist-activist" is increasingly used in discussing Ai Weiwei, and to his slight dismay, "dissident." His activism is not new; Ai has been on the fringes of China's political vanguard ever since advocating free speech and democracy became possible in the late 1970s. The Internet didn't turn him into an activist, but it enabled his activism on an exponentially grander scale. He has destroyed Han dynasty vases, coated prehistoric stone axes in paint, dissected ancient tables and temples, immortalized a stream of urine in fine porcelain, and brought 1,001 people from China's outer reaches to a tiny town in Germany. He has been labeled a Daoist and an anarchist, or one could even describe his fervor as the "make-revolution" destructive spirit inherited from the Red Guard: no matter what context you place him in, he will revel in subversion, and will fearlessly confront both cultural and political authority.

Influenced in no small part by his father's legacy, Ai Weiwei's audacity is in his blood. The narrative of his life, already mythologized by the media, can be recounted here in brief. His father, the poet and intellectual Ai Qing, had made remarks critical of the regime; in 1957, shortly after Ai Weiwei was born, he became one of the first intellectuals to be politically dehabilitated and labeled an "enemy of the people" in

the first Anti-Rightist Campaign. The entire family of five with infant Weiwei was "sent down" to the hinterlands for labor and reeducation, first to the bitterly cold forests of Beidahuang in Heilongjiang, where they lived on a tree farm. Two years later they relocated to western Xinjiang province, China's "little Siberia," where they literally carved out an existence in an earthen pit. As specified in a series of measures for "rightists" in political exile, Ai Qing endured daily political humiliations, manual labor, and reeducation, and due to his particular fame and influence was assigned the most humiliating tasks. Ai Weiwei was too young to help, but he vividly recalls watching his father scrub the public toilets to nearly immaculate cleanliness.

Ai Weiwei's already politically saturated childhood was infused with the madness of the Cultural Revolution, or as it was known then, the Great Proletarian Cultural Revolution. Instead of studying Chinese, mathematics, or science, students split their time between working the fields and reading Mao Zedong's little red book. The "dictatorship of the proletariat" might have been over their heads, but his generation was instilled with a sympathy for the masses and a social utopianism that is still reflected in Ai Weiwei's artistic practice. When the Cultural Revolution ended and its primary instigators, the Gang of Four (Jiang Qing, Zhang Chunqiao, Yao Wenyuan, and Wang Hongwen), were behind bars, Ai Qing was rehabilitated, and the family returned to Beijing in 1976 to find a liberal atmosphere flourishing in its wake. This period is sometimes referred to as the Beijing Spring. Ai Qing's friends taught Ai Weiwei his basic drawing skills, and he developed an adept hand. In 1978 he was accepted and enrolled at the Beijing Film Academy; later, he said that his enrollment was not so much due to an interest in film as it was a means to "escape society."[3]

Originally encouraged by the new regime as a platform for criticizing the Gang of Four, the Democracy Wall in the Xidan area of Beijing, circa December 1978, marked the first stirrings of political activism in China. Civilians and students publicly voiced their opinions by posting hand-written "big-character posters" on a Xidan neighborhood wall. On December 5, former Red Guard Wei Jingsheng posted his landmark poster "The Fifth Modernization," which called for democracy as the only "modernization" China really needed. His oblique criticism of Deng Xiaoping's "Four Modernizations" (in the areas of agriculture, industry, national defense, and science and technology) and overt public appeal for political change were too much of a threat to Deng's young regime. In the spring of 1979, Wei Jingsheng was arrested and sentenced to fifteen years in prison, and other supporters and activists involved with the Democracy Wall were also severely punished. Their harsh sentencing left Ai Weiwei, who also participated in the Democracy Wall, "very disappointed with politics."[4]

At the same time, Ai became involved in the Stars, a loose organization of artists in Beijing who were asserting their individual artistic expression after more than ten

years of prescribed realism, "art for the people," collective paintings, and propaganda posters. On September 27, 1979, the Stars' first exhibition was hung renegade-style on the fences outside the National Art Museum. Crowds flocked to see the fresh and unfamiliar art styles, before the show was shut down two days later. Influenced by the postimpressionists, who were popular among Chinese artists at the time, Ai Weiwei exhibited a watercolor landscape titled *Landscape IV*. Around this time, when precious little printed material introduced the art world beyond China, Ai was given three art books by a family friend, one on the impressionists and two monographs on Van Gogh and Jasper Johns. "I just couldn't figure out whether it was art," he said of the book on Johns,[5] and it went straight into the trash.

Years later, Ai expressed frustration that not enough people at the time were questioning the traumatic events of their recent past. The sentencing of students involved with the Democracy Wall also left a deep impression on him. Ai left the country at the first opportunity that arose, in 1981, for the United States. He knew he wanted to be a famous artist; he joked with friends that they would see another Picasso when he returned. He has also admitted that he never had any intention of returning.

Arriving in the United States with thirty dollars in his pocket, he eventually settled where he knew he belonged—New York City. In 1982 he enrolled in the Parsons School of Design where, surrounded by a very different art milieu, his impeccable technical skills made him stick out like a sore thumb. He encountered the work of Marcel Duchamp and Andy Warhol, the two artists who would most influence his own career. He never finished at Parsons, and began working odd jobs such as carpentry and house painting. Meanwhile his East Village apartment became a kind of sanctuary for cultural luminaries from mainland China who were hovering around New York. While he described himself as being "in" the art scene but not "of" it, he claims to have seen every show in New York during the eighties. Allen Ginsberg was his upstairs neighbor; though German expressionism, Jeff Koons, and Basquiat then dominated the art scene, he remained infatuated with Dada. His first solo exhibition in 1988, titled "Old Shoes, Safe Sex," featured his early object manipulations: a wire hanger bent into the profile of Duchamp, a raincoat with a condom affixed in a "just so" location, and a pair of shoes sewn together where their heels ought to meet. One forward-looking reviewer praised him as an "irreverent talent" and "a force to be reckoned with in the international avant-garde."[6]

New York wasn't distant enough for Ai to avoid being affected by the traumatic events in Tiananmen Square on June 4, 1989. Shortly after the incident, he endured an eight-day hunger strike with a group called Solidarity for China. Foreshadowing ideas he would promulgate on his blog years later, Ai was quoted in the *New York Times* as saying, "We want to bear witness to what happened and we want the Chinese government to be less brutal."[7] Despite all this, Ai still maintains he was "wasting

his time" in New York (he never graduated from Parsons, he had no property, no citizenship, no wife …), although he inaugurated his Warholian habit of documentation. Having abandoned sketching for photography, he captured his life in self-imposed exile on hundreds of rolls of film that were developed and archived only recently.[8] In 1993 his father fell sick, and Ai was faced with a decision. Never one to straddle fences, he packed up and moved back to Beijing. It was his first trip home in twelve years; he had never even posted a letter.

He arrived to find a nascent art scene growing on the capital's outskirts, where experimental artists were gathering in a place they called Beijing's East Village. Together with Feng Boyi, an independent curator and critic, Ai Weiwei began working on a series of underground publications known as the Red Flag books, released in succession from 1994 on. Titled the *Black*, *Gray*, and *White Cover Books*, these publications had tremendous influence on artists in China. For the artists included in them, they posed the task of conceptualizing their own practice and introduced an unfamiliar mode of critical self-analysis to Chinese contemporary art. The series also introduced the practices of international contemporary art to China, including those of Duchamp, Warhol, and Koons. The "Cover Books" acquired an almost cult status, and are perhaps the closest thing to a manifesto that China's emerging avant-garde can claim.

Ai's experimental conceptualism was precipitated by the infectious creative atmosphere of Beijing's East Village, which begat some of his most iconic images: the Coca-Cola urn, *Dropping a Han Dynasty Vase*, the photo of Lu Qing demurely lifting her skirt before Tiananmen Square. By 1997 he had already begun his furniture recombinations, and his avant-garde activities gained further momentum in 1998 when he helped to establish the China Art Archives and Warehouse (CAAW), China's first contemporary art archive and experimental gallery space. Throughout the 1990s and the early 2000s, Ai undertook countless curatorial and artistic projects, and through his numerous connections and his willingness to cooperate in new projects he earned himself the reputation of an art world enabler.

In 1999, the architectural forms emerging in his artistic practice translated into architectural space with the completion of the now renowned Studio House, Ai's Beijing residence. Inspired by a photograph of Wittgenstein's Stonborough House, he was determined to build his own home-studio, and completed the plans in a single afternoon. The construction lasted only one hundred days, and his career as an architect was born. New gallery space for the CAAW became his second architectural project in 2000. Limited budgets and simple construction techniques spurred the demand for his low-cost, gray-brick chic, and he founded the atelier FAKE Design in 2003 (its Chinese pronunciation is deliberately similar to "fuck"). Before downsizing significantly in 2006, FAKE would realize more than seventy building and

landscaping projects across China, including the ORDOS project in Inner Mongolia, in which he planned the construction of an entire city on desert sands. His revolutionary contribution to Chinese architecture is his elegant simplicity, which stands in cool, stark contrast to the garish China-baroque constructions favored by Beijing developers. The materials in his raw constructions became their sole embellishments, creating dramatic starkness and imbuing space with what he describes as "freedom"—the potential for anything to transpire within them.

The now notorious show Ai co-curated with Feng Boyi proved to be a critical moment in his international career. As a peripheral exhibition to the 2000 Shanghai Biennale, more than forty avant-garde artists were included in a show entitled "Fuck Off" (the Chinese subtitle read: "Ways to Not Cooperate"). It taunted the authorities to shut it down, with artworks that included allegedly poisonous gases and acts of cannibalism. Eventually "Fuck Off" was closed, but not until it was seen by all the right people, including troupes of overseas curators in town for the Shanghai Biennale. Some observers were angered by what they saw as a publicity stunt, as Ai became a highly sought-after interview subject. Nevertheless, the exhibition is unequivocally viewed as a milestone for Chinese contemporary art, and Ai Weiwei was becoming an influential go-to man in Beijing's globalizing art world. His friendship with collector Uli Sigg, the former Swiss ambassador to China, led to the opportunity to co-curate "Mahjong," a significant exhibition that introduced contemporary art from China in Europe, and in 2003 he collaborated with Jacques Herzog and Pierre de Meuron on their proposal for Beijing's new National Stadium (now known as the Bird's Nest). Ai's intimate involvement with the development of contemporary art in China was thus extensive and absolute. When he received a seemingly trivial offer to participate in Sina.com in 2005, no one could have predicted that his already successful career was about to burst into the blogosphere.

To promote the launch of its new blog platform, Sina.com had invited various "celebrity bloggers," Ai Weiwei among them, to open blogs that would be highlighted on its homepage. Before his first blog post, in October 2005, Ai had had almost no contact with the Internet. He even joked that he barely knew how to type. Yet the blog initially appealed to him as a chance to explore his literary talents, which he had been curious about because of his father's career as a poet. He began spending hours blogging each day, discovering in this digital platform a place to divulge his life through photos. Using his Ricoh R8, he chronicled his life with hundreds of photos every day, some of which were posted to the blog daily.

The more than seventy thousand photos in his archives document Ai's works in progress, visits to Jingdezhen or to raw materials markets and factories, visits by collectors and tour groups, the open notebooks of curators and interviewers, dinner parties at his now closed restaurant (called Go Where?), trips to Europe, and nude

self-portraits in hotel bathrooms, among other things. He took photo series: haircuts for his assistants, preparations for *Fairytale*, and early morning photography sessions often featuring his constant companions and gatekeepers at the Studio House, the dozen or so cats that live there. They lounge in the garden; sit on blueprints, books, in urns, on temple fragments, they destroy architectural models—cats are clearly the creative muses in the Studio House.

As Ai explored the connective potential of the Internet, experimenting with how much digital information could be circulated and marveling at how far it would reach, he learned how close he could become to thousands of anonymous readers, and how quickly. This connectivity would soon be exploited for his artistic pursuits and provide inspiration for *Fairytale*, an epic-scale artwork that was facilitated over the Internet. Through his blog he invited applicants to participate in a "mass movement" performance piece that would bring 1,001 Chinese citizens from all walks of life to Kassel, Germany, for Documenta 12. *Fairytale* would be the largest-scale performance piece ever created, an incorporeal labyrinth of interpersonal and cultural interactions whose effects would multiply exponentially and ripple through all layers of society. In it he surmounted all traditional frameworks for local and international art hierarchies, directly harnessing the power of what could be called the "masses" (*qunzhong*), a word that had fallen out of fashion after the Cultural Revolution. The concept was so simple that it spoke to audiences across all geographic, linguistic, and sociocultural borders; in some senses, it was a manifestation of the powers of the Internet.

In 2008, as the capital bedecked itself for the twenty-ninth Olympic Games, Ai Weiwei was one of the first Chinese citizens to publicly boycott the Olympics—even though his name was linked to the new National Stadium, a poignant symbol for Olympic Beijing. For his design contribution he might have been hailed as a national hero, especially with his father's reputation now rehabilitated and his poetry considered an important cultural heritage, but these implicit contradictions of his boycott don't seem to bother him in the least. To the gall of many observers in the Chinese blogosphere, he persisted in flinging invective across the Internet, spurning the glorious ceremonies and condemning the regime.

For Beijing, the honor of hosting the Olympic Games promised to fulfill the new China's collective dream of being on equal footing with the rest of the world. But at the same time that national pride reached a high-water mark, social and natural disasters threatened to dampen the mood. As the giant clock in Tiananmen Square ticked down the days, hours, and seconds to the opening of the Olympics, the triumphant year began with hundreds of thousands of holiday travelers snowed in at train stations on their way home for the Spring Festival (Chinese New Year); then ethnic tensions in Lhasa, the Wenchuan earthquake, and Yang Jia's murderous rampage in a Shanghai police station shocked the nation. Ai reacted to each of these events with a critical

perspective very different from the mainstream opinions that dominate media and online forums. His wasn't the only dissenting voice online to call for social responsibility, government accountability, and transparency, although his was often the most direct. "Many people think that out of all the political writers on the Internet, my essays have the most clear concepts," he said, "and this has been a great influence on them."[9]

Gradually Ai Weiwei became one of the most sought-after social commentators in China, and his fame enables him to take an increasingly outspoken and critical stance. He often entertains more than a dozen interviews a week, with interlocutors ranging from international and domestic press to students and curators alike who query him on issues of art, culture, politics, collecting, and everything in between. As his presence expanded online and his blog began mingling with his artistic practice, Ai Weiwei's lengthening digital shadow encroached on the world of tangible activism, and the threat of censorship grew more ominous.

On March 20, 2009, Ai Weiwei posted an invitation for volunteers to join a collective effort that would pressure the Sichuan provincial government to take responsibility for the shoddy quality of the school buildings that had collapsed during the Wenchuan earthquake, resulting in the deaths of thousands of school children. He called it the "Citizen Investigation," and he promised, "We will seek out the names of each departed child, and we will remember them." The Citizen Investigation called together a loose team of about one hundred volunteers who traveled to quake zones to interview families, officials, and workers and made phone calls from his office, pressuring officials to provide the number of deaths that had occurred. Although many bureaucrats insisted that there was already an accurate figure and complete accounting of the dead, not a single person could identify where the figure came from, or where the list had been previously published. The transcripts of volunteers' conversations were published on the blog, only to be deleted minutes later by the blog host, surely under pressure from the authorities.

The Citizen Investigation produced a list of names, with the date of birth, school, grade, and a parent/guardian contact number for more than five thousand children (the list numbered 5,210 in August 2010). Volunteers met with bereaved parents and collected their stories of being detained in prison or forced to accept payments in exchange for their silence. The investigation resulted in a deep and sensitive pool of resources and hours of footage that was later edited into a documentary film that Ai's office distributed widely and without cost around the nation, almost to anyone who requested it over Twitter. After the Citizen Investigation, blog deletions became more frequent, and tensions increased as police tapped Ai's phone, intercepted text messages, and monitored his house, with two conspicuous cameras pointed at his door and the occasional minivan stakeout. In Sichuan, police detained the volunteers,

delivering messages to Ai through them: "Say hi to Ai Weiwei for us, but he's not welcome, don't let us see him here."[10] On May 26, when plainclothes officers harassed his mother in her home, then attempted to interrogate Ai when he arrived on the scene, he invoked the rule of law, refusing to speak unless the men presented identification. When they were unable to produce police identification, Ai dragged them in to file a report. A few police incidents and deleted posts later, the mounting pressures over the Citizen Investigation and the approach of the twentieth anniversary of the Tiananmen Incident finally contributed to the closure of Ai Weiwei's blog on May 28, 2009.

While volunteers opened new blogs on various overseas hosting platforms, Ai discovered a new forum: microblogging. Ai has said that Twitter's 140 characters are all he can manage these days. But the fact that 140 Chinese characters provide significantly more content than their English equivalent makes microblogging more interesting in the Chinese language. At any rate, Ai deems microblogging better suited to his personality, because it is instantaneous and allows creative outbursts. Besides—as he has been known to say—all of Mao's quotations are fewer than 140 characters long.

The impact of the Internet on Ai Weiwei's artistic practice is indelible. After *Fairytale*, his first major work that demonstrated interaction with the blog, the influence of the Citizen Investigation and reflections on the Wenchuan earthquake detritus were visible in his 2009 exhibitions. Major solo shows at Tokyo's Mori Art Museum and Munich's Haus der Kunst echoed what Ai said was the most lasting image of his visit to the quake zone—children's backpacks lying in the rubble. On the ceiling of the Mori Art Museum, purpose-built black and white backpacks snaked in a coil; at Munich's Haus der Kunst, backpacks in bright primary colors spelled out on the museum's entire facade a quote in Chinese from the mother of a victim: "She lived happily in this world for seven years." The mother, whose daughter was one victim of "tofu-dregs" school engineering, had written a letter to Ai which he posted on his blog.[11] The anonymous backpacks were like the names of children who had been reduced to mere figures. Through the list, Ai attempts to replace each fraction of that figure with something capable of symbolizing the unnecessary loss of life, and restoring to these children the only thing that belonged to them in the world: their names.

Intermittent volunteer arrests stunted the progress of the Citizen Investigation. Although most were detained and then released after brief questioning ("Are you working for Ai Weiwei?"), the intellectual and activist Tan Zuoren was one prominent exception. Tan Zuoren had independently begun advocating for the collection of names shortly after the Wenchuan earthquake. When he was detained and charged with attempts to subvert the state, it was clear that the charges were being levied as a result of his involvement with the collection process. In August 2009, Ai traveled to Sichuan with assistants and several other activists with the intention of testifying at Tan Zuoren's first trial. Shortly after their arrival in their Chengdu hotel on August

12, it was apparent that the local police were aware of their movement. As customary for Ai and entourage, videographers were filming the entire process. Ai was awakened at nearly three o'clock in the morning by pounding on his hotel room door. When the police entered, there was a scuffle, recorded in audio only, and Ai was struck on the head, sustaining head injuries that weren't properly diagnosed until he arrived in Munich in preparation for his exhibition at the Haus der Kunst that September. On September 14 doctors in Munich diagnosed a cerebral hemorrhage and immediately undertook a life-saving surgery; the hemorrhage was believed to be a result of the beating he had sustained in Chengdu. After the surgery, the painful headaches that had been plaguing him since the incident subsided, but his concentration and focus still suffered.

Ai Weiwei's sagelike reputation in the Chinese art world and his later blog notoriety have made him a nearly untouchable figure to authorities who might otherwise have stopped him, but he is not above being criticized. Chinese observers tend to confront him with equal parts awe and censure, and when the blogosphere speaks, he reacts through his sometimes erudite, othertimes lowbrow prose.[12] When critics challenged that he only dared to criticize because he held a foreign passport, he posted his Chinese passport online. The most popular insults include "shameless," "unpatriotic," and "a lackey for American imperialists." Other contemporaries believe his enthusiasm for critically engaging the authorities and his confrontational conversational habits are a result of what has been called "post-Cultural Revolution stress syndrome." But he may have summarized his personality best himself when he wrote, "All the defects of my era are reflected in my person."[13]

Generational defects aside, Ai Weiwei's father was an enormous influence on his extremism. Although he trained as an artist, Ai Qing was a well-known poet in pre-revolutionary China, and poets in his day were necessarily political revolutionaries. After the 1942 "Talks at the Yan'an Forum on Literature and Art" that unified all communist intellectuals and artists under the directives of the party, Ai Qing's poetry became a tool for "inspiring the masses" to make revolution and to sympathize with the communist cause. His father's own distinguished literary accomplishments energized Weiwei to try his own hand at writing; perhaps he feels a degree of responsibility to address the wrongs of the political party his father once supported.

There are an estimated fifty million blogs in China, and with the rising influence of blogging, microblogging, and bulletin board system (BBS) sites among the computer-literate post-1980s generation, no one can deny the Internet's growing power in shaping public opinion and advancing the development of civil society—the state least of all. In China, information spread on blogs enjoys a uniquely high credibility because, unlike in nations with accurate and free news sources establishing a public record, the antiquated media on the mainland are thoroughly managed from top to

bottom, susceptible to information blackouts, and highly sensitized. In addition, incidents like the SARS scandal in 2003 highlighted the already widespread distrust of the media. To the chagrin of many, the Internet increasingly threatens the monopoly on information held by sanctioned news factories such as the Xinhua News Agency, the party's answer to the Associated Press. News of social unrest, worker strikes, or other scandals breaks first over the Internet; and blogs and BBS sites have become recognized as irreplaceable information channels, China's only outlets for critical or alternative viewpoints.

The enormous popularity of blogs has begotten a unique brand of blogger celebrity, such as the piquant young Han Han, currently the most popular blogger in China and thus the most widely read blogger in the world, with his blog receiving nearly 100,000 hits every day. Although he dropped out of high school, Han Han won a prestigious literary award in the same year. He also went on to write China's best-selling novel of the past twenty years, following it with four more. The unapologetically independent views Han Han promulgates on his blog have earned him the handle "the voice of the post-80s generation." His blog sparks debate with his acerbic social commentary, and he himself endures occasional censorship because of his unwillingness to avoid sensitive topics. Han Han's popularity demonstrates that his generation is capable of more than self-centered consumerism and isn't entirely lacking in social responsibility. Han Han's "rational thinking" on political and cultural issues has even earned him praise as the "next Lu Xun."

Outspoken Chinese bloggers are posing a serious challenge to the government, which is constantly negotiating between citizen satisfaction and the control and suppression of information that might "upset social harmony." As Google Inc. is well aware, censored search results and blocked Web sites are a frustrating reality inside China's Great Firewall, but with various "ladders" to "climb over the wall" (fanqiang) it is becoming harder to conceal facts in the age of global communications, and Chinese hackers are one step ahead of the programmers. Disparities in access to information have given rise to a whole new era of tense international relations. In countries like Iran, Tunisia, Uzbekistan, and Vietnam, various official attempts to thwart Internet surfing eventually led to Secretary of State Hillary Clinton's speech on the "freedom to connect" in January 2010.

Like Ai Weiwei, countless bloggers have had sensitive posts removed, and cyberdissidents have even been imprisoned. Authorities are working to make censorship so accurate that the Great Firewall might become obsolete. Demonstrating their commitment to information control, a network of "secret police" estimated at more than 280,000[14] perpetually trolls the Internet, almost immediately deleting posts that aren't politically correct. In addition, the "fifty-cent army"—paid commentators trained and funded by the state—manipulates public opinion in chat rooms or in blog comment

feeds. Comments advocating the official line have even begun appearing in comment feeds on English-language news coverage, attempting to shape public opinion around the globe. For months after the July 2009 riots in Ürümqi, the Internet and text messaging were shut down across the entire Xinjiang province. But the guerrilla war for Internet freedom has already begun, and the increasing severity of official counteractions reveals a definite nervousness about the threat connectivity poses to the regime.[15]

Ai Weiwei's writing has activist implications, but the texts collected here are not all political posts. They represent the very best of his blogging between 2006 and 2009, completing a profile of the artist and his unique worldview, one equally shaped by Marxist theory and underground New York. These translations reveal at last Ai Weiwei's progressive, humanitarian views in his native voice, covering everything from evolution to animal rights. The texts also divulge memories; and ideas and themes significant to his personal philosophy emerge as distinct threads, such as simplicity, official responsibility, reconciling "truth" with facts, and a commitment to promoting basic civil rights like freedom of speech.

The chronological organization of the book evokes the artist's subtle interactions with his audience while also reflecting the sociopolitical context and a whirlwind of unfolding events. The biggest share of the texts presented here were posted in 2006; these include original posts written for the blog along with postings of Ai Weiwei's previous writings. In 2007, preoccupied with *Fairytale*, he posted more photos than words. In 2008, during Beijing's Olympic preparations, there was a sharp rise in political irony in the texts, which carried through into 2009 with Ai's heightened sense of political awareness and involvement with the Citizen Investigation. Many of the final posts before the blog was shut down included journals and notes from citizen volunteers working in Sichuan and lists of students' names; these posts have not been included here.

Ai Weiwei's writing style often elicits the extreme reactions of love or hate. This translation adheres as closely as possible to the author's idiosyncratic style, indulging his manifestoesque statements, run-on sentences, and penchant for blending vulgar curses with the most eloquent of insults. Due to his heavy use of literary allusion and many cryptic references to Maoist language or current events, the hidden meanings in Ai's prose style can be difficult even for Chinese readers, and removing it from its cultural context has increased the need for annotations; the footnotes here attempt to elucidate the implied cultural references.

Internet literature is breaking and making the rules as it evolves, reflecting the nature of dynamic language in a global era. In these texts, Chinese words have been directly transliterated in some places, with the hope that one day pinyin won't look too foreign to English readers. There are also some "Weiwei-isms." Ai uses the term "C Nation" (*C guo*) as an obvious indirect reference to China and double entendre,

with *guo* attempting to evoke the classical character for "kingdom" and its feudalistic sense. But in "My Regards to Your Mother" (see the 2009 texts), a direct translation of *wenhou ni de muqin*, an Internet euphemism for the dirtiest of insults, will remain buried in cultural obscurity for most readers. On a few occasions Ai makes metaphorical references to China as a battered old ship, but more often he disapprovingly alludes to it as a "patch of land." He also uses classical language to compare the party and its policies to a ruling dynasty, referring, for example, to lawyers "for imperial use" or "palace eunuchs." The nuance of classical Chinese is diluted in translation, but his analogy should be clear.

Other usages are direct translations: "humankind" (*renlei*) reflects the gender neutrality of the term in Chinese; recurring netspeak, like "P citizens" (*pimin*) and SB (*shabi*) is explained through annotations. Popular Chinese Internet memes such as "eluding the cat" (*duo maomao*) and "doing push-ups" (*fuwocheng*) are sociological peculiarities in the Chinese Internet world, and are explained in detail; references to Cultural Revolution-era agitprop or Deng Xiaoping theory have also been annotated. Asian names appear according to the Chinese convention of placing the last name first, and the Hanyu pinyin romanization system and metric system have been used throughout.

Years from now, phrases such as "doing push-ups" will sound outmoded, but they will testify to the strangest events of these times, silent written evidence of incidents that certain parties would have whitewashed from the historical record. Ten years ago they would have succeeded—but the Internet has proved an invaluable tool in preserving the collective memory of a nation that has had too much experience with amnesia. Ai Weiwei is all too aware of this, and in the cyber fight for civil rights in China he's crusading on the front lines, blurring the lines between his artistic practice and his activism.

As for Ai Weiwei's activism and the artistic legacy he has bequeathed to a generation, unanimous approval would be impossible. Condemned by few, controversial to others, Ai's commitment to unequivocal freedom of expression has nonetheless earned him praise from all corners of the world. Free speech should be at the foundation of any authentic artistic practice, and in his struggle to bring that basic right to a greater populace, his art truly serves the people.

2006 TEXTS

Problems Facing Foreign Architects Working within a Chinese Architectural Practice

POSTED ON JANUARY 10, 2006

China has rapidly become the fastest developing and largest-scale economic entity in the world. This phenomenon has, in turn, transformed the Chinese architecture market into a force that the whole world watches attentively. In the course of its nearly thirty-year conversion to capitalism, China has accumulated great hopes and demands: thousands upon thousands of villages are more closely resembling cities, more than 100 million peasants are now becoming urban dwellers and industrial producers, more than 100 million households are in the process of relocating. People thirst for overnight riches, and they are always ready to reinvent themselves, to live in new homes, new neighborhoods, new cities. Desire has stirred this ancient culture from the dead and allowed it to live again, suggesting, moreover, the revolutionary potential for a completely new attitude toward the state of human existence.

In nearly one hundred years of Chinese social practice, a variety of social ethics and aesthetic forms that employed traditional cultural forms as their foundation have been scarred and battered—nothing remains. What has replaced them is a Marxist concept of utopia, the cruel ideology of "class struggle," and an inhuman societal reality. The economic reform and opening[1] nearly thirty years ago was the unavoidable choice for this calamity-ridden people at a historical impasse. After several decades, this choice has already pushed this land of 1.4 billion people into gradually becoming a part of global economic and political systems. China and the world were mutually astonished to discover each other, and this has forced both parties to rediscover themselves, and to refigure the world's spatial hierarchy as well as the structure of all its systems.

In every sphere of its influence, this nation—whose architectural output has recently surpassed the sum total of its entire architectural output over its combined thousands of years of cultural history—is currently displaying all the charm of a famished beast. China is consuming one half of the world's concrete and one third of the world's steel, and it is producing nearly half of the world's textiles. These contemporary realities are causing the world to stare, and to gasp, eyes wide open, mouth agape.

In the midst of this suffering, the Chinese people are learning loathsome realities, one after another. After struggling for the past one hundred years, we have returned to those inescapable foreign systems of thought, "science and democracy,"[2] and as we share in the fruits of human culture, are discovering that we must also choke down other harsh realities.

Chinese architectural practice, aside from just barely managing to solve the basic demands for sheltering its people, has no spiritual substance or cultural legacy. In facing the speed and scale of today's development, avant-garde culture and mature technological resources gained from abroad represent the necessary path to fulfilling the demands of China's development. This is a question of life and death, not a question of emotional preference. Although the situation is thus, in different times and practices, clear reasoning nevertheless suffers from crazed obstacles posed by outdated traditions and the special-interest groups who represent such beliefs. Such forces have persistently advanced under the mottoes "to benefit the nation" and "for the national spirit" to cover up the hypocrisy of such cultural viewpoints and the incompetence on an academic level.

"A changing China" has attracted global interest. Over the past several years, a great number of foreign architects and structural engineers have taken on projects large and small around China. These offices include both the "elite" pinnacle of global architectural culture and large-scale, functionally flawless, commercial enterprises. These also include idealistic young architects attempting to discover new things and to put their ideas into practice, and equally as many college students. They bring all of their past knowledge and experience to this unknown land and unknown culture.

Those practitioners who possess an astounding courage must take the greatest risk that any risk-taker could possibly take: they must face the infinite confusion created in the many situations in which they encounter different languages, lifestyle conventions, systems and structures of social power. They likewise confront projects of enormous scale consisting of opposing cultural values, unimaginable speeds, low fees, lack of clarity, illogical ordinances, simple tasks, complicated goals, absurd operational routines, and fickle, unclear, ambiguous projects that lack verifiable foundations or laws to follow.

The mysterious culture that birthed Confucianism and Daoism, adopted Buddhism, and likewise has faith in a system for realizing socialist ideals; this cultural tradition with the most comprehensive and systematic ethical code, yet the most materialistic, desire-driven reality; this society overloaded with dogmatic political theory but likewise inundated by laissez-faire practice; this plot of land is energy and injury, it bears possibilities and impossibilities, opportunity and danger, surprise, excitement, frustration, and despair.

People still come to China, and pay attention to her, because she is a part of humankind. Be it in her philosophical significance or in real life, China is becoming a veritable, irrefutable part of world culture. As the West confronts China, it is also coming to recognize the other side of the world as another potential mode of civilization and humanity. In doing so, perhaps it is likewise recognizing the limits

and weaknesses of reason and order, and experiencing the happiness that comes from realizing this.

WRITTEN DECEMBER 16, 2004; TRANSLATED BY PHILIP TINARI

Architecture and Space

POSTED ON JANUARY 13, 2006

The most important factor in architecture is space. The relationship between space and subject, the relationship of space to other space, the beginning, continuation, transformation, and disappearance of space …

Light defines objects and gives spaces their unique characteristics. The strength or weakness, direction, and changing nature of light and shadows alternately invite and repel people's emotions. Emotions are the primitive foundation of aesthetic sense.

The volume of light, proportions, structure, and materials determine how we experience space. Space can also be psychological, it is capable of arousing the imagination.

A person's sense of space has an inscrutable effect on his emotions and intellectual existence. When a person attempts to determine his relationship to a space, he attempts to understand that which is outside of his own body, he attempts to understand existence beyond the material.

Our understanding and description of a given space originates in our understanding of things that will one day occur in the given space. This includes the reasons why events occur and the reactions they provoke. To understand space is to be human.

To better understand the potential of space and its related events, you can examine a leaping cat, or the raising of a flag.

A builder's grasp of space and of the possibilities for formulating space reveals his understanding and interpretation of himself and what lies outside himself. This is the recognition of limits, and a feeling of restraint.

When people attempt to understand existence outside of humankind, including a prehuman age and what will be a posthuman age, puzzlement ensues. Such bewilderment, and the attempt to interpret it, are a dream from which it is impossible to extricate ourselves—the reality of existence is the reality of puzzlement. It is ubiquitous, and our eternal pursuit of truth originates in our perpetual dependence on bewilderment.

People become their own obstacles, and the inability to transcend these obstacles is the fate of humanity. Enlightenment seems ever unattainable.

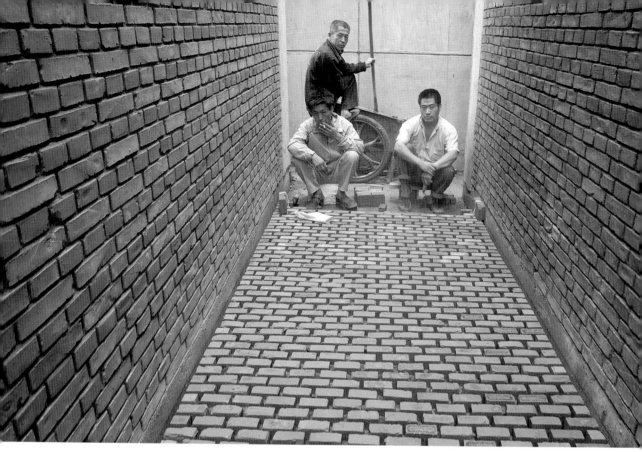

1.1, 1.2 Bricklayers at work on the Caochangdi Red Brick Galleries, March 19, 2007.

Construction is not a natural act, it is something that mankind does to benefit itself. Utilitarian function is dictated by how you use something, how you use it simultaneously dictates who you are, and the implications of your existence.

Ways of building perplex people. Stating thoughts and emotions, conquering material obstacles, penetrating or prolonging sentiment can all cause material things to become psychological carriers, and enable material objects to transcend themselves.

Objects are essentially objects. But the objects we see are never essentially the objects themselves; what we see is merely what we see.

Strive for clarity, simplicity, straightforwardness, and accuracy when building. In addition to "is" and "is not," "whether or not," "or," "other," and "also" similarly exist. In many situations, the art of building now faces the problem of how to provide effective devices. Power is manifested as the destruction of people's psychological order. Uncertainty is eternal puzzlement—something that cannot be conveyed in

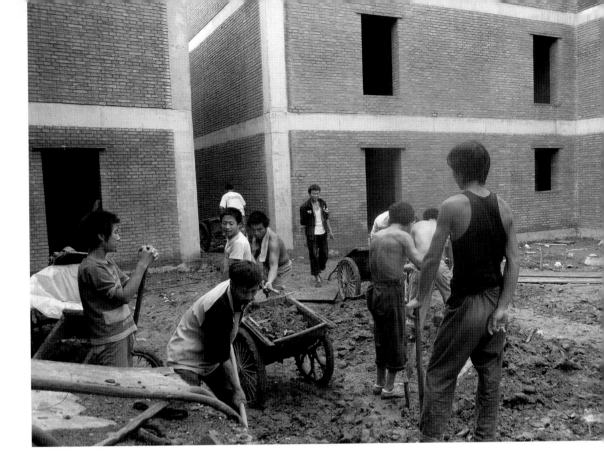

words. If any constructed object is not imbued with its builder's reverential spirit for the unknown, or does not make a higher intellectual appeal, then it is merely a dumping ground for materials.

The difficulties of construction originate in the fact that the experienced and the inexperienced will face the same kind of difficulties; the inexperienced strive to gain experience, and the experienced strive to abandon their experience. Such attempts are futile, like waiting for a gust of wind that might fill us with good humor, yet such a wind never arrives.

This is like playing a game that seems simple, but there is no way to find the obvious answer. Thus, we cannot help but overthrow all of our previous efforts and begin again. The problems of construction are in fact of a philosophical nature, for building is a game in which we must never cease in returning to the beginning. Every attempt to build marks an attempt at questioning, but the answer always slips away, like a black

cat attacking its own shadow—futile. When we begin again, all that remains is a thirst for authentic objects and ideas, with the intention of getting closer to the purpose. Once a game that never should have begun has started, it will never end.

Artists are not beauticians. They are not obliged to provide services to anyone, they do not need to create pleasing scenery. Art is a type of game—you either play the game or you pass. It's up to you. The relationship between art and the people is a normal relationship in which neither side serves the other, and the only difference between public art and ordinary art resides in the fact that public art is placed in a nonprivate space.[3] This makes you unable to do certain private things while beside the artwork, but at night, when no one's around, you can still urinate beside it.

The "public" in public art actually refers to a personal space. It does not contain an artistic value judgment. It does not serve the public. It was not created for the public. It could be targeted at the public, but it could also completely ignore the existence of a public. Here, art has simply made effective use of a public spatial environment. It does not have an obligation to beautify or to adorn.

If you want to believe in public taste, you must have sufficient faith in the people. If the public can become infatuated with a piece of fabric dyed red with chemical pigments, then it definitely can love—or at least understand—a concrete barrel.[4]

The public's normal state is one of numbness, but if you stimulate the public, it will reap a sense of happiness. Construct a 100-story building, and everyone will come to take a photo in front of it; yet if that same building is destroyed, everyone remains as happy as if they are celebrating a collective birthday.

Art is an artist's business. The ultimate relationship between artwork and spectator is difficult to judge, and is sometimes entirely separate from the artist's original intention. Understanding art is like taking drugs: you either don't know what it means to be high, or you've already gotten high and you'll never again need someone else to explain it to you. You know if you're pretending.

I don't understand what it means to "beautify the environment." Why does the environment need beautification? Who will beautify it, and how? The most common result is the opposite of what is intended. Most public art is the embellishment of popular and mediocre sentiments, the approval of a safe and stable state of mind, and an abuse of a practical value system and the aesthetics of the ruling class.

The core beliefs of middle-class society have been formed by a mainstream, orthodox consciousness, a sense of security, and various attempts to aestheticize these; the series of related emotions produced by this phenomenon as well as the many efforts expended on behalf of this goal also contribute. These types of societal ideals as well as the laws, education, propaganda, and their many costs are the basis of a mediocre government and social aesthetic. Interesting artworks effectively disturb tradition, this popular and vulgar aesthetic, and social ideology. Attacks on and subversions of this

mediocre visual system, ideals, and beliefs have led to the formation of a conflicting relationship between modernism and real life. They have also revealed modernism's true identity.

An artwork unable to make people feel uncomfortable or to feel different is not one worth creating. This is the difference between the artist and the fool.

TRANSLATED BY PHILIP TINARI

Photography

POSTED ON JANUARY 16, 2006

The practice of photography is no longer a means for recording reality. Instead, it has become reality itself. Photography as a medium is also endowed with all the fundamental implications of a material object, such as scale, density, and focal points. It also acts as a gauge for all potential realities, having evolved into a marvelous relationship between our understanding of material images and photography as a material object itself. Images become an important reference point for distinguishing between the authenticity and potentiality of objects, and within this distinction they once again become truth itself.

Photography as reality provides the act of photography with another layer of significance. This is similar to the seemingly truthful—but actually false—state of various kinds of "knowledge." No matter whether or not we are convinced of the information that is presented to us, every bit of it is useless in allaying our doubts about the likelihood of the photograph. Analyzing light, density, and amounts causes logic and emotion to become dissociated amid a dependence on facts and feelings of unfamiliarity.

Once photography has broken away from its original function as technique or means for documentation, it is merely a fleeting state of existence that has been transformed into one possible reality. It is this transformation that makes photography a kind of movement and gives it its distinctive significance: it is merely one type of existence. Life is merely an undisputable fact, and the production of an alternate reality is another kind of truth that shares no genuine relationship to reality. Both are waiting for something miraculous to occur—the reexamination of reality. As an intermediary, photography is a medium endlessly pushing life and perceived actions toward this unfamiliar conflict.

WRITTEN JULY 25, 2003

1.3 Ai Weiwei gives his camera to a friend during a New York civil rights march, c. 1987.

With Regard to Architecture

POSTED ON JANUARY 22, 2006

Architecture has always been, and will always be, one of humanity's fundamental activities. This basic activity has moved, and always will move, in tandem with humanity's basic needs for survival.

The essence of architecture lies in the search to satisfy the demands for human survival and in transforming people's life state. This could be a demand for safety, comfort, desire, or individualization. Similarly, this could be a demand to display one's power, pursue one's will, express a fear of god, or manifest one's morals.

As different architectural forms attempt to regulate the different manners of any given person's activity, they simultaneously inform us of who this person is, how he or she is different from others, and of his or her predicament and ideals. Architecture can also be silent. It can remain aloof above the world's popular discourse, like a stone statue buried in a riverbed.

The many human efforts that go into creating architecture represent our place within the natural world, and our understanding of order and possibilities. The essence of this understanding is a reflection of people's worldview. It reflects the philosophy of an era, political ideals, and aesthetics, but in material form. It possesses dimensions, materials, functions, and form, and at the same time architecture is endowed with the tasks of acknowledgment and of recognition. No matter what type of architecture we consider, or from what time or place, all architecture will reveal who the builder was, will reveal the meaning behind this architectural action, what kind of building it is, how the builder interpreted and depicted the state of things, how he or she envisioned possibilities, made necessary choices, how he or she regulated our manner of behavior and our ideals, and thus eliminated outdated clichés. It will also reveal how they told people, "Things can also be this way, this is better for everyone, more interesting, more convenient, and distinguishes us from the past."

People live, people act. At the same time that people are living and acting, they are also interpreting the potential of life and the possibilities of their actions. Living and acting are basic human activities. Living and acting have always been, and will always be, accompanied by suspicion, hesitation, and uncertainty. Striving to bring oneself closer to the essential, observing the meaning of one's personal fate, or describing the logic of one's actions can all turn a builder into a disaster victim who must shut his eyes in the darkness, which might be the only way he can finally see anything. A building more resembles a necessary action; only then might it attain its directive or have some sort of meaning. Observe a child's happiness while playing on a sandy beach—the entire significance behind his or her happiness lies in the action of participating in a transformation that is taking place. Among the delights of architecture, this is real significance.

Any well-founded architecture or urban plan is like a person's behavior. There is no way to cover up someone's inherent nature, they could be wicked, crazed, inimical, narrow-minded, or ill meaning. Similarly, we can see how people express their good-hearted desires and appease their souls using cities and architecture. But what we see more frequently is how people mutilate themselves, how they are filled with enmity, how they worship deities. This is why, when entering a city, I sometimes say, the people here are crazy, they cannot be fortunate, for the people here have no way of understanding the natural order. They have no means of feeling the sun's rays, raindrops, or the wind against the exterior surface of a building. They lack mysterious light or fast-changing shadows, they have no complicated space or form, no comprehensive understanding, no frankness of attitude, no tiny details. People here are numb. They are crude, or they cling to styles, methods, and expressions that never change. Architecture is not the theory, skills, styles, or schools promulgated by architecture institutes; architecture is the suitable manifestation of morals. It is the ultimate manifestation. It must rid itself of doctrinal ties and sensibilities. It must become itself.

1.4, 1.5 The Studio House in the early morning, August 2006.

Although any morally despicable person can cater to a similarly jaded era, good architecture must necessarily come from good morals. Ultimately, architecture is a kind of interpretation. It can also be an attitude for dealing with things; thus, we could deem it either sincere or insincere. Good architecture is necessarily provided with good judgment; architecture of muddled character and low tastes stems from a muddled mind. Good architecture necessarily has spiritual implications, because the way in which we view the world and the conclusions we arrive at determine who we are. Good architecture cannot be duplicated, it inevitably possesses innate beauty, it cannot be copied. It is one time only.

Modernism is not a fad, nor is it a style or trend. Modernism is an attitude toward life, a worldview. It is a system for people to decipher both today and tomorrow. Among the many types of cultural thought, only the modernist modes of thinking are effective, and they are effective across all realms of cultural behavior. Aside from modernist methods of comprehension and analysis, all other foundations and attempts are

unilateral, temporary, or provisional. This includes all the stale platitudes that attempt to invoke the banner of modernism. Authentic modernism's understanding of people and its evaluation of society are developing, are uncertain and unknown; they are also relative. Modernism with a critical edge excludes all previously formed conclusions, including modernism itself.

2. <u>All love is self-love.</u> All interpretation is self-interpretation. The value of "interpretation" is that through it, one might expose reality, or explain oneself. But interpretation is also a reality, and its practice is likewise an event. Reinterpreting a very common truth is one of the pleasures of our game. It is necessary to spare no pains in interpreting, for no matter how we change, we are all forever expounding on a basic truth. No matter whether or not we are willing, repetition is unavoidable.

To speak of beautiful dreams and grand ideals is safe—you could go on forever. But to realize them through action is dangerous. You will stumble over the very first stone that lies in front of you. What's more, actions cannot be accomplished with imagination. Action can only be executed with actions. Interpretations or understanding of behavior are merely interpretation and understanding; they do not have a deeper meaning. "Action" and "nonaction" is the same. With regard to certain problems, we have few choices.

WRITTEN FEBRUARY 20, 2004; TRANSLATED BY PHILIP TINARI

Chinese Contemporary Art in Dilemma and Transition

POSTED ON FEBRUARY 4, 2006

In China, contemporary art has been openly accepted by society and become widely known to the public in only the past few years. "Improvements" in the cultural climate have come about not because of an ideological acceptance of contemporary art on the part of this communist nation, but as a result of reform and opening and the triumph of Western material culture and lifestyle over this plot of ancient land. These improvements also stem from the gradual recovery of self-confidence by a people who hope to test their position of prestige among the contemporary cultures of the world. Despite this, and after years of art exhibitions and related discussions, modern art audiences are limited to circles of the artists themselves and a few other small groups.

Because it lacks a foundation in contemporary political culture and society, contemporary art has been labeled as "bourgeois spiritual pollution," and viewed as a product of degenerate Western ideology for several decades. China's culture and art likewise played no active role in social ideology, and lack a rational attitude or independent outlook on social reform. Even after so many years, it has yet to emerge from the relatively closed-minded state of "self-adjustment."

This state of affairs is simply the continuation of a long tradition of psychologically dodging one's own fate, the idea of "maintaining personal purity and integrity" that still prevails among China's cultural elite.[5] Although contemporary art from China has little direct participation in the unprecedented social transformations occurring today, it still exhibits a firm grasp of reality through its rich expression of reason and emotion and through its reflections of history and its opinions on the possibilities for modern life. Most works still evade issues of politics and society, or address such issues only via cynical asides, equivocation or ambiguity, evasion, self-mockery, ridicule, self-flagellation, introverted self-regard, or an almost monastic focus on one's personal awareness.

Since the end of the Cultural Revolution and after the 1979 Stars exhibition, which was the first public attempt at emancipating individual artistic expression since 1949, contemporary art from China has attracted attention and regard in the West for its "anti-establishment" ideology. Even today, when China's government is not what it once was, this kind of simplistic ideological labeling still occurs. These Cold War-based concepts arise on the one hand from simplistic judgments based on a flawed understanding of another culture and its development, and on the other from the complexity, chaos, and fractured illogic of modern society in the political and cultural environment that is today's China.

It's not at all strange that the contemporary art system in the West, from galleries to museums, art critics, collectors, and cultural activities, should view art from a distant and mysterious Eastern country such as China with curiosity and bewilderment. Furthermore, due to the long-term isolation and peculiar nature of this feudal empire, it remains difficult for Westerners to gain a true understanding of contemporary Chinese art—even at the most basic level of understanding "where," or "what happened." In most circumstances, introductions to and exhibitions of this country's modern art are brief, fragmented, and arbitrary, executed carelessly or only out of a sense of novelty. Who can imagine the soul-stirring calamities that occur in the deepest oceans by simply observing the flotsam and jetsam washed up on the bright and sunny shores?

In most cases, in the East–West cultural exchange exhibitions prevalent over the past few years, both large- and small-scale exhibitions, as well as the majority of works by overseas artists shown in domestic exhibitions, stem from a lack of common sense about the current cultural conditions or state of existence, or from conditions of irrelevant self-interest that occupy the largest part of the market. This art addresses politics and ideology in a simplistic fashion, attempts to address small and big matters all at the same time, and boasts political correctness, while such hypocritical and sanctimonious actions were dictated by absolutely Western standards. Constant misinterpretation, infatuation with misinterpretation, and an infatuation with this "infatuation with misinterpretation" leave the interpretation of contemporary art from China caught up in a farce as each generation proves lesser and weaker, a perfect reflection of the many dilemmas that beset contemporary art throughout the process of cultural exchange.

Under the mighty influence of Western cultural standards and cultural discourse, we can see Chinese contemporary art continuing to move gradually toward confidence and maturity, even despite China's political/cultural fragmentation and disintegration. This maturity arises from knowledge about the present world, and from consideration of one's own cultural surroundings.

Over the last one hundred years, China has experienced political, economic, and cultural calamities not comparable to those of any other nation or country. The deep historical and cultural causes of all these wrenching transformations, and the political and cultural complexities and possibilities brought on by these changes, are unique in human history. The arbitrary, chaotic, uncertain, and changeable elements in Chinese culture (which are rooted in the Chinese people's understanding of their place within nature) are precisely what so often lend it its miraculous powers of recovery. They allow it to snatch victory from the jaws of defeat, and to find new life on the brink of death.

Looking back over the past thousand years of history, China has been conquered and ruled many times by outsider cultures or foreign nations. Following each of these

massive political and cultural upheavals, she has absorbed some characteristics of the invading nation and then returned to normality, with her new cultural modes.

Interestingly, two thousand years ago, the Han dynasty (25 BCE–220 CE) was the most perfect embodiment of China's central plains culture, and the Tang dynasty (618–907 CE) represented the total domination of the Persian culture over China. Today, the unprecedented enthusiasm displayed by the entire Chinese nation for the alien Tang culture is truly mystifying. During the Tang dynasty, all aspects of culture—from aesthetic principles to everyday sentiments ranging from the spiritual to the material—were subverted and remade. Later, the artistic styles and forms of the Tang, originally unrelated to traditional Chinese culture, were universally accepted as her most quintessential representations. All of this stems from adopting the West's approval of the value of a culture similar to its own, and such approval makes up the imaginary storyline of culture and implied consent. Different values coexist and complement each other, then resolve and integrate into one, in a process that has long vexed the development of China's history and culture.

Over the past twenty years, China's artists have lived through violent political, cultural, economic, and ideological changes. Shifts in political power have—without exception—been accompanied by ideological struggle. Economically speaking, a system on the verge of extinction remade itself as a materialist society; a society replete with utopian communist ideals transformed to a society beset by both crises and potential, and one becoming more integral to the world. The profound cultural uniqueness resulting from this series of changes still holds a mysterious power.

The lives of Chinese artists are marked by remarkable multiplicity and confusion, change and disorder, doubt and destructiveness, a loss of self and the emptiness that follows, hopelessness and its attendant freedom, shamelessness and its accompanying pleasures. Reflection on and exploration into China's politics, her history and culture, into the individual and the collective, reform, the authenticity of the self, repentance, spirituality, sex, the West, material wealth, art, and methodology are now commonly seen in artworks.

The indistinctness and uncertainty embodied in these works, their ability to change and transform, their secular nature and their mistrust of public morality, and their spying on the individuals' inner world make up the inquiry into the national plight by contemporary Chinese artists. Metaphor, ambiguity, manifold significance, illusion, and the willingness to deliberately confound right and wrong have always been signature expressions of Chinese culture and particular modes of thought and speech within this ancient Eastern country. If we abandon our understanding of both ancient and contemporary Chinese history, especially her unique quandaries and their connections to the West, we are ill equipped to understand the value of contemporary Chinese culture. Without an understanding of the true implications of contempo-

rary art in China, artistic exchange will come to a standstill, suspended at merely a superficial glance.

Only a solid grasp of the above concepts will allow us to avoid Orientalism, cultural colonialism, and the simplification of conforming to absolutist Western art standards. Only thus may we face the true plight of this nation's culture, the true state of its arts, its true psychological characteristics, and embrace it as a true alternative. Perhaps this world is no different from the world we are familiar with, or perhaps we believe that everything we are familiar with will eventually become strange and turn upon us. The stability of the physical world is no longer certain, but the power of fantasy is thus born.

The problem of the international status of contemporary Chinese art, like so many issues expressed in Chinese art, is related to reality and our understanding of it, to certain characteristics and ways of expressing them, to the right of existence and the legality of our cultural rights.

The pursuit of identity and cultural values is evident in so many works by Chinese artists. This pursuit reflects the formation of a new set of values that occurred following China's revolutions and in the midst of reform. Behind these immense queries, artists are likewise casting doubt on the truth and legality of old, authoritative value systems.

A hazy world follows a moment of clarity, and with our knowledge and in our quest for knowledge, the powers we marshal in pursuit of this desire and the prices we pay for it all lead us toward an ideal world. What will become of art in such a harmonious world without wants or desires? Will we become a part of it?

Uli Sigg is a former Swiss ambassador to China. Before taking that position he already had years of experience working in China, and was both an important participant and an incorruptible witness to the process of reform and opening that distinguished China's recent history. Before he was appointed ambassador, he was a professional athlete, and he was also a journalist for many years. Mr. Sigg has had tremendous influence on political, economic, and cultural understanding, communication, and cooperation between East and West. His experiences in China are among the most unique and significant of his rich and varied life.

Mr. Sigg has spent the last decade completing his Chinese contemporary art collection. During this time, contemporary art in China has gradually transformed from the activities of a small minority to a public institution in the global eye, and today, it is a rare exhibition of substance that does not include a Chinese face. The energy created by Chinese art, its strange and idiosyncratic expressions, and the attention and praise it has attracted all attest to the fact that art and artists from China have already stepped onto the world's cultural stage. Sigg's collection follows China through its vast series of reforms—reforms affecting the fate of one-fifth of humanity—and charges headfirst into various unfamiliar and unforeseeable possibilities.

The more than two thousand objects in Mr. Sigg's collection include painting, sculpture, installation, photography, video, projects, posters, paper cuttings, and more. The categorization of these works ranges from individual works to entire categories, from enormous installations to a single grain of sand. What distinguishes his from most art collections is the fact that Mr. Sigg personally collected every single piece. The collection represents the works of 170 artists from different provinces and different backgrounds. Mr. Sigg is on familiar terms with, or at least acquainted with, each and every artist. He has been to the studios or homes of most of these artists, and has held long and deep conversations with them about art and life. There is a strict order and method to Mr. Sigg's collecting, which is simultaneously meticulous yet vast in scale, deep and richly inspired, rational and passionate. All these factors have made Sigg's collection of works irreplaceable, the world's most unique collection of Chinese art.

The fortuitous currents of history brought the world of contemporary Chinese art into contact with this particular man. What role has he played amid the fierce torrent of cultural and political reforms? How did he influence an entire period of history? While the future holds the answers to such questions, today we are only able to say that the depth and breadth of Sigg's collection has already deeply influenced the scale and development of contemporary art in China, and has played an important role for Chinese art worldwide.

WRITTEN SEPTEMBER 2004; TRANSLATION PARTLY BY ERIC ABRAHAMSEN[6]

On Photography

POSTED ON FEBRUARY 11, 2006

If we reflect on the history of photography, we realize it has been widely accepted as a medium of artistic expression only for roughly twenty years. Prior to that, it was treated as a purely technical means of recording history.

In recent years, in the development of the photographic arts, various elements such as plot, color, chiaroscuro, and compositional narrative have maintained a parallel developmental relationship to the methods and characteristics of Western painting. It remains difficult for photography to break free from being habitually recognized as an arbitrator, but this historical misunderstanding originates from much deeper ancient and enduring philosophical issues, such as: what is reality, is it possible to record reality? Or, what is the nature of the relationship between truth and reality?

Evidently, such conclusions lean toward the interpretation of photography as merely an illusion, something that falls short of reality's reflection. The material existence of such an illusion furthermore becomes another kind of irrefutable reality.

1.6 In the bathroom of Ai's Third Street Alphabet City apartment, with *Hanging Man* (1985), c. 1985.

It doesn't matter if this material's features are dynamic or static, black and white or color, large or small, or realized via chemicals or binary code—whenever photography occurs, it is endowed with all the characteristics of an independent material, proving that photographs as objects themselves are identical to any previously existing object. Despite the fact that photographs appear to have originated in the process of documenting the object that is being photographed, the real documentation of this so-called objectivity has a greater attraction and a dualistic nature. It is even more unfaithful to reality, calling our physiological feelings and fundamental means of expression into question.

Photography is a deceitful and dangerous medium; and medium is method, it is significance, a ubiquitous feast of hope, or a hopelessly impassable ditch. In the end, photography is unable to either record or express reality, it rejects the authenticity of the reality that it presents, making reality even more remote and distant from us. People from East Asia are inclined toward another possible aesthetic attitude: they rarely see artistic activities as a means for understanding, or they rarely show an interest in

this topic; instead, the process of achieving understanding itself and the means of expressing this understanding are seen as the ultimate essence. This essence is precisely our mental outlook on the world, and as for the reality of the outside world, that is even more of an illusion.

The universe's reality is limited and ruthless; humankind's reality is comparatively psychological and emotional, indeterminate, difficult to ponder, idealistic, and self-centered. As for a familiarity with the self, isn't being cognizant of one's own personal feelings and psychology even more perplexing and fascinating?

WRITTEN FEBRUARY 9, 2006

1.7 In the bathroom of New York's Maritime Hotel, March 9, 2008.

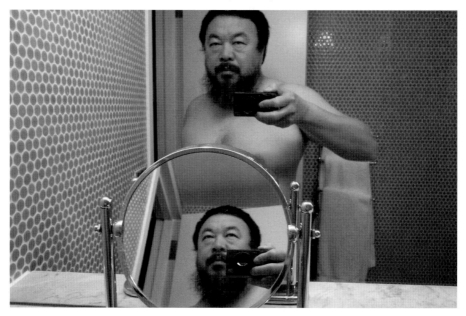

Who Are You?

POSTED ON FEBRUARY 16, 2006

People who work in design speak the language of design, just as those who write fiction, essays, or poetry have their own language systems. Even plain vernacular is a style. When people talk about style, they're actually attempting to systematize their treatment of a certain language. Everything has its own order and logic: plants have one way and animals have another, and living or nonliving, all things exist in their own particular state. Humans are the only animals constantly adapting to their

situations as they evolve, for we are the only animals that don't rely on style to distinguish ourselves. For instance, if certain animals change their colors or shapes, this is in response to the pressures of existence itself, but only humans choose to do so because of emotional and subjective intentions, because of their personal understanding of the world, or as a means of communication.

Regardless of one's chosen approach, there are two possibilities, the first of which is finding one's place within the natural world—even if one's relationship is conflicting, this is still the kind of harmony we must seek. Harmony may also be that kind that is full of conflict or sense of crisis. The second possibility is to announce yourself to the world, and this is because only human beings possess the need to distinguish themselves. In certain social situations we may say: "I am you, you and I are the same." In other circumstances we may say: "I am myself, I am different from all of you."

We have all experienced both ends of these extremes, and it is clear that a person's self-definition has much to do with the politics, economics, and culture of the society they live in. It's the difference between a windy or windless season.

Rarely do I strive for a particular style, yet at certain times, my circumstances will exert a particularly strong influence on me. The things you create—including their limitations—are all embodied through your state of existence. I seek to eliminate those limitations through various alterations, or to make them more obvious; this is entirely possible, and is also another form of expression. I do not have a clear style, nor would I limit myself to popular ones. Life itself is more exuberant, more meaningful than any style imaginable.

The fruits of cultural production, whether literary, artistic, or fashion, are incomparable to nature itself. But nature is not something we can absorb directly; most people require some degree of predigestion—and that is culture. Very few people have the perspicacity or ability to derive their sustenance directly from nature. Human wants and interests are narrow and biased, and if we were to concern ourselves with only the human world, we would be limiting ourselves to a very narrow worldview. Open a newspaper to any page and you'll discover that everything is written from a human-centric point of view, no matter whether the article is discussing the environment or humanity's relationship to natural resources.

A divine force lies beyond human law that is incomparable to the forces of humanity. Human order applies on earth and in cities, and the majority of people are simply riding this bus along that road to this or that spot, or they use the fruits of thousands of hours of their labor to purchase this car or that. Such actions already place people within the supposed great mechanism of human order, from which they are unlikely to be delivered. Because our psyches and souls rarely have the opportunity to experience—but seeing and experiencing are the major source of intellect—these become inherent resources, and they are provided by mere existence. People today expect to

gain status, acceptance, or pleasure from the particular number of square meters in their homes or some set of fixed standards, a life of simply filling in the blanks. The game is so simple, and it's not something that everyone is prepared to accept. But accepting it implies the collapse of a series of hierarchies, although educational and other surrounding systems tend not to permit this sort of thing. It's hard for an individual to state his or her mind frankly, or to smile, or to make contact with someone else, or to observe a thing plainly. These might sound easy, but they are not so easily executed.

Innocence and a lack of desire make people wise. Once you perceive a thing straightforwardly, with a clear mind and no obstacles, you will discover that your resources are inexhaustible. This is because your heart is connected to and in harmony with the order of the universe.

This issue is obvious: if you forget your basic philosophy and ethics, design becomes a foundationless activity. In truth, design is touching upon this question every second, that is, how much will I take, and how much will you give? Do I give and take in equal measure? A majority of the time, a person's driving motivation is only to take, or to convey, but what nature of substructure is assisting this conveyance? This is ambiguous, and turns it into a cry of neither joy nor pain. You may see at one glance the depth of this person's torment. Joyful people are also easy to recognize, but what so often leaves us perplexed is the counterbalance that comes after the cry. It stands in contradiction to the system, and to logic.

When people relinquish their intentions, they possess the utmost wisdom, because in the moments when you are not articulating yourself you appear immeasurably large, you become a part of nature. When you act for yourself, you are merely representing yourself, and in comparison with nature you are infinitely small. This logic is very plain. However, when we forget or abandon ourselves, we can become immeasurably great. Design may appear to be diversiform; however, very little of it is any good. True quality, in the form of things that can affect humans on a spiritual level, is very rare. Merely thinking something is a good idea may influence only our behavior, but not our minds. It may, for example, offer greater speed or convenience, but what will you do in light of such advantages? And why do we require such convenience or speed? These are important questions, but rarely do designers ask questions at this level. They think, "I need to decorate this wall," or "This square stool should be round"—but what are they ornamenting? Our considerations tend to stop at a certain level, on a level that provides a sense of security. How many people willingly locate themselves in a state of insecurity?

No cup can compare to drinking water from your own two hands, and it's been a long time since we took a drink of water without having to twist off a cap—but wasn't it wisdom that begat these circumstances? Amid our pursuit of profits and manufacturing possibilities, we've placed ourselves on the road to extinction. Simple

lifestyle is one way of allowing humanity to find a path to Eden, so why do you want to develop so fast? Will you gain more at such speeds? I find both ideas very attractive, and am constantly subject to their temptation.

WRITTEN DECEMBER 2005; TRANSLATION PARTLY BY ERIC ABRAHAMSEN[7]

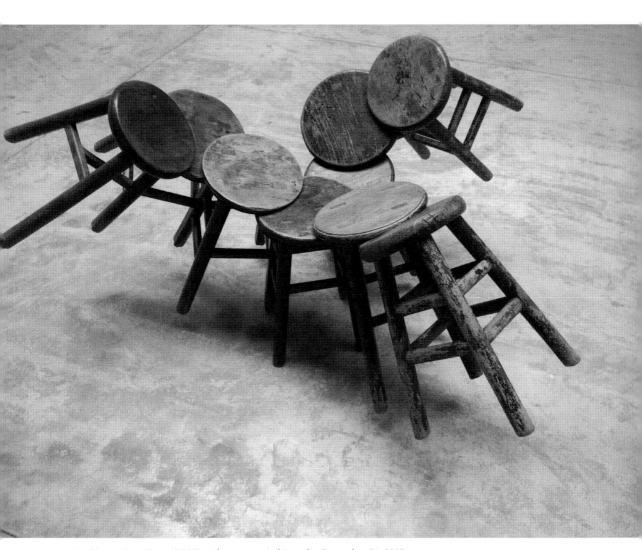

1.8 Ai examines *Grapes* (2008) with a camera in his studio, December 26, 2007.

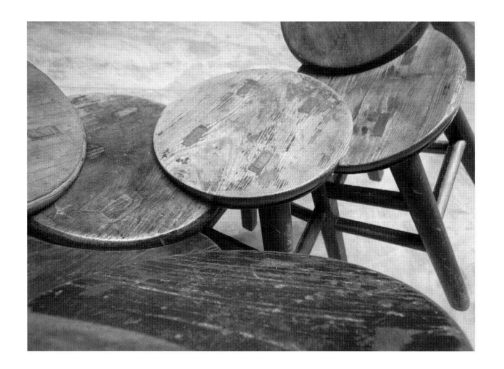

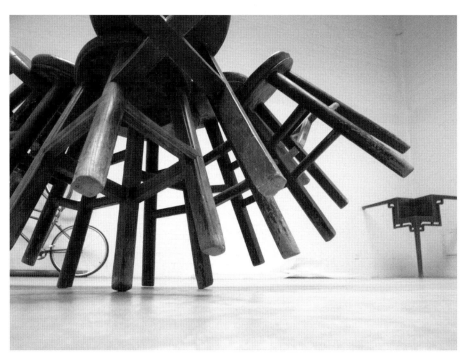

1.9, 1.10 Ai examines *Grapes* (2008) with a camera in his studio, December 26, 2007. The furniture work *Table with Three Legs* is visible at lower right.

The Longest Road

POSTED ON FEBRUARY 23, 2006

China still lacks a modernist movement of any magnitude, for the basis of such a movement would be the liberation of humanity and the illumination brought by the humanitarian spirit. Democracy, material wealth, and universal education are the soil upon which modernism exists. For a developing China, these are merely idealistic pursuits.

Modernism is the questioning of traditional humanitarian thought and a critical reflection on the human condition. Any other art movement that does not belong to this modernist culture is generally shallow, or lacking in spiritual value. As for activities lacking intellectual value, or creations that deviate from or appear to be modernist, these are but superficial imitations.

Modernism has no need for various masks or titles: it is the primal creation of the enlightened, it is the ultimate consideration of the meaning of existence and the plight of reality, it is keeping tabs on society and power, it does not compromise, it does not cooperate. Enlightenment is attained through a process of self-recognition, attained through a teeming thirst for and pursuit of an inner world, attained through interminable doubts and puzzlement.

An unadorned reality, panic, emptiness, or ennui exhibited in modernist works results from such fearless truth. This is not some cultural choice—just as life is not a choice—this is a concern for one's own existence, the cornerstone of all mental activities; it is cognition, the ultimate goal.

Reflections on modes of existence and mental values are core issues in modern art, facing the vivid and distinct facts—the inevitability of life and death. After primal impulses have passed, such reflections leave a hollow, dreary sense of reality behind.

All of this develops toward an inevitable conclusion: an understanding of the solemnity and absurdity of life. We cannot avoid discovering cognition, just as we cannot avoid the actuality of our own existence.

Our dreams are composed of realistic limitations on life and the eager impulse to surmount these limitations. These impulses and the efforts expended working toward this goal are the pleasures of life.

Humans are destined to be narrow-minded empiricists, animals who have renounced a natural state. From among every possible path, humans have chosen the longest and most remote path leading to the self.

An artist comes to understand himself or herself through making choices. These choices are related to one's spiritual predicament, concerned with returning to the self, and the pursuit of spiritual values. These are philosophical choices.

One painful truth of today is that, as we import new technologies or lifestyles from other nations, we are helpless to import the corresponding mental awareness or the strength of justice. We are unable to import souls.

Modern Chinese cultural history is one that scorns the value of the individual, it is instead a history of suppressing humanity and spirituality. Intellectuals are invariably attacked from all directions by powerful Western culture represented by aggression, and by decaying cognitive structures represented by Chinese feudalistic influences. All of which have placed our intellectuals in an embarrassing predicament.

Over the past one hundred years, virtually all reform efforts have begun with submission to Western culture, and all conclude with compromising native traditions. Simple emulations and resistance have amounted to a central characteristic in China's modern cultural development.

Doubtless, the tides of history are pulling this archaic ship ever nearer to the banks of democracy, as communication, identification, understanding, and tolerance have begun to supplant methods of coercion and exclusion. We have realized that cultural and spiritual totalitarianism and exclusionism have deflated people's spirits, shrunk their wills, and made them myopic. Burying troublesome opinions and evading difficult questions are nothing short of skepticism and denial of the value of life; they are the blaspheming of gods, an acknowledgment of ignorance and backwardness, and a blatant expression of support for unchecked power and injustice. Today's culture and art are still lacking the most basic of concerns—the social function of artists, social enlightenment, and independent criticism.

No manner of linguistic exploration, no possible appropriation of strategy or medium, and not even plagiarizing techniques or content could possibly conceal the shortcomings of artists lacking self-awareness, social critique, and the ability for independent creation, thus exposing pragmatic and opportunistic style-brokers and reflecting impoverished spiritual values and a general lowering of our tastes.

When the attention paid to "trends" is shifted toward personal methods and issues, when explorations into form are transformed into explorations into the plight of our existence and spiritual values, art will thus be enlightened. What a very long road.

WRITTEN NOVEMBER 1997[8]

Their City

POSTED ON MARCH 12, 2006

After dinner, I politely declined my host's offer to drive us home and decided to walk to the hotel. There was one primary road in their city,[9] and, due to a power outage,

it was bathed in darkness. The blinding headlights of cars passing back and forth on the road illuminated the people walking toward us, bright and then dark, making them seem farther away, and then nearer. Hair salon mistresses stood fidgeting outside their storefronts with nothing to do; unable to stand still, they looked strained and distorted.

A bicycle lane of about three meters wide ran parallel alongside the main city road; further outside of the bicycle lane was a six-meter-wide pedestrian walkway. Lining this walkway were beauty parlors and hardware stores, and a motley assortment of restaurants, clothing shops, and electrical appliance sellers squeezed in next to each other, competing for space. We were walking on this road, there were no traffic lights, we took one irregular step after another, necessarily cautious. The road was uneven and potholed with little ditches, it was impossible to determine how things came to be in such a mess—scattered about us were concrete, bricks, plank beds, brickwork, overturned road, and cast-off or broken shards of brick. Pedicabs, motorcycles, and bicycles were parked on the sidewalk.

Curiously, there was a path for the "vision impaired" on this road we were traversing; it is a feature designed for the blind. This sort of path comes in a standardized shape, and you can find similar paths in different counties and cities: it is a dazzling yellow path that is about one-third of a meter wide with protruding ridges. It is just one component of the urban road, and clearly, this was a newly paved road.

There were no roads like this in the era we grew up in, there were also no cars, and blind people didn't walk up and down the streets. The blind, just like the rest of us, held the "Little Red Book of Quotations" in their hands, with their hearts shining just as brightly as ours. Moreover, we had heard about the barefoot doctors who had already cured most of the deaf or mute people in the countryside with ancient Chinese medicine like acupuncture and communist "ideological weapons."[10]

The government often repairs or lays new roads within a few days, and it is usually on or around May 1 (Labor Day), August 1 (the anniversary of the founding of the People's Liberation Army), or October 1 (National Day), or during the Two National Party Congresses that people begin to see the road leading them home transformed. These homeward-bound citizens will soon discover that the bricks on the road have suddenly become loose, missing, or broken, and all of this just seems normal—they have too many things to think about, they can't be bothered with these affairs. But the walkway for the blind on this stretch of road is different: I don't know why, but at a distance of every dozen steps, there is an electric pole erected squarely in the middle of the path. In addition to this, steel cables are used to stabilize the poles and coverless manholes also obstruct the "blind walkway."

The special condition of this walkway seems to cause everything unfolding before one's eyes to suddenly transform, to make this town, the road, and the people, it

makes everything seems different. The people walking along this road suddenly feel uncertain, convoluted, and hopeless. This town's urban planner most likely doesn't live on this road, and he probably doesn't often come down this way. The workers who laid the road all come from the outlying villages; they don't understand the special function of this kind of pavement, and they don't understand why such a path shouldn't intersect with cement shafts or slanting steel cables. If they did have any complaints, they would probably lament why a city with so many electric poles has such frequent power outages, which significantly decrease their road paving speed.

There's no shortage of blind people in this town: blinded because they were treated with faulty medicine, blinded from drinking fake alcohol,[11] blinded from work-related injury; perhaps they fell ill and couldn't cover the medical bills, or perhaps they even had some money, but ran across a quack doctor. And then there are the people who have never known the world of light and shadows, those people will never care whether there are electric lights or not. Those blind people exist quietly and peacefully on this earth. They'll never know there that somewhere, someone has designed a special walkway just for them, in these blind walkways that stretch across every boulevard and alleyway of the city, connecting every road in China. They will also never know the obstacles or pitfalls that suffuse these paths. Perhaps, if they knew there were walkways for the blind, and attempted to traverse them, their hearts would be filled with warmth, they might go on suspecting once again that those legends about a seeing world are really only unreliable fluff.

N Town

POSTED ON MARCH 19, 2006

In N Town,[12] in the nation of C, the first Qin emperor established a city where three rivers converged. I found myself in N Town on some rather absurd business—I was helping to jury an architecture award. Standing at the side of the road, I could see that N Town was no different from other southern cities.

All cities in C Nation inherently maintain a faithful record of the scars left by authoritarianism. Unlike actual ruins, which are caused by rational, ordered destruction, these cities are elegies on frenzied architectural activity. Their creators and their landlords are victims of their own idiocy and base behavior, and as a result of their nonexistent conscience and lack of common decency, cities are thus humiliated. The elderly are too ashamed to tell the newest generations about the past, and the young are left with more despair than hope. People's hearts are fast becoming mediocre,

shrewd, and old. Year after year, people have become so accustomed to finding their diversions amid darkness and suffering that they are able take pride in their shame.

Even though it is utterly unaware of this fact, C Nation has become this way as the result of its self-punishment. Cruelty does not arise from savage competition or a bloody reality, but from contempt for life, homogeneous standards, and a numbing of the senses. Life is no longer flourishing, souls become muddled, and the vitality of dreams pale.

Years of abuse, crudeness, and wantonness have caused the people in these cities to walk with a quickened pace, and to see with lifeless eyes. They have nowhere to go, and nowhere to hide. At last, the people lose their sense of belonging. They aren't attached to their homes, villages, or cities, and they become strangers in permanent exile.

News of N Town emanates without pause from a central city plaza designed by Mr. M. Surrounded by sumptuous commercial centers, his enormous new plaza is the favored destination for urban residents enjoying relaxing strolls. Beneath the gently flapping flags, an ingeniously crafted musical fountain graces a marble-lined pool, where films are projected onto a screen of falling water. Mr. M's design is unlike the rest of N Town, it appears to be at the cutting edge of style, is novel and unique, and has a festive lavishness that adds a light touch to this otherwise outmoded, degenerate place. Like other economically developed zones, the city is besotted with music halls, opera houses, and art museums.

N Town's art museum is also brand-new, and I arranged with a friend to pay it a visit. The enormous establishment had not a single piece of art to display, and was showing instead mounted skeletons of enormous animals from the Jurassic period. A clumsy ignorance was evident in every aspect of the exhibition's garish displays—the lighting, special effects, explanations, and wall labels. All of this sat in powerful contrast to the inconceivable wonder exuded by the skeletons of these giant beasts. That was an age of true glory—the earth once boasted such landscapes, skies of such color, such winds and rains! What destiny shaped these giant beasts that ruled that world, and what disaster finally exterminated them, and turned them into fossils to be displayed here in this museum?

The eons rolled on, at last begetting the weak, fragile-bodied, and calculating race of humankind. The fossils were small, yet hugely presumptuous, both greedy and faithless. I lingered before these fossils, filled with a sensation difficult to describe.

One of the halls in the museum had attracted a crowd of locals. It featured a display of human organs and corpses. In the midst of the crowded hall were displays containing conjoined twins, and mummies dried in a standing position, amid assorted organs and brains. In the center of the hall was a woman's body floating in formaldehyde like a giant fish. Her skin was pale white tinged with yellow and she was wearing black

silk gloves and long silk stockings. Even more fascinating were the two objects placed in adjacent bottles besides her, labeled: "broken hymen" and "unbroken hymen."

There are places one should not go and there are things one should not see. The principles are very simple: knowledge and experience come at the cost of innocence and decency. Such ugliness isn't frightening, but such corruption of social morals will make you hopeless.

This exhibition was N Town's most popular in years, attracting thousands of visitors daily, from the silver-haired elderly to young girls and boys. The country in which N Town is located is the world's largest producer of and dealer in cadavers.

Mr. M's buildings are stylized and pretentious, and shiny new, but when you look closely, there's just something not quite right about any of it. The problem is, no matter how artfully this new skin is arranged, you can never forget the decrepit body that hides beneath it.

China's cities are striving to dress themselves up, as if they are rushing to attend a lavish masquerade ball. The onlookers are accustomed to jeering and catcalling at spectacle, and just so long as there's spectacle at hand, everyone is energetic. Every participant hopes he or she won't be recognized, but even if they can only hide themselves for just a moment, it will be such great fun. The people are unwilling to spend another moment in pain and humiliation, they would much rather strive for a feverish happiness that might help them overcome their self-loathing and fear of death.

Take leave of N Town, forget that musical fountain, and those films projected on water.

S Village in Beijing

POSTED ON MARCH 30, 2006

Outside the city of Beijing lies Suojia Village, a community where many artists reside. They will live there until the day that their dwellings are forcibly demolished, because they were "not built in conformance to building codes."[13] Beijing is the capital of C Nation, a place where demolishing row upon row of inferior housing is no big deal at all.

Many other villages surround Beijing, each with countless structures that do not conform to code, and there are more than ten thousand cities in C Nation, each with countless illegal and temporary buildings violating various laws and regulations. But it's possible laws or regulations will never arrive at their doorstep, unless they are in the path of an engineering project that is to be the highlight in someone's political career, or perhaps someone's relative takes a fancy to their land, some Hong Kong

businessman or Taiwanese compatriot wants to invest and develop it, or perhaps they are just unlucky bastards who could get even cold water stuck between their teeth.

For so many years, the primary affairs of state in C Nation have been focused around demolition. The sounds of roofs caving in and walls crumbling are everywhere. Another of its national characteristics is sales, because aside from your house and your land, you can sell resources, mineral rights, factories, banks, enterprises, and equipment. They will sell everything till the floor falls right out from under you. Nothing left to sell? Sell your official post, a professional job title, diplomas … sell everything that can be sold and even anything that can't.[14]

Looking closely at all of this business, each transaction could be in violation of some law or fail to conform to some regulation. This is because, no matter how poor or how ruined C Nation may become, it will never be empty handed.

Oftentimes the people living in those houses waiting to be demolished are breaking the rules: they have no papers, they wander in groups, and they are unemployed. They surge into the city from the countryside to do those jobs that no one else dares: demolish homes, repair roads, transport goods, sell vegetables, sweep the streets, collect the trash. … We can't say they aren't courageous: they've witnessed coal-mine explosions and still send their husbands and children down the shafts, they've seen the dead fish in the river and they still drink the water. One day, as you walk down the street, the oncoming pedestrian traffic will be entirely composed of migrant workers hailing from strange, faraway lands. Their expressions speak of panic, their behavior is strange, and their manner is coarse. You'll want to avoid them, because no one is willing to face poverty and hopelessness square on. Both poverty and hopelessness come from the uncivilized "other," and are products of injustice and hypocrisy. But we are this "other." Of those country kids, all the boys who can stand up straight and can walk properly become gatekeepers or security guards; all the girls with symmetric facial features turn into beauticians or masseuses; and the city dwellers are filled with a sense of gratefulness. But to thank them would be to break the show of unity, and yet observe how the urbanites are forever beseeching the Buddha, offering incense, seeking divine guidance by drawing lots, and kowtowing. Those country people were born into the cult of fake medicine, charlatan doctors, and fake goods; venomous neighbors and the trafficking of children are common sights for them.

The vast majority of domiciles in the outlying urban areas of C Nation are either temporary dwellings or were built in violation of regulations. These substandard structures are sustaining the development of C Nation, and they fill in the cracks left by society's development. Hundreds of millions of peasants pour into cities, where they plant themselves and rest their heads in these temporary and nonstandard structures. Where else could they live except in these substandard buildings? These are the places that so many people call home, and the economy of C Nation is resuscitating

itself under these circumstances. But with a nod of the head they become illegal, and this is an issue of the legitimacy of the law.

Of these people from poor and remote regions who are surging into cities like moths to the flame, how many have the guarantee of basic labor laws or living standards? Who should take responsibility for this? They are creating value brick by brick; with every doorframe and every rooftop, they simultaneously struggle to maintain their own life necessities and sustain the stable development of the entire society.

If law merely prohibits but does not protect the weak, it loses its impartial significance. Law protects civilian property, and temporary and substandard buildings are also civilian property; civilian property is not classified into the distinguished and the humble. If property is old or decrepit, squalid or miserable, that is because these people only have so much. Who doesn't see the inevitable relationship between the dirt, the chaos and their inferiority to the superwide highways and the luxury shopping plazas? Laws should not only be created to demolish, they should likewise respect personal rights, civilian rights.

There are many misunderstandings in Beijing; for example, art districts should not be filled with circus troupes, and protecting ancient architecture isn't just to improve the scenery, and nor is it to give the city a competitive edge, it is because people need to remember. When we confront an old city and ancient architecture, we cannot simply discuss the value of cultural merchandising while refusing to face authentic cultural issues. The livability of the city is not a question of its physical appearance; if a city is irrational, inhumane, unsympathetic, and cannot treat others with benevolence, what good is a pretty face? A city is for its inhabitants, multifaceted people with fragmented, petty emotions, and who by right should have the potential to enjoy the use of the city, the potential to communicate and to make demands.

WRITTEN DECEMBER 2005

Wrong Place, Right Time

POSTED ON APRIL 10, 2006

Rome is a city that can easily carry you back two thousand years. Her roads are paved with black, nail-cut stones that broil impatiently under a dazzling sun. Unlike Rome, the streets of Milan are paved with marbled granite, each block is probably thirty centimeters wide and forty or fifty centimeters long, and they are earthy red, yellow, and dark gray. The width of these granite blocks is standardized, but their lengths are not uniform, and the paving process would have been convenient, the selection of materials likewise not wasteful. Car tires of various widths are treated to the repetitive sound of the granite blocks under tire as they pass over them.

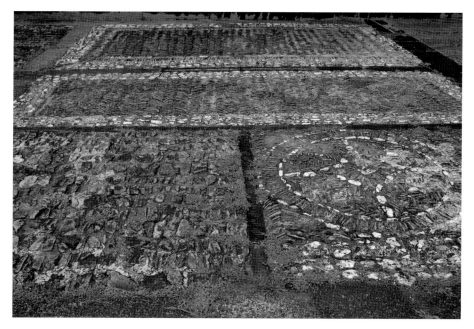

1.11 Ornamental stone inlay from an unidentified Qing dynasty building. Part of a photo series of floor fragments, March 2006.

1.12 Stone steps from an unidentified Qing dynasty building. Part of a photo series of floor fragments, March 2006.

I had made arrangements with friends for dinner. As soon as it passed eight o'clock, my phone rang. I said, "I'm in the lobby, where are you?" My friend told me to walk out of the lobby and find him in the bar across the street. The sky was already dim, the street lamps were dim, and across the street there was only a pitch-black alley and a church. There were no bars across the street, only a church. He was talking about another hotel. My friend is Swiss. They always have the wrong place, at the right time. The sky was already dark and the sound of jazz began to float to my ears, the crowds of bustling people were already thinning, and mopeds shuttled across the roads. This was Milan on an April night. Dusk had fallen, and the dim evening light was glorious.

Recently the Italian prime minister made a remark about China. The things that he said happened in China made people uncomfortable. He also said that he read about it in a book he read, and China retorted that his comments hurt the feelings of several hundred million people.[15] There will always be people in this world who don't concern themselves with the feelings of others, people who are easily hurt, are fragile, weak, unwilling to be hurt, but are always hurt by others.

I don't like the Italian prime minister, he simply doesn't have a likable appearance, and I don't care if he hurt the feelings of the Chinese people. I don't pay a lot of attention to feelings, to the point that I distrust the very idea that the feelings of more than a billion people could be hurt. What happens when you hurt them? What could the feelings of a billion people be like, anyway? Even if the Italian prime minister made a billion people love him, or if he indulged the feelings of a billion people, I still wouldn't like him. My inexplicable distaste for him perhaps comes from the fact that I don't like the cut of his suit, or the way that he laughs. I don't like him, and that doesn't need any clear explanation. My taste is superficial, it has no deeper significance. But the fact that I do not like him does not arise from the notion that I don't believe what he said is true, or because I believe that the circumstances in China are better than what he described.

Invoking the emotions of more than a billion people to make a point makes it seem as if there exists an apparatus that can measure the feelings of more than a billion people. In my understanding, feelings aren't that easy to hurt, and I don't believe that the universal feelings of a nation are selective, that they can only be hurt at some specific time or place. In fact, the Chinese people have weathered many great storms, and their feelings have proven rather resilient. How deep is the wound, once an injury has an opportunity to heal itself? Why are these feelings only revealed when they are hurt? Once such a situation touches upon the masses, the dubious facts multiply to excess.

Distracting Thoughts Overhead

POSTED ON APRIL 12, 2006

The following is written in the air. This Boeing is suspended 10,000 meters from the earth, and to kill some time, I'm attempting to write on one of the plane's airsick bags. Opening it up and flattening it out makes a rather suitable sized place for purging one's mind.

I don't know what kind of person Han Han is.[16] I know him only through the debate and dispute on the Internet. Who's who isn't important; this kind of person has gracefully proved that truth is capable of defeating absurdity. The people vilifying Han Han are classic hypocrites, and they can no longer cause even the smallest bit of harm. That is how young people grow up today, they naturally understand where the power behind hypocrisy originates from. The keenest device for dealing with this is allowing the whole truth to emerge.

Invariably, these people shield themselves with the Confucian classics or their morals, even though such rubbish was dumped long ago. The only reason for their pitiful existence is to give others an opportunity to point at them and say, "Can you believe it? Once they perpetuated a dark age, and all of this is part of the lie."

They are still imagining that noble and sacrosanct literature exists, a kind of fantasy that is enough to make them feel noble and inviolable, and gives them an opportunity in this conscienceless age to flaunt themselves and flatter each other. They are fraudulent and greedy, and they peddle their cheap morals and stale aesthetics while posing as respected elders.

The virtues of Confucianism are enforcing justice and random acts of heroism on our streets?! Who buys that? When will people grow up? It might make an interesting character in a television drama, but who could be so flimsy in real life? Is the curse "Whores have no feelings and actors no integrity" really effective for eternity? Isn't filmmaking just capturing shadows on chemical-coated plastic? Don't bring up life or humanity, or make yourself cry for an audience that doesn't even care. Films are films, and anything a film might imply is merely that film itself. When the lights come on and the audience leaves the theater, we are no longer in the movie; you won't die if you can't make a decent film. Life is like a rubber ball, you're kicked around by other people, it is your fate and life's duty, don't get any ideas, otherwise, just let your air out.

People throng together; if they're not old friends, they're old veterans. What's so terrible about fraternal brotherhood and kindred blood ties? If it weren't for the

enormous size of the trashcan we call the blog, how could Han Han find room to trash all their soldiers and pawns? This is truly a legendary age, and you'd better adjust your glasses before great catastrophes befall, just to see where you're standing. Take some advice and don't even attempt to figure this out, that's impossible. It's not that there can't be a whole story—right and wrong are indistinguishable, you understand the "mandate of heaven" and must respect the gods. One minute play the fool, then in the next disguise yourself as some naive coquettish brat. The sun has come up, and no one has sent you all home? Go home, and don't come out again.

Are we still debating what qualifies as literature? Based merely on your drama, it seems you really believe you are engaged in the production of literature. Go play in your cliques and at your forums! Liking literature but loving film can't possibly be called a bad thing; it's not even a problem if you're an adult, just don't disguise yourself as a sage. Everything under the sun can be settled or worked out with discussion, but the one thing that can't be changed is stupidity. If you know your legs are feeble, why are you standing on the racetrack? You're working hard at "anti-corruption," and the more anti you are, the more corrupt you become, and the more corrupt you are, the more "anti" is needed; isn't this what they call straightforward security measures?

Do father-son bonds really need to be provoked? This is definitely some mortal error coded in your DNA, wild animals on the brink of extinction trying to bring their fathers down with them. But the elderly and infirm are certainly nowhere near extinction, much less are they feral.

If you know your comrade is stupid, then don't let him come into plain view. You can disown relatives legally, but that doesn't mean your comrade isn't like a brother. Just don't help your brother lose like that again, do you really think that he can afford it? I've seen musical genius, but I've never heard of a lawsuit master.

You were born for the darkness, so don't go out in the daylight. People who shout about how we must respect feelings are people who live in fear. You're always talking about friendship and moral responsibility, otherwise you might doubt that you were human. Since life is a struggle to be an upright person, you ought to continue on.

It's said that beating your face with a leather belt is suicide; sound like magic? This is pretty ridiculous. Some people wish they could explain it this way, other people wish things really were that way. It's ridiculous to try to use popular ideas to simplify something as exclusively personal as suicide; explaining something that even the living don't understand is, at the very least, disrespectful to the dead.

The dignity in suicide comes from the fact that suicide doesn't come from external suffering, but is the abandoning of the self. Murder lays responsibility on another, but suicide is just the opposite. To misrepresent the dead is to misrepresent the living,

among the dead. A handful have died for their beliefs, but among the masses, how many of them are living for their faith?

If you want to defeat it, you need to stand on its side, but that is impossible, because it will forever exist on another side. Ignorance is a reflection, it exists but cannot be captured. The truth they seek and protect is their own stupidity and arrogance; perhaps this will bring them comfort.

After surmounting the final attempts you'll have no more enemies. Every time you return to that place, the same people who do not like you will turn their heads, in their eyes you no longer exist. But this time you're still a little unhappy; the thing you are fighting, as it turns out, isn't a thing at all, it has no real shape and it isn't tangible.

It chose you, this is the most devastating fact. It chose you and that is part of its mistake, and you are only one among many, perhaps the itch they're dying to scratch. Not like what you were expecting, or what the people say, they won't be punished for mistakes. It's not that punishment doesn't exist, it's that the punishment does no harm—you can't harm someone without real feelings. Your day of victory is but the day they give up on you.

You can break their steely strength, but you can't bring the rotten back to life. They will always find a way to realize the very thing you least want to happen. Their world is of a different kind, another color, and in the still of the night, you can always hear another kind of sound. This wasn't even their choice, they can't help being that way, if they weren't that way, they couldn't exist. Lies are the foundation of existence. You won, but you lost your luster because your opponent was never respected.

WRITTEN APRIL 12, 2006

A Straightforward Angle: Liu Xiaodong

POSTED ON APRIL 15, 2006

I met Liu Xiaodong in 1992, when he and Yu Hong were on their honeymoon. At the time they were staying in a borrowed Lower East Side apartment. There, in Chen Danqing's Forty-second Street studio, Liu Xiaodong completed several paintings on his "American experience."[17] Those carefree paintings left a deep impression on me. Years later, at his retrospective exhibition, I had the opportunity to see many of his other works.

Liu Xiaodong's painting originates in the profound tradition of Western painting. This tradition was once a visual approach through which a people interpreted their culture and history; for an entire people, painting was the elucidation and a tangible memory of a spiritual world. Despite China's century-long history of oil painting, and

owing to the decline of traditional culture and the politicization of art's ideological framework, here in China the medium has yet to emerge from the childish practices of academia or the unctuous mire of the pseudo-literati. Over the long years of practicing ideological painting, followed by the aesthetic practices of today, realist painting has been transformed from exaggerated, grand narrative styles into attractive, delicate works that seem brimming with hope.

Liu Xiaodong's work is, however, an exception: it is rich with representation and integrity. In these canvases like film stills, the world he is infatuated with lacks hypocritical, artificial clichés or the dubious cultural standpoints and strategies that distinguish more commonplace artists. His "straightforward angle" speaks genuinely, freely, and candidly about everyday life stories. The people and events in his paintings are a mirror image of reality: strange and distant, they seem alienated, as if they were from another generation, and they look as if the tangible world has been coated with another layer of significance.

A unique way of looking at the world, and a sincere and sympathetic disposition, add to Xiaodong's unrestrained, bored, and helpless mentality to create a profound contradiction. His appreciation of the humanistic characteristics of an average person's life, and his infatuation with elucidating commonplace lifestyles through the artist's expression itself has transformed our heartless world into something enigmatic and sacred.

Anything that meets Liu Xiaodong's eyes could naturally be transferred to his world on canvas. These natural and realistic attributes allow us to disentangle ourselves from our world, and it leaves viewers speechless. This result is not only a product of his methods of observation and realization, but even more so comes from the resolution of his unique language of painting, how with his brush he transforms reality like ice melting under flames. This natural and flowing painting style magically supports and subsumes an indisputable world, transforms scraps of art into a parallel reality, and endows us with another possibility to draw nearer to people who live in difficult or powerless states, that we may all show consideration and sympathy.

Newly Displaced Population is a new work by Liu Xiaodong.[18] Throughout the history of Chinese oil painting, both the subject matter and the wide breadth of range that this painting touches upon have equally incomparable precedents. The complex significance of this work, the shocking power of its form, its humanist standpoint, and its superb language never fail to either move or leave an indelible impression on each and every viewer. This work is a direct extension of Liu Xiaodong's former works: its commonplace details are honest and noble, and provide the tableau with a reality that is truthful to the point of implausibility. The expressive power embodied in its epic emotions and his superlative workmanship leave one awestruck by both Liu Xiaodong's person and his facility.

Newly Displaced Population is an artist's perspective on the world. This perspective is comparable to concentrating on all the misfortunate facts that make up the history of the Three Gorges: compulsory emigration; the demolition of villages and the locals' stories, personal anecdotes, and ideological disputes; historical change as irrefutable, impossible to overcome yet equally strange and absurd; and eventual heartless and remorseless disintegration. A blade of grass, a tree, a bird or a beast, one brick or one tile—these fragments comprise the most unforgettable painting in Chinese contemporary art history, revealing the wounds of a nation and one artist's wordless point of view.

In this work, painting exhibits the ultimate power of possibility. Time has been suspended, allowing the silent to speak and affording those people who lack either the opportunity or the prospects one glance—just one glance at the universal tacit consent that is happening in this world. No matter from what angle we look at it, *Newly Displaced Population* has become one of the most extremely rare and most important works of the era.

WRITTEN NOVEMBER 6, 2004

Quietly Settling Dust

POSTED ON APRIL 26, 2006

This dusty weather persists in China's north, and, just as usual, every time a situation reaches its most implausible extent, silence reigns over everything, just as if nothing has happened at all. People are all too familiar with such circumstances—don't make a sound, lest great catastrophes befall.

Yes, you can be silent. And just the same, you don't have to smile, or put on your pretty dress in the morning, or promenade the streets with your friends, ride your bicycle to the suburbs on a spring outing, play by the riverside, go shopping, or chat about fashion. You don't have to discuss anything related to beauty or makeup, and you don't need plastic surgery. You don't need to talk about luxury anymore, or rising costs, the Internet purge, a creative society, and you don't need to talk any more about advanced culture, because it's very simple: we are all living amid this dust. This is a singular reality, open your eyes and you will see it—a truth that no one can deny, a truth that won't go away. But how is this kind of truth identified? Here, this becomes an eternally perplexing puzzle.

No matter how many newspapers or television stations, journalists, or writers there are, no matter how many experts or scholars, it has been proven possible that these all are irrelevant to the truth. Truth is the one thing people are least interested in.

You can overlook everything else, but it is impossible not to breathe. Breathing is one task you are compelled to undertake, even when you are utterly disheartened, you breathe because you must live.

There are still so many children who want to live fairytales, young men and women who want to be in love, young people dreaming of their life to come, successful people who want to drive BMWs, buy luxurious apartments and take a second wife, participate in important meetings, discuss academic issues, develop real estate, put their company on the market, open a joint venture, expand their investment portfolio, sell medicine, produce, sell tickets, promote, improve … so many "wants," but no desire to breathe. No desire to open our eyes. It seems people can exist in the suffocation and darkness.

The dust quietly settles, silently covering people in gray. It reminds us of the tragedy a few years ago, the air became equally still, and the world was similarly serene. It was the same time of year, and in the same place. No one knew what had happened, they only knew their neighbor was in the hospital, or their workplace had transferred documents. More people were kept in isolation, and the death toll was secret. It was the conscience and courage of one old doctor that rescued an entire city.[19]

Every time something big happens, newspapers, print media, and television no longer act affronted at the injustice, they are no longer filled with righteous indignation; they become one part of these tragedies. When the truth is not staring them directly in the face, could any one of them stand up? There is no investigation, no judgment, no suspicion, and no point of view—there is only the increasing technical prowess of our flashing fluorescent screens. Reality is transformed into a tedious comedy. Our waterways are polluted and dry, banks are hoarding dead accounts, greedy officials live free and unfettered in the suburbs, coal mines are collapsing, and state-owned enterprises are sold off. Imagine if you were born into this moment in time, what kind of life would be waiting for you? If all of this is in retribution, what could it possibly be for? Who shall pay the price? Who will bear the responsibility?

We live in a nontransparent world, and only in an opaque world could such tragedies occur and be sustained. But let's believe that all the misfortunes that occur here are natural disasters, that they are all because God, Allah, or Śākyamuni hasn't yet made time for the hard-working, brave, honest, and kind people of this land.

Fragments

POSTED ON APRIL 29, 2006

Nataline Colonnello:[20] This is your first one-man show in China after so many years. What do you think would be a suitable title for it?

Ai Weiwei: The first thing that comes to my mind is "Fragments." Something similar to "pieces," "clippings," or "leftovers," from a body, or an event … material, history, or memory; it's something broken or left over, fractured or useless.

"Fragments" is a metaphor, not a value judgment of these objects; it's like deciphering the DNA of an animal from a single hair. The title "Fragments" alludes to a previous condition, or to the original situation.

We are witnessing a dramatic historical movement, you can call it social change; a simultaneous, big transformation that we are all in together. It has a destructive and, at the same time, creative nature. To me, it's just a changing of forms and a remolding of our lives, our experience, or our behavior.

NC: In the exhibition "Fragments" opening in April, you will present your installation *Fragments of a Temple* (2005), and three of your recent videos: *Beijing: Chang'an Boulevard* (2004), *Beijing: The Second Ring*, and *Beijing: The Third Ring* (2005). All these works are associated with architecture, urbanization, Chinese culture, tradition, and contemporaneity. In my opinion, these works are suited to be shown simultaneously, as they cover a broad spectrum of topics linked to China's peculiar historical, sociopolitical, and economic development.

AWW: Yes, they have a unique dialog with Beijing's current conditions; the wood I employed for my installation is fragments of pillars and beams from hundreds-of-years-old dismantled temples originally located in the south of China. I bought these architectural components from a furniture dealer; they were originally intended to be recycled for furniture making. They are of an incredibly hard, weighty wood called ironwood (*Tieli mu*). These pillars and beams were moved piece by piece from Guangdong province to Beijing. Of course, many smaller pieces were left over from my previous sculptures, so I used the remaining fragments in this latest installation. I gave my assistants very vague instructions: I told them, "I need all those pieces reconnected." It was a rather blurry program, and eight of my carpenters worked independently for half a year to bring the installation to the present condition. This work began more than a hundred years ago, and I don't think it is fully realized yet … it is merely resting in this stage.

Fragments of a Temple isn't exactly my design, but that of the carpenters who have been working with me for eight years. They considered what I would have liked to do with those previously unused wooden pieces, and the result is more interesting than what I would have designed myself. Of course, there's little artistic judgment in it, and I purposely left it open, unfettered from contemporary ideas about sculpture and installation—I left it to the carpenters to decide. When I asked them what they were doing, they told me they were making a dragon. I thought to myself, "I'm not so interested in dragons," and only later discovered they made it according to some veiled rules, where the structure's eleven structural posts are placed on the borders of

an imaginary map of China. It's not apparent, but they insist that if you could view the installation from a bird's-eye view, you would see it. I can't really imagine it, but I trust that they are very precise. First they drew a big map and lined the eleven poles on the borders; that is how it was reconstructed in my studio. I find it very ironic that when the carpenters tried to predict or guess at what I might find valid, they put me in a position far from my own artistic appreciation. In this way I was able to appreciate their independent thinking.

The three videos I did in late 2004 to early 2005 are conceptually similar to *Fragments of a Temple*. Lines drawn on a map determined the locations where these videos would be filmed. I gave this concept to my camera assistant, Zhao Zhao, and told him that I needed one-minute shots; I instructed him to use the video recorder like a camera, telling him to simply press the Record button and make one-minute exposures. I told him that whatever happens in front of the lens would be okay. He worked for some months on these three projects, the entire winter. We chose the wintertime because there's no other season that shows Beijing in such a clear way before the camera. Throughout the entire filming process I was never—not for a single minute—by my camera assistant's side. I saw the footage when he brought the videos back to be analyzed, which was mostly for technical discussion, never anything artistic. These three videos are conceptual; they are not pursuing any visual effect. In fact, even the editing was given to professional editors. I never even saw the footage on the editing monitor. But certainly they make a strong visual impact: this strict, rational, even illogical, behavior is so precisely disciplined and it works in tandem with the randomness of the subjects.

NC: This exhibition is interesting because if we analyze the installation and the videos, they are actually completely different, but as a whole they constitute an organic body. Observing *Fragments of a Temple*, it looks like a kind of résumé, a summation of the previous works you created with furniture, a realized installation to which your carpenters contributed to more actively, not only through manual labor, but conceptually. They have followed closely all the stages of your work for so many years and are so well trained in traditional Chinese carpentry techniques, that they know how to solve specific problems and how to handle the materials, which are usually ironwood and/or ancient furniture. What is amazing is how their accumulated skills and the experiences gained through dealing with various technical difficulties, and the resolution of the difficulties to which they are used to coping with, all culminate in this work.

Fragments of a Temple is an architectural masterpiece based on experimentation and rigor; at first glance it appears chaotic and puzzling, but it is actually extremely complex. It is very strange what happens in this work: parts seem randomly placed without specific reason, but at a closer look the different components reveal an elaborate

balance of relations and a mastery of the theory of joints. For example, the instance of the huge pillar erected on the top of the whole installation, or the unexpected intersections piercing the furniture and blocking them in the skeleton of the entire, massive framework. If on the one hand *Fragments of a Temple* is a gathering of discarded parts from your previous works, on the other, it encompasses all of your past wood installations. It is reminiscent of a prehistoric, makeshift construction or a temporary building. It is a very strong work, and in its solidity it also paradoxically conveys a sense of transience and uncertainty. It takes on the whole history of China.

AWW: It's interesting that you mention that. These original temples were built according to very moral, aesthetic, and strict standards. But now the same materials are rearranged in a random and temporary way, in an irrational and illogical structure. It seems like it has a big, gaping wound; you almost don't know whether it's alive or not.

I think the same thing about the video piece. You have a nation with two thousand years of feudalism, fifty years of communism, and then thirty years of materialism and capitalism. You can see the fifty-five sky bridges on the Third Ring Road, or the thirty-three bridges along the Second Ring Road. Chang'an Avenue (or the "Avenue of Eternal Peace"), as the axis between the East Sixth Ring Road and the West Sixth Ring Road, somehow captures the current condition in such a realistic way: motionless, nonjudgmental, and very objective, and at the same time absurd, crazy, and nonsensical. We cannot quite identify its history, or even make a simple guess at what it might be—that's impossible. History is always the missing part of the puzzle in everything we do. I think that they only have a momentary truth, that's the fragment: these momentary pieces.

NC: History is like different segments, like the ones you recorded—the views on the Second and Third Ring Road bridges and the sequence of exposures at measured distances along Chang'an Boulevard. The technique in which these videos are recorded is indeed not sophisticated, it is the very opposite of *Fragments of a Temple*.

AWW: Yes, it lacks skills and technique. One only needs to know "on" and "off," like the opening and closing of an eye. Like the voice recorder that we are using at this very moment that can be turned on and off—it's just as simple as that. Yet, on the contrary, *Fragments of a Temple* is so complex. Each piece is joined differently, each is a different size, and each has a different angle. None of them has any rational need to be connected to another; but at the same time, each one is precise and requires meticulous craftsmanship to be shaped so definitely, precisely, and supposedly correctly.

NC: Each single fragment in your installation somehow reminds me of the people, the cars, and the buildings you find in your three videos. While the videos are shot in a simple and calm way, everything seems to be moving independently from its surroundings, and running with the same frantic speed of the immense, diverse Beijing.

And in your installation different components, which similarly have no relation, are joined together; but in this instance they are static, fixed in a certain form and locked together by the weight of the wood itself.

AWW: Everybody knows that each architectural element in a temple has a precise order. The fragments I used in my installation are from three or four different temples, so everything is connected improperly and misfit. The fragments have no functional relationship to each other; the whole structure serves no purpose at all.

At the very beginning I had to resort to more hired help and many of my carpenters quit; this was despite the fact that I paid them a relatively high salary and I never rushed them. They quit because many of them didn't know what their job was, or what they were there for.

There is a very simple logic driving everybody to work: What is it all for? They need to know why the table must be cut in a certain way, why I require such perfect workmanship, why the patina should be kept and why hidden joints should remain concealed. They have to understand why this work has to be reconstructed in that particular way.

Later on, many of the carpenters started to enjoy the work because it became a lifestyle; they started to make perfection itself a challenge. Once they created something interesting, you didn't need to tell them why. Their relationship to their work became synchronized like two people ice-skating; they matched each other perfectly.

NC: As you said, you like to set a certain distance between yourself and your recent works. You entrusted other people with the further development of *Fragments of a Temple* and with your video works. Why is that?

AWW: I started thinking that in order to make myself feel a work is more interesting, I couldn't be too involved in it. In this way I can always be surprised by the result. For this reason I started working with different kinds of skilled labor and masters of traditional techniques; for example, the ceramic and the tea works were all crafted by very qualified Chinese traditional workers. To me, it's interesting to have very slack control or no control at all, to disappear somewhere and to see how far the work can go by itself.

Of course, those pieces are going to be shown in cultural venues, museums, galleries, etc., and I think that distance makes my work more challenging. It provides the possibility of more results and enables a new status for artworks as reproduced or mass-produced. They could be factory-made, but they are made for a different reason and with a different kind of control.

NC: But there is still a firm conceptual framework supporting these works; the whole installation has a structure, even if it seems illogical. Your videos have a structure as well, which is also highly disciplined. Both of your works pose their own questions about China and its transformations.

AWW: Nobody can avoid the signatures of the time, even if you're trying to. The only difference is that these works bear their own nature in addition to my initial input. Even though I contributed definitive creative ideas, I tried to allow each work's individual nature to develop. A carpenter knows more about wood, a tea merchant is more familiar with tea; this is a kind of collective wisdom. The reasons why the Second Ring Road and the Third Ring Road were built are very different, yet it looks as if they were built for me, so that I could make these videos.

I filmed the Second Ring Road on cloudy days and the Third Ring Road on sunny days. I think it's interesting that I only needed to make one such decision … I've invested the minimal effort and the project already displays a very strong character.

NC: In your videos, everything is continuously changing, in the sense that each exposure records the same view for only one minute. The installation of *Fragments of a Temple* within the exhibition space is also conceived as a work in progress, since the work will be mounted and taken apart slowly, piece after piece, therefore subjecting it to an interminable process of construction and dismantlement for the entire length of the show. I think that this resembles Beijing, the ever-changing city in which you live. What I would like to ask you is: What do you think about this city?

AWW: If I were a soldier, living in Beijing would seem like an endless watch over a castle or a giant mountain. I try to conquer it, which is impossible. But, in a way, it's more symbolic to me. It's a big monster, gigantic and with its own motives: either political or economical; folly or love; happiness and sadness, everything is entangled together. Tragedy, history, ideology, stupidity, and wrongdoing: everything is in here, and it's a big, big monster to me. I think that by being here we can feel each other, but at the same time, just by being here, you also have a respect for the city. You can only guess what is going to happen, and whatever happens will always surprise you. This is always very interesting.

JANUARY 8, 2006

A World without Honor

POSTED ON MAY 4, 2006

If there were a history, it could not be revealed to the public. The concealed portions of history outnumber the obvious, and those unclear moments would easily outnumber the identifiable ones. This is a cultural history in decline and it reveals the character and psychology of a nation.

On the topic of the recent competition for the Olympics opening ceremony: if there was any honor, it has only been tarnished.

Every competition has a winner, and the victorious side always uses its success to prove a fact. A competition isn't just about the two competing sides, but also about the platform they are vying for, the impartiality of the competition, the moral character of the observers, and even the absentees who aren't interested in the competition.

Zhang is the winner.[21] But like almost all so-called winners in China, his victory was one rule of the game, rules that reflect the will of the authorities. The rules allowed you to win, you may not *not* win and you must win; this is your fate. Of course, yours is not a glorious victory, because you never had the chance to strike that fatal blow.

A nonglorious victory is the product of a competition with no real losers. This winner lacks wisdom and courage, he has no exceptional power, he does not invite public acceptance, and he has no admirable skills. Everything is unclear, there is no true time, nothing is definite, nothing is true. There are only tacit understanding, false drama, stage sets, and hidden rules.

Only valiant fates can bring about glorious victories, this is a ruthless law. If the unjust victors possessed even a shred of self-respect and sobriety, they would be ashamed. Everything after that is a historical disgrace, and no kind of honor can hide dishonorable actions.

In a place lacking both justice and conscience, there will invariably be contention, competition, physical blows, and struggles to the death—all to the sounds of fake cheers and artificial sighs that make up our history year upon year. In this protracted battle, flesh flies throughout the countryside and the struggles could move one to tears, but there are still no brave souls, no wise elders, no heroes, nothing to remember, and nothing worthy of commemoration. In this game, there are no clear rules, no fundamental standpoints, no genuine obstacles, and no necessary provisions. There is no need to persist, no delight, no painful wailing, only a heavier silence.

A world with no true goodness and no beauty is necessarily this way. In all competitions here, there are only the painstakingly arranged victors, losers, and observers. The weak triumph and the superior suffer defeat, and losers defeat those who should be victors. This is already common knowledge, for the theory of evolution does not apply here.

The weak are useless in a true fight, and they don't dare to confront the laws of "survival of the fittest." Those who can't make themselves stronger can only make their opponents weaker, excel at those unspeakable methods of deceit and confusing their opponent, and rely on covert techniques to finish their kill. If any competitor always had the ability to choose weak opponents, he or she would always be a winner,

and base persons would remain in control, maintaining the treacherous upper hand in this absurd world.

Insidious victories, idiotic celebrations, and ignorant insolence are revolting, but, after all, we can choose to look the other way. What we'll never see are the losers, and their lifetimes of enduring shame and an inescapable, chaotic world.

In such a dangerous place, ignorance and hypocrisy always win.

WRITTEN APRIL 23, 2006

Yesterday I Cut My Hair

POSTED ON MAY 9, 2006

He washed my hair and I got in the seat.

The barber asked, What style?

When it was over he said, You're a director, right?

I've never met anyone with such taste.

And he even took a photo with me.

Ai Dan after drinking said it looked like Tie Guaili,[22]

The painter Yan Lei said it looked like Kublai Khan,

The feeble-minded student said it looked like "the Red Boy,"[23]

Photographer Zhao Zhao said, Something's wrong with Mr. Ai.

Old Ye from Lang Fang asked, You seemed crazy yesterday, how'd you become a fool today?

Wife Lu Qing said, When it's neat it looks like Nezha,[24] when it's messy it looks like a cadre.

My shadow looks a bit like old Mao.

My carpenter was unhappy, he said: It's hideous, hurry up and go shave your head!

1.13 Yesterday I cut my hair.

Here and Now

POSTED ON MAY 10, 2006

I was born in a courtyard on Beijing's east side called Tofu Alley. We accompanied my father when he was "demoted" and sent to do physical labor in Dongbei province, and moved into the home of a lumberjack in the Dongbei forest.[25] Later we were transferred to Xinjiang, and moved into Soviet-style block housing; when we were placed in our company of troops, we first lived in a dormitory, and then in an "earthen pit"—a ditch dug into the ground, and covered with branches and mud. When we vacated it, it was turned into a pigpen. After that we lived in a guesthouse, what they call an "inn" today.

Later, when I went to the United States, I lived in a Philadelphia townhouse; in the Berkeley bay area I stayed in someone's home on a hillside overlooking the San Francisco Bay. I've also lived in a young men's club, which was a room under the rafters of a building. In New York, I lived in an artist's warehouse-style studio. Because I was a self-funded student, cash was tight, so I either stayed someplace cheap, or I lived with someone else. All together, I've moved almost twenty times. In New York I also lived in a long underground apartment; a television drama about New York was filmed there.[26]

Soon after I moved back to Beijing, I lived in a courtyard home, and now I live in my studio. In terms of residential dwellings, I've lived in essentially every possible variety. Traveling in Europe I've stayed in family-style bed-and-breakfasts and boutique hotels; in Italy I lived in a three-hundred-year-old home whose furniture and furnishings hadn't been altered over the years, and I've bedded down at a friend's castle and in luxurious casinos. With the exception of a prison camp, I've been in virtually every kind of structure.

The house I live in today relatively suits my liking, because it suffices for all the potential ways that I might spend each day. It allows me to do things as I please: if I want to move around in the middle of the night, I do. I eat when I want to, there is freedom in everything. My studio is a mere step away, and it's convenient for me to chat with friends. It is a flexible space.

When I hear words like "sleek" or "chic" in relation to design, I can't help but think they are medical terms, something like "diabetes" or "nephritis." I hate those words, although I rather like "simple," which is employing implicit methods to effectively deal with things in a straightforward way. Because I'm a rather simple person, the activities that I encounter don't require me to use my intellect, and I'm very fortunate that, generally speaking, nothing requiring the heavy use of my intellect comes my way. The affairs of architecture and interior design are quite simple, as you merely

need to rely on intuition and the simplest craft to complete your task. Basic materials and treatments are also sufficient to satisfy our sense of happiness. Just like cooking: you don't need to throw all your spices into the pot, vegetables boiled in plain water can also taste good, because their essential nature, color, and flavor are provided by the sun, the air, and the earth.

The cats and dogs in my home enjoy a high status; they seem more like the lords of the manor than I do. The poses they strike in the courtyard often inspire more joy in me than the house itself. Their self-important positions seem to be saying, "This is my territory," and that makes me happy. However, I've never designed a special space for them. I can't think like an animal, which is part of the reason why I respect them; it's impossible for me to enter into their realm. All I can do is open the entire home to them, observe, and at last discover that they actually like it here or there. They're impossible to predict.

My design possesses a special characteristic: it has leeway and possibility. I believe this is freedom. I don't like forcing my will upon other people, the ways that you allow space and form to return to their fundamental states, allow for the greatest amount of freedom. This is because fundamental nature cannot be erased, and outside of that, I don't believe anything else should be added. Perhaps all you need to give any space a memorable feeling and look is really a lamp, a table and chair, and a drinking cup. Why must you insist on making everything in a certain style? Why must you add

1.14 Self-portrait in his Long Island City studio, c. 1983.

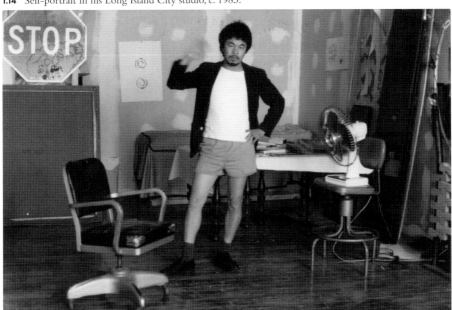

a fireplace? And why must the floor tiles have a pattern? I think all of this is pointless. No designer can draft human emotions, they have their own paths, and like the direction of a cat's next step, I am powerless to predict such things.

Like walking at the seaside, if you see a pretty shell you might collect one or two, or you'll pick up a few interesting stones. A chair that has been passed down over hundreds of years will similarly arouse your curiosity. You can observe the chair and imagine the postures or the thoughts of previous generations, but I wouldn't advocate it or flaunt it for this reason. I don't believe that aside from being able to satisfy my curiosity, such a chair has any genuine value.

In most circumstances there is no one influencing me. I have many books, and a decent understanding of ancient Chinese vessels, no matter if they are wooden, bronze, or jade. But, most of my efforts go into forgetting these things, avoiding taking the same path, or saying what has already been said, and attempting to contribute a new way of looking at the situation in everything that I do. There can be no substitute for the "here and now." It is the most important element in every kind of art, architecture, and design.

I don't like Beijing, it is unfit for human inhabitation. It was not designed for the here and now, or we might say that in this here and now, the city's development lacks a human dimension. I didn't use to like nature, because the nature I knew was cruel. The place that I lived as a child had no electricity, and it lacked sanitary conditions. When you went to the bathroom, you only needed to walk a dozen meters from the front door to relieve yourself anywhere. The sandstorms were incredible, and the winters were cold enough to freeze you solid. Humans are moving gradually toward developing civilization, which will bring its own set of problems, but comparatively speaking these ought to be fewer than those accompanying a lack of civilization.

Accuracy is not the highest standard in design, and a high degree of accuracy is often deliberately mystifying. Whether in architecture, interior design, literature, or even in speech, everything has its particular details, style, method, or sentiment. This is a kind of language, it can be meticulous, it can also be boorish, but these are not critical standards. Good or bad design depends on whether or not it possesses a conceptual framework derived from the designer's worldview, aesthetic cultivation, and judgment on basic things. The thing most often lacking in design is actually common sense, including large concepts like good and evil or right and wrong, and down to little details like materials, craft, or the capacity to determine the value of one's design. The precondition for having such common sense is many years of experience—engineering, aesthetic, and social experience.

I've written before on my appreciation of space. Space is intriguing, because while it can be materialized, it simultaneously has its psychic implications. Many people think that a high, big space is ideal, but that isn't always the best. Small spaces have

their small ambience, low has a low atmosphere, narrow has its own narrow feeling—every space has its special characteristics, and each space has its own potential.

I've yet to see decent designers emerge in China, most lack a clear understanding of the here and now. As to what kind of era we are situated in, what kind of times we've been through, and what times we will see in the future, they haven't thought clearly through any of these questions, yet they are extremely proud, and only because their work is related to the arts. Generally speaking, they are satisfied with merely superficial understanding, they lack the essential attitude needed for work, and their aesthetics are muddled. This is despite the fact that interior design has existed already for more than a dozen years in China, beginning with the early Great Hall of the People[27] and developing into the design of private homes, and finally into second homes or villas. Designers today should clearly recognize their status and obligations, avoid previously existing styles, and create a stylistic schema that at once belongs to the local environment and is related to the experience of the native people. Such a system could be small, and even if they elaborated clearly on merely one or two issues within the entire field, that would be a great improvement.

Say what you need to say plainly, and then take responsibility for it. Or, speak when you have the chance, don't waste your limited space saying something meaningless; this is what concerns me. However, this is actually pointless: I'm not interested in fame, and I have no illusions about the fact that all manner of social critics work within an extremely limited framework that can either bring you honor or destroy your name. I'm also not too interested in the public's criticism of me, I'm one part of the public and my critique of myself is not interesting.

I have no regrets, and I've never exerted any great effort. I became aware of many things only after I finished working on this or that project. For instance, when I finished building my house, I learned that I was an architect; I like to have fun, and after I created some objects, people said I was an artist; because I like to talk, people say that I'm on top of trends or that I'm up-to-the-minute. But all of these traits emerged from my most fundamental needs, because I'm a human and therefore I think, and because I don't want to conceal my opinions. I won't admit my mistakes were my own, I think they must be the will of heaven, and because I haven't the time to understand everything completely, how could I be dissatisfied? If you think about it carefully, perhaps all news is good news.

In fact, an ego is having self-confidence and trusting in the inherent power of life. Such a power can resist education or ideals, everything. This power serves a great purpose, and every person has it.

My life is characterized by having no plan, no direction, and no goals. Some people wonder, how can that be okay? But in truth, this is very important: I can throw myself into the things that I like, and because there are no obstacles, I can never be trapped.

After I finish working on the architecture projects that I've already committed to, I will not accept additional projects. I dislike the entire building process, and I could be doing something else, perhaps something that I lose at instead. This kind of success makes me embarrassed, after all it's the general "inferiority" pervading the profession that makes me successful—what am I still doing in this field? I've got to get one foot out the door, and not do anymore architecture-related projects, because there are so many other things to do, like fold a man of paper or go skipping stones. It's like the ever-changing fads in cuisine: Guangdong cuisine is fashionable for a minute, and it's Sichuan the next, but we will always have our favorite dishes, our favorite pot of soup. When everyone can distinguish what they like best, this world will be an interesting one, and people will say with conviction, "This is what I like." If everyone blindly followed trends, the world would become incredibly boring, for lifestyle is everyone progressing toward their own place, doing the things they are most willing to do.

Returning to one's self is the most important and most difficult thing to do; after so much struggle, suffering, and poverty, and ideological duress, educational debauchery, and aesthetic decay, our reality is already riddled with gaping wounds. Even though returning to the primal self is difficult, it is important indeed.

Ideal Cities and Architecture Do Not Exist

POSTED ON MAY 12, 2006

When we call any building a piece of architecture, it is merely a product, just bearing the weight of certain information. Architecture is not just an issue of architecture; it is also a social issue, and a statement on an era's identity. The shape of a city's architecture shares an important relationship with its cultural status.

In my experience, it seems that over the past decade everyone is moving house. No matter if you live in the countryside or the city, finding a person who hasn't moved house over the past ten years is an oddity. This is similar to postwar situations. Currently, China alone is building at a rate equal to the sum of the entire world's construction, and is consuming one-third of its steel and glass. What brought about such great architectural activity? It's common to see buildings being erected amid the ruins of demolished ones, and even though China currently appears to be one enormous construction zone, no one is contemplating the plight of man or his relationship to architecture, and there are no architects in the real sense of the word. That includes our current state of blindness with regard to urban planning and traffic issues: there is a lack of cultural, aesthetic, and ethical cultivation, and even when logic is employed, it is fragile and weak.

The concept of city that we are discussing now is a place where many people are biding their time together, not a space that could be called a "city" in any meaningful sense. For instance, we could say that the space in which we hold a lecture is meaningful because there are seats, people have come of their own free will, and a projector sits in the rear. A city should be a prolific space that cannot be controlled, is free, multilayered, and endowed with various potential; it is a space where we are able to interact, make demands, and develop. Currently, Beijing's residents can be simply divided into those who have a Beijing *hukou*[28] and those who do not, and this reveals its crude and backward state. This city is lacking functional parts, and humankind's essential rights have yet to emerge. Society is in the midst of transition, and the entire city has been thrust into a state of simply frenetic confusion. I don't want to get involved in this madness.

As for those people who hope to seek out the feeling of the countryside in the city, or achieve an urban feel in the countryside, they should be sent directly to the madhouse.

I do not believe that ideal cities or ideal architecture exist, I can only say that meaningful, significant cities do. Put simply, my earliest experience with architecture was when I was eight years old, and we were "sent down" to Xinjiang; as punishment we were forced to live in an earthen pit. I think that in political circumstances like those, living underground can provide an incredible feeling of security—it was a pit dug right in the ground, in the winter it was warm, and in the summer it was cool. Its walls were linked with America, and its roof and floor were flush, and often enough, when pigs would run overhead, their bottoms would fall through our roof, making us all too familiar with the sight of swine nether regions.

I remember some details: on one occasion, because there was no light in our earthen pit, my father was descending into our home and smashed his head on a roof beam. He fell immediately to the earth on his knees with a bleeding forehead. Because of this, we dug out one shovel's depth of dirt, an equivalent to raising our roof twenty centimeters. Architecture requires common sense, a ton of common sense. Because we were a family of readers, we needed a bookshelf in our home, and my father dug out a hole; in my opinion that was the best bookshelf. These are reasons why I don't believe in ideal architecture.

Cities are also like this, and the most appealing thing about New York is that it was built from mistakes. In its early stages, Greenwich Village was a hamlet, but after some simple planning the lifestyle was preserved. New York's ruined factories were taken up by artists and have become fashionable districts, and the nearby immigrant communities chose their locations because they had to. Thus the city has become a most interesting place. The most fascinating thing about the city is the different interest groups and people of varying status, all of whom form their respective spheres of

influence. This conforms to human nature: it is both rich and mysterious. When we want to see and be seen, we leave our houses, but with the turn of a corner we can disappear, and throw off our pursuers. These needs are similar to the habits of animals. We need to find more freedom than we need in cities.

I have a small firm that began accepting architectural commissions five years ago, and we have designed more than forty buildings to date, roughly equivalent to one finished product each month. Foreign architects can't believe this. However, after I've finished all my remaining architecture work, I don't intend to continue with it. Erecting a few more shoddy buildings doesn't really achieve much. Originally, I had hoped to seek new possibilities through architecture, I had hoped I'd be inspired, but in practice it is actually extremely tiring. Architecture is not a one-man show, it involves the whole of society, touches on various different realms, and leads one into endless frustration. In addition to that, I'm the kind of person who will create endless obstacles with every detail. I'm already forty-nine years old, and even though I really don't want to do "ordinary" things, I can't be so frenetic everyday. Obviously, this is some kind of sickness.

There's a saying going around that "China has become an experimental play-ground for foreign architects." This couldn't be farther from the truth. Chinese people like to hear a certain saying and then base all their opinions on it. Every year China breaks ground on many new projects, and nonnative architects participate in only the extreme few. In most cases nonnatives who win a competitive bid watch as the Chinese complete the project to their standards and then hang a foreign name on the finished building. Outsiders bring in a different system, but because we are so comfortable in the preexisting system, the "other" system will never truly exist here. Koolhaas and Herzog & de Meuron have multiple proposals in China, but none of them are realizable. The China Central Television tower and the "Bird's Nest" are outliers—thanks to the new planning offices of Beijing, and a young generation that has been properly trained. These two proposals were rare engineering projects for China, the opportunity for nonnative architects to compete before a panel of judges. But in reality, aside from commercial architects who meet the most common techni-cal requirements, there are only a handful of projects that reflect non-Chinese design or ambitions. To say "China has become the experimental playground for foreign architects" is bullshit; the experimental architecture in most Western cities exceeds that of the whole of China over these years, including many years to come.

Before Herzog & de Meuron (the firm responsible for the "Bird's Nest") sent their bid in to the competition, I recommended that they take on a Chinese partner, and they asked if I was willing to participate in the project design. I'm willing to engage in anything unfamiliar to me, and of course I didn't consider in what way it was related to the Olympics. When I agreed to join, the preparatory work was already completed,

and the time had come to make a decision. I simply asked, What do you need me for? They told me they needed my opinion.

Owing to my participation, the results of their previous discussions were altered dramatically, including the basic concept, shape, construction, issues of structure, and function of the stadium, including the exterior form and cultural characteristics. We connected on many aspects, and because we thought the possibility that the proposal would be accepted was rather small, bravely absorbed unfamiliar methods. In the end, the project was successful. Before I came home, they told me that they had originally hoped to take a step forward, but ended up taking two.

Herzog and de Meuron like to create things that have uniform characteristics when viewed from different locations but that are also irregular. However, they are incredibly self-aware architects, and they know that formalist methods are something to be avoided. The "Bird's Nest" is an integral structure from inside out, its exterior form is a structural support. This form is actually the result of a rational analysis, only later was it misinterpreted as the shape of a bird's nest.

There is increasing discussion on urban issues, but the concept of "city" increasingly resembles a cosmic mystery. Neither pure urban science nor architectural sciences exist, and effective discussions on these matters must include other materials and scientific realms, touching on politics and sociology. Concrete analysis can achieve positive results, and could be as minute as individual case analysis, but Chinese research organizations and academic institutions are unique the world over in that they do not conduct such research. Of course, research is admittedly important, but the prerequisite to any scientific method is that we are able to confront reality, and humanity has yet to discover a path nobler than the pursuit of truth. We must bear the burden of the simple truth, for it is the foundation in shaping new viewpoints.

An uproar is raging over the issue of preserving ancient architecture. On one hand, this is a reaction to the ruthless development, and on the other, it is the need to create an urban identity that any competitive city must put forward, least of all to attract economic growth. When most people bring up the issue of tradition, they have not declared exactly what culture we are protecting—what is tradition? China's understanding of culture has stalled at what is currently a very superficial level. It's a question of simple benefits, which cannot have any benefits for the protection of Chinese culture, and thus the "altering" of ancient architecture is not much better than its "destruction."

On the notion of architecture, I believe the first thing to consider is that everyone should confront the reality of the here and now: Why are you here, what surrounds you, what happened in the past, and what will happen in the future? If these questions are not clarified, no judgment can be clear. For instance, if you want to buy a car, you should have a basic reason: Will you use it to take your child to school, or to travel

somewhere for pleasure? But if everyone's motivation were merely to conform to the logic of others, what kind of society would this be?

As Soon as You're Not Careful … an Encounter with Idiocy on a Sunny Day

POSTED ON MAY 14, 2006

At a friend's urging, I set off headed for the rather poor *feng shui* of Beijing's western district for a gathering of scholars who were discussing the current "cultural crisis."[29] I'd heard there would be some cultural critique involved, and my suspicions were doubling the entire ride there.

I was already late. First we listened to some guy with a Shanghai accent expound on music. His tone was very similar to the flatulent voice of a teacher I once had from the "precious island" of Taiwan. He began talking about prehistoric music, and carried on until contemporary music, nearly working Shanghai's new shopping center Xintiandi into his discussion.[30] At first I was confused, and then I became bored to the point of madness, but near the end, when he brought up the names of certain Chinese musicians, I almost threw up.

Later on, and even worse, the great fool of a man named Zhu spoke.[31] I had overheard he's a cultural critic—that kind of person who makes a living by criticizing other people's books and then eats for free at cultural events. As soon as he opened his mouth, he started in about how Yu Hua's new novel was a failure,[32] his reasons being more or less that the novel was self-indulgent and lacked any literary relevance. This guy was so pretentious and criticized Yu Hua so harshly that he nearly made me believe that "Yu Hua" was some inanimate object, or a kind of bird that could write. Zhu concluded that although Yu Hua was good at selling himself, he would never be a literary master. I don't understand why "egocentric" people can't become masters. Does that really even matter? Isn't everyone self-indulgent?

I don't follow literature, so I didn't pay much attention. Finally, this Shanghainese guy seemed to have forgotten who he was, forgotten that he was on the West Third Ring Road of Beijing, and forgotten that there are no innocents or adolescent undergraduates here, and he began blabbering about the evils of Internet literature. I'm not into literature, and I'm new to the Internet—new to the degree that I love it too much to part with it—and I did not want to hear that kind of talk.

This guy even said that the teenage star novelist Han Han's level of literary cultivation was inferior to that of his middle school students, and that Han Han held no promise for the future. Next he said that, even though the actress Xu Jinglei's blog

and Web site for culture and fashion have among the highest number of hits in China, their content was still garbage.[33] Based on his tone of voice, he was trying to say that Chinese culture was in the process of ruination at the hands of these Internet mongrels. His basic theory was: because the moral character of netizens is so low (all they can do is *click, click*), their reasoning is tantamount to mob mentality. They have no idea of what literature is, not to mention an appreciation of high literature.

While I lack the means of investigating the moral quality of netizens, I do believe that Chinese literature can't really be that much better than Internet literature. Furthermore, I'm positive that the transcendent, timeless form of literature that he was referring to simply doesn't exist. But he was still blathering on: "Time can be the only measure of quality for this branch of literature," which, in my opinion, sounds like nothing but the kind of cliché claptrap rampant in those academic and literature circles, those kinds that I haven't been treated to for a long, long time. I would have the bad luck to run into these cultural critics and university researchers and their boastful audacity and unique brand of ignorance. They are shameless people with one foot in the system and the other out the door. China is so unfortunate, it's almost impossible to find a decent person rubbing elbows in these types of circles, phonies are everywhere, with wannabe phonies hovering around them.

Before leaving, I very clearly told all the people at the forum my opinion of this stupid ass. He screamed out that I didn't understand literature; I replied: "I don't understand literature, but how could I not understand that you're a tool?" It was the first time I used the term "SB." Mysteriously, at that precise moment, I just couldn't find a more suitable word.[34]

Perhaps it's because I've been surfing the Web too much lately, it must be rubbing off on me. But with this I swear, from this moment on, that that term will become a specialized bit of my vocabulary. I'll never use it on another person.

In addition, I need to remember: never again appear at any horseshit culture forums. Cherish your mind, stay away from ignorance.[35]

A Path to an Unknown Place

POSTED ON MAY 22, 2006

Writing one's feelings is simple, but can also be a difficult thing, for at least the following reasons:

1. You can't be sure this is really what you are thinking.
2. If you write something down, it will never be anything else.
3. It's difficult to maintain a good writer's posture from beginning to end.

The fascination with this nation is the indefinite and indeterminate nature of everything. It is a labyrinth, a road leading to an unknown place.

Humans are different from other animals, because they are always attempting to improve their own situation. In some places, human actions and behaviors are entirely not so—although there have been a few such experiments on a minute scale. Most were canceled due to failure. This is the result of secret, unchanged formulas among which there are some reasons that are difficult to talk about.

He won't forget you, and once he does, you will remind him. You are unable to forget him.

This space is given to you, from this moment it belongs to you. It is your space exclusively, and it is impossible that you will not act on it.

A space can be entered, it can be paced backward and forward, and it can also be forgotten.

When you are unaware, you are already situated within it; when you realize, you will be thrust outside.

You begin to doubt all your past actions.

You are a composite of all the things that happened to you, all of which you have no knowledge of.

I think this way, not because I want to write something down. I'm here thinking because my hand is holding a pen that is easy to use.

You close your only exit. From this moment on you have no intention of leaving.

Now you begin to worry whether or not someone else will inadvertently open the door.

Writing like this, I could write a lifetime, because I obey the will of an invisible hand.

Now, it makes me stop, stop immediately.

You are powerless to build a mansion, you will never know who will live there in the future.

You can build a dam, to resist an inundation of waters.

The floods of years past are merely the dried up burial grounds of today.

You cannot stop the tears of the tomb-sweeping masses.

One half is garbage; the other half is garbage too.

When you do use all your force, you can throw something very far, but it will inevitably come back.

In the event of a cultural dispute, determining right and wrong becomes an issue of upholding respect for one's elders; this is a result of mistaken gene combinations, and identifying the ties of blood as superior to judging between right and wrong. Such people will fight to the death to defend their clan, draining away their very last

narcissistic drop of life. National and ethnic issues then become neo-Nazi issues colored by blood relations.

No matter what the reason, it is simply like saying, "Since we are two melons from the same vine, let's rot together."

Any significance would be impossible to understand. When you do understand, it would be indescribable. Everything is different when there is no meaning.

A Curse for Zuzhou

POSTED ON MAY 24, 2006

Zuzhou is a Shar-Pei dog that bites, and won't let go.[36]

In a documentary film about SARS entitled *Eat, Drink and Be Merry: The SARS Outbreak*, director Ai Dan chose Zuoxiao Zuzhou's song "Labor of Love" for the soundtrack. Although this was not a decision of mine (it was Ai Dan's), we are both fans of his music.

There is a phrase circulating online: "Of all China's poets, including my father, Zuoxiao Zuzhou is my second favorite." But I think that statement was reversed; I originally said: "In addition to Zuoxiao Zuzhou, there is my father." Actually, that's not right either, I said: "Zuoxiao Zuzhou *is* my father." Ha! They all heard wrong, it's a joke. Zuoxiao Zuzhou is fooling you all. What? He denied ever saying that? And you still believe him? Is Zuoxiao Zuzhou a person you can trust?

I am very fond of the underground novel he wrote, *The Rabid Barking Tomb*. When I finished reading it, I was keen on publishing it, but we were too slow, and Zuzhou is impatient. If it's possible, I'm still interested in reprinting it.

The novel is rather morbid, like Zuzhou himself, who is a morbid person. I won't deny that I'm morbid as well. Everyone is morbid to some degree and in some way, but I don't identify with his statement, "If artists didn't use art to vent their inner conflicts, they would all be convicts." Every one of us is a potential convict.

I doubt that Zuzhou and I have any mental connection. This is because we absolutely do not understand each other, so, every time we meet, everything seems fresh. Personally, it seems that being able to see my friends, or even share a meal, is a world-shaking event in itself.

No matter if you are a musician, an artist, or a writer, I believe, there is no such thing as a "best circumstance" and, therefore, I say we all have our complaints, our grumbles, and our less than perfect state. But this cannot become your excuse—the desert grows its own kind of grass, and tropical plants only thrive in the rainforest, so debating our circumstances or external conditions is completely pointless. Any environment is still *your* environment, and everyone has his or her own unique situation.

People who cannot adapt to different circumstances should be left to their own devices. What I'm saying is: if one method proves useless, create another; if you are not equipped with creativity, you're a goner, and you deserve your fate. People who believe they are standing in a worse-off place truly have a problem because, actually, everyone is standing on equal ground.

Zuzhou's musical chronology demonstrates a kind of transformation and reflects distinct evolution. I consider this mostly a change in form. Perhaps it's for his listeners, for himself, for the market, or it could be any number of reasons. All in all, there is actually no change. I don't believe that people can truly change. Zuzhou has his own resolute point of view, and this is incorruptible, no matter how he packages himself. Sometimes he's a wolf in sheep's clothing, sometimes he's a hungry wolf, sometimes he's a horny wolf—but he's always a wolf.

It wasn't long after I returned home in 1993 that I met Zuzhou. Occasionally I would call on him in his East Village home. He lived in such a tiny room that once you stepped in the door, you faced the other wall. On the floor was a bed, and on the bed was a pile of *dakou* CDs,[37] but the rest of the room was spotless. Zuzhou asked me if I knew of Lou Reed, he seemed to idolize him.

I'm not a huge music fan; I gift all his discs to my friends, and I'm his biggest buyer. But Zuzhou doesn't even acknowledge his friends or relatives, he's a very cruel

1.15 Zuoxiao Zuzhou next to the men's restroom in Beijing's East Village, c. 1994.

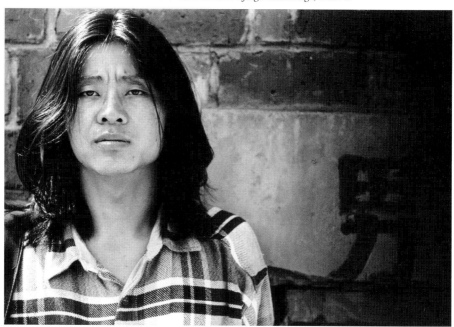

person. Ruthless. Absolutely do not let him trick you, and don't believe anything that he says. One might say that his entire life has been built on tricking people, and he's the same with everyone, but some people can see through him, although others don't understand him at all. That's just how he is. There is no intention behind his deceptions, and no hidden advantages; this is merely the nature of his relationship with reality. This isn't deception in the often-spoken-of profound sense—I'm just guessing that Zuzhou lacks the potential to communicate with reality. This is also the reason that he has been locked in struggle so long.

Of course, he could proclaim himself a realist, but everything he says is useless. He could be a realist, a surrealist, a realistic-surrealist, or a surreal realist. In the end, we only watch him perform, or we help produce his recordings. I think that, of late, he's only interested in his musical endeavors.

I've seen all of his live performances, well, at least three or four. Generally speaking, if he performs in Beijing, I'll be there. But usually, I don't listen. But I was quite moved at his last performance, where he sang very loose, open. It wasn't bad at all, and it was apparent that he had finally matured—he was a full-grown delinquent. Zuzhou has a lot of pluck, and his kind of courage demonstrates that he really respects his own emotions and lifestyle. He's a person with high self-esteem.

And speaking of overrating ourselves and attempting things far beyond our ability—who doesn't?

I can't tell if Zuzhou is hardcore or not. But I do believe that, to a degree, perhaps everyone needs to compromise. However, he's still like that Shar-Pei dog that bites and just won't let go. Perhaps he'll go to his grave filled with hate, but people will remember him for the gusto with which his jaws clamped down. He'll use that kind of attitude to prove that he once lived that kind of existence.

WRITTEN APRIL 2006 [38]

Ordinary Architecture

POSTED ON JUNE 22, 2006

Architecture serving as a home is a place filled with one's individual character. Different from any concocted meaning of "home," it is an independent, inclusive entity that deserves to be respected. It embodies the free will of all those therein and may represent the modern pursuit of comfort and the independent mind.

The interior and exterior of a home are linked by the relationship that joins them as an integral entity. In any such structure, mutual respect and communication exist between the home and its environment, the street, the neighborhood, and everyone

who lives there together. The logic of its construction is intrinsically organic and everything is derived from a common origin. It achieves true power through this fact, allowing it the refusal to imitate a single architectural style, or a single cultural form.

A house serving as a "home" is an illumination on life, it tells people about the possibility of a certain kind of life—that is, that life can be simple and real. But this sort of new possibility necessarily changes, and is necessarily filled with creativity. It must be interesting and fresh, safe and unpredictable.

The comfort and safety of a home is derived from the self-confidence and self-respect of the people who dwell there, as well as from the richness of their creative powers. These qualities are derived from a frank, sincere attitude about life and from a contented state of being. The inhabitants possess the ability to experience and endure completely new, modern experiences, to narrate their attitudes and ideals regarding life: tolerance, distinction, bravery, richness.

A home is life's basic necessity; it reflects life's basic character and possibility. In addition, it should give material form to life's most basic qualities and potential. It is also a complete philosophical proposition; it expresses who we are.

If I were to use only one sentence to describe the characteristics of my design, I would only say, I do not create difficulty. No matter what one chooses to do, various possibilities will always present themselves. In truth, such possibilities are precisely the various difficulties. I am simply attempting to return to the most basic of possibilities, and to minimize difficulties. I put forth as little as possible—this is the most basic feature of my house. This is also the most basic feature in the majority of my architecture.

It is not a strategy. Strategy is one of your choices, and you can always use a different strategy. The following can be understood as one characteristic of my actions: I am willing to do everything as simply as possible. If I must create or carry out a mistaken action, I will make sure that this mistake is as elementary as possible. I am willing to return to the most initial state. I am never willing to cross this line. If I cross it, I will return to the beginning and commence anew.

I believe that the concept of a proactive Chinese domicile is nonexistent. A special mode of behavior has taken shape resembling regional dialects, it exists because difficulties in transportation have created obstacles to communication. But without the joy of communication, it is difficult to form a systematic, effective praxis. China is currently replete with incompetent, self-styled architects working inside this system. They are designing for seemingly complicated problems, but are in fact creating obstacles to the obvious and salient. If such people did not exist, our architecture would be better, and the city would possess a greater strength. But this group of people represents authority, they have the absolute right to speak. So when we discuss the "Chinese domicile," we could say that it is a composite term

1.16, 1.17 Lu Qing on the roof of the Studio House, February 8, 2007.

signifying ignorance, confusion, ludicrousness, corruption, vulgarity, and impudence. These traits constitute the so-called contemporary Chinese residence.

There are absolutely no modern strategies embedded in the concept of the Chinese domicile. We all live in the modern era, and any strategy could be a modern strategy. Today's modern era encompasses the meaning of life for every person, every village, every town, every city, and even the whole country. Our native land has long since abandoned its traditional concept of the home (*jia yuan*); this concept of the traditional home is no longer valid. We no longer own land, no longer have relatives and friends, no longer have memory, no longer have real comrades, and no longer engage in authentic enterprises. This is precisely the puzzle we now confront. Our conditions today are still inferior to what they were after the war. After the war there were wounds, and you still could feel sorrow for relatives and friends who had died. Now, there are simply too many facts awaiting clarification.

The Chinese people are unwilling to discuss these questions, and if you are unwilling to discuss these questions, you become a beast, a walking corpse. So what kind of modern strategies can we rely on? Every day, people are busily attempting to solve all our problems, yet all of these problems were created by their incompetence. The structural system surrounding the Chinese home has rendered it unable to adapt or improve itself. Suspended in such a state, it maintains absolute power. Its every judgment and every decision are the root cause of this society's various calamities. What remains is only an issue of size, and the question of whether this calamity will continue, or will it be stopped? Yet, even if it is stopped, it will be replaced by another disaster.

This is the general background. Next, we should discuss education, the state of society, social aesthetics, knowledge of personal history, and knowledge of the state of our society. What is the current condition of Chinese architecture? The position of society, social formations, the shape of the economic upswing, its potential and the obstacles that it may encounter, its structure, et cetera. Who are the people that constitute these various abstractions? In the end, how many urban residents are there, really? How many peasants? How many workers?[39]

Now, you may notice that when people speak of the Chinese domicile, they are only discussing the homes of those "wealthy first few"[40]—the portion of the population who has become wealthy before the poor masses—but they do not discuss how those people became wealthy or whether they will continue to be prosperous, nor do they discuss the nature of the relationship between their wealth and the poverty of other people. If such questions are not mentioned, isn't it true that to discuss the Chinese domicile we must discuss the survival conditions for the majority of Chinese people? What kinds of possibilities are open to them? Are there effective means for improving and resolving the difficulties they face? What are the basic problems of

habitation and the most basic ideas about "home"? This is an issue no one discusses or researches. When even the most basic conditions are unclear, how can one do anything? You must investigate what is possible and what is not.

In this sort of situation I feel hopeless about architecture in China. I've accepted a few projects, and the design activities are basically revising other people's plans. I am especially capable of solving problems; for me, solving problems has always been the most important, most basic characteristic of my personality. What is the problem? Where does it appear? How can I solve it?

I do not want to follow a Chinese style, and I don't believe that China still maintains any styles or traditions to speak of. To illustrate, it is entirely possible that the Forbidden City could be Vietnamese or Indian. I don't believe it has any relation to us today—it belongs to the monarchs, to centralized state power, to tourists. It is merely the Beijing of films. This is to say, those people who still speak of roof tiles, roof brackets, and mortise-and-tenon frameworks when discussing Chinese architecture are the ones unfit to present themselves within this industry. On these grounds, I think that we are merely using local materials to put forth a familiar attitude toward local history, politics, and lifestyles as a means of dealing with something. I do not intend to include any obvious cultural characteristics in my architecture.

I don't care if my buildings have any cultural characteristics, and I don't care about "culture." The sorts of things I care about are efficiency, reason, and suitability to one's identity. I believe that if you do anything, you necessarily have a method. This is simply another system and the logic that it creates. For example, take a handrail: no matter if it is ten centimeters or one centimeter wide, its function is already fulfilled. The characteristics embodied by the logic of this handrail could be "thick, heavy, and stable." But it could also be "dangerous." It cannot be denied that danger is likewise a fundamental human situation. Sometimes, I am simply reawakening people's consciousness and mindfulness toward danger. This danger and mindfulness toward it comprise just one necessary part of architecture. All architectural standards say that safety is a human necessity, but as far as I am concerned, an awareness of danger is actually a part of the human predicament and quality of life; it is an element that architecture cannot ignore. This is a philosophical interpretation, not an interpretation based on architectural standards.

There is no such thing as a standard person or two people who are completely alike, so there should not exist two buildings that are exactly the same. People determine standards, and standards don't tell us anything, other than when to abandon thought and emotion.

I think that the meaning of home changes entirely with different people. For example, if an individual feels that he is special, his home may be an uncomfortable place to other people. I believe that I am an absolutely ordinary person, so the

majority of people who come to my home will be comfortable when they see many ordinary things. They can enter audaciously, they can walk into any space that they would like to enter. Being "ordinary" is my most fundamental trait, and ordinary can have its own individual traits. My architecture is ordinary architecture.

TRANSLATED BY PHILIP TINARI

Ar Chang's Persistence

POSTED ON JUNE 24, 2006

He Yunchang[41] has been doing performance art for more than ten years, and before that he was a painter. His gift for painting is rather exceptional, both in technique and in intensity. These days, he lives in the Binhe Community, a twenty-kilometer straight shot east from Tiananmen Square. Most of his days are spent playing chess with a few friends, playing video games, or eating. Performance art is the only thing he feels compelled to do.

He is constantly in preparation for those few moments, or at least that's how he appears, as if he's incessantly thinking and making plans. Of all of Beijing's artists, not a single one dares to challenge him to a smoking contest, he lights one cigarette from another.

The most important performance of He Yunchang's early works is his personal history *Golden Sunshine* (1999). In this performance he covered his body in yellow paint and suspended himself in the air to a specified height. With great difficulty, he held a mirror with which he managed to divert some sunshine onto the shadows of a high, overbearing prison wall. At the time, he was still living in Yunnan, and this was around the time when people started calling him Ar Chang. The heroic form and ironic allegory of this performance made him unforgettable in art circles, and the fundamental principles of this initial work reappear without fail in all of his later works, albeit in different forms.

Dialogue with Water (1999) was an even earlier performance in which Ar Chang held a knife in his hand, suspended himself upside-down above a river, and "sliced" the water for thirty continuous minutes. Since the water was flowing at a speed of 150 meters per minute, 4,500 meters of the river were "cut" that day. Ar Chang's arms were also cut open, 1cm deep each, and blood flowed along his arms and out into the "wound" of the river.

Ar Chang, knife, river, and blood created the conditions for this dialog with water. There was no audience, no lighting, and no music, but the work itself provided a sufficient experience to speak hard-to-believe facts. These facts pierce our spiritual

reality like a sharp weapon. This omnipresent and idealistic reality is our history, our present condition, and everything in our future that hasn't yet happened.

With a focus on individual emotions, willpower, tenacity and putting these all into practice, Ar Chang's works discuss the nature of man, of willpower and ideals, as well as the violent conflict between desire, willpower, and reality. Though this conflict is violent, it often gives us a false sense of beauty.

In Ar Chang's performances, he executes his personal will with persistence, ultimately accomplishing his goal through simple but difficult means. In most circumstances, we see only the finished attempts. In the pictures of his live performances, this completed attempt at proving his willpower has been sanctified to the point of absurdity; as we say in Chinese: "He moves one to song and tears."

The "persistence" in Ar Chang's works wears different disguises, and he always brings his one-man battle to the scene. In this battle, the enemy is everything that lies beyond himself, and this confrontation between a feeble individual and a powerful other makes the war appear unjust but glorious. From start to finish, as long as he's still breathing, he will forever talk about the meaning of willpower and why it is indefatigable.

Ar Chang's performances have a nearly religious significance—the struggle for one's belief or suffering for one's lack of beliefs. This is precisely why his efforts go far beyond what we usually call performance art. The works are difficult to execute, and in most cases he's far from happy with the result.

Ar Chang also likes to play chess. His chess style is something like that of those unruly guerrilla competitors who play on the roadside. On more than one occasion I saw him squirming out of a predicament that looked like certain failure—in Cantonese they have an expression for situations like these, they call it "flipping the salted fish." In these moments his opponents will become furious, for they truly experience, as they say, "the cooked duck that flies away." But this always makes Ar Chang so happy that he just can't seem to close his big, black-toothed mouth for a whole week.

WRITTEN MARCH 6, 2004

The Computer Worth "Several Hundred Million" and One Worthless Brain

POSTED ON JUNE 27, 2006

The Facts:

Zhong Nanshan is an academician at the China Institute of Engineering. His life has been rather eventful of late.[42]

Zhong Nanshan's laptop computer was stolen, and both Guangzhou city officials and Guangdong province officials attached a high importance to the case. In a memo to his subordinates, provincial party secretary Zhang Dejiang instructed police to "break this case as soon as possible," and dispatched more than one hundred officers. The case was solved in less than ten days.

During the process of investigation, the police "inadvertently" tracked down eighty-three stolen mobile phones and twenty-eight laptop computers.

Zhong Nanshan's Version:

"What is so wretched is that there were some important academic documents stored inside."

"If the research contained inside were to be turned into a new medicine, it would be worth several hundred million!"

"Only a narrow stream separates the urban floating population from thieves and plunderers."

"In cities like Guangzhou and Shenzhen, the population of nonnatives is too high."

"Why is it that after endless crackdowns, thievery is still rampant? The core of the problem lies in the fact that appropriate criminal action has not been taken against these people. I feel like they have been dealt with too lightly, and thus these criminal elements proliferate."[43]

The national repeal of the compulsory asylum policy was a step forward in civilization's battle against barbarism.[44] It was a victory for individual rights and the dignity of citizens and is an important part of legal reforms, even despite the fact that it came too late to this nation, and at too great a cost.

If the perspective of Mr. Zhong, the academician, definitively reflects that of the intelligentsia—or at least the humanitarian character, level of cultivation, viewpoint, and legal consciousness of the scientific intellectual community—does it also reflect their meager collective capacity and low standards?

What force causes individuals to abandon their fundamental sense of goodness and their capacity for judgment? What causes people to forsake reason, a sense of right and wrong, and the capacity to feel shame? What power inspires a person to defend a hypocritical order, unjust privileges, and barbarous beliefs?

An appeal for compulsory asylum for unemployed migrants is in disregard of the most basic legal processes. Being fully aware of his privileged rights and status, but pretending he is a common person, Zhong Nanshan ought to know: in all circumstances, national interests are above those of the people. Although the face of this coy Chinese intellectual looks so vivid on paper, even one stolen laptop computer could be linked to national interest. People can be ignorant, but there is no excuse for shamelessness.

Mr. Zhong had his laptop computer stolen. Because he was a "common citizen" of Guangzhou, the provincial party secretary made it a matter of high importance, mobilized a generous number of police officers, and swiftly solved the case to the satisfaction of all.

Has anyone inquired about whose resources were put to use? Inquired about who paid the price for all this? You didn't know that the personal rights of migrants were part of the cost? Mr. Zhong should first of all thank those people whom he surreptitiously robbed of their rights, and then feel grateful for his servants—the party and the state. That would be a true show of good will.

Half a century ago, the urban drifters that he speaks of would have been the backbone of the revolutionary proletariat forces. To coin an old phrase, "Without them, there would be no revolution; to deny them is to deny revolution." Before you get ruthless, you ought to first weigh the consequences, sober up, and try not to act drastically. For those in important posts, acting dumb and stupefied is easy, but if they really are dumb, the nation is in crisis.

There is blatant robbery in this world, and there is hidden deprivation. Those countless urban migrants weren't born as drifters, and they are nothing more than the common victims of blatant robbery and hidden deprivation. When, and under what circumstances, their property is lost will forever remain a mystery. Without a doubt, this is the darkest and most underhanded criminal act after which no one will inquire, but we hope that you leaders enjoy your share!

Zhong Nanshan was quoted as saying: "Only a narrow stream separates the urban floating population from thieves and plunderers." But to put it more accurately, only a narrow stream separates political gangsters from Chinese intellectuals.

Zhong Nanshan also said: "With respect to the creation of laws, what kind of person should we assume is the foundation of our society? Our societal foundation should be good people, and not criminal elements; lenience toward the enemy is cruelty toward the People."

Protecting human rights is an important part of the constitution; it is the fundamental spirit of humanitarianism. Human rights are not exclusively for "good" humans, they are innate rights for each and every individual, with no distinguishing between good and bad people. Mr. Zhong's statement, "Our societal foundation should be good people," not only causes one to worry about the speaker's intellectual capacity and academic circles themselves, it makes the present state of human rights in this nation seem even more alarming. If those international anti-China human rights organizations were aware of it, wouldn't this cause a stir? What kind of world does Mr. Zhong—who sees himself as a good person—yearn for? Hopefully his fatuous point of view and prejudices don't influence his scientific research, medical practice, or educational duties, and especially not his social practice.

For those incompetent, abandoned, forgotten, injured, unfortunate, and aggrieved urban migrants of good conscience, hopefully no one will bother you tonight. Hopefully, you will sleep safe and sound.

A Road with No End

POSTED ON JULY 5, 2006

Oxygen-scarce plateaus, remote paths, hearth-fire signs of habitation—it is the will of heaven, these hardships and barriers that protect the unique culture and land that is Tibet.

But all of this is disappearing. One long, inland-stretching railway is inescapably accelerating the decline of this culture.[45] A profound and far-reaching history, an intrepid race of people, and an independent, integral spiritual world are vanishing in the name of civilization. Such are the sorrows of humankind, such is this tangible truth.

Pious and irreverent men and women from across the world are surging into Tibet. They bring back *khataghs*,[46] bring back their stories, and they paint pictures of emotional departures and moving experiences. But what they cannot bring back are the colossal mountains, the mysterious lakes, and the silent faces that most of them cannot bear to confront. Although anyone can appeal to heaven before he or she starts out on a journey of supplication, it is not easy to arrive at the destination.

Close your eyes: imagine an unimaginable world of spiritual consciousness, believe in its existence, and then completely convince yourself that it can be reached only in your imagination.

I will never visit that place, even if there were increasingly modern means of transportation. There is no reason, and no need to go. I want to learn how to maintain the distance between us.

From a faraway place, I invoke a blessing to the people of that pure land: be as content and harmonious as you once were. And I caution them: keep your distance from those suspicious strangers hailing from other lands, those offensive folk from Chang'an Road, Wangfujing, and Xintiandi.

Ignorance and Hypocrisy Always Win

POSTED ON JULY 7, 2006

I do not care for honor. Like all people, I possess that sort of honor naturally derived from being an upright person. I am not afraid of confronting any person, or any

power, no matter how formidable it, or they, may seem. This is because I trust in my ability to protect my fundamental rights. I must be this way, there is no other choice, and I must be willing to sacrifice for this. Any cost of safeguarding the right to act as an upright person is invariably not worth mentioning.

Freedom is a god-given right. It is unequalled, absolute, and priceless. No matter if you are rich or poor, intelligent or not, it belongs to you, and no one can touch it.

What is the problem with profanities or blaspheming? Can you be cursed to death? In the material and psychological reality of those ignorant, useless, hopeless, frustrated lost souls, curse words are all they have. For base and uneducated people, having a few curse words at your disposal isn't all that bad.

No one should pretend to represent the mainstream, or use civilization as an authority or force. Civilization does not belong exclusively to the society's upper crust, it is not a precursor to keeping social order; civilization is an amalgamation of human nature, the sum of your exceptional points and his weak points. Furthermore, correlative relationships between wealth and power do not have to be inevitable.

Theories of superiority, optimization, and cultural purity harbored by cultural fascists will always be disgraceful, lamentable, and pitiful. All this is saying is: I am better than you, I will not speculate with you because you are lesser than me, in my opinion you are lowly, I am powerful.

Eugenics arises from an inner panic. It is the wishful thinking of people or authorities who don't dare, or who aren't willing to speak frankly or straightforwardly. There is no justice in such a world, and a shortage of good intentions everywhere, and whether they are intellectual or emotional efforts, all energy goes into safeguarding the basic conditions of such a dishonorable existence. Freedom and transparent standpoints and value systems are a direct threat to the societal foundation that such an existence relies on.

None of this seems strange, what is strange is that with gains comes loss. And what about the other population of people? Where is your so-called social conscience? Who is protecting fundamental principles or truth? Who is speaking for the interests of others, which is the indispensable basis of civilization? Generally speaking, it is not worth the trouble, because this is a society with no true kindness or geniality, a society where beauty makes way for ugliness. All of my actions and selfish behaviors are merely for my own benefit, I can never truly understand others, for I lack a sympathetic heart. I argue for my own benefit, my personal rights, and I believe my selfish position might be related to others.

When the brilliant and accomplished persons of a society collude with the dark powers to become thieves and deceivers, ours will continue on as an overwhelmingly misfortunate era lacking in conscience. All of the humiliated and deceived people struggle to gain sympathy, deeply believing this is their fate, and they have neither

aspirations nor campaigns to improve themselves. They are merely a flock of sheep sent out to graze on the road, thereby renouncing their lives' pursuit of religious discipline.

Why I Am a Hypocrite

POSTED ON JULY 12, 2006

A recent trip to Jingdezhen provided me with an opportunity for reflection.[47] I discovered that I'm an ignorant and shameless person. I've used my shameless media sensationalism to achieve shamelessness even greater than the public's, and I've used my individual shamelessness to realize a collective shamelessness. And I don't see shamelessness as a disgrace, but instead shamelessly believe in shamelessness, and this has led to my shameless state that you see today. My life's goal is to make myself into that rare kind of negative example, to endow my existence with a certain kind of necessity, and now it looks as if there is no degree of difficulty in achieving this.[48]

It is also a possibility that "shameless" is not a curse word. "Shameless" is an evaluation of one's ethical state: it implies that one is impure in any given situation, or has lost a certain quality that humans ought to possess. But this is a normal state for our compatriots, otherwise why else would we be striving so hard to reestablish a sense of honor and dishonor? In this respect I'm not only shameless, but I'm also somewhat enlightened. Having a sense of shame is nothing to be extolled, and no one will praise you for it, because even possessing a sense of shame doesn't mean you necessarily know what honor is. Grasping both of these concepts entails a degree of difficulty.[49]

Saying that a person who doesn't know right from wrong is "shameless" is not exactly an appropriate assessment. It is highly probable that a person's words and deeds are not within the realm of moral evaluation, and what's more, our sense of morals can be completely different in various situations or times. Even if we shared the same morals, it would be difficult to measure or determine who was more shameful. We might know what an ideology sounds like, but we can't know its true intentions. People are profoundly complicated, and it's hard to draw clear distinctions between who is more shameless; for example, when a husband says his wife is shameless, his wife has the same to say about him.

Our capacity for distinguishing right from wrong is dismal, and perhaps this is due to intellectual flaws. But intellectual shortcomings aren't even real shortcomings, provided they are physiological and not psychological—in which case they fall outside the realm of ethical debate, and all ethical arguments have their flaws; none can stand up under excessive deliberation. Alleged intellectual shortcomings in ordinary

thinking patterns are the result of thinkers who possess a sense of judgment inferior to, or different from, the average person. Assessments of mentally handicapped persons are broadly suited to the majority, if not the total sum, of scholars, academicians, and intellectual circles.

If the intellectual activity of such people proves to be insufficiently dynamic, it causes them absolutely no harm, and they will continue to be regarded as symbols of national wisdom and to enjoy their lofty positions of noble character and high prestige. Fortunately, over the past one hundred years in China, affairs requiring intelligence have been few, and theories that were considered progressive a century ago are in "inexhaustible supply," "continually put into use, and are valid everywhere as the fountainhead of all thinking."[50] Material civilization, science, and technology are the affairs of the "barbarous Western powers." As the world's factory, we have already won for the people of our nation an opportunity to gasp for air and resuscitate the economy. What's more, a nation's level of intellect is no longer important in the globalized era, what is important now is finding ways to preserve authority and wealth under these new arrangements.

The entire world over, there shouldn't exist a person as traitorous, oblivious to shame, or wildly deviant from human nature and social ideals as myself—but these people fill the streets today. As for those social elite, those influential figures and prominent personages who stride forward in the glimmering rays of hope, even the most venomous appraisal wouldn't be excessive.

And don't fantasize about humiliating anyone. People cannot be humiliated unless they humiliate themselves. I'm humiliating myself right now, by going one step further just to prove that I am a hypocrite, a beast in man's clothing, even though I fully realize that hypocrites won't likely come to a happy end.

If some people believe my venomous language and my dark heart have tarnished the glorious reputation of our nation's brave men, or really believe that true heroes are so vulnerable that they topple when confronted with just a few words of evil, then they are mistaken. They don't know what a hero is made of. You may not know what you are made of, but you cannot pretend to be a hero, even in times when heroes are mass-produced;[51] heroes have never been people merely fulfilling their duties. This appraisal of heroes reflects the mental outlook and value system of the average person. How humble and low must we become before our endlessly falling standards allow us to praise as lofty and sublime heroes those sycophantic workers who are merely fulfilling their duty?

Gratefulness is a genuine emotion and reciprocal expression of good conscience, a natural reaction to the good intentions and benevolent actions of others. We should be remembering the actions of another doctor, whose courage prevented the people from a true disaster. Other people can claim they had no knowledge of concealed

SARS-related facts, but you, in the teeth of the storm, you did know. How is it that any doctor—duty-bound and sworn to rescue the dying and heal the wounded, as well as a respectable elder and influential figure in the medical world, an honest and loyal, dynamic model worker—could lack the courage to face facts squarely?

I was in Beijing during the SARS outbreak, and although viral mutations did not fill me with terror, people will never forget the system's habitual lies, the silence of medical professionals, and the silencing of the news media. The virus stirring in the souls of our compatriots proved much more terrifying and disappointing. Neither I nor my friends wore surgical masks, for fear that it would mask our very last ounce of pride; I never poured a single glass of Chinese herbal medicine, I rejected all the apocalyptic depression, flew kites in a deserted Forbidden Palace, went fishing at Tanzhe Temple, and filmed a documentary, muddling through my days just as if it were any other time.

The migrant workers who couldn't usually be prodded out of Beijing fled in droves, escaping from this heartless, untrustworthy, and misfortunate place. Villagers in the outlying hamlets took up sticks in their hands and guarded their village entrances, staring down those now pride-shattered Beijing urbanites. The elderly in the countryside begged their sons and daughters not to return from the city. In the face of a disaster, people without conviction will reveal their foolishness, their cowardice, wretchedness, and hateful underbelly. Those days had a special significance, and the image of an abandoned cat running across the Second Ring Road in the rain still comes clearly to mind.

People are still willing to lump an individual's behavior with his or her family background and intellectual makeup. Such an interpretation is essentially a negation of humanity, for anyone can potentially be of good conscience, anyone's soul can transcend reality, anyone can alter his or her own fate, or find hope in the midst of despair. Respect is not something that can be inherited from previous generations, nor is it doled out like charity; respect is the result of self-confidence and persistence. People will generally accept the dominant mentality, whether it comes from one's family, social stratum, or nation, and regardless of whether it is materialistic or spiritual. People generally approve of order, whether or not it is righteous or good-natured, and regardless of whether it is related to the human potential for existence. But for a people without conviction, basic life principles are dependent on the successes and failures of personal gain, and the world becomes but a vessel with no possibility.

Can a nation that denies fundamental fact, conceals and evades information, possibly renew itself? What kind of foundation must an organizational system lacking an ethical conscience be built on? And what kind of price will we pay for it? The status quo beseeches people to consider the most naive and simplistic issues, so when will society learn the benefits of real knowledge derived from fundamental common

sense? When will it endow us with a primitive sense of respect, simple pleasures, the luster of a polished rationale, and basic freedoms? Philosophy, science, literature, art, and politics are only meant to help these possibilities flourish. Deviating from these principles, or replacing them with excuses or another model, can only incur unfortunate costs.

Even though it is necessary, clarifying the facts is almost impossible. Any need to explain or defend the rights of individuals and the efforts we make to strive for them are already superfluous. Generally, we say human rights are god-given, which means that we should spare no effort in protecting them and making them an integral part of our lives. Seeking out excuses or sophistry on the issue of human rights, either knowingly or not, is an exoneration of ignorance and injustice.

The People, the Moon, Zidane, and More

POSTED ON JULY 15, 2006

The People

Take one glance, people are everywhere—going to work, shopping, standing around, strolling, earning money, suffering losses—there's truly an abundance of people.

But I've never seen "the People." What is the People? The People is the sum total of many persons, and the summation of people is imperceptible and intangible. Mao said: "Only the People have the power to create history." One person is a person; a multitude of people is the People. One ambling person is a vagrant, a pariah; a throng of people cramming into train cars to go on holiday, tens of thousands of people flooding into the same location—this is the People.

The Great Hall of the People is a giant room where "the People" hold meetings. If the People were to hold a meeting, even a larger room would be insufficient, thus they have Representatives in the General Assembly, and these Representatives represent the People. So when we see them, it is analogous to seeing the People. It's impossible to envision this clearly. But nowadays it's surprising—with all the talk of the People, and of "Serving the People," it seems that the places with those words emblazoned in gold letters above their doorways are precisely the places where people do not dare pass. For these are places people do not go, despite the fact that such gates have been erected to serve them.

"The People" has already become a manner of speech that excludes and tramples people. Look at yourself: Do you deserve to be a called a person? You're also one of the People. "The People" is the most injurious of curses, it denotes a crammed populace that no one pays attention to, people living out their lives as individuals who

don't deserve to be treated like people. Just like gravity, the People will always exist, but they will never reveal themselves … we see the house collapse, and the apple falls from the tree, but no one has ever seen gravity. Someone who helps another is a nice person, someone who helps a few people is a good person, but someone who helps the People—something that never even existed—is a fool.

Corrupt Officials

If I were an official, either a minor or a major official … the mere thought stirs my blood. I want to say honestly, I would only want to be a corrupt official.

I'm clear about the fact that merely being an official is not enough, and being an upright official is a pointless and impossible goal. Upright officials scurry anxiously about over the everyday concerns of the people; their hearts are crystalline and their "sleeves are empty of bribes." They burden themselves with the responsibility for caring about everything and everyone under the sun, and are always the last to take their enjoyment—this is a fate more agonizing than hard labor, the mere mention inspires fear, to actually achieve it would be too depressing.

But that's all different when you are a corrupt official. Life as a corrupt official holds many pleasures. Treated as an equal among your fellow officials, welcomed in and sent off amid illustrious gatherings of distinguished guests, your macro-control would display great leaps of progress, even your pets would ascend to glory with you—just thinking about it brings a surge of thrilling emotions.

The Complicated Circumstances of Assaulting a Police Officer

If the police are assaulted, this event is not called assault—it's called suicide. Either those doing the assaulting are asking for death, or they are of unsound mind. Severe punishment calls for summary execution, light punishment would be a direct escort to a mental hospital.

If more than ten people mount a collective assault on the police, this is an action of a completely different nature. Common sense tells us these people must be gangsters (those most undesirable social elements), and they are always ten or eight troublemakers strong. If there are too few of them, then they won't have enough force, and if the resulting crowds can't be suppressed, everyone will suffer a beating. But, if there are too many thugs, it's a spectacle, they become a virtual army, and then there isn't enough profit to split between all the commoners. This is why gangs and triads are always fighting among themselves on television and in films, and always fixing to kill each other; the police needn't waste a single bullet. There's no song and dance in this kind of movie, you don't need to tell the good guys from the bad; this kind of inside "housekeeping" is based on the rules for survival of the fittest. A ten-person attack is a similar mutation on the same situation.

In the event that an assault involves over one hundred persons, the term "mob assault" would be inappropriate. Where would a small town get so many thugs and criminals? To report an event like this, the newspapers must have water on the brain.[52] This type of event should be called a "nonstandard assault on police in an abnormal society," or "the People bite back."

But the most difficult incident to define is when the police force in one town assaults that of another, or police between cities struggle, such as when the Shanxi police attack those from Beijing, or when a police operative violently cudgels a traffic cop. Such situations are complex but are generally clear-cut and cutthroat, and since they're in the same business, they know each other's sore spots and can strike without hesitation. In most cases the outcome is a bloody scene unsightly to behold. But this is an internal affair, something akin to drilling troops for armed assault. Any results are dealt with cleanly and squarely, and are sure to leave the public wholeheartedly convinced. Just as Jiang Zemin said as he was surveying the army, "The character of the troops still appears high, their mannerisms still look stiff, and the overall effect is still of unity."

Zidane

The World Cup ultimately becomes the "World Curse," as the object of the world's fanatical joy finally begets sorrow. Dozens of matches, hundreds of millions of viewers, and billions in cash—we might say that this is the mobilization of all of society's forces. From the preliminary tournaments in Rome to the final matches in Berlin, humanity's love of spectacle remains unchanged, except that it has sunk to the lowest possible state of decline. Humans have become civilized, and stadium tournaments are no longer bloody scenes; there is no spectacle of a hundred lions roaring in chorus, and muscular corpses will not be carried from the stadium one by one. Instead, football fans sit on their sofas facing a flickering screen and listening to the bogus passion and pseudo-madness of sports commentators spouting off their humorless, witless commentary.

During the championship finals, Zidane,[53] upon whose shoulders rest the hopes of the general public, couldn't tolerate the slander of a contemptible little flunky. After a throw to the ground and a red card penalty, France lost the game and Zidane said, "I will not go back on the field."

Now, I'm not a football fan, but listening to everyone talking about how he lost it, or how he broke his cool, begins to sound wrong. When one's calm and intellect are not maintaining one's dignity, it is merely an excuse for the fools to cower, a nauseating excuse insulting to one's intellect. True calm and intellect are always on call to maintain one's dignity and hubris; they are the very soul of any competition, and I'm afraid this is the reason that Zidane is Zidane. It reminds me of the Dou Wei

incident,[54] which gives little cause for criticism because he was acting to protect his pride and dignity.

The Moon

The moon is always there. As long as it's a clear sky, it unmistakably hangs in the place where it ought to be. A friend has an old German military-issue telescope, and on the fifteenth of every lunar month the moon that I see is a perfect circle, the craters and mountains on its surface alternating between reflective and dim. When I observe it during the second part of the month, it has already begun shifting to the western part of the sky, turning its face to head downward. The ancients often gazed at the moon, and both one's mood while gazing at the moon and the lunar calendar are closely related to the character of the Chinese—this is why the lunar expedition was not worth it: it destroyed our illusions. There were no goddesses to be found in the vicinity, and everything else was uninteresting.[55] Humanity has proven to be just like a person—once it grows up, its stories are no longer fun. Humans have gotten lazy, seeking out the cool shade and avoiding the heat. Why don't we try landing on the sun?

The characteristics and personalities of the moon, sun, and planets are as individual as people; the boundless universe is unfathomable. Perhaps this world is the one they sing of in legends and fables, and reality is a part of a mysterious, far-fetched fantasy, but we are too minute, too ignorant to be conscious of it. What are humans? Only those living things in the universe that are light as dust, they are a babbling kind of living thing, who can also see the spirit of the moon.

Some Thoughts on Future Cities

POSTED ON JULY 25, 2006

To discuss what we call the city is actually to discuss the spirit of humanity, the spirit of a collective, and its fantasies and confusion.

When I was living in New York, there was a period when I liked playing cards and I went to Atlantic City a few times every week. Over those two years, I sat in a car and set my record for intercity travel, gliding between these two cities about two hundred times with my butt just a little more than one foot off the ground. Why would I do that? Of course it was my desire.

I don't have much of a relationship with the city of Beijing—if there's traffic congestion, I can choose not to travel. But there are people who must travel to pick up their children at six o'clock in the evening, and then celebrate a birthday at their

parents' home; perhaps at ten o'clock they need to go back to the office to put in overtime. In these circumstances, if the roads they must travel on are congested, they will be affected.

It's impossible that my days could be altered by such things, because I don't make such demands, I've lowered my expectations to the lowest possible. Today a friend told me he used half a year's time to finish writing and then defending his thesis. I've never used my time in this way. I don't do things that I don't enjoy.

It's possible that nothing about this city attracts me. If I don't want to spend an evening at home, and want to go out, I will inevitably think: Where is there to go? This city has no style, it's as simple as a book with only two pages—you can flip it back and forth, but there's no content, there's no potential for different stories to emerge.

Beijing can really torment people. There are countless large districts, and if you were to walk the circumference of any one district, you would die of exhaustion; there is no place to stop for a rest, it is very inhospitable; there are no facilities for outsiders, and none of the districts has a suitable relationship to the city. In this special period of history, everyone has moved house, none of the neighbors know each other, and there are no friends that you grew up with.

In terms of convenience, Shanghai outshines Beijing. Shanghai's problems are different, and due to historical reasons Shanghai's people have been affected with an eternally arrogant and servile mentality. They will eternally be the stingy petty bourgeois, the satiated petty bourgeois, or the petty bourgeois rising quickly to fame. The old face of the Bund has grown a few new layers of skin, but no amount of powder can cover the dust of former days: Shanghai is only the illusion of a megacity, it lacks a cosmopolitan spirit, it's like a beautiful pseudo-Broadway.

Compared to Beijing and Shanghai, Guangzhou is relatively natural, and is a city for its citizens. Even though its buildings are dilapidated and congested, you can always find something to eat right downstairs, or walk a few more steps to a store. Guangzhou isn't half-baked, it's like a bubbling pot of boiling stew. Beijing will never be well cooked—some places are overcooked, and others still frozen inside, or raw. This city will never be uniformly cooked.

When I refer to a "natural city," I'm not implying that nature should be moved into the city; I mean that the city should develop naturally. Like sleeping, for example, you can't stipulate a sleeping posture, everyone's position is different, and the same person sleeps in different positions in different weather conditions. If sleeping postures were prescribed (what blanket to use or what kind of pillow), no one would sleep well.

The "natural city" is a similar concept. Different groups in the city form a natural relationship with their surroundings, creating a competitive ecology, and these are

not prescriptive relationships. It is inevitable that cities will have high-density districts, areas with traffic congestion or thin populations, or several centers. But to call a city "natural" isn't saying that the forest should be moved into urban areas.

Relative to a city with excessive government interference and overplanning, we cannot hope that farming fields will appear within a natural city, we also can't expect the CBD won't have traffic jams.[56] That is impossible. The city is not simply a race-track, and fast isn't always better. If the traffic in one area is congested, perhaps you won't choose to stay, but you will choose somewhere else to grow. Human adaptability is improving, and cities are becoming more dynamic.

The government is the primary land developer, and real estate development agencies work in tandem with the government. They share common interests, but they are not the future. The future of a city lies in its people, and all good cities are the same; they should rely on the decision-making power of the citizens.

The ideal future society would ensure the rights and individual characteristics of all the people, and allow these to develop. Only in such a time can pluralistic and abundant cities emerge, instead of broad boulevards like Liangguang or Ping'an avenues,[57] roads whose ugliness shadow them their entire lengths.

China's annual consumption of cement is currently that of half of the entire world, and the yearly increase of Beijing's buildings is greater than the sum total of all of Europe's new architecture. This presents issues humankind has never before encountered. But the problem with architecture today is neither its speed nor its scope; the problem is that it's steeped in an aesthetic that falls short of our current state of reality. Buildings in China today are built on a false, popular aesthetic, analogous to a farmer's daughter wearing platform shoes to walk in the fields.

The new CCTV tower fills the city with a sense of fantasy and insecurity. Insecurity is a characteristic of modern cities; the countryside does not know this kind of insecurity because it is unique to urban centers. Cities should have areas that generate this kind of instability. "Instability," "disharmony," and "sense of danger" are all positive words. My understanding of a "harmonious society" is one in which all "unharmonious" elements can exist simultaneously, allowing all contradictions and diversity to be displayed.[58] A homogeneous society cannot be harmonious.

Cities must provide possibilities for individual survival and should include personalized elements, for example people who sell DVDs, raise animals, or deliver takeout. If the basic living costs in a city are too high, small stores with low profit margins cannot exist, and then all that's left is haute couture. That is true misery; there's no street worse than one selling only designer labels. All they are hawking is discrimination and prejudice; they are selling lies about aesthetics. Most designer labels are flagrant garbage with values often worse than their products.

People harbor different opinions on the "Bird's Nest," but it is impossible for such a unique thing not to take some criticism. The censure is focused around three

main points: the first, whether a "foreign" architect should have been employed; the second, whether nonnative architects truly understand the Chinese national spirit; the third, whether the structure is safe and reliable, or wasteful.

My response to such commentary is this: first, architecture in China is a decaying industry, it is part of an old system in which outdated forces cling frantically to profits and benefits while vehemently opposing intruders. Other professions do not confront similar problems. Science and technology belong to humankind, they are not exclusive to "foreigners" or Chinese, or else they would deteriorate and become the basis of narrow-minded nationalism. Second, we were the ones who invited them to participate in the bid, and they were the winners. This is not charity, and no one is begging. Third, do you feel unsafe in planes designed by "foreigners," or on the maglev train?[59] The Chinese side stipulated the budget; if it was necessary to keep costs down, the designers would have put forth a correspondingly low proposal, and thus the budget was not a decision of the designers.

Domestic dwellings in Beijing are fundamentally devoid of imagination; most are peddling the most ignorant values and appealing to a population that lives in a constant state of anxiety. The majority of gated communities are simple and crude, and most consumers are unenlightened, having either been deprived of or having forfeited their power for independent judgment as well as their basis for decision-making. In short, design is forced to confront an uneducated market.

An architect should be a normal person with average feelings, and he or she should have perfected standard judgment, have relatively good aesthetic rationale, be capable of dealing with relatively complicated problems, and have genuine emotions. However, the current educational system doesn't provide these qualities in any capacity, and a great number of people are sacrificed to the system. What's different about me is that I never had a proper education, and having been excluded from mainstream society since my youth, I'm rather suspicious of social values. When investigating problems, I bring my own point of view, one that is completely outside of the system. In the dozen or so years I was trifling around in the United States, I was never able to integrate completely in its framework. Upon returning to Beijing, I am still an outsider. I don't think that being "independent" is a bad choice, it means you treat yourself well, and there's nothing compelling you to abandon your basic point of view or your fundamental common sense.

Being independent spares you from difficulties, while the alternative is riddled with complexity. Humans' alleged difficulties actually revolve around the question of survival, and still I'm unwilling to admit this, lest mere existence alone becomes too melancholy. If we eliminate these, our greatest difficulties would be in learning how to respect our personal choices and interests. I don't dispute the end of the world, which can only be a part of rebirth, and in this sense, talking about the future

is meaningless. But even more so, I am the kind of person who makes absolutely no demands on the future.

There is no utopia. If there were, it would include universal respect. There is no monolithic moral sensibility, and everyone would have his or her own little world, including thieves and whores. This topic is a little hollow, and in truth, our happiness today is important because it affects our tomorrow. In the same way, the city today is the city's future—it has no specific shape, it cannot be measured, it is eternally changing. A city has a temperament like a person, it is happy, angry, it laments and is joyous, it has a smile and a frown, it has pain and memory, misery and madness; it has familiar friends and the necessary enemies, people who support each other or reject each other, while at the same time it is a lonely individual.

In the Swiss capital of Bern they have maintained old traditions. Driving twenty kilometers outside the city, you begin to catch the scent of fresh cow patties. Pull up to one of those farms where the milk is right from the cow and the cheese is fresh, and the proprietor will tell you his father brewed alcohol from the grasses growing right outside the gate. They say that if the grass is in abundance this year, then there will be heavy snow in the coming year. ... That's living—when you can enter into a certain scene every day and leave your troubles behind, all because you can see a larger space. You are conscious that when you are focused on one thing, another person is

focused on another, and that kind of life, where people can borrow ideas from each other, is prosperous.

It's not like that here, where everything is determined by the powers that be, and the entire population is unrelated to the whole process; all we can do is pick up the bill. And thus we have Liangguang and Ping'an avenues, and we know other similar boulevards will appear in the future. Beijing's West Railway Station isn't just a poorly constructed building; it is a humiliating part of a city's history and an embarrassment to all of its inhabitants.[60] The cultural chaos, transformations, uncertainty, and a building's ability to resuscitate itself should be reflected in its construction, but it is crude, dismembered, inhumane, and rather unreasonable.

To put any city to the test, examine a day in the life of one of its ordinary citizens. Follow him or her to work, observe the choice of transportation, travel routes, how long he or she waits for a car, and what kind of people he or she encounters. A good city will offer speed, convenience, and comfort.

Cities have desires; they are humanity's greatest consumer good. You create it, you consume it, you watch it mature and then die off. It is built for our own desires. You wish that you could appear in a flash, or disappear immediately; at two in the morning, there is still somewhere to be, something to eat, you can sleep until you naturally wake up, spend some cash to make yourself happy, or work if you want to earn some money. If you can't make money, you can find some other means. … But in a truly misfortunate city, you can't even steal.

Letting Our Mistakes Keep Us Down

POSTED ON JULY 27, 2006

Here are several concepts: tradition, urban space, architecture, and the human race.

Let's start with people. The concept of the human race is very clear. Humans today are not the same as humans of the past, just as we are sure to be different people from those ten years from now; there is no abstract concept of "person." Living in Beijing is completely different from living in Tokyo or India; even the most basic concepts such as suffering, anxiety, or happiness are different. This is a vague concept. Take New York, for example, and Wall Street, where people carry briefcases, monitor the stock market, are engaged in trade, and are concerned only with matters of money. What we spend the majority of our time doing determines who we are; this is the mark of one's profession.

Not far away from Wall Street is Chinatown, and what are people there thinking? They're thinking about how best to run their restaurants, which university their

children will attend, how their relatives back home can get a visa or a green card. These two types of people are two completely different animals. Just one street away is Little Italy and yet another scene: dessert shops lined up in rows with customers who go in, and come out hours later. The corners here are always filled with whispered conversation, and the sounds of gunshots seem to threaten at every turn. Soho is infested with the fashionable and the wealthy, artists and designers. More so than anyone else, they are thinking completely different thoughts from one moment to the next. Their jobs consist of sitting idly, thinking incredulous thoughts and fretting over trifles. No city would be complete without this kind of people.

When cities are taking shape, they become home to all kinds of people: the poor, the rich, the struggling, a leisure class—they're all there, and they compose a very ordinary society. However, the people of Beijing are generally of two varieties: those with a Beijing *hukou* and those without, they are either locals or outsiders. The question of the residence permit has been under discussion for a very long time. Graffiti covers city walls with ads for black-market papers, and the citizens are divided into those with papers and those without. This is an extraordinarily crude, inhuman society, one that does not permit dignity.

China has never created authentic cities or authentic urban citizens—urban citizens are free, they possess various interests that they pursue and protect by appropriate means. In authentic cities, all layers of society find their own means of stability and self-sufficiency. Conversely, Beijing is a society administered by concentrated power. Here, there are those who issue orders and those who bear the consequences; urban citizens, properly speaking, do not exist in such a society. In a society like this there is no freedom to speak of, nor are there authentic cities.

When judging a city, we should first strive to understand the people who live there. A city should not be judged by whether or not the buildings in it are attractive. That building was built for a purpose, what does it matter how it looks? Why would you need to appreciate it? You may flat out dislike it, but you can use it; it is functionally complete, with excellent shops, grocery stores, cafés and restaurants, clean toilets, clean walkways, it is safe, and so on. These are the issues we encounter daily, but if people ignore them, and only discuss whether buildings are attractive or not, that would be ridiculous. First, you should think: will your child trip on these sidewalks, and end up as brain-damaged as you? Will the people walking toward you threaten your safety? When you need to rest, are you able to find a clean seat nearby?

All people love to talk about their city and its urban planning. Urban planning is not something we have any say in, and the urban world we come in contact with is very small. For instance, you may wish to drink a cup of tea, but are unable to, and thus you will be put in a bad mood. A city may be old and decrepit, it may be very dense, even downright crowded, but without any problems whatsoever. If you visit

Japan, you will see that it is richly varied, and it has its strengths. There are offices up above and shops and public spaces down below; there are ample layers of walkways underground, increasing efficiency and production by reducing your expenditure of time.

Architecture comes in all forms, but it is never form for form's sake. We don't cook simply to produce something nice to look at, but for taste and nutrition; this is beyond dispute. But yet we still debate the issue of form. This is a flaw of the educational system: schools fail to produce people who understand lifestyle, who are capable of feeling, and who have desires and dreams. Our forms and appearances are bound to be inferior because our system is substandard; we are simply made that way, so our greatest failure is the failure of education, the failure of aesthetics, ethics, and philosophy. This failure has led to a crudeness and simplicity in the people of today. Beauty and goodness are interrelated, and this is a fundamental consideration of aesthetics.

My status is that of artist, the kind with no serious affairs, with not much relation to others, and one who won't spend too much energy on the question of aesthetics. I make stringent demands on the fundamentals of space and its dimensions; I have few strict requirements about art. I don't aspire to be surrounded by precision, and my own life experiences have little to do with precision, but I do aspire to rationality and reason in art, as well as methods of judgment that suit me personally. This has nothing to do with other people. I can respect a worker whose home is very simple because, like everything else about him, you can't expect a simple person's home to look like that of a Hollywood star. This is what I'm trying to say: life changes. Some profit, others are underdogs, but no change should affect a person's dignity; at least, we hope it won't. All people have a responsibility to speak their opinion on things, to state the simple principles of their lives, to hold on to what they have, or what they think they have. We believe that God gave people these rights when He created them, and these rights are unrelated to future wealth.

China Central Television was lucky,[61] Rem Koolhaas formerly worked in media, he's an author of many interesting books, and he understands mass media very well. In his field, only a handful of people have a deeper understanding of the media, and in the domain of architecture he is peerless.

We all know what kind of media China Central Television is. It's not real mass media; CCTV's existence and programming rely on the administrative power and policies of the government. To say it is very "interesting" is bound to contain all kinds of internal contradictions; and such is contemporary life. That is to say, different interpretations, conflicts, and confusion exist within our understanding of value systems, technical expertise, digitization, and change. Moreover, conflict and confusion are exactly what Koolhaas knows and loves best. For him, the social and political implications of a work of architecture far exceed its value as architecture itself. Of course, these implications still need to be expressed in a physical form, which will be

endowed with its own significance, but it is impossible to express that significance today. Whether or not this was a lucky chance, it seems to have become reality, just as other projects currently being realized in Beijing will awaken the world to the possibility of a powerful new presence.

I don't care much about the superficial look of a city, or if it gets even worse. But what do I care about is streets like Ping'an and Liangguang avenues, broad boulevards whose planning ultimately harm the city and eliminate her possibility for revival. Whether a work of architecture looks good or not is a secondary consideration. Beijing is full of absurd architectural projects, and practically all its prize-winning projects are ridiculous, but this isn't very important.

It simply doesn't matter to me. The city isn't here for me to appreciate, it's here to be used, like shoes. You wear hiking shoes to go hiking, and you wear jogging shoes to go jogging. If you insist on wearing sandals in the winter or high-heel shoes to go hiking, you're going to suffer, and this is a common mistake in China's industries. Such suffering serves you right, you should deal with the consequences, because this is the only kind of architect you have. This all has little relation to me; I don't go into the city, but live on its outskirts and have little to do with it. At the most I will have dinner with friends there, and even then, dining still isn't a pleasurable thing: unpleasant environments, unsafe food, vile service, high-priced food of low quality—nothing is done properly. I'm at a loss whenever visiting friends ask me where to dine or where to have fun.

It's not a question of time, it's that people today lack a certain frame of mind. Time is no excuse; your time should be spent on self-improvement, there's no better way to spend your time. Many architects complain they can't pick their own projects, or that their clients are this way or that. It serves you right, that's your fate. Why not just refuse to build? Who forced you to be an architect? Why can't you say, "I'm a professional, I'd rather quit than create that"? The only way to make this place respectable is for everyone to work a little harder at self-improvement.

So-called good architecture is significant only in a certain time and place. In another time or place its significance would fade and then vanish. Good architecture is relevant, and only relevant things have real meaning. It's very simple; take ice-skating, for example: you may analyze an ice skater's postures, but it is impossible to repeat them exactly. China's performance today is pitiful; we keep falling again and again. This is an inescapable fact. The only thing we can do is honestly learn from our falls.

TRANSLATION PARTLY BY ERIC ABRAHAMSEN

Aftershocks

POSTED ON JULY 28, 2006

There are two types of disasters: visible and quantifiable natural disasters, and invisible, immeasurable psychological disasters.

In natural disasters, the power of nature destroys the original order of things, and life and death change places. But invisible and immeasurable psychic disasters take place deep within our psychology, and directly constrain our souls. They are like a scar on the spirit of a nation: What happened? What caused the hurt? Where is the source of the shock? These are eternally avoided questions, eternally sealed mouths, eyes that can never close, wounds that refuse to heal, and ghosts that will never disperse.

A nation whose soul has suffered such disaster will not just die off; it will not disappear on the horizon. It will use corporeal means to rejoice, celebrate, and rave as it always has. Observing our present surroundings, this couldn't be any clearer.

A natural disaster that occurred thirty years ago struck yet another heavy blow on this land eternally burdened by disasters: in the early morning of July 28, 1976, at 3:42 a.m. and 53.8 seconds, the industrial center of Tangshan was instantly leveled to rubble. The earth's crust dislocated and buried more than 800,000 lives within the resulting debris; 600,000 were hurt, and close to 240,000 people were killed. Similar to the majority of statistics here, this figure was never confirmed by an accurate official statement for many years after the fact.

In the same year, three national leaders passed away in succession,[62] endowing the natural disaster with a tint of folkloric good and evil and the omenlike prescience of a celestial phenomenon. The historical significance of the Tangshan earthquake reflects the dialectical philosophy of our ancestors in regard to humankind's will to survive and the will of nature.

I cannot know the will of heaven, but when the Tangshan earthquake occurred, it was a painful epilogue to one of humanity's darkest periods in history. But history cannot truly come to an end, and an inhumanly brutal reality won't vanish on account of a natural disaster; instead, it will continue to nibble on the spirits of the survivors with another quiet and inconspicuous means: harmony and bliss. Thirty years later, to the very day, the people are still unable to escape the reality of that nightmare; they cannot determine the precise nature of that disastrous scene—What exactly happened, was it real or an illusion, and have we awakened from this dream yet, or not?

We can say that all histories will have their dark spots—that the power and wickedness to violate the will of nature will always exist—but it is quite another story on this patch of land. Here, both the crimes and their execution come via the creators of

history; those who suffer are also those who inflict pain. History is a dark, bottomless pit, and if is not yet, it soon will be washed over in black.

The extermination of a nation's collective memory and its ability for self-reflection is like a living organism's rejection of its own immune system. The main difference is that this nation won't die, it will only lose its sense of reason.

Spiritual Orientation and the Possibilities of Existence

POSTED ON AUGUST 1, 2006

If we say that artists must interpret their existence, and interpret their physical and spiritual state, this interpretation would unavoidably touch upon the era in which they exist, and upon the political and ideological state of that era and, naturally, the artist's worldview. This worldview is presented through artistic languages and ambiguity, and just like all the other things that we call "facts," it has clear-cut characteristics and is immiscible.

Even so, art's transparency is then possibly "multiple" or "indistinct." Here, ambiguity and suggestion create a substantial spiritual orientation, like an outstretched hand pointing to an indecipherable and unexplainable space, a forward direction where nothing, and everything, can happen.

Who can clearly explain that utter lack of substance that is left after a fixed gaze? Contrarily, who can clearly understand the profound deceit that remains after careless and inattentive eyes?

Today, if we can still call the parameters that we are touching upon a complete world, we could say that its spiritual characteristics are fractured and modified. Multiple languages, pluralistic standards, and pluralistic values have already shaken humankind's traditional aesthetic sense to the utmost possibility. The spiritual world of today is precisely in need of a new aesthetic judgment and value system, just like a lotus pond anticipating a sudden burst of rain. The existing, outdated system is hypocritical and ineffective, it's impossible. But new potential truly illustrates our current state. Humanity has been through thousands of years of hardship and glory, and after a spiritual and material culture, after eliminating the obstacles from one realm of necessity to another, we have finally a state of nothingness, are surrounded by emptiness, and exist only in our potential.

All possibilities come from within. Reality's manifold chaos and unconditional madness, and her theories that seem right, but are so wrong, have all made the world into a complicated and confused place.

1.19 "Buddha's hand" citrus fruit and hulu gourds on a platter in Ai's kitchen, November 14, 2007.

Super Lights: Yan Lei and His Work

POSTED ON AUGUST 16, 2006

In 2002, Yan Lei[63] started on a new kind of painting. From the very first canvas in that series, we knew this was the beginning of something boundless, a drop of salty liquid culled from the vast ocean. Since then, Yan Lei's works have continued to be concerned with examining and explicating the artist's interpretations of the fundamental relationships between culture, painterly action, and expression.

The method of production and critical position embodied in these works emerges from the artist's reflections on and understanding of painting as a flat, two-dimensional means of expression. His position was culled from the co-dependent relationship between expressed significance and the mode of expression, the necessity and depth of expression itself, the precision of narration and the reasons for it, distinct characteristics and their most ideal form, and the consistency between the worldview expressed and the lifestyle of the artist. This understanding coolly releases the artist from the simplistic purview of personal experience and the narcissistic sentiments that typically grow out of the descriptive process as such.

The specialized nature of the artistic process manifests itself in the artist's unique method of control over the implications he is manufacturing, as well as in the integrity of that method. Even as he looks for an appropriate methodology, Yan Lei has already sensed that standardizing artistic expression has revolutionary implications for painting. These implications become manifest in the abandonment of all familiar working methods that occurs when any new technology comes onto the scene. When this happened, painting was no longer simply a space for individual expression, but indeed a flat, rational, encoded space for production. The integrity of a painting, the degree to which it is circulated, and the extent to which it is appropriated are all factors that will ultimately determine its perfection. Painting becomes more than simply painting; it becomes a reason for production, something more akin to a popular production method.

On this level, Yan Lei's daily labor makes him seem like a man who chooses to walk down the only deserted street in a dense urban area—and he makes this his daily route.

On the issue of what ultimately needs to be expressed and the impossibility of its expression, the substance and form of Yan Lei's works are simply an outgrowth of his worldview. This is something like the way a housefly sees a world quite different from our own. Yan Lei uses photographs and images; he collects his materials, manipulates his images digitally, prints them, assigns them a standard color, and then instructs workers to paint them. He drinks, chats on the phone, looks at apartments, he buys cars, relocates, submits proposals, prepares exhibitions, and sells paintings. His precision and tranquility resemble that of a soldier carefully wiping down every component of his gun, an action he performs each day in the knowledge that even if we live in peace, there is always war waging on someone else's borders. Yet at the same time, Yan Lei carries himself with the intensity and nervousness of a Wall Street trader, whose constant motion and endless opportunities never allow for the chance to switch emotional registers.

Yan Lei's articulate modes of expression and his control over them ultimately derive from his faith in an overarching system, and from the consistent application of one production method. This consistency allows his depictions to detach meaning from sentiment, substance from stratagem, and artist from work. The viewers' urge to separate the artist from his intermediary clearly vindicates the artist's chilling, sharp understanding of the world beyond his body, with the events, tasks, and emotions that bear on his life.

When I look at Yan Lei's art, it occurs to me that I only call it "art" because if this weren't art, then it would be nothing at all. Whether he uses colors or monochromes, or some of each, the paintings in his studio lie unstretched on the floor. He never feels the need to mount his canvases. Later, when he ships them, he just rolls them up.

Any image can be a potential painting. By "any," I mean that it is impossible to find an image unsuitable to be the subject of one of his paintings, despite the fact that the artist sometimes doesn't believe so: "I have to choose what I want." But he never clarifies what "I" is; he's like a sentence without a subject.

These images have included a circus troupe of Documenta curators; the girl next door; portraits of the dull workers who manufacture his works; the twelve animals of the Chinese zodiac, with the dragon missing (Yan Lei doesn't believe in the ancient Chinese representation of the dragon); banquets; the China Academy of Art (his alma mater); views of the Alps as glimpsed through plane windows; cityscapes both familiar and foreign; the works of other artists, regardless of whether he actually likes them; and overexposed photographs. Everything looks familiar to us, seemingly important and unfamiliar, intangible things: golden Buddha statues; white flour noodles; abstract images; visual images, and so on. Whatever the world can provide, Yan Lei's canvases contain, or will contain. His artistic attentions have no focal point, no axis, no interests to be served, and no sentiments from which they cannot be divorced. There is only the order in which they appear and disappear, and his arbitrary encounter with them and their necessity. Through this method he attempts to pluck himself clean; this is precisely Yan Lei's pathology.

This world and all its desires have tortured Yan Lei into being an "old society" relic. He is an innocent sophisticate, self-satisfied but full of illusions, intolerant but not bigoted. He embodies the characteristics of human nature in this era with his cosmopolitan spirit and provincial style, his shallow suffering and deep satisfaction, his fear of love and yearning for friendship.

Yan Lei has faced the world and made a pragmatic choice; he has chosen the most appropriate possibility: an endless story, with no end and no beginning; it can be told, telling it would be in vain, it is a story that shouldn't be told. Despite all this, it remains that the speaker still has no objective. All the intentions lie with the listener.

TRANSLATED BY PHILIP TINARI

Flat-Bottomed Cloth Shoes

POSTED ON AUGUST 18, 2006

Flat-bottomed shoes are only good for walking little countryside roads, as long as it's not raining. The soles of your feet are sturdy and the tops relaxed, and even on journeys across foreign lands, as soon as you step into them it feels as if you've come home.

But flat-bottomed cloth shoes are no good on the cobblestone streets of Europe; they're clearly not meant for arduous trekking, or very long hikes, in which case you would need to bring many pairs, and to prepare yourself for changing into new ones at any time. That would be the only way you could go on. Long ago, when their men went on long journeys, women were endlessly stitching shoes.

Nation

Aside from such formal validations afforded as habits of faith, or the typical historical reasons for forming groups, this nation shares one true national characteristic—its lack of faith is a prominent feature of our national character. Sinking into the ethical dilemma that is the inability to differentiate good and evil, ours is naturally becoming a nation with a feeble sensibility for distinguishing disgrace from honor.

A race with no principles of good and evil need not remember the past. With no lasting joy or suffering, no self-confidence or courage can be restored, simply because this sort of people has no future: they are wallowing in torturous pain, pathological joy or sorrow; they are unable to extricate themselves. The future is always too short, and today seems so long.

When will this country truly become an independent nation? When has its people done anything for anyone outside its borders? In a nation called the "Motherland" by scads of people, we can only hang our heads. She lacks true deeds and ideas; she has only idle hopes, no true dreams; her children flippantly turn their backs on her, never thinking to gaze upon her again, and they feel no ignominy in doing so. Scorn and shame are causing her people to lose the courage to call her name.

Factionalism

Forming alliances, that near-deified primitive and savage concept, indicates, at the very basic level, the exclusion of outsiders. This is the modus operandi and the self-justification of certain people who envision themselves as a different species, one with lofty and noble ideals, and which trusts that it is composed of forward thinkers.

Extolling violence to obtain benefits, they have instead become the very opposite of their fantastical illusions and proclamations, become a mouthpiece for the power of capital and profit-monopolizing corporations. Habitually concealing faults and glossing over mistakes to cover each other's backs, they maintain an illusion of dignity, maintain the lasting pain.

Fate

Fate, as we typically understand it, has never been fraudulent. Unless the fraud is concealed so deep that in all my travels, purposeful or not, and even in those wanderings that were prolonged to the point of stagnation, I'm unable to comprehend or to grasp

it. A love of personal rights and the desire to protecting them have accompanied me the whole time, and these rights should be inherent throughout. From the moment I first became aware of them, human rights have been irresistibly attractive to me. Let me put it this way: issues related to humans and the human will open up a web of thought, like the oar of a small boat rowing away from shore, disturbing the calm surface of the water. I see, and my relationship to everything on the shore is changed.

Familiar Curse Words

POSTED ON AUGUST 20, 2006

Bullshit

Human life is sovereign, and we are born into the rights and dignity that are inherent to it. These are superior to any power save of death, either spiritual or physical.

The above statement is complete bullshit. Human beings have never been sovereign, they have always lived under oppression, and they must constantly remind each other of this, or there will be an even higher price to pay. This is the history of civilization.

Rights

Of all the words in the dictionary, this word is the most disgraceful, and the word with the most unpleasant connotations. This word is always involved in tales about tragic figures, unfortunate events, gloomy places, and cruel history. It is a filthy word that should never be mentioned again. No matter when or where, the cry for human rights is humiliating. The unfortunate thing is, for a very long time in the future, we will continue to hear this most familiar of dirty words coming from completely unfamiliar places.

Numbness

When it comes to being numb, certain people take first prize—those who sacrifice the people closest to them in order to prolong their own ignoble lives; people with interests but no principles; people with adequate food and clothing but no faith; people with no determination, who only know opportunism; observers, sound in mind yet bereft of courage.

As far as one's life is concerned, the highest purpose would be to sacrifice your self for integrity. Similarly, there is no greater disgrace than being too weak to make such a sacrifice, or living simply for the sake of being alive. Centralized state power is continuously testing the humanity of the common people. Don't try to find a reason

for justice—justice is a reason in itself, it doesn't need any other validation. Don't try to find a reason for evil, because no justification for evil exists.

Despicable Things

POSTED ON AUGUST 21, 2006

Discernment

I never received a proper education. That proved to be impossible quite early on, and by the time I actually realized it, it was too late. I was like a traveler at dusk who was surrounded by trees before he realized he was in the forest. All that was left to do was to struggle to remember the path that had brought me there, and to discern which direction I was headed.

Temptation

Existence is temptation itself. In this body, temptation is already there, and each time you approach it, you retreat again. But this is only to create eternal temptation.

That which cannot be grasped, that which you see with your eyes but which slips from your hand, that which will never belong to you, and which is impossible, is what leaves you frustrated and disappointed, and will require more time to comprehend.

Unravel

The formulation of thoughts and their subsequent articulation are akin to finding a loose thread in a knit sweater, and gently picking at it until the entire woven pattern comes unraveled. But there are always exceptions, such as if you don't know how, or you don't have the desire.

Symbols

If you're building with limited materials, or if you're facing an unreachable, distant shore, then you can only use symbols. A symbol is a road on which you can run, but one that doesn't exist; a road that can be easily abandoned and doesn't need to be understood. A symbol is the fastest and most convenient of all roads, but is also the most profound and unreachable road.

Despicable Things

In a great majority of circumstances, it was difficulty that helped me. I'm a despicable thing, because I have hope for people.

R

Mr. R is an original thinker in the general sense of the word. There are not many people like him around. When talking about concepts, he believes that the true significance of a "concept" lies in personal experience and know-how. It was this kind of thinking that prompted me to go to Kassel for Documenta.

Even though two lines appear superimposed on the same spot, and it seems as though they might cross, they are on different planes, and ne'er the twain shall meet.

Traps

People who do not understand happiness making great efforts to ensure the happiness of the next generation—this seems more like a trap.

Frailty

Weakness will incite a yearning for extraordinary strength, and not just an ordinary kind of desire.

Imagine the feelings of a weak blade of grass in a tempest. Imagine its fragile desire for strength, and the probability of it being conquered, or not. Even though it is fragile, it cannot be conquered, it is reliant and invincible, and at any moment it can rebel. Power is a common sight, nearly abandoning the body; it is only moans without howls that make the moaning seem more persistent.

Bile from Living Bears

POSTED ON AUGUST 25, 2006

Pandas

In the course of shady political dealings and amid the ingratiating ways of humans, the panda's status as national symbol has become a kind of reality. When Nixon came to China in the 1970s, pandas were paraded as far-fetched proof that humanity still exists on this patch of land. They were exploited by both Chinese and Western media as mediators in mitigating the ambiguous discussions that took place between ideological adversaries.

Today, as one of the party's friendly gestures to placate the government in exile, Tuantuan and Yuanyuan are only ineffectual manifestations of one-sided desires for unification.[64]

With their blubbery bodies and clumsy movements, these utterly unbearlike vegetarians in a family of meat-eaters make their homes wherever they can find food.

They have a docile temperament and, because they mate only with great difficulty, are on the brink of extinction. They are the symbol of the modern Chinese spirit.

Bile from Living Bears

The Moon Bear is a bear native to Asia, and bile extracted from its gall bladder is an ingredient in some of the most mysterious and potent Chinese traditional medicines. Thus, in China, the moon bear faces an inescapable doom. For the entire duration of their lives, captured bears are locked in cages too small for them to even turn around in, tubes are inserted into their gall bladders, and bile is extracted continuously. The wounds of these bears fester, and the sight is too horrible to behold. Even after being rescued by animal activists, the bears remain wrecked in spirit, displaying characteristics common to manic depressives.

If sacrifice is necessary, it must be accompanied by the appropriate ceremonies. An unceremonious sacrifice is a crime against the natural world.

Foreign Concessions

Outside a park in old Shanghai's legation quarter was a sign reading "No Chinese or Dogs allowed." Of all the myriad evil deeds committed by the various foreign powers in China, this sign has become the focal point of the people's fury. The logic behind this is simple: the Chinese are contemptuous of dogs, so how could the two be mentioned in the same breath? Had the sign read, "No Chinese or Pandas allowed," naturally, there would be smiles.

The Chinese may be stupid, but they mustn't be compared to dogs. However, what the Chinese don't know is that dogs enjoy an entirely different status in the West—dogs are man's best friends, and one of the few animals that can live in harmony with people. Dogs as pets is generally a Western custom, and in Tang dynasty paintings, as well as Liao and Yuan dynasty depictions, bearded foreigners are always accompanied by either falcons or hounds.

Evolution

People, dogs, and pandas are animals that belong to the natural world. In the evolutionary chain they are accompanied by the unknown secrets of the cosmos. Genetic mutation and reconfiguration generate varieties of life; they are organic parts of a complete world. As the saying goes, "Harm one and harm them all, the death of one is the death of them all." Any animal that considers itself of a higher order should, by duty, protect weaker animals. When other animals perish as a result of human ignorance, we see not only terror and cruelty, but a sanguine, helpless world.

Evolution is not the power of the strong to kill the weak, and civilization is not an excuse to find a reason for every massacre. Genocidal massacres in this country have already occurred more than once.

A powerless mind is caused by the forfeit of moral and ethical codes. Moral bankruptcy makes the mind even more worthless.

Trust

The most important thing in personal relationships is not social skills, but trust. All true crises arise from a loss of trust. When people coexist with animals, trust is still an important element. When trust disintegrates, the world will crumble, and nothing can thrive.

This world belongs to the animals, and they are willing to live with us. I believe this is a true statement.

For a people who revere the traditions of Confucianism, Daoism, and Buddhism, who revere the virtues of benevolence, justice, propriety, wisdom, and trust, and who boast of a long history of civilization, their treatment of animals proves that their "progress" has absolutely nothing to do with civilization. At the very least, we can say that this nation has failed to nourish or look after her own soul, and by inflicting cruelty on other living beings has mutilated her own psyche. A people moving toward spiritual hopelessness should harbor no illusions about it.

Respect

What is respect? Respect is not touching something. No matter what the reason, pity, charity, and redemption are not respect. People and things have their own identifying traits, and life has its own rhythms. We shouldn't disturb personal aesthetics or mysterious cycles; these shouldn't be interfered with, much less should they be shamelessly sacrificed.

Humanity is perpetuating endless acts of barbarity upon itself, sustaining endless wars, poverty, famine, hatred, deception, and still wanting to cause utter misery for other living beings—all for profit. When one's existence is built upon the extermination of another ethnic group, can that person still claim to have good will?

We live in a society with no ethics. Can there be personal happiness in such a society?

Different Worlds, Different Dreams

POSTED ON SEPTEMBER 5, 2006

Once a month I return to my home in central Beijing. It is a small courtyard inside the Second Ring Road, that kind built of gray brick, having three rooms in the north and a few side rooms. All together the buildings and yard occupy about one *mu*.[65] The Chinese pagoda tree in the yard is already as thick as my calf, and there is a magnolia tree which flowers every year. Before his death my father's vision had begun to fail,

and I would often see him counting its buds, over and over. Even in the most tumultuous times, flocks of pigeons still fly overhead. No matter how chaotic the outside world becomes, a return to this yard always finds it quiet and ablaze with light.

Today I went home, the taxi turned into our alley, and our gate is on the north side of the alley only a hundred meters from its west entrance. The courtyard is in one of Beijing's few remaining cultural protection zones, in the city's eastern district, so there are no tall office buildings in the vicinity. Even though a half-century of property rights disputes have left Beijing's buildings and neighborhoods poorly preserved and ill-maintained, even decrepit like weak old men, they still retain a sense of composed calm. However, the scene unfolding before me today was unimaginable. The unthinkable had happened—I couldn't even distinguish my own front door. The entire alley had been covered in a coat of paint that shone with an artificial, cold gray-blue light; every dilapidated old door had been painted bright red; and no repairs had been made whatsoever. It was as if every resident on the street had been issued an identical hat and identical clothes, regardless of whether they were male or female, old or young, fat or thin.

Our courtyard home was rebuilt in the early 1990s, with gray bricks and a red door. The craftsmanship was coarse but solid, and inexpensive. In the space of one night, ours and every home on every alley here met with the same fate: a giant hand had come down and had plastered everything with concrete, eliminating all traces of history and memory at the same time.

Atop a layer of concrete was a coat of dark gray paint, and bogus brick outlines were cut into it. Private property has been altered beyond all recognition by this single crude and absurd decree. The place we call home suddenly lost all the personal characteristics of "home," and was stripped of its sense of security, privacy, and identity. They say that along with the rest of Beijing, all the alleyways in the city's eastern district will get this treatment, but the day that happens, this ancient city will vanish completely. Using taxpayers' money to erase the entire city, with no regard to green or red, black or white, they've tried to accomplish several goals in one blow. Their intentions are laughable, their methods crude, their attitude despicable; it's almost impossible to believe.

This is Beijing in 2006, only two years before the Olympics. This capital, becoming more international by the day, is revealing the true meaning of the Olympic slogan to the world: "New Beijing, New Olympics." Or "One World, One Dream." Not long ago, a newspaper reported that, based on the results of research by a group of experts, gray has been designated as Beijing's basic color, and the entire city is to be renovated accordingly. Who would have guessed that, after the renovation, people would be unable to recognize their own homes? The whole city is like a poorly assembled and cheap stage where all the people passing through it—men, women,

1.20 Ai Weiwei and his father, Ai Qing, in their Beijing courtyard home, c. 1994.

the young, and the old—were nothing more than props, all part of an unsightly performance on culture, history, and political achievements. Once again, the rights of the common people, humanity, their emotions and sense of self-determination have been taken from them, after a thousand such brutalities. Truly perplexing is why this society, lacking in both honor and integrity, is so fond of painting and powdering its own face.

Various remodeling projects continue in the city's alleyways. In the alleyway opposite us, more than ten families live in courtyards crammed to the bursting point, but such conditions have gone unchecked and unimproved for years: plumbing and running water are a mess; pipes are cracked, electric wires are in a tangle; right at the very spot where their doorway opens onto the street, someone is building the kind of moon gate you might see in an imperial garden. Everyone has become accustomed to this kind of absurd reasoning; no one inquires, no one questions, and hardly anyone even pays attention to what's happening.

There have been three major makeovers to Beijing's alleyways that I can remember. The first was for Nixon's China visit, when residents discovered that in the space of one night, their walls had all been painted. At that time they used a gray whitewash with a color similar to the bricks. The second time was for President Clinton's visit, when workers used paint rollers to transform the entire city into a sort of medium gray color. Clinton probably never even noticed. All they can do in this "land of etiquette and ceremony"[66] is paint the walls, again and again.

Times change, and we should already be living in a rational era. I so rarely return to my central Beijing home, and then, one day, the elderly in my home wake up to find that their homes have taken on a completely new look, a thick layer of cement has flattened the brick walls.

The alleged "preservation of Beijing's old city" actually means plastering over the walls with cement and then redrawing the outlines of bricks, irrespective of the buildings' age, history, or ownership, whether they are of private or public ownership, ancient or modern. A brand-new fake city—a fake world—has been created. In a city like this, how can we even begin to talk about culture? What "spirit of civilization" is there to speak of? This is a brutal, incompetent, and coarse society, heartless to the point of lunacy, and, according to the workers, it's not over yet: doors and windows have yet to be renovated. The plans are already in place. Over the past few decades, which of these "renovations" haven't been destructive?

Prior to the 2008 Olympics, as Beijing is undergoing a total urban-planning upheaval, how many more opportunities will remain to protect this ancient city? How many more opportunities will the people of the world have to come to Beijing and see a fake, unnatural city?

Spare the homes of the common people; if you can't help them, then leave them some peace. Keep your distance from them, and please do not try to speak for them, let them quietly, silently pass away. Continue the corruption of large-scale projects, of the banks and the state-owned industries, but don't paint the faces of the common people.

This nation, our home, has been whitewashed so many times, we can't even recognize our own faces, or perhaps we simply never had a face at all.

TRANSLATED BY ERIC ABRAHAMSEN

Hypnosis and Fragmented Reality: Li Songsong

POSTED ON NOVEMBER 4, 2006

"Hypnosis" generally refers to the use of special techniques to bring a subject into a state similar to sleep. Or rather, it is guiding the hypnotized subject to lose control of

his or her proactive state, leading to a weakening or loss of decision-making ability and self-control. Perception, thoughts, volition, and emotions all melt away as the subject accepts the induction and suggestions of hypnosis.

Li Songsong was born in 1973. When he was three years old, Mao Zedong left this earth, and in that same year the Tangshan earthquake ended 240,000 lives in a single night. It was a fabled farewell to the reign of terror that had ruled this land for the previous few decades, a valedictory to the brutal realities of class struggle and the dictatorship of the proletariat. This era left a long shadow of ruins and crumbled walls in its wake, but its thorough conclusion would require many years and a long, rugged path.

This is an era marked by widespread unconsciousness, ambiguity, and haze; it lacks rationality, consideration, or humanist grandeur, moral judgment, and any possibility for distinguishing right from wrong. On these muted gray canvases, history has arbitrarily, suddenly, and unintentionally been cut into a thousand pieces. Truth exists only in details and fragments, causing this broken and severed historical scroll to miraculously reassume its shape, a hundred contradictions to fold into one and mutually support each other.

One day at dusk, after chatting with Li Songsong on the way from my studio to dinner, I looked out the car window. The night was approaching like any other, the lights had just flickered on, light breezes were at my face, and people shuttled here and about. Along the street, store after store, family after family, building after building composed this little part of the city's landscape. These people preparing dinner were not concerned with right and wrong, and were indifferent to the affairs of their ancestors or descendants, they didn't care whether the waters of this pool were still or rippled, or where the river would flow in the future. It is the same under any dynasty; there are too many people here with ordinary trifles, sharing their pains and joys. One thing remains constant: these pains and joys are all fragmentary, they cannot be truly described or expressed, they cannot be multiplied or rendered, they can only be sensed, they are unutterable.

These are ruins in the truest sense, vast and limitless, extending beyond the horizons of space and time. For a long time now, people have been born into them, lived and walked atop them. These people's behavior, observation, perceptive ability, language, vision, or voices do not accidentally resonate with sentiment and attitude—we were born here, grew up here, and will die here. This is a special civilization, with its particular course; it's like a plant that grows only on high ground. In different climates and temperatures, only the adaptable can survive.

The existence of these ruins proves that former strength and glory can be destroyed and obliterated thoroughly. It proves the weakness and fragile nature of rationality, that the soul can collapse, the spirit may depart, and that good conscience might possibly go extinct. On this patch of ruins the old refuse reason, while the young find pleasure wherever and whenever they can.

Ruins reveal the power of violence and barbarity, they attest to a potential for survival that lies only in weakness and the loss of principle and that demonstrates the joy and freedom in tragedy. Ruins cannot exist independently; they are forever accompanied by violence and stupidity, and abandon their coexistence alongside fragility.

Li Songsong paints in layers thick enough to cover anything and everything. In the past three years, he has completed over fifty works. His early works are essentially monochromatic, with thick, strong brushstrokes. In these black-and-white canvases, the relationship between the layers and colors carries a definite order, as the rough brushstrokes recapitulate and create an unusual visual shock. In recent works, his palette expands beyond the monochromes of the early paintings into multiple color schemes divided by area, forming a patchwork of colored squares, and scenes are composed of different layers and pieces. Only in a few small canvases does the logic of his pigment begin to approach the experience of reality, or does his use of color proceed naturally and without interference. Several other works are painted on sheets of aluminum, the even light of this metal lending the works an air of mechanical coldness and brightness as the silvery gray tones reflect the environment around them and violently enter the work, to combine with his thick and imposing brushwork in a stimulating visual experience.

If we say that everything will become history, then all painterly subjects will become historical subjects. Any painting truly concerned with reality carries a whiff of symbolism, and has a suggestive and provocative function. Everything that a painting conveys will become the face and color of history. These paintings by Li Songsong—whether historical or not, intentional or contingent, heavy-handed or meaningless in their subject matter, eternal or transient—are forever and inseparably connected to these layers and layers of thick brushwork, the speed of the strokes, what each stroke blots out, and how the light shines on the colors. At the same time, they are interrupted and disturbed by another kind of system, broken off and independent from others, floating somewhere beyond them. Methods for reading these paintings beget obstacles, interpretation proves difficult, and problems arise from the confusion brought on by the desire for their interpretation. At this time, excitement and fatigue appear side by side, and the possibilities of art become hypnotic. People disappear into their search, their desires wane even as they yearn, they watch themselves become helplessly induced and become subject to suggestions.

Humanity does not allow individuals to exist independent of history. All the traces of truth and the falsity that they leave behind can be seen as traces of history. Sometimes they are lucid and transparent, nearly invisible; other times they are obscure and stagnant, inseparable and unclear. From a superficial glance, Li Songsong's works appear to belong to the latter. Although Li Songsong's painting derives from the

Western oil tradition, in fact it still possesses the connotations of Eastern painting. These paintings, and the strength of their totality, do not depend on the intensity of visual effect, logic, light, or color. Rather, this strength comes from deep within the psyche, from sentiment and free will. These manifest an uncertainty and dissociation. Color is simply the internal demand of the psyche; it is ineffable, while the brushstrokes are pure necessity. Their quality derives from his handling of the canvas and the tenor of his emotions, disconnected from the objects actually portrayed, but inseparable from his state of mind.

If there is a necessary connection between individual expression and the nation-state, national history and the world, and if the crude cause–effect relationship theories of materialism are indeed correct, then the world we see today is more abandonment than persistence, more chaos than clarity, more contradiction than order. People grow ever more emotional, further from rationality. Emotion is weak and has unlimited boundaries, but logic is different, it is stubborn but easily broken, unambiguous but limited in possibilities. In this patch of Eastern land, only the bright moon is a real, eternal spirit, even if it hangs on the other side of the earth. Forty years ago, the moon that man had just recently walked upon was just another stretch of ruins. But the people here don't need to go rediscovering these ruins; that moon the Americans spent so much time and energy reaching is not the moon in Chinese people's hearts.

WRITTEN OCTOBER 2006; TRANSLATED BY PHILIP TINARI[67]

Documenting the Unfamiliar Self and the Non-self: Rongrong & inri

POSTED ON NOVEMBER 15, 2006

There are many cats here. All of them are Dami's offspring.

You can find many cats on the outskirts of Beijing; this city is like Rome, it is sprinkled with ruins. Cats don't abandon ruins—or we could put it another way and say that ruins were designed for cats. This is also a reason for cats and humans to be together, for any place with humans will have ruins. The disposition and home of anyone who keeps cats will always have a ruined quality to it. Cats may suddenly disappear, but humans cannot simply abandon cats, who just move from one pile of remains to another. Cats are self-aware and proud, and being lost and then found is instinctual to them. This is a cat's world, but they don't mind sharing it with us. Each time a cat changes its location, this adds to its melancholy. Cats have been melancholy throughout the ages.

The photography in this volume represents a portion of Rongrong and inri's works spanning the eight years between 1994 and 2002. These works document their life, activities, gatherings, cats, love, and lastly, the destruction of their small courtyard in Beijing's Chaoyang district, the location where all these activities transpired.

Rongrong took most of the black-and-white photos. He's never had much affinity for color. In Rongrong's two-dimensional world, black-and-white is a manifestation of the outside world, the only possible relation with the world. Monochrome is one of the basic characteristics of his works, whereas inri's world is full of colors.

Throughout the short duration of the Beijing East Village, Rongrong recorded life and death in this artist's colony. That was a distorted and transformational era when artists struggled and expressed themselves here. Most of their perspectives were very different from those of the majority of people. Such was the case with Rongrong, who was an inseparable part of the East Village's reality. Those photographs became rare documentation of Chinese contemporary art; they became a segment of the physical reality that was the East Village.

At that time, Rongrong's works were not considered art; instead, they were part of the hazy everyday life in the East Village, a lifestyle outside of life, another kind of action. They were a record of the ceremonial works of friends and of the artists that gathered there; they were a part of that gloomy period. Popular ideology looked on modern art as a scourge, a conspiracy that would allow the Western world to destabilize China. In such a confined era, the activities of artists seemed even more like underground exploits—they were hunted and dispersed, and they faced a reality that included arrest and jail. Among all the Chinese artworks from this period, the East Village was the sole place preserving relatively integral visual forms, and these were inseparable from Rongrong's activities.

Activities in the East Village represented the first juncture where Chinese contemporary art became self-consciously and soberly concerned with the indigenous state of affairs, addressed the actual relationship between art and reality, focused on the character of artists themselves, and engendered experimentation with the artists' own bodies. In regard to the declarative, enlightening activities of performance or action art, it was entirely native, the beginning of a new here-and-now awareness and thought. It produced a group of enlightened beings, Ma Liuming, Zhu Ming, Zhang Huan, Zuzhou, Zhu Fadong, Cang Xin, and Rongrong among them. It's just as hard to believe that the underground publications of this now world-renowned East Village—the Black, White, and Gray Cover Books—would rise to such a prominent position.[68] In truth, the actual life of this village lasted only a little over a year. I remember artists discussing their works and the possibilities for their implementation in the 13th courtyard; these conversations included how to hide out, to conceal oneself, or prepare to flee.

If photography can be considered art, then it must necessarily be a scattering of art's inherent qualities, an innocent pressing of the shutter, a lie in the face of reality. In that moment of recording, the world that it faces dissolves like smoke. Anything realistic that remains becomes a reliable lie.

Photography appears to be the most unreliable media of all; it's so intimate with life, yet the furthest manifestation of it. It forces us to believe, tempts us to reenvision and create a world that can never exist. It seems to be the most authentic, with what we call a vision and reasonable logic of its own, it tells us what the world is like now and what it was like in the past. We all willingly believe that our memories require evidence, and such a piece of evidence is the path to our next actions; or perhaps it is a trap, or an obstacle.

In their works from this period, Rongrong and inri were most concerned with their personal lives, each tiny detail, even if nothing was happening. Life was just so, and the days just passed one by one. In this period, their photography entered a unique stage as they began to pay more attention to the shooting process itself. A brand-new world evolved, as if it were springing from an inexhaustible pool of the introspective, the inner self. Such was the state of gratuitous aimlessness, simultaneity, disorder, and chaos that gave rise to those endless stories and indescribable emotions, all those things we can't make sense of in life—a personal world, behind a closed wooden door, in a place that no one knows.

It is always possible for a person to enter himself or herself, to look deeply inside where the soul is like a barren wasteland. Desolate places and self-exile are among the most common of life's territories; they are the most familiar path to violence, and the most direct result of violence.

Ruins are proof of systems and civilizations that once flourished. Eternal ruins are lifeless pieces of deserted land, places with no potential, bereft of all confidence and goodwill, hopes or expectations. They are places that seek to be forgotten and provide evidence of the violence that once transpired upon them. We live in a similar age of deserted ruins; by celebrating the ruins, we point our fingers at them and declare ourselves a part of them. These ruins existed long before we even became ourselves; our existence only proves the power of their eternity.

Ruins, uncultivated ground, and the savage power that runs contrary to civilization prove the undeniable truth of death; they prove the enormous dark shadows and the unlimited possibility of large-scale destruction.

Caught in the undercurrents of a painful era, we must die a hundred times, a thousand times, ten thousand times. With our deaths we take with us a sinful era, an era of atrocity and with no humanity. Each time we behold these ruins, a feeling of joy burns through us, through our world, the entire world.

Powerful art is like a powerful government, but facing personal choices, they are equally weak and will both fall at the first blow. We live in a time where black and

white are reversed, in the utter absence of right and wrong, a time with neither history nor a future, where one is ashamed of one's own shadow and embarrassed by one's own face, and an era where our greatest efforts are poured into concealing reality and truth. It is an age where our greatest, most diligent efforts go into camouflaging reality, an age that gradually fades from our personal files, from the details of our existence, from our most vague emotions. Like snow melting in the sunlight, these details can only be dim and shadowy memories, and they will be replaced by the daily joys and irritations of fresh lives.

Rongrong was born in a village outside Quanzhou, in Fujian province, in 1968. His real name is Lu Zhirong. In 1992, he came to Beijing to study photography, and we met shortly after that. Rongrong and other artists lived in the East Village for more than a year before they were forced to move; the police then were endlessly hassling and purging Beijing's artist communities, there was a period when the plight of Beijing's artists was something akin to distressed mice scurrying across a street.

Inri's full name is Inri Suzuki, and she and Rongrong got together in 2000. She has a calm, elegant, naive energy, and eyes with a clear and tough glitter. This is a contrast to Rongrong's effeminate, bashful introversion. The aura of a Japanese female like her is rarely seen in China.

Dami, which means "Big Kitty," is their cat. I recall that after she gave birth to nearly eighty kittens, after she was spayed, she mysteriously gave birth to another litter. In some way, cats prove the stupidity and impotence of humans. Everyone worships Dami and talks about her, she has witnessed everything that has happened to Rongrong over the years, she remembers the courtyard where Rongrong lived for eight years, its demolition, and she is just as familiar with Rongrong's new home. But how she sees all of this will always remain a mystery.

WRITTEN OCTOBER 1, 2006; TRANSLATION PARTLY BY PHILIP TINARI[69]

1.21 One of Ai Weiwei's cats and *Table with Two Legs on the Wall*, January 31, 2007.

Widespread Beliefs

POSTED ON NOVEMBER 20, 2006

Battered Old Ship

Anyone who has had a glimpse of the ocean knows this is just a battered ship afloat, a lousy ship, a destinationless ship that left its homeland with its accursed fate and will never be able to turn back, nor will it ever reach any port of call. To where is it sailing? And what is the fate of this ship, or of its passengers? The cost will be no more, no less, than the fate of its passengers' feelings and the fate of reality. This ship's fate was predestined decades ago, a hundred years ago.

This ship was not destined to travel in bright and glorious channels, but will be forever shrouded in the interminable darkness of decline, shame, and evil conduct. As a ship that violates the common ideals and fate of mankind, it floats in gloomy waters. Or perhaps this is not a ship; it has no captain, no passengers, no direction, and no destination. It is merely an object afloat—it can't even sink—it can only wait for a tempest to tear it to pieces.

National Honor

If national honor did exist, it would merely be something that the autocrats busy themselves with ruining. The People, the so-called People, are really simple-minded loafers who linger on in any steadily worsening situation, people who have been dulled and forsaken by the deceptions of culture, their personalities deprived and lost, they are people who have abandoned their rights and responsibilities, who walk like ghosts on the ever-widening streets, and whose true emotions, dreams, and homes are long lost. They will no longer feel warmth in the night, no longer have expectations, and they shall not dream again.

People

These are the crudest, most simple substance on earth. The idea of being the "master of one's own affairs" or a "representative of progress" has become a mere joke, a joke that reveals the sensibilities and intents of the dictatorship as well as the ingratiation of these instinctually lowly slaves. The rights of the people, and anything that could be called a right, must originate from the self-identification and expression of worth of those who possess them. Rights are necessarily a part of any individual's vitality and consciousness. This word inexorably implies a god-given status. There is no person who can bestow rights on others, just as there is no sunless day, and no such thing as a night when the sun hangs high in the sky. In such matters, why do people prefer to believe such lies?

Eternal Nation

When can we call a nation "eternal"? What are the proper kinds of sovereigns or subjects necessary to establish the unassailable status of a place with no crises, no obstructions, and no potential for decline? It must be a land with no truth, no justice, and no soul. It must be a place that unanimously breaks faith with its people. This is by no means hard to achieve, for such has long been the reality in this land. In these respects, this nation already possesses some sacred attributes—it excludes itself from the laws of evolution; there is no good or evil, no willpower, and no choice. So-called destiny can only indicate a state of otherness.

Widespread Beliefs

Here, there is no end to the extremes of corruption and degradation, both ignorance and deceit hold a power hard to resist. People generally believe that individual consciousness is among the most useless of social ideals, that fate entails resigning oneself to one's hardships and plight, and choose to patiently compromise their way through an arbitrary life. A society lacking individual consciousness is truly gloomy and cold, and widespread abandonment will cause the very last green leaf to wither; it is capable of extinguishing the very last candle.

Cherishing your life, restoring its original value, and insisting on individual consciousness are the only true possibilities for existence. Throughout your life, these will be an unassailable, inexhaustible source of vitality; these are the protective gods that will illuminate your surroundings. Defending individual consciousness safeguards others and societal ideals: this is the pursuit of truth and an appreciation of beauty.

Historical Concepts

In today's world, what kind of person has no concept of history? Who would believe that humanity would abandon its instinct to pursue beauty, or that the rights and interests of a nation and its people could be permanently consumed by stupidity and humiliation? Who would believe that centralized state power could be higher than truth and good will, or believe that reality would eternally resign itself to falsehoods, that wisdom would remain inaccessible forever, or that beauty would surrender to the repulsive? What sort of person enjoys being bound in selfish interests and losing all good conscience? At the very least, it would be a shortsighted person. This shortsightedness has been maintained over several decades and cost the lives of several generations; it has transformed the fate of the nation into a vehicle for achieving the gains for a mere handful of individuals and the ruling party. To the universe, this is merely a tiny tragedy affecting a small portion of people, but in a twinkling it will become the past, something to be held in contempt by later generations.

The Ethical Foundation of Justice

POSTED ON DECEMBER 30, 2006

Over the previous two days, two people were sentenced to capital punishment.

Saddam Hussein, former president of Iraq, was taken prisoner three years ago and lived out his last hours after undergoing a lengthy trial process. Today, at six o'clock in the morning, Baghdad time, in accordance with his sentence of "crimes against humanity," the new Iraqi government carried out Saddam Hussein's sentence of death by hanging. This is a symbol of the United States' achievement in Middle Eastern strategic gains. Their actions under the banner of antiterrorism have left the rest of the world dumbfounded.

On the other side of the planet, one Qiu Xinghua of Houliu village, Shiquan county, Shaanxi province, a commoner of the lowest social class in this postsocialist, precapitalist society, cruelly murdered ten innocents.[70] Two days ago he was executed by gunshot in Ankang, on the north banks of the Yangtze River. Shaanxi's high courts ignored the numerous appeals of sociologists to carry out psychological testing on the perpetrator, and rejected judicial processes that might lead to the perfection of China's weak procedures, eliminating the only possibility for revealing truth with the sound of a gunshot at dawn.

On opposite sides of the planet, a monarch unparalleled in his own time and a man from the lowest caste who had never been looked at with respect in his life were scrutinized by two completely different societies, accused of two different crimes, and their spirits merged in the same fate.

Casting aside their fates and all their possible criminal paths, casting aside any noble ideas related to humankind's hope of upholding justice, casting aside ethics and morals and speaking with the force of justice that accompanies the development of social civilization, in the moment when life is eliminated by another, all the possible evils that a person might have committed, everything, returns to silence. In this moment, the value of life is subjugated by another force. In that same moment that life is deprived, a force wipes out the bright halo from the crown of justice, and sullies the essential dignity that should be upholding kindness and love.

The very foundation of justice crumbles when humankind uses any nature of high and mighty excuse to deny another of his or her life. Using nation, ethnicity, or the name of another as the justification to end another's life, or as the price of revenge is behavior lacking justice or righteousness.

Trial by death penalty is an ethical foundation of humankind. Such a despicable and barbaric state of being makes innocent lives even more helpless.

2007 TEXTS

Life, Crime, and Death

POSTED ON JANUARY 7, 2007

To say that we are all born equal is like saying that every person's life is endowed with identical value and there is neither lowliness nor nobility. Life in its original state includes both honor and evil; it exists independent from any system of human values and is merely a vehicle, it does not differentiate between good and evil. Each person's life is added to the lives of others to compose an inseparable whole that is the life of humanity.

The value of life originates from the fact that we each have only one chance. Life is irreversible, unique, unpredictable, and it has been appropriately endowed. Its significance can never be truly understood. It is a vehicle, and only death can bring about its end. Sympathy is a valuable attribute in all humans, for it allows us to integrate our personal feelings with those of others and our surroundings. Sympathy is the foundation of confidence, communication, understanding, and other desires. A world without sympathy is an inhuman world; a world without smiles or song is a callous and suffocating world. Such a world is necessarily filled with dread, suspicion, jealousy, hatred—it is humanity's final hour. Humankind's most revered values, such as freedom, equality, universal love, human rights, and a spiritual world, are all rooted in the identification and veneration of life's value. But without this identification there can be no honesty, determination, tolerance, understanding, dignity, faith, or sacrifice, and there could be no true substance to this spiritual world, no high-minded feelings or independent principles, no devoted souls or social ideals.

Life is given and taken away only by forces of nature. Obstructing life on any other grounds or means is tantamount to sin. Any ideology, spirit, or religious doctrine thwarting the natural course of life is just as evil.

Any distortion or underestimation of life's true value is also a crime, and blindly bestowing life or appraising it with alternative meaning is a slight to its fundamental honor.

Evil is any action or attempt to change the natural course of development or death.

Death is the termination of life. In one respect, it is misconduct in the human world; in another, it is an infinite void. After death, life becomes a blank. Values and ethics accompany our lives from beginning to end; happiness, joy, and hopes are linked to the value of life.

However, paying back debts with one's life is blaspheming its value, and such an action would be comparable to murder. These all use ethics and persuasion to eliminate life and its potential for progress. Confusing narrow ideology and life is a moral and ethical self-mutilation.

Capital punishment is incapable of inhibiting crime, and is even less capable of promoting equality or justice. Even criminal acts are incapable of destroying the inherent values and integrity of life itself. On the contrary, capital punishment supports crime and exonerates evil. It is impossible to purge evil with punishments that terminate life. Capital punishment is incapable of sustaining life's dignity, incapable of safeguarding good intentions or good conscience. Any manner of excuse for ending a life is a crime in itself. The death penalty is a manifestation of savage ethics built on the backward concept of "a life for a life." It is the incompetence of a nation, religion, community, and individuals; it is hopeless scorn and punishment for a criminal or a probable offender's crimes, it is public society renouncing its belief in deliverance. Contempt for any individual's life will always injure the common honor of the life of the collective, harming this most valuable part of every single person in that collective. Any person who deprives another of life by any means—including the punishment of criminals or revenge in the name of justice—is a criminal.

Capital punishment is a crime. It is the engineering of incarnate suffering through contempt and defilement of life; it threatens and mutilates the dignity of the people; it exploits another person's life crisis for pleasure or entertainment, or to pay for and obtain the satisfaction of revenge. This is a primitive and uncivilized precept, and a deviation from the humanitarian spirit that drives civilization forward.

Death is life's final conclusion, it is the antithetical and infinite state of life; death is one part of a complete existence, an inalienable right and one essential attribute of existence. Together with life, it takes shape around a value system that believes in the existence of an ethical classification beyond life. It similarly possesses a supreme quality: no one has the right to interpret or judge death.

Up until now, any attempt to pass judgment on life or death would be the wishful thinking of a one-sided argument, an incomplete guess far from reality. No judgment is able to touch upon the essential nature of the matter. That is because the essential nature of the matter is life and death itself; it doesn't beg for sympathy, explanation, or inference. Both life and death are provided with their own complete and independent qualities; their perfection and value are based on the fact that they exceed the scope of human understanding. Life's eternally mysterious nature determines life's eternal sanctity.

No matter in what era or what place, humanity's most noble thoughts and actions, most courageous behavior and most romantic sentiments—regardless of whether they are political or religious, cultural and historical or pertaining to spiritual ideals—merely illustrate and safeguard the esteem for life's honor.

On the other hand, cruel governance, tyranny, villains, all the ignorance in the world, evil, and calamity, are all blasphemous practices trampling life's honor.

Live happily. Value life. Learn through the practice of moral character and life's experiences. Amid the most profound sorrows in the world, nothing has proved more worthy than defending life's value.

Standards and Practical Jokes

POSTED ON JANUARY 17, 2007

Standards and practical jokes—they attempt to standardize everything, yet in the end nothing can be standardized. What should really be standardized is government power, the government's opinion of itself, its understanding of power, responsibility, and the limits on those powers. Somehow, for a certain few folks, these simple issues are forever, infinitely, and eternally misunderstood.

The Ministry of Culture wants to standardize art forms. This is as funny as a dog catching mice. Furthermore, establishing a "Chinese Broadway," building "ten outdoor theatres before 2008," and erecting "three hundred film screens in the year 2008" are equally corrupt practices that disrespect the people's money. Even if you built ten thousand "Chinese Broadways," a hundred thousand outdoor theaters, or three million film screens, China will always be a nation rife with cultural poverty.

2.1 Antique temple doors at Beijing's Lujiaying antique market, a portion of which lies under a highway overpass, March 2, 2007. Some of these doors would be selected for use in *Template* (2007).

Why? Because governments who want to manufacture culture are committing a crime that neither man nor the gods could ever forgive.

The Ministry of Culture is the department that least understands culture; it's impossible for them to have any relationship with culture. This is a universal principle of the universe, and the great tragedy of Chinese culture. Apparently, our Ministry of Culture isn't only incapable of managing culture, it could use some refresher lessons on the subject as well: the Olympic insignia is just a logo; if people aren't using it for profit, it is not a copyright infringement. The Olympics are for the entire populace— if someone wants to tweak the logo, go ahead and alter it. We're lucky enough just to have people with enough creativity to play practical jokes.

APPENDIXES

Performance Art to Be Standardized under "Performance"
Published in *Xin Beijing News*, January 17, 2007
Different forms of performance art are to be standardized under law. Yesterday, the head of Beijing's Ministry of Culture, Jiang Gongmin, revealed in a radio interview with the City Management pertinent regulations that the MOC will use to set distinct boundaries and baselines for the art market, especially in regard to artworks. Art should conform to aesthetic conventions, and Jiang pointed out to listeners that in regard to nudity and seminudity appearing on the screen and in public performance art, he feels "that already these problems are rather severe in society."

Assistant to the MOC and policy director Guan Yu said that Beijing's art market, in places such as 798, Songzhuang, etc., have developed very quickly; at the same time, a host of problems have appeared in some of the works. "From a traditional perspective, it is very difficult to accept this nature of things." Since last year, the MOC has stepped up its investigation and research into the art market, progressively establishing and drafting relevant management programs in response. Jiang Gongmin said, "Only when a hundred flowers bloom can we have springtime," but pointed out that this is under the premise that we uphold the constitution and conform to the benefits of the average people. Also, they hope that art will be suitable to the aesthetic traditions of a majority of the people; these are the relevant conditions to be followed in adherence to the "law."

Jiang further implied that Beijing is planning to build a theater district, or a "Chinese Broadway," and indicated that certain performance industry associations are currently in negotiations with intermediary companies, who hope that ten to twenty theater houses can be built in a concentrated area of Beijing, which would constitute a Chinese Broadway. Owing to the fact that building an area with a concentration of multiple theaters requires a competent administrative body, the idea has not been

programmed in any specific stages, and has not been placed in the Ministry of Culture's work plan for this year.

In regards to constructing low-priced-ticket outdoor theaters, Jiang Gongmin says that ten outdoor theaters will be constructed in 2008, and professional troupes will perform for the citizens with the financial subsidizing of the government.

The department of Cultural Affairs will also create a structure of four-star cinemas. Between the years of 2003 and 2004 in Beijing, there were only 94 screens in the city, with an average of 120,000 people per each screen. In 2006 there was an increase to 199 screens, with an average of 75,000 people per screen. It is now estimated that the number of screens in Beijing will increase to around 300. Presently, the MOC is setting about building a framework for four-star cinemas: urban specialty cinemas, suburban second-string cinemas, village and town digital multiroom cinemas, and film centers in administrative villages. Among these, rural cinemas will provide low-cost films and free tickets for residents.

Poking Fun at the Olympic Logo Is Rights Infringement
Xin Beijing News, January 17, 2007

The Beijing Olympics logo, the "Chinese seal," has been spoofed and turned into a logo for a public toilet, while the heads of the mascots, the "Friendlies,"[1] have been replaced with the heads of film and television stars. In a Web interview, the responsible head of legal affairs for the Olympic organization noted that this trend of spoofing the Olympic logo and mascots not only blasphemes the Olympic spirit, it is in violation of national laws. The Beijing Olympic committee will monitor related developments, and in regards to violators of the law, will exercise full rights in enforcing related laws and statutes.

Rowing on the Bund: Wang Xingwei

POSTED ON FEBRUARY 3, 2007

Wang Xingwei's dreams are always of the manly sort, and any man who is tormented by sexual desires yet still suppresses them will forever be meandering in that narrow fissure just before the flesh comes off track and just after the spirit is derailed.[2] No one doubts that he is an adept painter; to him, painting is like gazing at the wife you grew up with—no matter what angle you look at her from, nothing seems new. Wang Xingwei is a problematic person; he will never be content with his painting, and thus takes what are originally insignificant details and turns them into laborious things.

When he is capable of releasing all his excitement on canvas (as in the case of that big mushroom),[3] it is always onto a rectangular canvas, and then hung on an evenly lit, white wall. He hopes to liberate himself from his inexhaustible worries to simplify, popularize, and symbolize his self, his life, his painting, and everything else around him, and this will afford him nothing more and nothing less than an obvious, plain sort of pleasure. It's as simple as the wind pushing open a window and the sunlight pouring in, or tweaking a faucet until the water pours out, or chocolate melting on your tongue.

Wang Xingwei migrated to Shanghai from the northeastern provinces. He dreamt about becoming one of those legendary figures on the Shanghai Bund,[4] about his tall bamboo-like frame with its jaunty right angles in a Prada suit of good taste … just that expression on his face could take people back a hundred years. Shanghai is a city with no pizzazz, it never had it and never will, its crafty and calculating people will drown everything first with their petty conniving. But under the neon lights of the Bund, Wang Xingwei's skin glistened, his face turned pink, and the only thing that didn't change were those vibrantly exuberant tree branches with their drooping tendrils of leaves.

Somewhere between the choice for expressive power and the power to express, he gave up on the latter. The only things that remained were transparent hints and illusions produced by the obstacle of eternally unrealizable desires. These illusions often cause him to forget the greater meaning of life, so, instead, he checks his belt and the zipper of his pants over and over again in the mirror.

In Wang Xingwei's painting we clearly see a wise man vanquished by his own playful and naive practical jokes. Art hasn't been an issue for years, and painting has already become an impossible thing. That is, unless he's trying hard to play a dirty trick, exhausting himself completely, till he's spent like a burning a cigarette, or one shoe that belongs to a pair. His paintings exist only to call attention to things that have already transpired, or things he hopes will happen.

Many years after his forays into art history, there was a period when Wang Xing-wei painted bright, violent, crude, and uncouth paintings. The series that he began last year was pinkish and warm, but whether or not his future paintings will get seamy red is very important to Wang Xingwei. If it continues to be so important, we really can't help but worry.

We've been acquainted for more than ten years, and he's always looked about the same age as me or even appeared more mature. Later on we discovered this wasn't the case at all.

Eternally Lost Confidence

POSTED ON FEBRUARY 11, 2007

At one of Tianjin's Bird and Flower markets, cat-loving volunteers had discovered someone selling cats by the scores. Through the tenacious hard work of these volunteers, and after struggles with and the eventual persuasion of the cat mongers, policemen, and businessmen, more than four hundred cats were safely entrusted into their care and then transported to a nearby storehouse.

We left Beijing at two o'clock in the afternoon and headed for Tianjin, where I was accompanying Beijing's rescue team to the warehouse. It was very early spring, a sunny day, and the weather was increasingly warm; the lunar New Year was just a few days away.

After passing many roundabouts, we arrived at the warehouse door, one among a long row of doors in a warehouse district. Fanning open the two steel doors, I was treated to one of the most miserable sights of my life: more than four hundred cats were scattered in groups and heaped into the various corners of this one-hundred-plus-square-meter warehouse floor: groups of thirty or fifty nested together in piles, behind the door planks, or the idle kitchen cupboards, and they emitted hungry and terrified moans. More cats were hiding in the roof beams in fear, or in the spaces between the walls and the support beams. There were cat breeds from the entire world over, a variety of colors, patterns, ages, and it was obvious many of these cats had once been loved by owners, for a few of them tried to slide their way over, rubbing their heads on our legs in the hopes they might win some of that former love and protection. The primary similarity between them was a look of unconcealable terror in their eyes. They had lost faith in humans.

These cats were fortunate; thanks to the help of the young volunteers, they avoided meeting the fate of slaughter or being peddled. The young volunteers endured threats and intimidation by the cat dealers, and one of them was even beaten up by some deviant policemen and was hospitalized.

In the process of loading the cats into the rescue cars for delivery to Beijing, the volunteers' hands were scratched and bitten, every pair. And although blood was flowing, the volunteers were without complaint, and their selflessness and compassion made everyone temporarily forget pain and sorrow. They had forgotten their disdain for and disappointment in the wicked deeds of men.

What is the relationship between 430 abused and injured cats, twenty volunteers, Tianjin's Bird and Flower market, police misconduct, millions of slaughtered dogs, the 2008 Olympics, and all the boisterous hoopla over a harmonious society? These

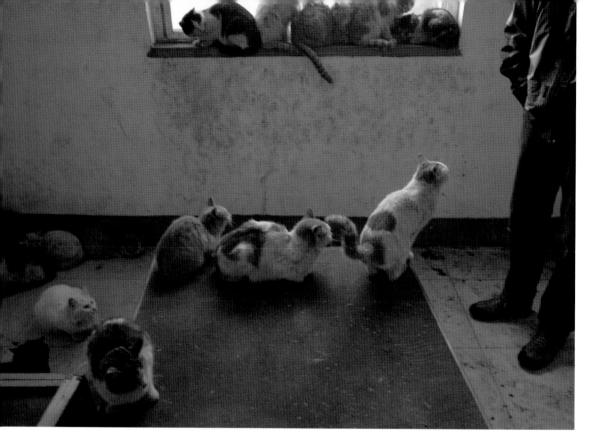

2.2 Hundreds of cats huddling in a warehouse near Tianjin after being rescued, February 7, 2007.

cats, slated for murder, were discovered by chance. There are many such markets in Tianjin, where, year after year, an unimaginable sum of cats and dogs meet their doom. Across the entire nation, every day, every hour, every moment, there are countless animals who meet a similar fate; they are unable to speak in a language humans can understand, and are eternally unable to plead in defense of a life of dignity. In their eyes, all that humanity can offer them is an undefeatable, extreme sense of dread.

Owing to a lack of animal protection laws, such evil knows no restraints, and these murderers will never be punished. When such laws are absent, human's intuitive knowledge and good will are similarly laid to waste, infinitely doomed, and all that remains is an ignorant and twisted world filled with inhumanity. The greatest self-punishment the Chinese people will know is that they will forever lack the trust and respect of other races and forms of life.

Dog Massacre in Wan Chuan

POSTED ON MARCH 16, 2007

Sichuan province's Wan Chuan district is preparing to slaughter all of its dogs.[5] Since September of 2006, there have been three human deaths from rabies, and in the past few days, there was another death due to the same cause. Thus, the Wan Chuan local government has decided to slaughter all of its dogs. Beginning on March 16 (today), all of the dogs in Wan Chuan (thousands of them) will be rounded up and summarily executed, regardless of whether they are family pets, guard dogs, or attack mutts.

People raise dogs, who live in close contact with humans, and thus they became human companions. Dogs often appear on television overseas: Reagan, Clinton, and both the Bush families all appeared on television accompanied by their family dog. These governments understand how to put on a show, or at the very least they understand that we need to see man interacting with other animals to demonstrate human nature. A few days ago Russia and Germany held a round of talks, and the headlines in Germany featured Putin's enormous black dog—the kind that Chinese legislation wants to exterminate—and in the background the two leaders are observed, its master and his guest.

The Chinese don't believe in spirits, and aside from shaking hands, they won't do much more for the media. The robotic, formulaic photographs haven't changed in over fifty years; all you need to do is change the head, and no one has grown sick of it.

Furthermore, the government should be a servant of its people. What is government? In plain vernacular, the government should be the dog of the people, and there are only two kinds of governments in this world, guard dogs and housedogs. Most democratic governments are like housedogs. The United States government is like two kinds of dogs: it is servile to its residents, and fierce to outsiders. Of course there is also the opposite, schizophrenic dogs, governments who put their tail between their legs when they see outsiders and only bite their masters. If the people are afraid of their government, then that dog of a government is crazy, because a good government is the pet of its citizens; even loving its citizens till death wouldn't be excessive. The relationship of any good government to its people is that of a dog to its master: if the master points east, it is forbidden from going west.

But in China, the government never seems to understand, for this dog is always in the position of master, and trying to make decisions for its citizens. To make matters worse, this dog often bites its master—we frequently see citizens who have been crippled by their government, beaten black and blue. Even though things are so, very few masters attempt to exterminate their dogs, because humans are kind, rational, sympathetic, and compassionate. Even if a government hurts its people, it's not necessarily

an evil government; maybe it is stupid or foolish, or perhaps it is only unfeeling and unreasonable. This kind of government can also be provided for.

A good government needs to learn from pets, play with its citizens, and so make its masters so overjoyed that they forget their troubles. Only then can we eat and drink our fill in a harmonious society.

A "Fairytale" Becomes an Artwork

POSTED ON JULY 20, 2007

Fu Xiaodong:[6] Why 1,001 people?

Ai Weiwei: I was mountain climbing in Switzerland, and watched a huge number of Italian tourists pass by, dragged down by their small children. It made me think of taking a group of high-strung Chinese on a journey. That seemed like a more complete slice of cake, and such a slice would include all the special elements of the cake itself. This was also the reason why I didn't choose fifty or one hundred, the amount had to achieve a specified quantity. The features of status, age, and participants coming from almost every province and region influenced the characteristics of this cultural development exchange.

FXD: Which of these participants are you most interested in?

AWW: I'm interested in all living people, anyone who can open their eyes, anyone who wants to go out and breathe fresh air, people who come home at night with sore feet, who want to add a blanket to their bed, people who don't want to feel cold; they are all extremely interesting to me. The participants will also encounter the issue of how quickly they will find their place in a completely new environment. You should understand the community you are located in, and the relationships between different communities. You can only know what yellow people are like once you've seen white people or black people.

FXD: The participants of *Fairytale* responded to a questionnaire of ninety-nine questions that touched upon religion, beliefs, East-West cultural differences, etc. Why did you set up such an examination?

AWW: The questionnaire was an interim practical procedure. I want to affirm to these people that we are earnestly at work, we aren't joking around. Leading them in by beginning to think about issues of Western cultural background and their own personal situations was related to the nature of the entire artwork. The farmers just wrote, "I don't know," but as long as they complete the entire questionnaire and sign their name at the bottom, that illustrates that they are identifying with the activity. This must be voluntary.

FXD: What other works have you developed in correlation with *Fairytale*?

AWW: With the participation of almost twenty directors from China and overseas, we completed a documentary that follows some of the interesting characters in *Fairytale*. We recorded their life, work, and daily experiences in China, and the various mental and physical efforts and costs that they expended over the course of their participation. This included their collective life experiences, their expectations and anxieties, their goals and present conditions, education, and families. The source material is already in excess of one thousand hours. We will also publish a book, a book of interviews with people who participated in *Fairytale*, to give them an opportunity to speak out on the Chinese plight during this time, and there is also a photographic record. I don't know what will become of it, I generally don't think too far ahead.

FXD: And you also distributed matching suitcases to all the participants.

AWW: Right, we also designed some products. I don't want this to become a big art display, which would be paradoxical to the entire significance of the work. I want to disturb the day-to-day life as little as possible, preserving original habits and rhythms. At the same time, there should also be a feeling of consensus among the participants. There are a few necessities, such as beds, sheets, blankets, pillows, partitions, and we want to make the room into small private spaces. Living in this unfamiliar city,

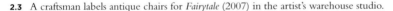

2.3 A craftsman labels antique chairs for *Fairytale* (2007) in the artist's warehouse studio.

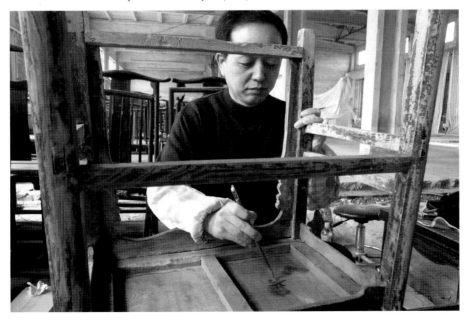

certain tools that constitute historical memory and special status are important; for example, 1,001 chairs, suitcases, and usb bracelets. These symbols that attest to their status are linked to a definite self-confidence and sense of pride. The details aren't important, but without them it would fall apart, there will be no identical experiences on this collective journey.

FXD: After arriving in Kassel, none of the *Fairytale* participants were required to participate in any collective activities. Everyone thought this was strange.

AWW: I don't want to fall into any conventional patterns. The integrity and crispness of a work have continuity with its original motivation and the means by which you complete it; it lies in control. Choosing not to include something is more important than including everything. When we don't do anything, the work is extremely large; if we were to do something, the quality of the work would change.

FXD: The media published a figure of 3.1 million in investments. How will you deal with reclaiming all that capital?

AWW: I signed a contract, which was in German, and although I still haven't read it, I know that it doesn't limit me too much. Until now, no one has inquired about my logic in using the funds. They trust in my art and gave me a lot of freedom; I also respect their trust. Reciprocation is an issue that I will inevitably be forced to consider.

FXD: The project has already been under way for five days. What will you do for the remaining month?

AWW: It seems like it's been so long, and it's only been five days. To tell you the truth, every day is quite dizzying; I don't have too many thoughts. This car will move forward for a bit longer, and will roll to a stop wherever it should.

FXD: Why is *Fairytale* receiving so much attention from the Western media?

AWW: First of all, *Fairytale* was one of the one hundred Documenta projects that went public rather early. It was instantly public when I recruited people on my blog. Second, this work is predisposed to discussion; anything—including the participants' status, how they were chosen, the funding—all exceeded the usual scope of an artwork. The state of the participants, their reasons [for participating], and significance all directly touch upon society, politics, and cultural background, so it became an interesting story for all major European newspapers, magazines, and television stations. There has never been such a great volume, such length of articles or depth of reporting. If you search "Documenta" online, three out of every ten articles is about *Fairytale*. My friends all tell me that no work has ever received such positive reporting, most of it on its novel concept, the work's integrity, and how thoroughly it took shape.

FXD: At the same time, this work has attracted tremendous curiosity from Westerners.

AWW: Even though none of it was premeditated, I have run into at least a hundred people who have expressed their interest to me. This work is so simple that anyone can understand it. The elderly, common citizens, ice cream salesmen, all have said they like it, said it is interesting. One person said it was poetic. But I don't intend to have them say any more, or bring in any academicism. The artwork is a medium; the fact that it gives pause to people with no interest in contemporary art is enough to make me amazed. This has evidently influenced their lives. The media is always hoping to find more possibilities, but they are still incredulous, even when I tell them I don't have anything else.

FXD: What kind of effect will this discussion and dissemination have?

AWW: In my experience, living overseas for more than a decade, the intensity of dissemination far exceeds any effort at cultural exchange. There has never been such an interest in the Chinese people; when people talk about them, their eyes light up, and they have a different expression on their face. But all of this will be over soon, and in the end it will only be a legend … there was once a madman who brought 1,001 madmen here. Although the media are applauding, the significance of *Fairytale* has not yet been truly understood; every time, I still have to express my thoughts clearly. In the future, a long time from now, people will understand these implications.

FXD: Do these Chinese masses from across different social strata reflect any social issues?

AWW: *Fairytale* is more oriented toward personal experience and individual awareness. The logo is written "1 = 1,001," because the personal experience, individual status, and imagination are the most important, are irreplaceable. The work itself was designed for each person's participation; there was no added concept of the collective will. The majority of artists use crowds to accomplish a particular form, but *Fairytale* is the precise opposite. Later I realized this was also one of the characteristics that allowed *Fairytale* to achieve such broad identification. It doesn't require things to be represented in artistic form, but requires art to be life, normalized. This is an interrogation of art itself, and I finally have an opportunity to realize this.

FXD: Compared to your previous works, *Fairytale* demonstrates an enormous transformation of form.

AWW: It has similar connotations, joining two or more elements together, but of course the materials and the scope that it touches on are completely different. This time it involves people: the producers and the appreciators of art have been merged into one. People have become a medium, and are also the inheritors, beneficiaries, or victims, and this adds to its complexity. But it is still consistent in asking fundamental questions about culture, values, and judgment.

FXD: *Fairytale* is another kind of artwork. Can we continue to believe that art hasn't yet died?

AWW: No matter if it's social or psychological resources or our understanding of life and culture, people are all in a state of crisis. The desire to transform, redefine, or use alternative methods is already a normal state. I'm just thinking how I can continue on with my personal game. If you can't continue, no one will continue to be interested in how you play your game. This is all pretty normal.

FXD: Are you satisfied with the work?

AWW: I'm dissatisfied with all my works. I'm not trying to please myself, and I'm not trying to achieve any goals. Artworks themselves inspire people with a sense of reality. For example, a criminal might commit murder in order to quench his desire to kill himself. Artists creating works are in a similar state.

FXD: What is your personal role in this work?

AWW: Usually I play a very active role in my works, that of a definite producer. *Fairytale* is the exact opposite. I cannot determine the state of each participant, I'm not acquainted with most of the people, and even if I were, I don't understand them. This is also what I like about it. This is the first time one of my works has such a great sense of uncertainty, potential for development, unpredictability, and an uncontrollable nature. Every day I have to solve new problems, things that I've never considered before. I'm not a producer, or leader; it's more like I'm an observer who watches what methods are changing the work. I'm a student, and I'm more alert than others.

FXD: *Fairytale* is a work embracing various cultures, religions, and concepts. What standpoint are you maintaining?

AWW: I don't have a standpoint. I'm just very willing to watch a group of contradictions naturally emerge. Just like dusk, which is inevitably in relation to your position on earth, and the rays of the sun, the clouds, and air humidity are all contributing elements. Though that's not to say that dusk is meaningful, only that people can endow it with significance.

FXD: From the early *White Cover Book* and *Black Cover Book* of the nineties, which saw Chinese contemporary art begin its feral state of affairs, to the "Fuck Off" exhibition of 2000, when art in China achieved its legal status, is it possible that *Fairytale* will represent a crucial turning point when art from China captures the international stage?

AWW: I think that for a work to become a cultural event, it must possess numerous independent elements. Whether it is the way you express the form and language, or the basic vocabulary that constructs it, all should possess their own individual characteristics. Although *Fairytale* is an enormous work, it still manifests the will of a place, and the way that it expresses personal existence could even be described as antiglobal. The majority of the people participating don't understand the Anglo-German language system; they don't have any knowledge of contemporary art, and are anticultural. These two contradictions comprise the enormous core conflict this work has with contemporary global culture, politics, and economics.

FXD: Do you think there is any continuity between these?

AWW: There are two features: the first, although I say I'm not concerned, expresses some doubts about the cultural plight and about culture itself. With the second, everything is discussing the initiative and possibility of the individual within the larger context, presented in an extremely individualized tone, and in the final analysis is searching for individualized means. Of course, as soon as you present distinctive features, limitations appear.

FXD: What are your thoughts on the backdrop that this era provides?

AWW: We are living in an era that is completely different from any before. This era will ruin all the former systems, powers, centers of discourse, and thus produce a complete system. Via digitization, the Internet and other new methods of propagation, via the consequences of a political economic structure of globalization, the relationship between individuals and the system of rights will see fundamental change. Similarly, the art of human consciousness and emotion will also face new language methods.

FXD: What political standpoint do you want to express with this work?

AWW: My political standpoint, if I have one, is individualism, anti-power, and anti-value standards that have been formed around profit. The best mutual value systems at work in the world are often accomplished on the basis of some kind of profit. In most circumstances they are all simple and crude, and they are unconvincing, whether they are economic or cultural.

FXD: Can you talk about your work with the doors in *Template*?

AWW: It's better to talk about just one work; we could continue discussing *Fairytale*, to discuss it more intact, otherwise, we'd talk about everything, and that's irritating. Maybe next time we can do an entire interview on *Template*. There's not much to talk about with sculptural installation works, they're not that interesting; it's just a thing, even though a lot of people are saying this is the work with the most impact in the exhibition. But I think it's pretty boring; whether or not the work is my own, I'm not that interested. I suspected that it might fall, or lightning would strike it or something, or it would burn down …[7]

INTERVIEW CONDUCTED JULY 20 IN THE DOCUMENTA FAIRYTALE OFFICE

National Day

POSTED ON OCTOBER 1, 2007

Today is another National Day, and Beijing awaits her fifty-eighth birthday in light rain.

In this "People's Republic" founded fifty-eight years ago, we have yet to realize "general elections." Universal education has yet to be implemented, basic medical care is still not realized, and no one dares question how our fundamental rights were lost.

All of the nation's soil and her resources have been washed away. Government officials are corrupt; our natural environment is polluted; humanities education is degenerate; management standards are so low that people have become hopeless. No one thinks to ask who acquired the wealth that originally belonged to the public and the nation.

Immediately after this birthday celebration we will welcome the great, honorable, and upright Chinese Communist Party's seventeenth People's Congress.

Welcome the worldwide attention brought by the Olympic games.

Welcome …[8]

2.4 *Template* in Kassel, Germany, June 6, 2007.

According to reports, during the National Day holiday, Beijing will play host to 740,000 security staff who will assist the People's Police force with their responsibilities.

This morning I neither washed my face nor brushed my teeth. The water supply in my Beijing suburb of Caochangdi has been cut off again.

Andy Warhol

POSTED ON OCTOBER 3, 2007

Twenty years ago, I was on New York's Lower East Side. I lived there for a long time.

On February 22, 1987, Andy Warhol died suddenly in New York, as a result of medical negligence. The news bathed the entire city in gray, and many people were saddened and grieved. The departure of an incredible man whisked away a certainly uncertain world, as well as the vain and legendary people and events that revolved around him. It was as if an enormous magnet had suddenly lost its pull.

Writings about the departed are always fragmented. Even if we are writing about yesterday's events and a still extant person, memorializing texts not only seem indefinite, they are also frivolous. This is because people take their spirit with them when they leave, that which can only be attached to the body of living people. People feel loss, and are unable to clearly vocalize what it is they have lost.

The island of Manhattan has three hundred years of history. Dutch settlers first bought the land from the indigenous Native Americans for twenty-something dollars, and on the southern extreme of the island there is a memorial stone carved with the words: "The impoverished and suffering, the helpless and exiled, let them come to me," and some babbling about freedom and equality that sounds like drunken nonsense. Later, such people, hailing from all corners of the world would not let this island rest for a single moment: risk-takers, heathens, fugitives, runaways, Trotskyites, anarchists, and poets came to live here during this wild, legendary era of ideals. The generosity, liberality, equality, and tolerance in this new land fulfilled their dreams, and the city and the nation acquired a magical layer of color.

Andy Warhol was born in Forest City, Pennsylvania. While his Slovakian immigrant father worked in a mine, Andy ran circles around his mother. He loved to eat candy and listen to stories. Compared to his dazzling future, his monotonous and lackluster childhood years created a transitional space that was difficult to cope with. In 1949 he moved to New York, where his innate sensitivity and refined hand helped him become an adept commercial illustrator. That was an era when artists were looked upon as sanctimonious beings, as martyrs, and Andy's mentor Emil De Antonio said to him, "One day, commercial artists will be the real artists." That statement was still a long way away from becoming reality, for it required a special person with an extraordinary life to put it into practice.

The amount of unconfirmed hearsay about Andy was just as bountiful as that which could be confirmed. His was America's most famous name, but only a few people really knew what he did. Andy's original name was Andy Warhola; he was born between 1928 and 1931; it is noted differently on different documents, although Andy claimed the date October 28, 1930 was incorrect. The date widely accepted as his birthday is June 6, 1928. All of us are certain of the date he died.

There is a wide range of publications about Andy, and he enjoyed incredibly high exposure in the media. The significance of Andy Warhol lies in the fact that while he was not widely recognized as a serious artist during his lifetime, his milieu and his works so far exceeded the expectations of the era that he changed the reality and ideals of American art. We can see his importance in the various misunderstandings about him: bashful homosexual; infatuated with materialism; self-contradicting workaholic; female impersonator; born for parties and for vanity, with eyes only for the superficial joys of fashion. He was someone obsessed with imaginary value. He repeated the same lines to different people in different places; he was never serious or profound, but was like a man carved out of wax. Maybe he was even more like an exotic flower, one that could survive only at high altitudes. Understand him, and you will understand the United States, for he is the most tragically beautiful legend in the history of American art, a unique artist of purely American values; he perfected art, and his departure brought the end of an era.

Marilyn Monroe, the electric chair, Mickey Mouse, Mao Zedong, wallpaper, disasters, comic books, the Empire State Building, dollar bills, Coca-Cola, Einstein—no one knows how many works he left behind; they are varied and miscellaneous, touching upon almost all the important personalities and things of his time, and encompassing almost any possible means of expression: design, painting, sculpture, installation, recordings, photography, video, texts, advertising. … Andy Warhol's creations have rebelled against traditional, commercial, consumerist, plebian, capitalist, and globalized art. The models that surrounded him helped him choose the colors they liked for his paintings; his mother signed his name on his works; no matter when or where, he was always taking photographs and recording; he was several decades ahead of his time.

The values of the 1960s generation replaced outdated traditions. Words such as "profound," "elite," "history," "eternity," "superiority," "established," "absolute," and "unique" were no longer important; they were replaced by "reality," "superficial," "flamboyant," "fleeting," "desire," "joy," "freedom," "equality," "simplicity," "mechanization," and "replication." These concepts updated the quality of American democracy and freedom. In that era the United States inadvertently created many of its own heroes.

Andy Warhol was a self-created product, and the transmission of that product was a characteristic of his identity, including all of his activities and his life itself. He was a complicated composite of interests and actions; he practiced the passions, desires, ambitions, and imaginations of his era. He shaped a broad perception of the world, an experimental world, a popular world, and a nontraditional, anti-elitist world. This is the true significance of Andy Warhol that people aren't willing to accept, and the reason that he is still not recognized as a true artist by everyone.

On the topic of Andy Warhol, no one could say it better than him: "My paintings are just that, there's no hidden meaning."

"If you want to know all about Andy Warhol, just look at the surface of my paintings and films and me, and there I am. There's nothing behind it."

"My artwork has no future, I'm very clear about that. In a few years, everything of mine will be pointless."

"In the future, everyone will be famous for fifteen minutes." A few years later he said, "In fifteen minutes everybody will be famous."

"My idea of a good picture is one that's in focus and of a famous person."

"I go to every opening with a toilet."

"I don't like big moments like weddings and funerals. … I've never liked holidays, I think that holidays are a kind of sickness. I never go traveling unless it's for work."

"I think everyone should be a machine, everyone should be exactly the same as each other."

"I like boring things. I also like things that can be endlessly repeated."

"My paintings are never how I want them, but I already think that's normal."

"If everyone is not beautiful, then no one is beautiful."

"Look closer, the department store is just like a museum."

"All of my films are artificial, everything I see has an element of make-believe. I don't know where the artificial stops and the real starts."

"I never read. I only look at art."

"What's great about this country is that America started the tradition where the richest consumers buy essentially the same things as the poorest. You can be watching TV and see Coca Cola, and you know that the President drinks Coca Cola, Liz Taylor drinks Coca Cola, and just think, you can drink Coca Cola, too. A coke is a coke and no amount of money can get you a better coke than the one the bum on the corner is drinking. All the cokes are the same and all the cokes are good. Liz Taylor knows it, the President knows it, the bum knows it, and you know it."

"I always feel like what I'm saying is insincere, it's not what I want to say. The interviewer should just tell me the words he wants me to say and I'll repeat them after him. That would be great, because I'm empty, I just can't think of anything I want to say."

"I'm never out of character, because I've never had a character."

Even though Andy Warhol was the world's most renowned social animal, after he passed away many of his achievements still seemed unbelievable. Each day he returned to his home on the Upper East Side, where he lived a hidden life with his mother, a cat, and two Filipino maids. His home was devoid of modern appliances or contemporary art, only "Louis" style furniture and oil paintings. Among the things that he collected fanatically were antique watches, pearl jewelry, Duchamp's urinal, makeup, toys; there was no fantastical thing that he was without. After his death, at the special Sotheby's sale of his personal effects, many of these items were opened for the first time. Every Christmas he worked at a soup kitchen in Harlem; every morning at nine-thirty in the morning he would telephone his secretary and dictate to her all the little things that had occurred the day before. He never missed a day, and those records became a detailed and enchanting personal history.

That was an unfamiliar world; it was hollow and vapid but pretended to be serious. But what kind of emptiness remained after the loss of this hollow and vapid world? On February 14, 1987, one week before he passed away, he wrote in his diary: "A really short day. Nothing much happened. I went shopping, did errands, came home, talked on the phone. … Yeah, that's all. Really. It was a really short day."

WRITTEN MAY 4, 2006

2.6 Ai Weiwei in front of *Self-Portrait* (1966) on display at Andy Warhol's first MoMA exhibition, a year after Warhol's death, c. 1988.

Designatum

POSTED ON OCTOBER 24, 2007

The interpretation of freedom and rights and their subsequent practice constitute life's true value; they are the core connotations of revolution and progress.

A government whose defining characteristics are the destruction of personal freedoms and rights is repulsive, for these are the true reasons for limits on both news media and freedom of speech. As we all know: if there were freedom of press and freedom of speech, it would be difficult to preserve fatuous monarchical motivations and to safeguard institutions that promote illicit gains, treasonous swindling, and a hopelessly devastating bullying culture.

One inevitable psychological characteristic of authoritarian power is weakness. Because they are weak, authoritarian governments shun the public, forgo transparency, and evade clear explanations; because they are fragile, they discriminate against dissension and cultivate lackeys in order to project a false image of peace and prosperity. Do colossal acts of good will by a government that is incessantly bullshitting about their good intentions really need to outshine those of others? This is no longer a conspiracy; it's more like an endless cycle of incompetence, and everyone is aware of it.

The characteristics of ruination are national celebrations and theatrical smoke-screens that lack all rhyme or reason. The rise and fall of any nation should not be dictated by the death of any one person.

The value of sacrifice is linked to a reverence for life, and death implies the existence of life. The value of life is demonstrated by loss, and a valuable death proves the possibility for honor in life. The question of life and death will remain forever unanswered.

The difficulty of striving hard is necessary, it is the impetus behind the great efforts we put forth when striving hard.

No matter what direction you are designating, you are always pointing to yourself.

Some Abnormal Numbers

POSTED ON DECEMBER 22, 2007

The Chinese people's approach to numbers and the role that figures play in the Chinese notions of history and reality are capable of illustrating this nation's detachment from the outside world. They are also capable of illustrating the nature of the culture and history that exists here, and how it has transformed.

In reports over recent years, an untold number of corrupt officials have escaped overseas, running off with their money and leaving behind muddled account books. The thieves know exactly how much they rolled up and stole away with, but the people who have been robbed have no idea how much they lost—was it five thousand, ten thousand, or fifteen thousand? Or could it even be somewhere between four hundred billion and a trillion? It's always been a mystery. Easy come, easy go, and although there are various policies in this world and varieties of parties and factions that might be good or bad, democratic or totalitarian, prosperous or in decline, not one among them can boast the same remarkable achievement.

What's more, in the Pearl Delta region, more than forty thousand workers lose fingers to machinery every year. During the thirty years of letting a few of the people get rich first, how many people have sacrificed their fingers? Throughout the entire nation, how many people have lost their arms, or legs? This figure could likely rival the statistics from any previous war.

And what is the population of Beijing? The people don't know, and the mayor doesn't know either. In a recent report, the number 17,430,000 suddenly appeared,[9] abruptly adding more than three to four million to the commonly quoted figure of thirteen to fourteen million. We boast a vast territory, abundant resources, and a large population, but as for how large it is exactly, no one knows for sure. Despite maintaining the world's most antiquated and severe household residency registration policy, we are still unable to produce a clear number.

And then there was that year in Nanjing when the Chinese took a beating and thousands of heads rolled.[10] Sixty years have passed, but do we have an accurate count of the dead? Was it 300,000? There is a lack of conclusive research, and there are no convincing historical resources. The Chinese have never understood that the dead must also be accounted for, and one by one the souls of the wrongly killed must be counted all the same. There cannot be one more or less: China would like it to be more, but fictional accounts are equally disrespectful to ghosts. This is a humiliating part of history, both a national disaster and a crime against humanity, but all numbers related to this incident are ambiguous. This is not a result of the cruelty and ignorance of the murderers, for they never had a conscience. Rather, this is the misery of the slaughtered, to have been neither treasured nor remembered by those more fortunate than them. They never had any definite status, neither in life nor in death.

In China, such historical figures are never clear. Exactly how many innocents were harmed over ages of tyranny and how they perished have long been sidestepped and covered up. This absent portion of reality has become the disgrace of the nation, and it arises from the inner soul of each and every citizen. The sorrow begotten of neglect by your compatriots is no less than that begotten of disparagement and trampling by foreign powers; both disregard human worth.

Perhaps it is for such reasons that the more practical politicians are driving themselves mad in the search for any ingenious device that could use figures to demonstrate both their superhuman intelligence and staunch rationality; for instance, the time-tested "Three Represents,"[11] rules so unequivocally clear-cut and precise that in any space-time continuum in any universe they could never be reduced to the "Two Represents," or even expanded to be the "Four Represents."

2.7 Ai jokes with uniformed guards in Caochangdi, June 2006. The first line of the poster behind them reads, "Implement the requirements of the 'three represents' with earnestness."

Numbers are no longer a measure between man and reality. They are uncertain, dubious, and insignificant, and they no longer constitute the relationship of the people here to the outside world. Yet neither can they sustain human emotions or imagination. Abnormal, illusory, and a sheer mockery, numbers have allowed this nation to at last disengage itself from the world of concrete fact and physical laws, to immerse itself in self-deceit and ambiguous pleasure.

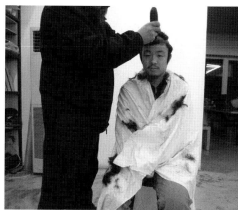

2.8, 2.9, 2.10, 2.11, 2.12, 2.13 Ai's assistant Xu Ye gets his third haircut. In 2007, one of Ai's favorite photo topics on his blog was these series of "haircuts." December 22, 2007.

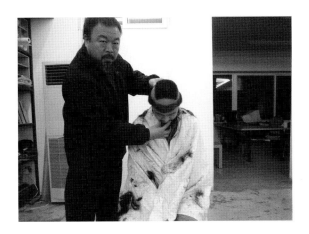

2008 TEXTS

Hallucinations and "Inhaling Poisons"

POSTED ON JANUARY 1, 2008

The use of methamphetamines is undoubtedly bad: they harm us in the same way as cigarettes or alcohol, or speeding through a red light. However, they do not directly injure society, nor do they cause bodily harm to others. That is because using them is a personal choice; even if they cause harm to the user, the decision to use them is individual, something like suicide.

On the other hand, when police enter a private home without a warrant, this is an issue of another nature. The casual entrance of police into any private residence to search and arrest in the name of law enforcement and acting as tools of the state has long been a common sight and occurrence.

After receiving an information tip-off from "a citizen," police invaded a residential home in the middle of the night.[1] This was a genuine threat to individual civil rights, and a latent form of intimidation ultimately more significant and destructive than the actions or behavior of any illegal narcotics user. The thirty-ninth item in the Constitution states: "Private residences in the People's Republic of China are inviolable. It is prohibited to unlawfully search or trespass on private homes. The inviolability of citizens' homes is a fundamental right of citizens' personal freedoms and human dignity. This right is protected under the law."

Further, the eighth law of the "National People's Congress Standing Committee's Decision on Anti-drug Laws" stipulates the following as punishment for drug use: "Drug users can be detained by public security authorities for no more than fifteen days, with imposed fines not exceeding RMB 2,000; drugs and other related smoking or injection equipment may be confiscated." This law indicates that drug use alone does not necessitate criminal law. The eighty-seventh law of the same document stipulates:

Public security organs, upon violations of public security acts, may carry out searches of personal articles. When an inspection is necessary, the People's Police should produce identifying documents and a warrant, issued by a Public Security Organ at or above the county level of the People's Government. If an immediate inspection is called for, the People's Police should produce identifying documents before investigating the scene, but in respect to citizen domiciles must produce documents at or above the county level issued by a Public Security Organ.

This issue is at the core of Zhang Yuan's "narcotics case," and yet no one is questioning the legality of the searches that were carried out in his home.

At the same time, whether on television news, the Legal Channel, or any other media, to some extent we should practice a little ethical treatment of criminals; this is called compassion. Once the authorities have assumed control, the legitimacy and impartiality of the law should be implicit.

However, the police berated this particular suspect in loud voices and then forced him into handcuffs, all of which had elements of a stage show. Dragging "spiritually vacant" artists from their home seems a rather excessive punishment, and demonstrates that law enforcers are not only unfamiliar with prescribed procedures but lack a concern for humanity.

The People's Police also summoned the local property management office to court, a modern version of "punishing nine generations of a family." Every single one of China's various baffling ways of implicating people in a criminal case are all incompetent and crude. No matter how they put it, the names they assign to the crimes never quite seem like something a person would actually do.

The customary term for drug use, "inhaling poison," suggests a person who uses drugs to achieve a state of stimulation or hallucination. As humankind trudges on this long road to civilization, each advance in consciousness and personal awareness is accompanied by experimentation with various psychological states and alternative consciousness. This is true from the practices of religious alchemy to the ability of revolutionary soldiers to stare unflinchingly in the face of death; both of these are associated with chemical secretions. From a cup of coffee to a cigarette, "ecstasy" pills, or the "invincible, universal Marxist-Mao Zedong thought," there is concrete evidence proving that each one is a material or spiritual opiate. The song "Fragrant Flowers in a Basket" from the Cultural Revolution could then be considered China's first "drug music," for that was the tune flooding the joyous hearts of Nanniwan when that wasteland was opened to opium production.[2] When I was young, I once tended to fields of opium poppies code-named "100" in the name of global revolution, and witnessed the Gobi Desert transformed into a vast and boundless sea of resplendent flowers.

The wanton maliciousness that is the wrath of public opinion and media brutishness are well above and beyond any harm brought on by weakness of personal will. No one sympathizes with the weak or ill; they let them run their own course. People are, in fact, more willing to become a part of the collective power, to become cruel and despising accomplices. But by acting this way, you are no longer a mere soul with a body—you have no soul.

Labeling stimulants and hallucinogens "poisons" and those who take them as "poison inhalers" is a Chinese characteristic; it reflects the local culture's extreme unfamiliarity with the human experience and spiritual world, and the high value it places on fear and hostility. If we can't say this kind of prejudice and bias comes from ignorance, at the very least it is antiscientific and unreasonable.

But an even greater calamity occurs when people tacitly approve the trampling of citizen rights. Irrespective of whether it's in the name of a nation or a law, this is a calamity that ultimately affects the entire population.

3.1, 3.2 In the artist's Beijing restaurant, Go Where? December 31, 2006.

We Have Nothing

POSTED ON JANUARY 30, 2008

One night, at a dinner party, I made the comment that we live in the era most lacking in creativity, but that comment was made rather hastily.[3] I almost never use the word "creativity." Rather, I am more inclined to use "fantasy," "suspicion," "discovery," "subversion," or "criticism," words whose accumulated capacity, in my opinion, define creativity. These are the fundamental requirements, or very substance, of life. They are indispensable.

Creativity is the power to reject the past, to change the status quo, and to seek new potential. Simply put, aside from using one's imagination—perhaps more importantly—creativity is the power to act. Only through our actions can our expectations for change turn into reality, and only then can our purported creativity build a new foundation, and only then is it possible to draw out human civilization.

Yet we do not belong to such an era, or to put it another way: we live worlds apart from other people who exist contemporaneously with us.

It's true. We live in a time that writes off creativity and poisons it to death. When creativity is so formulaically included in every official article and every advertising catch phrase, everyone knows we are living in precisely a despondent time that is deficient in—utterly lacking in—imagination. Politics are far removed from the common ideals of human society and universal values. Of course, no other political party would sever itself from the very land it survives on, or so lacks intuition and ability that it could so pathetically place the elevation of a mere few above the state and the nation.

A country that rejects truth, refuses change, and lacks a spirit of freedom is hopeless. Freedom of expression is one of life's basic rights, and freedom of expression and of understanding are the very cornerstones of civilization. Freedom of speech is just one part of the spirit of freedom; it is one of life's virtues and is the very essence of natural rights. Modernity cannot exist without freedom of speech.

Over the past decades, this land has been rife with various struggles and overwhelmed by endless political movements. It has teemed with inhuman persecution and death, and there has been only the ceaseless corruption of rights, inaction and abandonment, moral perfidy, lack of conscience, and abandonment of hope. But nothing else has changed; it's as if nothing has happened at all. In such a country, with such a people, under a system that controls the production of culture such as this, what could we possibly have to say about creativity?

Our Ministry of Culture is the cultural apparatus furthest removed from culture the entire world over. It is a bureaucratic organ that, culturally speaking, has never once offered any semblance of a contribution. The Writer's Association, the Artist's

Association, and the painting academies, whose members merely cultivate and live in their personal privilege, are living off the fruits of other people's labor. These organizations embody all of society's hypocrisy and fraud: not only are they culturally outdated, they have no creativity—a fact that they themselves are incapable of realizing.

In this respect, the world is in equal, near perfect equilibrium. Let those totalitarian rulers, those rich and heartless people, those who spend their lives double-crossing and desecrating with no volition or conscience, let them use their barbaric means to gain the wealth and power they so lust after. What will never belong to them is the trust that comes with honesty, the hope that comes with creation, or the happiness that democracy brings. No matter how abundant your riches, and regardless of your finesse or your status, neither you nor your progeny will ever know such pleasures or hopes.

You can keep that pack of muddle-faced, gold-digging, foolishly giggling "Friendlies," all the dragon-related nightmares you can handle, and year after year of that putrid Spring Festival television gala, with its hysterical and despicable forced smiles that lack any decent intentions, and all those other shamefully meaningless, extravagant celebrations.[4]

Because it is simple: this is a land that rejects freedom of both life and of spirit, a land that rejects fact, and fears the future. This is a land with no creativity.

Flickering Screens

POSTED ON FEBRUARY 5, 2008

When I was young, movies were shown in the village square. As soon as a movie would come on, the entire village would light up. There was no electricity in the village, only oil lamps, and even though the light was only from the film, we would unconsciously cover our eyes with our hands, it seemed that bright.

Each time a film finished screening in our village, it was passed on to the neighboring village to be screened again. We would travel with it, carefully placing one foot after another in the irregular soil of the fields and on the dark roads. The scene was something like pious devotees on a religious pilgrimage.

In truth, those were tedious and boring times, and the films weren't even that interesting. Perhaps it was precisely for this reason that we liked the villains in the films, they always seemed different from the rest.

Generally speaking, I enjoy Hollywood films, and never paid much attention to Chinese-language films or to Asian cinema. But now, I don't limit myself to Hollywood, because my affections for Asia and China are gradually increasing, an affection

inspired by the latest generation, their lifestyle, the way they express emotions, and their ability to endure pain.

The greatest difference between Asian and European or American films is faith. Some people have faith, and some films are an expression of faith, but in China the latter is a rarity.

When we say films from any certain culture are "good," I don't believe we are merely talking about the film itself. We can see the state of the entire culture from the film—Are there bravery and passion? Is the culture rich in illusion? What kind of hardships do they endure? Chinese film is lacking the ability to express what kind of an era we live in, and what the characteristics of that era are.

The overall aesthetic and philosophy of Chinese films can be rather frenetic, even deranged. But if you wonder whether or not Chinese film will surge forth, I think that it will. After all, China is a nation that likes to express itself—just look at karaoke. I think it's psychotic how many people love singing karaoke.

If only Chinese film could be like the karaoke industry, and everyone were able to make his or her own films. Film industry people surround me, and it seems as if the system gives them absolutely no support, so they search elsewhere for encouragement; overseas film festivals are just one example. At the same time, people only rarely have the power to make films, to work with more powerful entities, or to angle for their own benefits.

When working with unfair standards, all one can do is create deformities. Ultimately, these circumstances produce two kinds of people: victims of the larger environment and opportunists. There is no self-respecting, enlightened cultural class here, instead people are all looking for their piece of the pie. But such is the state of culture in China, everyone has become this way, not a single person is an exception. Young directors are often too eager to reap benefits fast, and they just embarrass themselves; the present state of culture is already such a mess, and you hope to earn some glory from it? The vegetable market has been trashed, and you're really hoping to steal a few edible fruits off the floor? It's embarrassing to be too immature to know better.

If I were making a film about life, I would pay more attention to reality. Reality is extremely harsh, but the subject must be broached. I've said before that all the defects of my era are reflected in my person, and if I were filming, I would be unscrupulous. Are you ashamed by your lifestyle? Or do you want to live by someone else's standards? We shouldn't pay attention to social taboos, we should pay attention to what we ought to be doing. The heavens will rain, but what will you do?

I watch films just as arbitrarily as I eat at a banquet or order take-out; it's all the same to me. Generally, I won't go to see a film alone, but always with friends. In New York, cinema is a public ritual, where everyone stands in line together chatting while waiting in line. But watching DVDs in your home is a different mode of viewing: you

can watch ten films in one night, you can fast forward, or you can start watching from the middle. You can integrate the films into your actual life. This mode of viewing has changed film narrative and how we interpret movies.

Films don't necessarily need ticket sales, nor must they be entertaining. If that were the case, the world would be awfully boring. Is popular taste influencing culture, or are films influencing the public's interest? The answer can't be only one possibility. I like films that are easy to watch, but I take greater pleasure in "difficult" films. Of the films I've seen lately, *The Sun Also Rises* by Jiang Wen has left the greatest impression on me. Everyone is saying: ticket sales are low—director Jiang Wen is finished. But using such inferior logic, simply the fact that such an "old" director as Jiang Wen would make such a film, earns him my respect. As an artist in the spotlight, the audience is paying a few RMB for the right to damage him.[5]

Our films are becoming increasingly oriented toward pure entertainment. The moment the crowds pile into the cinema, directors' tongues begin to tingle with joy.

Recently I watched Kurosawa's *Dodesukaden*. I think that most people would also enjoy it. Fifteen years ago I saw Hou Hsiao-hsien's *A Time to Live, a Time to Die* in a New York cinema. His narrative style, personal memories, and control are quite realistic, and they pulled me into the film. When I'm watching current films, I often can't even remember what happened.

Tarkovsky. Everyone talks about Tarkovsky so often, but I still think that he is the best. All of his films are good, *Nostalghia*, or *Zerkalo*; he is able to unify individual faith, literature, poetry, and the cinematic language into one integral whole. Many people have mastered one of these qualities, but it is difficult to achieve so many simultaneously; he has mastered them all.

A Word of Thanks

POSTED ON FEBRUARY 14, 2008

In the telling, it all sounds like something a human smuggler might attempt. First of all, I'd like to thank *Southern Weekly*, and the 1,001 brave Chinese who ventured out and were brave enough to return.[6] It's obvious that China is currently situated within an era of cultural depression, and one extremely lacking in creativity. This is undeniable, and I hope that everyone can soberly face up to that truth. I am also ashamed of this fact.

Creativity in the art world is unmentionable, it's best not to bring it up, in fact the nation is lacking creativity in every respect: national politics, culture, and society. The entertainment industry is no different, it can't measure up to Hollywood. It's like some kind of muscle fatigue where the entire body lies in a state of limpness.

The Olympic games that everyone has focused on lack all creative content. The torch design, the mascots called the "Friendlies," and the path resembling the character for "harmony" that the torch will supposedly follow within China … nothing can escape routine. If you want to talk about yourself, you need a history, but no one has figured out what our real history is.

Open up the newspaper and find mass migration, snow disasters, the Spring Festival television gala—various affairs that are dealt with in a manner showing no new inspiration or style, and that includes *Southern Weekly*'s annual tribute gala—can you find a trace of creativity in the stage decoration or lighting? Who could possibly continue watching after turning on the television set? Beijing still flies the same old flags during the General Assembly meeting, because this is a system unable to communicate with others, or even with itself.

At the source, it is individual will and personal consciousness that have suffered in the long-term; personal rights and obligations have yet to achieve unmistakable protection or manifestation; people have lost their sense of responsibility in regard to social rights and obligations, abandoning their viewpoints on even the most fundamental issues. In order to maintain this situation, the authorities retain their grip on culture, but after things are stable, what is all that authority for? If you scatter pesticides on the earth everyday, what can possibly grow?

Light as a Feather

POSTED ON FEBRUARY 17, 2008

Twenty years ago, Andy Warhol accidentally left his city and the people who were so familiar to him, the sounds, colors, and the climate. The moment he was gone, the world changed: this wasn't an arrow propelled from a bow, but the bow (and the world that supported it) fallen away from the arrow, separating in that instant, and forever.

Everything in Andy's life seemed surrounded by pretension, a kaleidoscope of colors and extravagance. Like a prophet who can truly see through the confines of time, long before the true arrival of the era that he prophesized, anything within his sight was blown up, replicated over and over, and thereby rendered emotionally fractured and empty. Both time and people are equally splendid and extraordinary, yet at the same time, can be so insignificant.

Andy was fond of his world of uncertainty, even though the same world equally distrusted him. Till the very end they shared a mutual resentment hard to define; together temporarily, and likewise forever separated, something like a remarkably original decree blurted out but swallowed back up, all it left behind was astonishment.

The absurd thing is, one day in November 1982, Andy arrived by happenstance in this unfamiliar nation. The people here were still drowsy under the artifice of a communist regime, and every face wore the same simple shyness. At these geographical coordinates, not a single person expressed interest in the artist. No one recognized that masklike face that was infamous throughout the rest of the world.

Although Andy had made innumerable portraits of famous figures, the most famous among them was ironically the archetypical representation of the leader of this nation, whom he had painted hundreds of times. In China the ubiquitous portrait caused Mao Zedong to be viewed as a god. However, in Andy's rendering, the allegorical force of Mao's portrait became conventional; its enormous size and multiple repetitions neutralized it into an everyday object, erasing its moral value as well as any aesthetic attempts.

China was a place unfamiliar to Andy, with a routine that he couldn't understand. He was in the wrong place at the wrong time. He could only exclaim about the length of the Great Wall; he even said that uniform dress as the "look" of thousands embodied the fashion sensibility that he yearned for. But throughout, he never once believed that a world without McDonald's could be sympathetic or kind—and in a child's eyes, a place without McDonald's could never be good, no matter what else it had. In an era when ping-pong and pandas were revered as sacred objects, many things were certainly absent: there was no lipstick, no pop music, no neon lights, no nightclubs, no homosexuality, no personal automobiles or apartments, and of course: no luxury or corruption—that portion of the population hadn't yet become rich.

The world today and the world in Andy's time are essentially the same, as astonishingly beautiful, elegant, or suave, and similarly consummate. What is different is that no one like Andy could ever exist here, a megastar from an average, conventional family who harbored democratic and humanistic values.

Facing a world that became stranger everyday, he endlessly recounted those apathetic stories: "Be careful what you ask for, you just might get it."

WRITTEN JANUARY 21, 2008[7]

The Space between Reality and Ideals: Zhao Zhao

POSTED ON MARCH 20, 2008

Aside from filling our conversations with irony and absurdity, what else can we do?

There is a certain kind of action that will become part of existence and will call people's attention to new possibilities and different results. Like a deliberately divergent discourse, such an action has a clear target that draws people's attention to its

alternative and absurd side. A person's minute movements, a persistence approaching arrogance, and sincere efforts always allow people to enjoy the initial excitement of digressing from their primary topics and moving toward the crossroads.

After major historical events and incidents, after their "proper" presentation to the public and their "definitive meaning" have been determined, gaps will emerge. After unspeakable new possibilities and methods materialize, cracks and leakage will occur.

The world is changing. This is a fact. Artists work hard hoping to change it according to their own aspirations. Art is merely a representation of the creator's personal world. Faced with facts they don't believe, people are, in effect, using their gaze and their touch to transform reality into something easier to recognize and understand.

No other language in the world exists to you, unless you start describing it in a familiar way. Language becomes possible in that instant when you start talking, when your words become a part of reality, become a possible relationship between reality and ideals, or a bargaining chip in transactions between the material and spiritual world.

Actions in the struggle for survival become proactive, become the main subject of self-awareness as it is occurring; they are potential, but they have no greater significance than this. Or we could say that they exclude other possibilities, and at the same time are bound to be another state of absurdity. This absurdness becomes the plausible basis that allows the possibility of its own existence.

"Cultural terrorism," like terrorism itself, is a defiance of and attack on power, politics, and the social order. This attack arises from its conflict with and distrust of power structures and their representations. Its effectiveness is demonstrated in the space for imagination that comes after the collapse of power and in the various unspeakable pleasures that accompany practical jokes.

Self-consciousness is a mutual confrontation with widespread ignorance and abandonment. A self-conscious action is always a manifestation of its feasibility and justification, which is the foundation of the existence of a personal viewpoint. It is pointing to another kind of reality—a rational, orderly reality that defies popular beliefs. This new reality is as light-hearted, fearless, and orderly as our current world is heavy, abstruse, and chaotic.

This new reality is like a well-defined map with roads and rivers no one has ever heard of, a place or country no one has ever set foot on. It undoubtedly implies a sense of strangeness, yet it feels familiar. It embodies a person's devoted attempts at communication and his feelings of insurmountable alienation and helplessness.

What are you saying? Is it possible to say it clearly? Are you saying what's really on your mind? What's the point of all this rambling? Or is it true that real meaning is far from the facts or the truth? If so, then where does it lead?

The actions of an artwork indicate the main theme of its "self-structure"; they are also the only readable representation of that structure. Its unique nature comes from the transformation of its practical application, which makes possible the survival of a modern spiritual culture.

Here in Caochangdi, a village on the edge of the Fifth Ring Road almost twenty kilometers from Beijing's city center, Zhao Zhao has lived for almost four years working as an assistant in an artist's studio. The works shown in this exhibition were created in his free time, for pleasure and enjoyment.[8] Some are lighthearted, others are heavy, but none of them lack humor; they are filled with a well-intentioned naughtiness and innocent guile.

In a world yearning for faster, higher, and stronger, these works suggest the possibility for the smaller, slower, and weaker to survive. In the eyes of God, games are one of the few things in which all men can find pleasure.

TRANSLATION PARTLY BY STEVEN HUANG

Divination and Democracy

POSTED ON MARCH 29, 2008

During the course of a banquet, the recent ethnic disputes were raised in conversation.[9] One older person said: "Fifty years ago their religious leaders were actually using divination to help them make important decisions; imagine how backward it is there."

But while this is true, I still don't know why I sincerely wish the leaders of our ethnic group could be as admirable as theirs, even if they've practiced divination once or twice in these past fifty years.

Alas, this is not the case. In recent years, the actions and conduct of our "liberators"—those who gather under sophisticated ideological armor to courageously undertake their historical responsibilities—when compared to these ancient and mystical behaviors can't honestly be called much better. That is, evil will always be inferior to ignorance, and the fact is that unbridled bigotry is no better than a backward civilization.

Everything can be blamed on their lack of divination skills, which are lacking to the extent that we make one mistake after another. Bad habits are hard to change, and each step brings us closer to a spiritual, ethical abyss. No one comprehends mystical allusions, no one is attempting to decipher obscure languages or graphs, no one is watching the night sky or listening to the wind, and no one is explaining the absolute meaning of life and death. We don't respect warnings, prophecies, or admonishments.

We are a vast and mighty mass of dauntless people who do not value facts, do not esteem history, and pay no heed to humankind's common fears and hopes.

In an era without divination, everything that remains is contemptuous of the spiritual world, slanderous and blasphemous to faith.

A large-scale show of force, even a revolt, has occurred. To step back a bit: Can a nation professing materialism, controlled by the world's most populous military and police force, deliver these slaves from their fate? It has made this a new century of increasing prosperity and strength, a crude wasteland with unprecedented harmony. At the very least, doesn't this prove the hypocrisy, wishful thinking, and misjudgments on our part about this ethnicity's religious policies?

A few "ruffians" and "lawless thugs" unexpectedly harmed several hundred soldiers and armed police, and a greater number were harmed among the kind-hearted, innocent masses. If this is true, that makes it difficult for our "PLA sons and brothers" to perform their duties in their typical style.

Reports from the news media, whether foreign or national, are always far from the real truth. This is because people who don't believe in the art of divination are similarly afraid of the truth and of unpredictable things. Tricky intellectual games, habitually contorting the facts and inciting various suspicions and hatred, are much easier to stomach than the bitter truth.

Efforts by the unenlightened have made the entire world ignorant; now, controlling and confusing public opinion are necessary to maintaining this state.

In the eyes of many, that distant plateau is no longer the place where a peaceful ethnic minority resides, it is no longer a tourist zone with beautiful landscapes, and no longer the "super-excellent" place where urban petty bourgeois and bohemians go to seek for Shangri-la or love. Leave your spiritual homelands in Tiananmen Square, the Bund, or Xintiandi! You may distort a place that you don't understand, and you may grow more prosperous and wealthy, but you'll never convince the incorruptible heart of a monk.

Back to the point, because we lack the fatuity of divination, we have no chance. We must continue to stumble around in the dark.

Divination is a primitive form of democracy. In the very least it is closer to the will of god, because democracy resembles modern divination. It results in decisions based on the will of the masses, instead of a fate decided by community elders. Its efficacy is almost the same as that of divination, and is similarly absurd and tricky. We have more of a reason to believe in the capricious and mysterious will of the human masses.

Such issues don't require a great intellect, because they are merely related to people.

Pray for our tribal leaders, pray that they might simply try a little divination, if even just once. Let that profound and unpredictable void determine the fate and the

future of the masses; at least it is superior to those minds lacking the intelligence and creativity we rely on now.

Citing the widespread practices such as divination and serfdom that existed before the communists "liberated" the Tibetan plateau, the Chinese media painted the Tibetans as backward and medieval. PLA armies were depicted as liberators who brought "the light of civilization" to a feudal society—this, and the notion that Tibet is an undisputed territory belonging to China, are the widely accepted views among the Chinese today.

Grief

POSTED ON MAY 22, 2008

Silence please. No clamor. Let the dust settle, let the dead rest.[10]

Extending a hand to those caught in trouble, rescuing the dying, and helping the injured is a form of humanitarianism, unrelated to love of country or people. Do not belittle the value of life; it commands a broader, more equal dignity.

Throughout these days of mourning, people do not need to thank the Motherland and her supporters, for she was unable to offer any better protection. Nor was it the Motherland, in the end, who allowed the luckier children to escape from their collapsing schoolhouses. There is no need to praise government officials, for these fading lives need effective rescue measures far more than they need sympathetic speeches and tears. There is even less need to thank the army, as doing so would be to say that in responding to this disaster, soldiers offer something other than the fulfillment of their sworn duty.

Feel sad! Suffer! Feel it in the recesses of your heart, in the unpeopled night, in all those places without light. We mourn only because death is a part of life, because those dead from the quake are a part of us. But the dead are gone. Only when the living go on living with dignity can the departed rest with dignity.

Live frankly and honestly, respect history, and face reality squarely. Beware of those who confuse right and wrong: the hypocritical news media so adept at stirring passions and offering temptations; the politicians parlaying the tragedy of the departed into statecraft and nationalism; the petty businessmen who trade the souls of the dead for the false wine of morality.

When the living stray from justice, when their charity is only meager currency and tears, then the last dignified breath of the dying will be erased. A collapse of will and a vacancy of spirit render that fine line between life and death's realm of ghosts.

This emptiness of collective memory, this distortion of public morality, drives people crazy. Who exactly died in that even bigger earthquake of thirty years ago? Those

wrongly accused in the political struggles of recent history, those laborers trapped in the coal mines, those denied medical treatment for their grave illnesses—Who are they? What pain did they endure while alive, what grief do they provoke, now dead? Who before them cried out for these suffering bodies, these troubled souls? Where are the survivors who belong truly to them?

Before we let murky tears cloud our already unclear vision, we need to face up to the way the world works. The true misfortune of the dead lies in the unconsciousness and apathy of the living, in the ignorance of the value of life by those who simply float through it, in our numbness toward the right to survival and expression, in our distortions of justice, equality, and freedom.

This is a society without citizens. A person with no true rights cannot have a complete sense of morality or humanity. In a society like this, what kinds of responsibility or duty can an individual shoulder? What kinds of interpretations and understandings of life and death will he or she have? The *samsara* of life and death in this land—Has it any connection to the value of life in the rest of the world?

As for all those organs of culture and propaganda who subsist on sucking the blood of the nation—What difference has their largesse from larceny? No one wants the charity of parasites; their greatest kindness would be to let themselves die off, just one day sooner.

TRANSLATED BY PHILIP TINARI

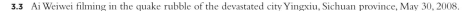

3.3 Ai Weiwei filming in the quake rubble of the devastated city Yingxiu, Sichuan province, May 30, 2008.

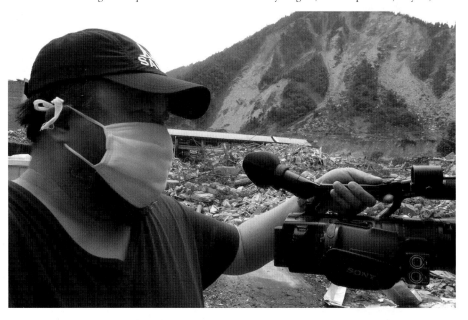

3.4 Soldiers trained in chemical warfare take a rest from clearing the rubble, May 30, 2008.

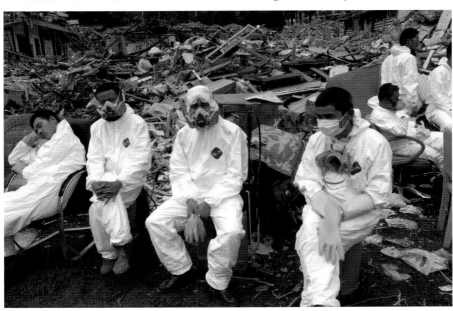

3.5 Soldiers filing down a demolished city street in Yingxiu, May 30, 2008.

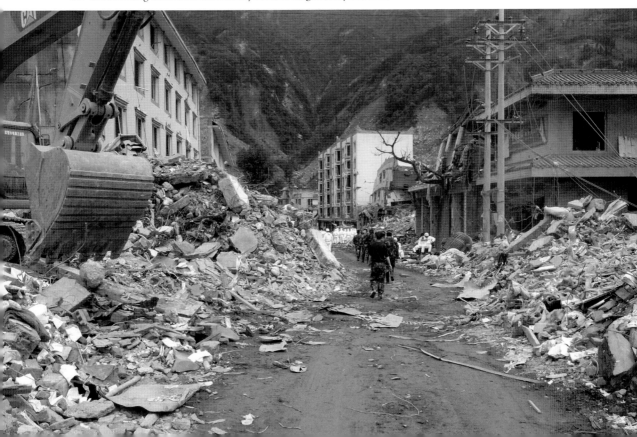

Silent Holiday

POSTED ON JUNE 1, 2008

If there ever were a day when pure and innocent children began to distrust the world and to lose hope in its people, it would be today.[11] Twenty days ago, when a trauma of the natural world caused thousands of schoolrooms in the quake area to collapse, an estimated six thousand students were buried in bricks and concrete.

Each living person in every small hamlet within the quake zone will extend a hand and point in the direction where nursery schools, elementary and middle schools once stood. The reality that all the survivors, every person who came to the rescue, and every volunteer or soldier from both far and near cannot accept is: these children left us. Why did such a fate choose them? Next to rows of collapsed schools and dormitories, scores of buildings were left standing, just as before.

Today, these ruined buildings conceal the bodies of children who will never be discovered, for rescuers stopped searching early on, their hearts gloomy and hopeless. It might have been better if those children had never walked in the human world, but sleeping peacefully among the concrete ruins, they will never again be disturbed by the clamor. The only thing that belongs to them now is the condensed terror, anguish, despair, and darkness.

Don't be too anxious to boast that disasters strengthen the nation or to brag about "unprecedented unity," and don't use conceited words to cover up the cold, hard facts. First, pull the dismembered children's limbs from the rubble, wipe them clean, find a quiet place, and bury them deep.

Twenty days have passed since the earthquake, and still there is no roster clearly listing the names of missing children, and there are no accurate counts of the dead. The public still doesn't know who these departed children are, who their families are, who neglected to reinforce the schools with steel, and who mixed inferior concrete in their foundations and concrete supports when they were constructed.

The people have shed enough tears for a lifetime; what plagues their hearts now is a willingness to give everything to protect or exchange their lives for those lost.

This is a terrifying holiday. On this Children's Day, every living adult with a shred of decency will be keenly aware of his or her failure to live up to those children, those far-off children who will eternally distrust this world. The fate of the children is that of the nation, their heart is the heart of the nation. There can be no other.

May those responsible live their remaining years in ashamed condemnation. Regardless of position, status, or honor, for just once in your life, stand up and take responsibility. Act like you have a conscience and shoulder the blame. But that would still not be enough to lighten our sense of shame.

Not only did those unstable schoolhouses collapse, the good conscience and the honor of a nation crumbled with them. On this day, beauty has perished. Have you not noticed the absence of so many laughing voices?

Those children left us before they learned how to be indifferent, before they learned how to cheat. This will come to be seen as a despicable extermination of decency; it will become a fable in which lies usurp the truth. This will be remembered.[12]

3.6, 3.7 Student drawings hanging on the wall of Juyuan Middle School, one of the "tofu-dregs" schools that collapsed in the Wenchuan earthquake, May 29, 2008.

Sacrifice

POSTED ON JUNE 4, 2008

Everyone knows today is June 4.[13]

What kinds of hardship must we endure before our hearts begin to suffer? What kind of suffering can be exchanged for enlightenment? There can be no more flippant presumptuousness or reckless ignorance. What's one little calamity? It will soon pass and be forgotten; those people will be considered the segment that died off. If death is an inevitable footnote to life, where have those lives gone?

There is an excess of lasting misfortunes, and too little good fortune in China. The difference is that, no matter what the nature of the calamity, the moment it occurs, this nation always ends up whitewashing itself in "unprecedented unity," and we trust that unification will inexorably stave off disaster. The revolutionary catch phrases of decades ago, "strength in unity," "the greater the obstacle, the greater our courage," and "disasters revitalize a nation," possess a "bring on fiercer disasters" spirit of audacity. Then come the satisfactory and absolute celebrations of the success, hailing "profoundly moving, great achievements" and "decisive victories." People are generally fond of evading the passions of reality and opposing the emotions that arise from human nature, but any species that exists amid excessive suffering for too long will evolve a special kind of emotions and traits, as well as alternative means and capabilities to deal with it.

A nation without spiritual beliefs is a fearless nation, and here we lack genuine mourning. There is no misery that this nation cannot extricate itself from, and likewise no moral accountability or ethical doubt. The relentless simulation of peace and prosperity, blindly singing their praises while shamelessly concealing the truth, will ultimately make for sobering dizziness and ignorance, and true hypocrisy will eventually become a ruthless and severe part of reality. Until the day when misfortune becomes the norm, this land will never again see such a disaster; misfortune has already been deeply impressed in everyone's hearts. This land is calamity in itself.

When the time comes that people feel a shred of sorrow, the dead will be forever gone, and they cannot respond. Indifference and madness have solidified and been neglected, and are no longer understood or forgiven. The departed are no longer concerned whether or not society is stable, or if the hearts of the people are at peace. The aphrodisiac of nationalism cannot sustain society's loss of public trust or the crisis of conscience, for the morbid reality of a fictitious nationalism is a treatment far worse than the cure.

Out on the street, crowds of ethics-killing people live in utter disregard of personal enlightenment; corrupt, incompetent autocracies and those self-deceivers and cheaters of men who praise them are running around blindly—Where are they going?

Karmic Retribution for Karma

POSTED ON JUNE 8, 2008

Ms. Sharon Stone said a few sobering things, and everyone understood what she meant, even though some feigned not to.[14] The other related person is named Yu Qiuyu,[15] and it wouldn't be an exaggeration at all if you were to call him a degenerate intellectual, or scum among scum. Just the fact that this kind of indecent scholar still rambles on today completely unfettered is nothing less than a miracle.

Both of these individuals made emotional statements about the earthquake, and both cited Buddhist concepts.

Ms. Stone is a follower of the Dalai Lama. The "karma" she referred to implies that all actions necessarily have consequences, and that all feelings must necessarily invoke a response. Therefore, everything we have earned, our fortune or misfortune, is due to karma, not necessarily implying secular punishment. She said, "Then all this earthquake and all this stuff happened, and I thought, is that karma? When you're not nice, that bad things happen to you?" This is a simplistic understanding that fails to deal with even the fundamentals. If she is referring to worldly punishments, Ms. Stone is simply wrong, because in this land, the day of reckoning will never come for the people and events that have inflicted prolonged devastation, such as Yu Qiuyu or the unpardonable Sichuan Department of Education and Ministry of Education. To the contrary of what we hope, the innocent common folk invariably meet with misfortune. The next time Ms. Stone has the opportunity to ask the Dalai Lama, she can find out why this is.

The Shanghai intellectual Yu Qiuyu does not believe in karma. With tears in his eyes, he earnestly admonished the parents of thousands upon thousands of wrongly dead children, saying, "Do not cause trouble, do not get emotionally disturbed." He said, "Your outstanding behavior since the disaster has already won the highest respect of the entire Chinese people. ... We need you to keep up morale and avoid creating unnecessary turbulence." This last comment filled me with a special respect for China's intellectuals.

Today I heard him say this: "Anti-China organizations that have disliked China for decades are waiting for us to make mistakes, and you must not become their tools." These are the incredulously contemptible and shameless words of a lackey, brazenly antihumanistic talk. Of course there will still be no retribution. Yu then borrowed a

phrase from some bald-headed monk when he said that those wrongfully dead children "have all become Buddhas, who will forever watch over and bless China." *Ha ha!* He also said, "Regardless of all the poorly built schools, the earthquake was, after all, a natural disaster. In theory, all buildings will collapse when an earthquake measures seven or eight." How should we respond to you? You and your bald donkeys can take your "highest respect" and go bless each other.

I've realized the vengeance that is the absence of karmic retribution—and thus China's survival is her most genuine form of punishment.

The Way of Teacher Fan and Ethics in the Ministry of Education

POSTED ON JUNE 16, 2008

The difficulty in doing good is that often the principles of kindness seem either too simple or too broad in range. However, true goodness is concrete.

In the pre-takeoff emergency procedures on planes, we are told that in the event of an emergency, we should first look after ourselves, and put on our own oxygen mask before we help children and the elderly. This is common sense. I do not believe that any powerless individual, political party, or nation could possibly provide genuine and reliable help to others. All ethical and moral foundations originate in the relationship between the life of the individual, his or her will, and nature. In this relationship, the self is always first; even if we are making personal sacrifices, they also stem from personal choice. This is why the broadly moralistic idea that we should separate the value of our personal life from our personal will is as irresponsible as it is hypocritical.

Fan Meizhong cherishes life and loves teaching, and he dared to tell the truth.[16] Suppose we say that Fan Meizhong has questionable ethics. This is like saying that the lives of certain people are unimportant, or that there are conditions to the ways we preserve life. But this is contrary to the idea that all life enjoys equal status and no one should be discriminated against when confronted with the choice to honor life. What's more, a teacher protecting his own life could also be seen as protecting a precious national treasure; if he can't be commended, at the very least he doesn't deserve such harsh criticism. The Ministry of Education holds jurisdiction over an area where hundreds of schools have collapsed, and the whole world has been shocked by the death of thousands of students, yet its own corruption and neglect of obligation are handled calmly, as if nothing happened. However, we refuse to pardon the lack of "ethical responsibility" of a middle school teacher who, in a panic, ran for his dear life. This is truly a joke with socialist characteristics.

Forget About It

POSTED ON JUNE 21, 2008

Does karma really exist in this world? I, at least, am no believer. If it did exist, retribution would have come long ago, and things wouldn't have dragged on this long. Both fate and efficiency have proved unreliable. If karma did exist, at the very least it would show itself to a certain extent, or let even a fraction of its spirit reveal itself, rather than allowing tens of millions of people within a few million square kilometers to descend collectively into sky-toppling desperation. It's all too vague and imprecise, enough to add to the sinking faith of any skeptic.

It's not a difficult conclusion to arrive at: we absolutely do not live in a world with karma. I've seen the light, my chest feels lighter, and so many things have become clear. Don't even bring up events of days long past; just earlier this year was the enormous snowfall that forced tens of millions of people on the road home for the holidays into freezing, starving slavery;[17] before the snow had even melted, Tibet rose in rebellion while people clustered around a flame they couldn't even see as it traveled the world. If our North Korean brothers weren't still around, it might seem as if the whole world was against us, and on top of that, everyone hurts our feelings so often.[18]

The torch business never ceases to rub salt in our wounds, and rattle our world, and after that came the floods, and tumbling market shares … and it's only June, there are still a few more weeks before the Olympics. The heavens work in their own ways, and in a world with absolutely no karma, everything comes tragically and furiously, but leaves gracefully and unhurried.

You may be as unscrupulous and willful as you please, just clarify exactly what is socialism with special characteristics.[19] A national airline can hold hostages on several airplanes like there's nothing to it;[20] the Ministry of Culture can use low-quality methods to control and monopolize the market in order to fabricate a false sense of cultural prosperity; and everyone plays the ass together. Though thousands of substandard schools crumbled to ruins, and thousands of students met with untimely deaths, this fact has absolutely no relationship to the Department of Education; such are the unavoidable results of high-magnitude earthquakes. No need to reflect on this or to suspect why it might be so, for misery has long been an endless spiritual resource in "regenerating the nation." Tears and "compulsory donations" over thousands of years of disasters have already been transformed into unprecedented "good fortune."[21] For years, deaths on such a vast and mighty scale have created "fortunate ghosts."[22] At least they will never have to experience another startling death.

Nothing that happens in this land is surprising. Nothing can be meaningful, and everything lacks cause-effect inevitability. The cause is the effect, and the effect is the

cause; what karma is there to talk of? Who's doling out retribution? Humans have always had the power to push the present and the future into the past; the future is uncertain, and the past can be altered at will. There are no difficulties that we heroic people cannot overcome.

Totalitarian crimes begin by denying individuals the value of their lives, avoiding reality, and refusing responsibility. This is tantamount to saying that life is petty and low, as worthless as it is hopeless.

But forget about it! Apart from your self and your not too long, not too short days, there's no other future for you. This is your complete and consummate everything; there will be no better life. Whether this world is warm or frigid and cold, indifference lies at its very roots. This is the kind of world that you live in, where everyone's life is too trivial to mention, and yet heroes surge forth. They arouse fervor through love, flatter with morality, and flaunt their shamelessness, all in order to maintain a legend. This is a false world without justice, partial to the ignorance and greed of the smallest minority, and reliant on trickery and unfair gains.

Paper Tigers and Paper Hunters

POSTED ON JUNE 29, 2008

On June 29, half a year after the South China Tiger Incident, the Xi'an city government submitted to the pressure of public opinion and revealed the status of their investigation into the "South China Tiger" photographs.[23]

This is a victory for public opinion. Amid prolonged contesting, truth has finally prevailed over appearances, false is false, and the disguise has already been peeled away. In a nation where knowledge is pitiably insignificant, where the media lacks conscience and principles, whatever the government says, goes. In a place where the cart coming before the horse is an irreversible situation, this is already no small victory. It proves that now, everything concealing the truth and contrary to the power of public opinion is only a paper tiger. Things might look frightening, but in reality, everything is laughable.

In this trial of strength, the miscalculations of one party still failed to touch upon the essential nature of truth and, using merely expedient measure of "sacrificing the pawn to save the rook," continued to throw dust in the eyes of the public and to conceal truth in a deep virtual chasm. Yet the people realized that this tiger is fake, and even paper tigers can flaunt their powerful connections to bully others.

If we were to look into who is to be held responsible, the first people who should be investigated are the National Forestry Administration and the Shaanxi provincial

government. They are precisely the departments who are speaking so vaguely, evading facts, refusing to take action and shielding liars. If they refuse to take responsibility, their so-called management will be only the deception of the public by avoiding major facts. If we believe that honor in our society belongs to such sophisticated organizations, shouldn't they likewise share responsibility and shame?

Either Zhou Zhenglong is a peasant or he's a hunter. He certainly isn't a chief conspirator, he is merely a focal point, but is not the true deceiver, and this is because his motivation for deception doesn't stand up to scrutiny. If local profit-seeking organizations weren't manipulating and instructing him, he would have no space in which to trick others, unless we believe that a paper tiger can arouse this hunter's thrill for the hunt.

As for this kind of "paper man," public security organs will not be weak-fisted when they deem necessary.[24] But don't forget, abusing power to illegally punish accomplices under duress, but allowing the principal actors to remain at large, is using the name of law enforcement to shame the law once again. This case was never a public hearing, but was carried out in secret trials. What kind of truth are they covering up?

Paper tigers don't alarm us because they don't eat people, and yet this "paper tiger" had the entire nation in upheaval for more than half a year. In a world of fake dogs and fake cats, where everything is fake, hunting even a fake tiger will of course present its own difficulties. It's not hard to discover that not only is the tiger fake, but Zhou Zhenglong, the hunter who created it, is fake as well. The hunt lasted for half a year, and everything related to this tiger is fake. How can we begin to combat this nature of falseness?

Smashing and Burning

POSTED ON JULY 1, 2008

On June 29, Xinhua online news wire reported that on the afternoon of June 28 in Guizhou province, Weng'an county, "smashing and burning" crowds besieged local government offices.

The news clip on Xinhua read: "Crowds of agitators unaware of the facts attacked the county public security bureau offices, government offices and county buildings," and "A few of these lawless persons seized the opportunity to smash and burn offices and some vehicles."[25]

Compared with the recent incidents involving the Tibetan independence activists, which are referred to as "Smashing, robbing, and burning," in Guizhou they are simply "smashing and burning." The distinctly different characteristics in both of these cases allow us to safely eliminate the possibility that the Tibetan independence activists

might have provoked Guizhou to rise for independence, or that there is any threat of fragmentation to the motherland.

Owing to the general low moral character of Weng'an county's "lawless persons," other national news media channels, in their ignorance of the inside story, were unable to report any news related to either the first, second, or third incidents of breaking news. We should congratulate ourselves that the "anti-Chinese" CNN and the "irresponsible" German media were slow to react, and have been gradually losing interest in this type of reportage. Such a lack of interest has become the industry standard for international news platforms, and it also fully exposes the Western media's favoritism for the Tibetan independence conspiracy. What should be pointed out here is that such methods greatly hurt the feelings of the Chinese people. In regard to the changing international situation, we must maintain steadfast clarity of mind, and truly live up to the saying, "If the Western media reports on it, we won't overreact; if they don't report on it, we won't be surprised."

This scene of "smashing and burning" was one of serious criminal offense. With the help of the government's incredibly self-restrained and patient mediations, the matter was satisfactorily ameliorated, and the situation has been returned to normal. The greater public is filled with confidence and is eager to join in the celebrations of the Chinese Communist Party's birthday this July 1. This incident was another vivid lesson for the general masses and the cadres: the process of reform and opening is not smooth sailing, and the government's power is steadily increasing. Today's harmonious society was not easy to come by. As long as we follow in the firm leadership of the Communist Party of China, any unlawful attempts to fragment the motherland, and even criminal activities that don't attempt to fragment the motherland, will ultimately come to a bad end.

Yang Jia, the Eccentric and Unsociable Type

POSTED ON JULY 4, 2008

When the media talks about Yang Jia, they always say he is the eccentric and unsociable type.[26]

It's possible that eccentric and unsociable people are bashful, or maybe they just don't like the people around them. Eccentric and unsociable people can be competent citizens, they can be useful to society and others, and in a normal society they could continue being eccentric and unsociable for a lifetime. What's wrong with that? Does that also make you uncomfortable?

Yang Jia was born in Beijing in August 1980 into a dual-income family of laborers. He was an avid reader. His father remembers him as a "kid who knew the rules, who

was always on the straight." In Shanghai he was violently humiliated, and he decided to claim justice through violence by himself. The Yang Jia affair once again reminds us that you can keep far away from the misfortunate, and allow them to run their own self-destructive course, but if you provoke them, that's your mistake. If you don't respect the misfortune of others, you'll eventually encounter demons. That person will say, "Now that I'm completely helpless, I want to exchange my ignobleness for justice, even if I must die in shame."

Yang Jia was labeled a criminal even before his case was investigated. Can people be born criminals? How many opportunities to become a criminal will arise in the life of any helpless or benign person imbued with a sense of justice? How many chances will there be for an ordinary person, one disinclined to cunning, to possess self-respect?

If a person upholds justice, assaulting police officers isn't necessarily criminal; for even if theirs resembles personal justice, there can be no justice belonging to individuals in this world. Anyone confronting state power must be a criminal? What kind of logic is this? If that's true, then the entire Communist Party before 1949 was filled with criminals, and the People's Republic naturally became a nation of criminals. This would be CNN's logic. This is logic derived from a single power, and not from justice.

In such a cruel place, why can't the child of a single parent, from a family on a worker's salary be a little eccentric and unsociable? On the instruction of psychological experts, Shanghai's police decided to increase precautionary police measures when confronting such eccentrics. But with so many people fitting the profile, only a nuclear bomb would do the job.

Throngs of helpless people who have been victimized, bullied, rejected, and neglected by bureaucratic and judicial powers are struggling between choosing violence and letting things be forgotten. The extreme few among them who still haven't sobered to the inevitability of their plight will, one by one, time and again, pursue justice within legal channels. For this unfortunate minority, there will be no justice on the road ahead, only an unsympathetic and unjust society. Justice can only come at one's own behest.

The Zhabei police suspected a tourist from another town of stealing a bicycle, and they beat him until he was crippled. If this is the truth, they should be punished, no more taking the hard road, clean out your eyes, and learn to distinguish the truth. The Shanghainese ought to use their shrewd perceptiveness to think a little more about their own safety and be more cost-effective.

Among all national incidents involving excessive police force, these people are the garbage of the lot, counting on their sinister powers to satisfy their weak and despicable inclinations. But this time, no one offered to negotiate a price with them, and

when individuals pursue justice, all such behavior will be punished. In this incident, Yang Jia not only disposed of a few policemen he wasn't acquainted with, or who were disrespectful to him, he was poking fun at society's numbness toward social injustice. But it's obvious that all the unjust bullying, lack of sympathy, and injustice in this world could never be harmonized in just one day. In a harmonious society, the rights and interests of each and every person must be respected. If one person becomes a criminal, the entire society pays the price. If one person is cruelly killed, in the end everyone goes to trial.

Truth can be altered, but today one truth will never be erased: that is the truth of Yang Jia, who came from Beijing, a young man born in the 1980s who killed six policemen at the Zhabei police station. There is one more detail: he didn't touch a single female officer.

When individual consciousness is forced to seek self-fulfilling justice, justice itself becomes equally vulnerable, pale and bloodless.

At least this incident will alert the Shanghai police: don't bully people like Yang Jia, or flippantly abuse any eccentric and unsociable types, especially those from the north, more precisely speaking from Beijing, and especially those born in the 1980s.

Six officers from Shanghai's Public Security Bureau, the Zhabei station, are gone. Yang Jia, an eccentric and unsociable type, will be remembered.

On the Bird's Nest

POSTED ON JULY 9, 2008

Business Week China:[27] You participated firsthand in the entire process of the "Bird's Nest," from its design to its competitive bid. What was the most moving experience throughout the process?

Ai Weiwei: Generally speaking, everything was very fortunate; there were proposals from almost twenty nations and the "Bird's Nest" placed number one. To speak immodestly, if the second-place proposal had been realized, the results would not be so fortunate. Ever since the Bird's Nest was selected, it has met with much frustration, even torment. The original plan has been continuously altered, the reasons for altering it arise from the need to balance national-interest parties and appeals from politicians. The Bird's Nest has become a platform for finding balance; these alterations have nothing to do with the design itself. The designers were reluctant to do so; giving in one degree could be fatal to the project.

BWC: After you joined Herzog & de Meuron and their team of designers, the proposal was altered dramatically. Why was there such a change, and how was it related to your participation?

AWW: I just shared some of my opinions. When I arrived in Switzerland, I saw their studio had already prepared two proposals. Herzog & de Meuron, several key architects in their atelier, and four of the firm's partners were on the scene, which told me that this proposal was extremely important to them. I discussed some of my reactions to these two proposals, starting on a fundamental level, including whether or not the stadium should be elevated or at ground level, the way the roof would open, and the composition of the structure itself, etc. I rather enjoy offering advice; and later on they halted these two proposals. Shortly after, we did some brainstorming on the structure and the outer appearance. At that time, an important point of discussion was the "collapsible roof," a retractable roof the size of a football field, which was an enormous challenge for all the participating designers. Some of my suggestions were used, and after one full day of effort, we had hammered out a potential new proposal and a direction for its development.

At the time, Herzog said excitedly to the former Swiss ambassador Uli Sigg: "When we invited Ai Weiwei we originally hoped to take a step forward, we never expected we would take two." The next day when I prepared to leave, he said to me: "You know, we've already won with this proposal." Was this very important to their winning the proposal? Herzog also said to me, "In the future, when you will see the various proposals, nine out of ten are the same, but ours jumps out entirely."

BWC: Did you have any disagreements during your discussions?

AWW: The pace of discussion was very fast, and there was heated debate on everything from the shape of the architecture to how the crowds would enter. It was very effective, and the work atmosphere was great, liberal and unobstructed. Everyone could only simply share their judgments on what was good, what was bad, and had no time to uphold a certain type. I've never experienced such a pleasant working process.

There were some troubles on specific issues, for example how to determine the "shape" of the Bird's Nest. In the beginning it was something like a "lantern" shape; all the European football stadiums they have worked on are in similar illuminated lantern shapes, very beautiful. However, I think that circles lack a sense of orientation. De Meuron asked, "How can a circular shape provide orientation?" I answered, "It's possible," and elevated two sides of the sphere, sinking the other two sides; after a period of adjustment, it became the shape you see today.

BWC: Some people are saying that you were the "Chinese consultant" to the foreign design firm; in this sense, are they saying that you brought Chinese elements to the design?

AWW: That is nonsense. In the process of design, we never once brought up any issue of alleged "Chinese elements." The reasoning is quite simple: I am a Chinese, and thus I possess reasoning and a mode of thinking that belongs to my native culture.

When the design was finished, and before it was sent to the competition, they said they should identify some Chinese elements in it. At that time it was necessary, so we talked about cracked ice patterns in pottery glaze, or the patterns on ancient painted pottery, I'm very familiar with these. We talked about it in the proposal as well, a so-called "ordered chaos," and ideas such as "perfect vessels" which demonstrate an understanding of the ancient Chinese classics. These were just to aid in identifying a pretext.

BWC: "Structure is shape, shape is structure" is demonstrated as an important characteristic of the Bird's Nest. How do you interpret this from the perspective of a designer?

AWW: This is a very important portion of the design. The National Stadium is called the Bird's Nest, which originated from the proposal's bid: "Similar to a bird's nest, its outer appearance and structure are unified." Now everyone is used to calling it the Bird's Nest. Its greatest breakthrough is expressed in its integrity; this feature makes it different from other stadiums. Why did we want to do something integral? Because the support strength needed to support an enormous rooftop is enormous; thus we were forced to consider how to reduce the structure of its supports while providing the best means possible to watch the competition.

3.8 *Beijing's Olympic Stadium,* June 4, 2006. C-print, edition of 100, 100 x 142 cm.

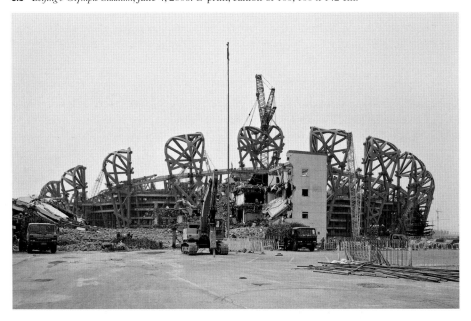

Secondly, there was an issue of directionality. The design's weblike structure is uniform: no matter where you sit during a competition, everyone feels like they are in a central position; watching games becomes more convenient, with spectators' line of sight unhindered. It isn't simply an issue of aesthetics, but must integrate with functionality, manifested in the integrity of functionality.

BWC: In the early stages of design were the possibility of implementation and the level of difficulty considered?

AWW: Theoretically speaking, any structural shape can be realized. The firm Herzog & de Meuron has plenty of experience, they know how to achieve desired results. Design is a product, it isn't merely a shell; just like a person, it has a heart, a soul, and a circulatory system, design includes all of these elements. On the possibility of the structural implementation, the Arup firm from the United Kingdom carried out extensive testing and appraisal; without the structural engineering support from such a firm, the Bird's Nest would have been impossible to create. No one can give professional estimates like them, and before the final competition bid was submitted, their firm had already given their professional theoretical analysis and approval. Later, more than ten outstanding architects from Switzerland worked hard in China for several years, going to great lengths to complete massive amounts of design work.

BWC: In the early stages of the competitive bid, the Bird's Nest encountered a lot of professional doubt. Looking back on that today, what do you think of this criticism and doubt?

AWW: This opposition and doubt almost buried the Bird's Nest, and early on it was very hard to imagine how the results would turn out. At the time, mainland Chinese architects collectively signed a letter, calling it into question as "colonial" architecture, and stating that China had become an "experimental ground for foreign architects," and saying it was wasteful, etc. Herzog & de Meuron had won the competition fairly; the allotted funding was four billion RMB, and the estimated cost of the Bird's Nest was 3.8 billion, which was in line with the budget requirements. The media reports in 2005 were steeped in opposition voices. Then there were other professionals who said that altering the "prescribed" Bird's Nest could save so much money. "Foregoing the shell and only making the platform" would save so much money, and these were Chinese academicians—you can imagine.

There were many objections, and the government was hesitating in their decision-making. In the midst of it all, a rumor surfaced that they were going to change proposals. I remember the day the Beijing Party Secretary said: "On the issue of Olympic architecture, the principles of opening and reform will not be altered." It's possible that, at the time, that statement played a role in the revival of the Bird's Nest. The final result was to omit the retractable roof featured in the original design. The original composition of the design was built around supporting that roof; without it, the

entire shape took on a different flavor. Now it cannot be added on. The steel has been reduced to the least appropriate amount.

BWC: Have you been to see the completed Bird's Nest? Which aspects concur with your expectations, and which, if any, exceeded them?

AWW: It is ultimately a good design that conforms to our imagination and our expectations. But there are no aspects that exceeded my expectations, and it is lacking in other places, but that is not an issue. Good design with a strong concept doesn't need to be perfectly executed. I've been to the construction site three times now, once a year ago, when we went to see the color code and decide which shade of red was most appropriate. Upon completion, we went again, to see how the seat implementation was progressing and inspect the VIP facilities. After Herzog and de Meuron saw it, they thought everything was excellent. But in truth, it was finished too roughly in some places, but the architects don't mind that kind of thing; they think that in the rougher places the efforts of the builders are visible, that these have their own kind of beauty.

BWC: Herzog once expressed his worry that "China would construct the Bird's Nest according to its own methods," implying that many incongruities and conflicts exist between foreign and Chinese architects. Is that so?

AWW: In the beginning the architects were almost crazy. De Meuron took primary responsibility for the project and he was required to engage in many meetings where he gave the same report to various officials. In a governmental system that hasn't come to maturity, it is inevitable that you will be at your wit's end when often confronted with such issues. You don't know who will control your fate, because it's possible that anyone could suddenly bring up some inexplicable problem or suggestion; on this point they were helpless in China.

Lately, these incongruities and conflicts were not of primary importance. In their opinion, it's more important whether the local people will like their projects than whether or not people will mention their names. They think that having such a great number of people working together to complete such a project in such a short time was an extremely difficult task. I am also very happy; already, whether or not Beijing has a "Bird's Nest," in terms of this Olympics, is a big difference; a piece of architecture can be a great influence on the city.

BWC: Not to speak of the structure itself, but to look back on the entire completion process of the Bird's Nest, do you consider it a milestone in China's opening up to architecture from the outside world?

AWW: The Bird's Nest is the consequence of this era's ambition and colliding ideals. It could only be realized in a globalized era, while at the same time, it could only be constructed under the existing Chinese system, one with such a strong focus on efficiency. China will play host at the Olympics, and it has made a promise to the

world, and at this time it must be subject to supervision. China's "reform and open-ing" is not just a catchy jingle; "reform" is the changing of ugly habits, "opening" is the introduction of other modes of thought and technology. The process will inevita-bly be painful. The public and transparent selection process by which the Bird's Nest was selected was in accordance with global standards.

BWC: How much time did you invest in the process overall, and what is your next project?

AWW: All together, only two months. The later concept for the environmental design was per my idea, for example the paths emanating from the stadium, a sunken public square and entrances, etc. The results were not good at all, and many things were not realized. This September I will collaborate with Herzog & De Meuron again on an architecture-related installation piece for the Venice Architecture Biennale.

Endless Surprise

POSTED ON JULY 10, 2008

The vast majority of the time, when we are confronted with the desire to discuss or understand the truth of any matter, intuition tells us this is impossible. This is a lasting grievance afflicting our people.

Evading anything touching on the fundamental elements and contradictions that make up the present situation, or avoiding responsibility, are ostensibly meant to ben-efit those in control. However, this is obviously contradictory to reason, because only after the truth of a situation is exposed completely can effective solutions naturally emerge. Likewise, only when the natural progression of events is undesirable will the true facts be concealed. For a long time now, the actual facts surrounding every important event have been concealed and distorted; it is impossible to lay truth bare before the public.

A habitual lack of self-confidence and weakness are at work here, as well as a mechanical mode of self-protection and precaution. The result is a public that mis-trusts power itself, and harbors a widespread skepticism that any legitimate mode of power exists. Today, democracy and justice are no longer simple political ideals, and yet throughout humankind's struggle for existence these have proven to constitute effective practice benefiting the advancement of the majority. To use various excuses to postpone or delay the course of democracy, or to prevent the emergence of a civil society, is to gamble with a people and a nation—and all for the temporary profit of a mere fraction of the population. It is very easy to see through this.

An ideal civil society would resist and eliminate the will of centralized power, and would pin down and fragment power structures. Limited political rights in China

result in consortiums, labor unions, and religious organizations with no real significance. Without a balance of or restrictions on power structures and without dissident voices, everything is a return to the Soviet era and leads to absolute corruption and impotence. Civil rights are laid to waste and a culture of ideals has collapsed, thus resulting in the fact that when China is confronted with competition, it is impossible to sustain the courage, responsibility, ideals, and identity that such a large nation ought to possess.

Only when personal dignity is consistent with human interests and values can such honorable or disgraceful emotions come to be known as "patriotism." This entails a degree of difficulty. In this world, absolutely independent interests are nonexistent, and as no portion of humankind can exist in isolation, the plight of the individual is inextricably linked to the values of others. Narrow-minded patriotism derives from myopia and shame; at its foundation is a lack of understanding. The concepts of nation, people, and rulers must not be confused. To confuse them would be to pollute the honor of the country, to plagiarize and betray public rights and will.

When the criticism of others touches on sore spots, there are claims that "the feelings of the Chinese people have been hurt." In terms of both linguistic logic and real-life practice, this phrase sounds infantile, causing the so-called "Chinese" to seem even more like some witless woman scorned. A social system declining into despair, the trampling of civil rights, a worsening of our ecosystem, a lagging educational system, the corrupt impotence of officials … nothing in this world could be bigger, more sustained, or more injurious to the feelings of the Chinese people, if anyone really cared, if, indeed the Chinese people still have feelings.

In the end, owing to cultural weakness, asymmetric concepts, and the opacity of information, this society will find itself in an awkward and panicked position. A lack of transparency, of scrutinizing public opinion, and a shortage of public channels for communication and a rational cognizance will make for deviant and contorted policies, and cause the nation and people to pay a price that is ultimately difficult to assess.

Any system has the potential to err. When a system only knows error, and every one of its responses is an aberration, shouldn't the people be conscious of their relationship to reality, the accuracy of facts, the rationality of language, and the effectiveness of policies? Regardless of whether these problems are international or domestic, if they are not solved they will always be on the opposite side of right. Lacking an articulated system of values, this system has no means for reacting to real changes or to collisions of different value systems. It distorts all the pleas for worth that are embodied in each new possibility.

Even criticism aids the advancement of society and works toward its systemic transparency and impartiality. The opposite of this is media like CCTV, a distorted mouthpiece whose distorted facts and fraudulent ways of guiding public opinions are

clearly a publicity program for political doctrine, clearly not a media to meet modern society's needs. This kind of media threatens with its power, deceiving and misleading us into believing in society's progress, and it bears unmistakable responsibility for obstructing the transparency of information. History will make this clear. When any of these people criticizes the "false statements" of another country or person, be they from the Dalai Lama's government in exile or the foreign imperialists, they nonetheless use all manner of shady and underhanded means to block out the most damning parts of the original statements, the real face and intention of these critiques.

In a society that dodges contradictions and cannot make a plausible defense for itself, no public topic is permitted, not even the most basic discussion, and the answers inevitably disappear into an enormous black hole. The cost of this is a loss of the public's basic faith and responsibility, the unchecked expansion of powerful and corrupt systems, and the unscrupulous postponement of the people's and the nation's advancement.

When the rights and the will of the people are limited to such an extreme degree, any expression of those rights will eventually come to be seen as either a threat to power or the outcome of unseemly social factors. A longstanding lack of restrictions on power itself, along with a lack of a critical examination of the legitimacy of power, have led to awkward policies and situations and ruled out all other possibilities. Therefore, the government either does not act, or it acts wrongly. How much longer can this power structure be preserved? Thirty years after opening and reform, and sixty years after "New China," basic questions such as the legitimacy of power and the appropriate use of power remain unanswered or are skirted around.

Rediscovering the possibilities and demands of development, recognizing today's common values, and seeking a new system of spiritual civilization constitute the only path to achieving respect and cultural discourse. When the government admits that it is merely one player in a larger drama of social and historical progress, it will begin to treasure criticism. Any government that rejects democratic rights and the will of the people can only be described as criminal. That a government like this can persevere, especially given the speed and structure of overall global development in today's world, is truly cause for endless surprise.

WRITTEN APRIL 18, 2008

Pipe Dreams

POSTED ON JULY 12, 2008

The Olympics are not far away, and we can already hear the sounds of its ceremonious footsteps approaching. Last night at dinner several foreigners were talking about recent inconveniences caused by the Olympics, and every one of them was astounded.

One father visited a diplomatic apartment complex with his six-year-old son who didn't have an identification card, and both of them were denied entry, absolutely. Likewise, visas are being denied; as one foreigner said: "I've lived in Beijing eleven years, and now I have to leave." The *Beijing News* reported that twenty-six inspection points have been built along roads leading from neighboring Hebei into Beijing to accommodate officers inspecting the identification card of every single person entering the city, one by one. It's as if they were confronting a mortal enemy, a single suspicious identification card will result in the entire car and all its passengers being turned away. Land, sea, and sky are under lockdown, the fighter planes are readied for war, divers search the waters, and forensically trained troops guard the land. Who are they trying to frighten? Has this child scared himself?

In an unsafe world, frightening and with its own subtle tricks, no matter how you look at the "Friendlies," they appear to be neighborhood watchmen.[28] This is a big world with big dreams, and the face of the Chinese has too long been in hiding—you can go ahead and wash it clean, but you don't have to scrub away its skin.

We ought to know that nerves are already fragile, so is it necessary to pester the people endlessly over these things? A totalitarian state will intrinsically have no hope of involving itself in the happiness of the masses. For all of her forced smiles revealing rows of white teeth, Beijing is quickly catching up with Pyongyang. Could a greater politicized display possibly exist? It will be the same old routine, torturing our native Shaanxi director,[29] who seems to be pulling out all his old tricks but will ultimately be mocked by the world. If he could only just amuse himself and make what he wanted, it would be much better. Forget politics, and militarize the whole affair instead; after all, this is our forte. For those foreign visitors who will have traveled from distant lands, the Olympics are little more than watching who runs faster. They aren't a matter of life or death.

A society lacking democracy is incapable of orchestrating true joy for its people. If we had diverted one-thousandth of these resources to Sichuan, those schools would never have collapsed. With a single strand of good intentions, we would never see the violence that is inherent in our society. With even a drop of sincerity, we would never have seen such a bloody incident as Yang Jia in Shanghai. This is your world—don't count on others to share your dream. Of course, the dreams of others have

nothing to do with your world. Inundated by all of their sappy boasting, if you truly wanted to do something humanistic, it would be nearly impossible.

Different worlds sharing "one dream"?[30] Dream on.

Doing Push-ups

POSTED ON JULY 15, 2008

According to the July 13 report on the Weng'an "6.28" incident issued by the Guizhou Public Security Bureau's Deputy Director: "As of July 12, 217 people were apprehended for involvement in the '6.28' incident; 355 have been thoroughly investigated, and 90 among these have been identified as local gangsters. Of the 100 individuals who have been detained, 39 are local gangsters. Certain individuals suspected of criminal activities are currently being pursued."

People can't help but think, with numbers almost exceeding those of the Taliban, exactly how many lawless people can a small county like Weng'an hold? According to the government's version, aside from people with "ulterior motives," the only people left in China are people "ignorant of the truth." These people can't be taught—try for a hundred years and it would still be in vain, because they'll be leaping at any instigation, they're tricked by anything.

The government wants to save face, but if they're constantly transgressing with widespread slaughter, things are bound to get counterproductive. If you threaten the common folk by detaining hundreds of people at every chance, is it possible that these people and their equally "ignorant" friends and family will willingly stand on the government's side?

Today it was disclosed that a local police station in Zhejiang province's Yuhuan county was besieged in a further "7.10 incident."[31] Public security organs called it "a serious hindrance to public security organs' execution of official duties; likewise, such organized mob assaults on national security organs are severe criminal offenses that will be investigated thoroughly, dealt with severely, and shown no mercy." First, let's not talk about who's right and who's wrong; everyone's eaten their fill these days, so why must these people continue to make life difficult for the police? They still haven't recovered from the appalling disturbance in Shanghai, can't they just give it a rest? Now that I think about it, even as the Eighth Route army was fighting the "Japanese devils," victorious news wasn't pouring in with such high frequency!

Chinese affairs are really too funny, with the public security, prosecutorial, and judicial systems united together in battle, "cracking down, punishing severely." It is precisely this disregard for the law and neglect of human rights and civil liberties that has led to the interminable layers of injustice, artifice, and misjudged cases. The

contradictions are becoming bigger and bigger, the disputes more numerous, and the ideal of realizing a harmonious society moves further and further away.

Actually the reason is very simple, and it's because our aged officials have learned only two things over the years: when they need to explain the truth of a matter, either to their superiors or to the masses, they can only "do push-ups."[32] But when their push-ups are finished, they turn their heads, and will certainly stick out their fists for a crackdown.

Public Trial

POSTED ON JULY 17, 2008

The Yang Jia case has already lasted more than a month. The Shanghai police are suspected of concealing the truth and distorting facts, and this has resulted in a peculiar case that has triggered a crisis in public trust. All that is left from the previous two weeks—aside from the one suspense-filled incident when the Shanghai Public Security Bureau's official Web site was suddenly altered, and several media outlets irresponsibly reported muddled information and fragmented truths—is the disclosure on July 7 of detailed facts on the case of police assault. The police's public statement was filled with contradictions and lacked logic. It seems time for the Shanghai government to assess the ability of Zhabei Police Station's supervisory board to assume responsibility.

Shouldn't the Shanghai PSB, which praises itself as having an immeasurably outstanding tradition of moral integrity, clearly reissue the facts pertaining to Yang Jia's trial? After an unprecedented loss of soldiers in battle, shouldn't there be less glossing over, and more inclusion of the facts? It's fine not to play the hero, but it's unnecessary to play the deaf and dumb lunatic; you're causing those masses who care so much for you deep heartache, and you're leaving them unable to share your burden of worry and misfortune.

Without any logical explanation, you detained and interrogated a tourist who never did steal a bicycle. You were not daunted by the hard work it required to travel long distances, and came twice to Beijing for mediation and legal processing. Why is it that now, as the eyes of the entire nation are fixed eagerly on you in anticipation of your courage, waiting for you to present some trustworthy facts, you get all soft? Everyone has suffered so much, and yet you still hide away the real facts about the assault—this is why people worry for you. This business in Shanghai is truly inconceivable.

No matter the result of the Yang Jia trial, it already proves that decades of "reform and opening" have yet to truly put China on the road to democracy and rule of law,

and the nation has yet to shake off the painful consequences of official, institutional, and legal corruption.

In the case of Yang Jia, it's obvious that Shanghai has covered up at least a portion of important facts, in an attempt to obscure any plausible defense for criminal motivation. The final outcome ultimately ensnared the Shanghai police in their own tangled web. Disregard and disrespect for the law, abuse and misuse of power have resulted in the government's current disadvantageous position and caused judicial reform and rule of law to suffer setbacks. State power, the government's reputation, and the dignity of law have all been humiliated.

As a result of the police's customary foolish reactions, the Yang Jia case has been elevated from an ordinary criminal trial to a historical case that touches upon the safeguarding of justice and the independence of the judicial system. Judicial reform is an unavoidable reality in the fight for social justice and equality.

If there is anyone who still believes that equality and justice are the foundation of a strong state, what you can do today is give Yang Jia a public trial. Make Yang Jia's life clear, and his death understood.

The Trial

POSTED ON JULY 19, 2008

On July 17 the Shanghai city detention center turned away Mr. Xiong Liesuo, the Beijing attorney whom Yang Jia's father had commissioned for his case. Unable to confirm whether or not Yang Jia had attained the power to assign his own attorney, Mr. Xiong returned dejectedly to Beijing. This makes it apparent that Shanghai inspection units have spurned lawful judicial procedure and have rejected Yang Jia's legal right to counsel, refused good will and conscience, and, in a rash attempt to bring this affair to a close, have insisted on doing things their own way.

Shanghai should be reminded of this: even though this might be your style of doing things, even though you are suffering unspeakable misery from your loss, and even though you are always confident of your success, I reckon this time you have wrongly estimated the situation, and you will inevitably face greater difficulties. The "July 1 Yang Jia Case" occurred on the eighty-seventh birthday of the Chinese Communist Party, and it happened in Shanghai, that most civilized of Chinese cities. It happened within one of the national government's administrative organs, and concerned the death of six officers and the wounding of four others. It immediately became a public focal point in society's interrogation of the impartiality of law, and is the highest profile case touching upon the lack of transparency and confidence in the government.

The judicial process is a social instrument, an arm of the state apparatus, and a concrete embodiment of social ethics; it must be integrated with state and national interests. The nature of this case has already far surpassed any potential criminal case based on suspicion of bicycle theft, police violence, or murderous revenge. The Shanghai police was vague about the truth, they muddled through their work, and they evaded and concealed facts. These factors, along with their long-established tradition of deluding the public, resulted in the July 1 incident's rise to become a larger social investigation into state, institutional, and judicial impartiality. This investigation has become a focal point as society takes tally of the government's repeated attempts to improve its governing proficiency and its plummeting credibility, and it tests the public's willpower and claim to rights. It is a barometer testing our safeguards on fundamental civil and human rights in this "harmonious society."

Today everyone hopes the trial of Yang Jia will be a public one. Only then will there be the truthful clarification of facts for the public, only then can we clarify the origins, development, cause and effect of the six dead and four wounded. Only a public trial can prevent this case from being reduced to the falsified claims that have led our Republic to humiliation. State, institutional, and judicial public servants, "Do what you must"[33] to get a clear understanding of the situation. That is what you excel at, do it only to avoid future unhappiness. Take your future careers into consideration.

Fair and impartial implementation of the law is a necessary step along which legitimate societies develop. Transparency is the cornerstone of fairness and impartiality, and a fundamental promise for the sound and stable development of any society. Any person who attempts to equivocate or muddle through these issues is committing a greater criminal act against society. On this piece of land, issues as simple as this have unexpectedly been courted for decades by bloodshed and the sacrifice of countless persons. Thus we see that the impartiality of Chinese law still lags at an extremely primitive level, social ethics and morals are still unable to separate themselves from the nightmare of outmoded ideologies, and political governance has likewise stalled at the mere protection of personal interests. These are the primary stages of socialism with special characteristics, a disregard for public rights and interests, disregard for the progress of social reform, and a disregard for public opinion.

As she struggles to gain the right to her existence, China must once again make fairness and impartiality the cornerstone of her social ethics. As for the governmental, institutional, and judicial folk in Shanghai who attempt to obstruct, thwart, or hoodwink the public, don't you find yourselves laughable?

According to reports, Yang Jia's mother, a citizen who has upheld personal rights and judicial righteousness for years, has wandered about in a desperate plight, lacking all legal recourse. After her son was taken into custody, the Shanghai police took her away to "cooperate with the investigation." Her whereabouts are still unknown.

Similarly, after being detained and sentenced, the family of "tiger hunter Zhou" in Shaanxi[34] has still not received notification of his punishment. The police began a new round of "crackdowns" after the riots in Weng'an and Yuhuan. The organization of China's institutions and legal system has withered and declined; absolute power has become absolute corruption, constituting the basic reason for this persisting social unrest. This couldn't be any clearer, don't pretend that you can't see it.

For those Communist Party of China members who still seek justice, even if you take a stand just this once, hold a public trial. Respect the will of the public. Respect civil rights.

Olympic Virus

POSTED ON JULY 26, 2008

I've been into the city twice over the past few days. My ears are full of the endless complaints of taxi drivers, and everything out the car window is indeed a scene of desolation.

There are a slew of new safety regulations; we need a travel permit even to enter our village. As for global "anti-terrorist" measures, we've already matched those of the American imperialists, or even surpassed them. A police state built in the name of fighting terrorism has become the greatest threat to a harmonious civil society. Aside from the injury to life and other related costs that any terrorist victory in the world might cause, an even greater price is paid in the consequent threat to society's collective psychology and the disruption to the peaceful nature of the common people's lives. This is the real cruelty and backwardness.

How many citizens will have their rights further encroached upon in the name of safeguarding the state? The people are paying such a high price for the "national benefit," is this the mark of a democratic country, or the foundation of totalitarian dictatorship?

We've been arguing about culture and creativity for so many years, finally pouring all our national reserves into Olympic design. It would have been a rare opportunity to gain face for the nation, and who doesn't want face? *Haha!* This time we lost big face! Bring out the results for assessment, because this is precisely why transparency and public disclosure are so great. Every bit of the Olympic design, from Beijing's masquerade, to the taxis, the "Friendlies," medals, torch, flag, posters, costumes, logos, fonts, colors, and symbols for each Olympic event. … A few years ago, when the professionals convened, they spent an unlimited amount of money, and the final result is a compromise in quality that has plummeted far below any of its precedents, and exceeded even the lowest known standards. There are throngs of designers in this

magnificent and vast nation, and not a single project or object could be called worthy of display.

Cultural creativity is going nowhere, and if we gave millions of party members all the money in the world, they still couldn't boost creativity. They are incorrigible. This society was never meant to meet with the true, good, or beautiful; it is filthy, denies individual creativity, scorns culture, and is controlled by a corrupt system, all of whose efforts will ultimately end up as a blaspheming of cultural ideals and truth. Today, Olympic design has embarrassed itself in front of the entire world—doesn't anyone feel their faces getting flushed?

Anything like this society's exuberant joy necessarily derives from lies and deception, and a society with no integrity necessarily has shameless lackeys. Chinese nationalists are attempting to fob off the Swiss-designed National Stadium of Herzog & de Meuron as "China's own." Although a few people know who its real designers are, bird's nests popping up across the city are beginning to look guilty.[35] I've seen immorality, but I've never seen this brand of stupidity. Imagine spending three generations' worth of your family's savings to buy a BMW, and then stubbornly insisting you had bought a knockoff—could there be anyone as foolish as you? This time I understand why shameless people fear reality and alter the truth; it is the hopeless incompetence and sense of inferiority that runs deep in their bones.

You've called me the "consultant representing the Chinese side" countless times. Let me admonish you one more time: I have nothing to do with "the Chinese side." I've never worked on your side.

In all the joint-venture projects, those cooperating with the so-called "Chinese side," to put it mildly, are nothing more than job-seeking migrant amateurs. They flock into the city, and then return home to their villages telling people that all the buildings in the city belong to them.

As for those striking poses after being crowned the "chief Chinese designers," perhaps the public isn't quite yet aware of the weight of your crucial significance. Why don't you get up on the scale now? We'll throw you a ladder and you can climb right up; anyway, both the masses and history are fools. Overworked to the point of "fainting" and "sleep loss"?[36] That's nothing, but acting naive and ignorant in front of the entire world, pretending to throw a tantrum like a child, daring to plagiarize and then still swagger around town—yours is not merely a "broken spirit," it's more likely a problem of character. As they say in Hebei, you ought to "inspect your reflection in a puddle of your own piss," or, they might ask, "What kind of weeds are growing on your ancestral grave?" Your miserable face has already become the very cornerstone supporting them, are you pleased with yourself? You really love your motherland too much, to the extent that you can't wait to smear mud on her face.

A phony military commander hollering commands, setting fires, pinching the ladies of the house, and grabbing a few chickens as he trails behind the Japanese invaders is already profiting enough at other people's expense. If you started bragging that you were Yamamoto Isoroku,[37] wouldn't you be looking for trouble? And what day was it that the Japanese imperial army surrendered? Your days are likewise numbered. Soliciting in the national whorehouse, eating on their tab and feeding the enemy under the table, you stand to profit no matter what wins. Judging from your skills, you should have started burning incense a long time ago.

Turning black into white and confusing right with wrong are at the very core of socialism with special characteristics, the very foundation and spirit of a despotic state and a cowardly people.

Does the Nation Have a List?

POSTED ON JULY 28, 2008

The headlines this morning read: "Wenchuan has announced it will establish an earthquake memorial."

The Vietnam War had a profound effect on the United States; it caused the kind of pain that cuts deep; and ten years after the conclusion of the war, they erected a memorial bearing the engraved names of more than 58,000 departed soldiers on a field of grass in Washington, D.C. As for the affairs here, all we get is a statement from the top such as the one above, and the excited clamoring of a pack of expert bastards kicking up a fuss. As you can imagine, this memorial isn't preparing to accurately record the actual events. Historical facts were altered even before they were allowed to run their full course. Even more impossible would be holding a memorial service for those who died as a result of carelessness. A dessert course of covering errors and singing praises will follow this feast of a disaster. The casualties are countless, except for one "tenacious pig" who emerged after surviving under quake rubble for forty days. No one asks about the shoddy "tofu-dregs engineering"; instead, we blindly accuse "running teacher Fan."

Nationalism is only a fig leaf for the feeble-minded, a tricky maneuver that prevents everyone from seeing the complete picture. As for those who have perished in the calamities over history, their survival or their deaths will only be forgotten, and forgotten in disgrace, even though such disgrace is more deserving of those who survived them. Justice is only selectively upheld, and tears may flow only seasonally. Hypocritical and exaggerated tears add to the charitable contributions, but cannot in the slightest amount abate the penetrating numbness and ignorance that comes with

life, they cannot pardon the hypocrisy, those despicable things that course in their blood.

How many people were actually killed and wounded in the Wenchuan earthquake? How did they perish, and who should shoulder the blame? Confronted with this question, the responsible Ministry of Education and Ministry of Architecture are refusing to answer, they want to eternally play dead.

The parents of those school children are helpless, even though everyone now knows what happened, and why death descended upon those children. All this was predestined, this was their reality, the only reality they might encounter. In their reality, there is no alternative fate, no other voice or alternative hand that might lead them on the path to fairness, or extend to them even the slightest bit of justice. They are saying, "It wasn't just a natural disaster," but who pays attention? The response is: We cried our eyes out when it was time, we donated with all of our strength, what else do you want?

Pain comes not only from the loss of flesh and blood; it can also arise from an indifferent world refusing to help, or from the enormity of a hypocritical social hierarchy. In this hierarchy, personal feelings are negligible, are powerless victims of a necessary sacrifice, unrelated to the severity of the loss. Helplessness arises from the neglect and mocking of personal feelings, public opinion, morality, justice, and rule of law.

In this world, there are only two kinds of history and reality, two kinds of institutions and governments: the ethical and the nonethical. The standard for evaluation is the attitude with which we treat life. In a society without democracy, there will be no space for the masses to speak their minds, and no possibility for safeguarding the power of the people's livelihood—the result is a deceitful and degenerate reality. The masses don't need pity after injury, they need even more a strong institution of self-protection, they need to know the facts, and they need action, the power to participate and refute.

It's easy to say that democracy is good; it protects the weak. Within any other system, the majority of weak populations has difficulty gaining protection. Only in democratic societies is it possible to return power and dignity to the weak and impoverished. Don't make decisions on behalf of the people; let them take their own initiative. To give them back their rights is to take responsibility and return their dignity to them.

Who will answer for China the question of exactly how many students died as a result of these tofu-dregs schools? And to the villains in Sichuan: Does this really require concealing state secrets? Is it really so hard to tell the truth, about even such things?

3.9 Ai Weiwei with Xiao Ke in front of Tiananmen Gate on the first day of the Olympic Games in Beijing, August 9, 2008.

3.10 Zhao Zhao in front of Tiananmen Gate on the first day of the Olympic Games in Beijing, August 9, 2008.

Closing the Opening Ceremony

POSTED ON AUGUST 8, 2008

Those incompetent tools perverted the Olympic opening ceremony into the archetypal example of bogus "traditional" rubbish, a blasphemous "spirit of liberty," a visual crap pile of phony affection and hypocritical unction. Offensive noise pollution and a monarchical mentality have been revived as a vaudeville variety show. It was the ultimate rendering of a culture under centralized state power, an encyclopedia of spiritual subjugation. Before we can stand up straight, we are heavily bent over once again.

We sacrificed the cheer and good will of the entire population in exchange for a worthless fantasy, a soulless political whitewash, and a hopelessly humorless display of puffery and helpless bravado. It was a phony scene of cultural prosperity, one that runs counter to reality.

This time no one dares to wrong you. You can possess power and domination, hold celebrations and revelry, and cause masturbatory orgies, but there is not a shred of real poignancy. You won't earn the smallest bit of respect, and you are incapable of securing reliable friendships.

As for the performance of those directors and their undermined sense of public morals, I've said it before: it's like savoring the flavor of a fly—a complete, aggressive, and overbearing housefly, from head to tail.

Such is your fate, and you must own up to it. That's your face bearing the revolting smile, and you will be remembered for leaving your shameful mark.

The Olympic Committee

POSTED ON AUGUST 18, 2008

There is no love or hate in this world without reason. If you don't know even this, then there are many things you won't understand; someone has sold you out, and you're helping him or her count the money. About the sacred Olympic committee, why do they look and sound more like military arms dealers, or the mafia? And why is it they increasingly prevent other people from saying this is so, shield themselves so enthusiastically and seek justification, while violating the truth with bigger, more ludicrous lies? This is not a brainteaser, the answer is simple, one word: profit.

The world has truly changed, and it would be a mistake to say it's become smaller. It's become dirtier. In this world, the real battlefield is no longer teeming with battles over beliefs and ideological wars. The real war is over profit, naked profit. Profit is

multiregional, straddles different groups, and is transnational. The dream of modern globalization is, time and again, the redistribution of profit by capitalists and global powers. In this sense, you discover that you and your enemy could possibly be fighting on the same side of profit, because you all face the possibility of being divided up.

This isn't hard to understand, because there will always be some international bad guys kicking up a fuss, holding you down while others beat you, or lying to you with their eyes wide open. That international committee is full of beasts in gentlemen's clothing, however much they stand to gain is how able they are to solemnly vow, "This is the best Olympics we've ever seen, the most effective management, the cleanest air."

We're all living together, so there's bound to be horseplay, and the inevitable conflicts and injuries. But the cries that come rolling in about an Olympic spirit from Olympic-mongers in faraway lands, they are just peddling fake medicine. Their every word, every action, and every glance are to seek out and protect their greatest personal profits.

Don't trust the internationalist hypocrites, who are even more frightening than the bare-toothed nationalists, and who would never truly concern themselves with the lives or the equity of their friends in neighboring countries. They could speculate on the universe for profit. This is a more accurate diagram of the world.

And this makes for a more extraordinary reality: the world is no longer just you and your neighbors—your home, streets, cities, and country are in the process of being, or have been, traded. When you finally wake up and open your eyes, you'll have no idea, but you might be a hundred times worth your original cost.

Joy and pain will no longer arise from right and wrong. Whether a person is good or evil, and distinguishing black from white, are merely the brutal competition of interests. It is above religion, stronger than beliefs, and triumphs over nation and state. Are the Chinese prepared, or could they just be jumping from the tiger's cave into the wolf's den?

This is precisely why we should forget thousands of years of ideological struggle, why we should sober up, and learn how to do business with this filthy world. Anything else would be destroying your kitchen pans to sell them for iron, and after you've sold everything, other people will point and laugh at you, saying: "look at that true socialist SB with special characteristics."[38]

For a moment, forget the struggle between tyranny and civil rights; forget the extravagant dreams of referendums or citizen votes. We should struggle for and protect those most basic, miniscule bits of power that we truly cannot cast aside: freedom of speech and rule of law. Return basic rights to the people, endow society with basic dignity, and only then can we have confidence and take responsibility, and thus face

our collective difficulties. Only rule of law can make the game equal, and only when it is equal can people's participation possibly be extraordinary.

As for our friends from faraway lands, we ought to look more deeply into their eyes, and much more often.

Obama

POSTED ON NOVEMBER 5, 2008

In a few hours, the American people will choose their new leader, hopefully rewriting history.

I am not a United States citizen, but all the same I'm happy for them. No matter how bad the bad gets, I always keep hope that things will ultimately be interesting, and some change will be affected. I naively expect that this may come to be, that there will be accountability … for sometimes curses from the mouths of the misfortunate can be effective. The shame should be washed clean, the weaker nations will mature, things will get easier, and the price of ignorance and the power of popular sentiment will present itself. Ignorance comes at a high cost.

I hope that my friends in Oakland will be happy, that they can uncork champagne and celebrate. I hope my brothers in New York will no longer mumble complaints, that they can kiss those days of feeling abandoned, forgotten, and neglected good-bye. I was selfishly hoping that they weren't going to do as they promised: leave the United States and come live with me in Beijing.

I hope that the so-called power of the citizens is realized in the ordinary people, realized for those children on the other side of the world who drink their milk with hesitation,[39] and for the needy souls of the students who left us in the earthquake. We ought to believe that we not only share danger, and that it's not only terror that strikes so suddenly, joy and hope can likewise cut through time and space. This is very important to Yang Jia and his mother; abuse and humiliation have long been a common sight in their motherland, where ignorance and evil blanket the earth, and for our coal miners who fall into the fatigued, anesthetized trap of their fates, so difficult to escape. This is also important to those taxi drivers on strike in Chongqing, because the proletariat is still lacking a motherland, and Chongqing's roads can be just as deserted as California's.

Tonight my heart thumps with anticipation, because I hope Obama wins tomorrow. I hope that tomorrow's United States will have a "non-American" president, an American of color with an accent who, like Yang Jia, comes from a single-parent family, who is young, inexperienced, and scrawny, even though I can't get too excited

about a democratic process that I have nothing to do with. I hope this new stranger will win.

That Liu Yaling

POSTED ON NOVEMBER 13, 2008

Liu Yaling. The name doesn't sound unfamiliar. For people that actually exist, a name is the sole and final symbol of one's earthly struggles.

This name is on the menu for Wang Qingmei's "compulsory treatment" that began on July 2. From that day on, Yang Jia's mother was no longer called Wang Qingmei, her name was changed to Liu Yaling.[40]

A name is the first and final marker of individual rights, one fixed part of the ever-changing human world. A name is the most primitive characteristic of our human rights: no matter how poor or how rich, all living people have a name, and it is endowed with good wishes, the expectant blessings of kindness and virtue.

The significance of a name can be just as lucid or muddled as life itself; it could be part of a curse.

Liu Yaling has another meaning, it means to be forgotten or to be forcefully rewritten or expunged. It was born of the stupidity of the stupid, the violence of the violent, the savagery of the savage. It is Wang Qingmei's fate today.

On the night that she was summoned, when she was tricked into coming in to make a statement, she had already stopped being a specific person. Who could have imagined that, unaware and under involuntary circumstances, one's name could be changed as a loss of personal freedom? What kind of nation is it, where you don't know what you gain or what you lose? True violence won't bring an end to your existence, but it will cause you to exist in an unfamiliar way.

Sun Zhigang died because he couldn't prove his status to his motherland at the right time.[41] The Chinese people are eternally locked in a struggle between having and not having identity. Identity is linked to the legitimacy of a people and a regime; all revolutions and restorations of power are a rivalry over status between despots and commoners. When Wang Qingmei was violated by the state, she lost the final right and protection that had belonged to her for fifty-three years.

Wang Qingmei said to her visiting sister, "It's outrageous: they tricked me here and put me in a dark little room, I have to stand and eat silently, and they even changed my name, they tell me I'm called Liu Yaling; what's this all about?" Wang Qingmei is despondent, her grief arises because her country demanded her son's life without explanation, because she went missing and was silenced. Now, she isn't even

herself. The party and the state say: Liu Yaling, you are sick, we are going to cure you, take this medicine.

Liu Yaling is a common northern female name, but when you are called this name, the world darkens without semblance of justice.

Liu Yaling is no longer an unfamiliar name: every Chinese will remember your name, every Chinese will be concerned with your fate, because our names are the same as yours. From the day we were born, we all became Liu Yaling.

In the eyes of an illegitimate government, all people born and raised here are illegitimate. We are all optional. This is our post-Olympic reality.

Good night, Liu Yaling.

Why Violence?

POSTED ON NOVEMBER 22, 2008

Stone Age techniques have once again been put into extensive use. How dignified must people be and what kind of moral character must people have in order to hurl stones at a loaded machine gun?[42]

People unprotected by the constitution have no legal status, so how can people with no legal standing possibly use "lawful channels"? They are bleeding just to obtain access to those "lawful channels"—if they were waiting for any day, it would be the day that "lawful channels" might be established. If there were lawful channels, these people wouldn't be demonstrating.

You say that torching cars, throwing stones, and breaking glass is violence; you say that Yang Jia is violent, but the lives of these weak, powerless, and hopeless cannot be exchanged for what you call "lawful channels."

You maintain that the public oppression and secret trials are not violent, and the clubs in the hands of military police on the Square are an expression of concern; the collective muteness of the news media is harmony; censoring images and deleting information is not violence. Neither is Sanlu milk protein, nor the stones it caused in infants, nor the desperation of their mothers' violence;[43] kidnapping the undefended mother of Yang Jia and forcing treatment on her is not violence; the silence from the families of some nineteen thousand dead students—a number still waiting to be confirmed—is not violence. The guards of the People's Republic treat their fellow countrymen with more cruelty and tyranny than any of her past barbaric invaders have shown, but that is not violence.

This world does not lack "lawful channels," the constitution and democracy are ready-made "lawful channels," but you don't choose to pay much attention to them.

"Lawful channels" are democracy, which will put an end to violence; this is different from the world you know.

What kind of "lawful, legitimate channels" could a government not elected by citizens design for its people? If "lawful channels" existed, no one would pay attention to you, or even care enough to throw stones at you. In a place where people have the right to speak, no one is willing to overwork their arm.

Wherever there are tyrannous, fatuous, and self-indulgent leaders, there will be stone-throwers. This was true in the past, it is true now, and it will forever be this way, until the People are armless, or there are no stones left in the world.

There will come a day when the People will grow tired of blood, and "lawful channels" will be established out of necessity. Once the People can "move fluidly within lawful channels," will there still be a reason for you to exist?

Against violence whose purpose is to dispel the opposition and resistance, there is no stone that can dispel state violence from armed police. Those people throwing stones are pitiful; to borrow a phrase from a friend on Sina.com, they definitely "don't want to live."

3.11, 3.12 Experimenting with sawing a bicycle into small pieces, October 29, 2008.

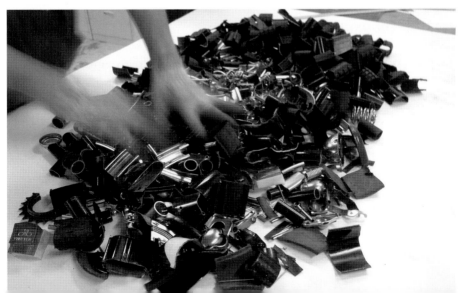

Kill, but Not in the Name of Justice

POSTED ON NOVEMBER 26, 2008

Go ahead and kill if you want to, kill to your heart's satisfaction. No one will care, so relax and bravely carry on. Exterminate a life, it wouldn't be the thousandth, or the ten thousandth, and it won't be the last time. When the tanks rolled over adolescent bodies, not a single one of you hesitated.

Since it became clear long ago that evil deeds will not be met with the slightest bit of punishment, since lies are the only means that might stave off your death, and since the grasses of justice will never grow on this barren land, there are no longer any arguments that could truly obstruct you. Using "legal channels," needing to present "tangible facts" to the highest civil courts, and talking about "fairness and justice" are as laughable as negotiating with a tiger for its skin. Is there anyone who can tell us the difference between the state and criminals today? If we said public security organs were whores, it would be slandering workers in the sex industry.

You hold all the power and wealth, the rivers and the mountains, you own every tangible thing on this patch of land, all the glory and joy belong to you—how could you be depressed? Seize at will, kill till you're content, all in the name of the magnificent cause of long-term stability for hundreds, thousands of years. You don't need to repeat the number of Tibetans you've liberated; you don't need to repeat how the spoils are now greater, several billion, and "there must be a transparent democratic process." Who still believes in bullshit? Here, aside from the heinous power, everyone else is an SB.[44] This is a more complete version of the history of our Republic.

Go ahead and kill, but not in the name of justice; that would disgrace everything. No regime cares that it will be remembered with contempt.

Bullshit Is Free

POSTED ON DECEMBER 18, 2008

Both social and personal transformations, anything with the connotation of transformation, comes at a cost; this means an expense. This is why when things reach a crucial point, even a not so crucial point, people start to bicker and calculate costs, they price themselves out of the market, and look for local money to bargain down. Looking at Chinese society from this angle, it's impossible to be blindly optimistic, because democracy is good, justice is good, and after bullshitting for days it definitely indicates the universal value of society, has the meaning of "universal benefits," and universal benefits require someone to pick up the tab, otherwise what are they worth?

Will China have a bright tomorrow? If so, where will it come from? What kind of people will pay what kind of price for it? That is the question that we must ask ourselves.

Relying on individuals to pay the price is taking stock in a notion of history created by heroes. There is no lack of courageous individuals in China's history, yet courageous people are in short supply. Everyone else is either an experienced and astute onlooker or an ignorant person rejoicing in the calamity of others.

People. There are many people, but they have not taken shape as a collective People, for there are no shared sentiments, no common will, or shared values and necessary human sympathy. A human sense of righteousness is lacking. This is generally why some people are always avoiding "universal values," and undermining the seeds of free democracy.[45] Touching upon the shared and inseparable parts of humanity, this concept doesn't exist in China. Once warriors are apprehended, all of their efforts come to a halt on the honorary lists of various overseas human rights organizations, and they will sooner or later be completely forgotten in their own nation. But that's a bit exaggerated—their fellow countrymen will never even know of their efforts. That sounds more like the truth. In the few pounds of brain resting on the necks of these warriors, perhaps they are fantasizing about how they could be remarkable, when after discharging some chemical mixture of excitement and anxiety, their plans are aborted before ever coming out of their mouths. So we cannot place our hopes in personal sacrifice, especially under totalitarianism. In actuality, it's difficult for individuals to match their personal will to the public ideal; if it weren't this way, humanity wouldn't be in the state it is today.

If we say that suffering leads to enlightenment, then either our situation today is a result of living in the most prosperous era and place, or our pain is far from what's needed to stimulate us, far from enough to shed the light of enlightenment, or we haven't arrived at the time when an explanation is needed. Even when that painful moment arrives, don't expect any outcome; it's only the death of several thousands, no harm done to the great empire.

Individuals shouldn't expect compassion from others. If the people here had evolved to the point where they might shed tears for the suffering of others, wouldn't they die crying? This is an obviously unrealistic expectation.

The remaining costs will be a tally of the warmth that truly belongs to each individual person, each family, son, and daughter. If any professional thinkers or activists want to state their personal ideas, they must weigh this against the safety of their pure and innocent wives and children; no notion of acting for the benefit of others will ever exist in this world. Twice before I signed a petition,[46] but I never expected it to amount to anything, because I have always disdained the collective behavior of people in this nation. Experience tells me that kindness and bravery are only legends for the

young to pass their time with; signatures and petitions have always been the stuff of scholars to seduce young girls with. But in the end I'm still just one person, and no matter how you mull it over, if you achieve your dream or just lose out, it's difficult to relate to the safety of others, and who cares? My most petty and base awareness is related to my own "existence," yet I can't even find a reason not to care only about myself. It's so pathetic that we should have to fight for things so basic that I can barely find reasons to continue on in this way.

Will those benefactors of democracy and social justice—the People—proactively shoulder the cost of reform? Obviously no. A group of people with no individual qualities cannot even begin to talk about the real People. The parents of hundreds of thousands of infant victims of toxic milk have not been exterminated, but they have remained virtually silent; thousands of children perished in one instant as a result of tofu-dregs engineering, and yet people sit in front of their televisions like wooden chickens. As long as life can continue, the high cost of personal suffering in relation to the cost of sustaining the nation will never be an issue; this is merely the tragic fate our nation must endure for its prosperity.

Will the state or the party take responsibility? This question is a little stupid. The answer is: in this land we have infinite greed and corruption, we buy and sell official posts, there are transactions and investors, and those who escape in flight, we can buy silence, there is profit, and there is joy and sorrow—the only thing lacking is a clear settling of accounts, but of course those so-called costs don't exist.

Stimulating Domestic Introspection

POSTED ON DECEMBER 30, 2008

Meddling with blogs and censoring comments is just a universal reminder of who the blog host really is on this patch of land. Although the government is not liberal or decent, it can't be criticized. The lack of freedom of expression and the absence of public debate are old habits; it's just that this makes blogging a little less interesting.

Peace is flourishing, and aside from relying on pens and the barrels of their guns,[47] all dictators can do is make the common people's lives a little less joyful, every day just a little less, every time just a little less. The erosion and disintegration of freedom, dignity, equality, transparency, and openness has encroached upon the innocent human nature of people and their free will, corroded our innate convictions, courage, and rights. All dictators are short on humor and are obsessive-compulsively sterile.

Nothing sinister has ever been accomplished by a single individual.

Yang Jia departed from this nation he so scorned more than thirty days ago, and his mother Wang Jingmei, incarcerated in a compulsory treatment center for more

than four months with her name changed to Liu Yaling, has still not received his ashes. You're afraid of living persons, and afraid of dead ones too; you conceal living persons, and you conceal their bones. This ought to count as mental suffering.

Imagine if the people's representatives no longer smoked and didn't wear watches, or at least not the newest models, then stimulating domestic demand could only mean stimulating more domestic introspection.[48]

2009 TEXTS

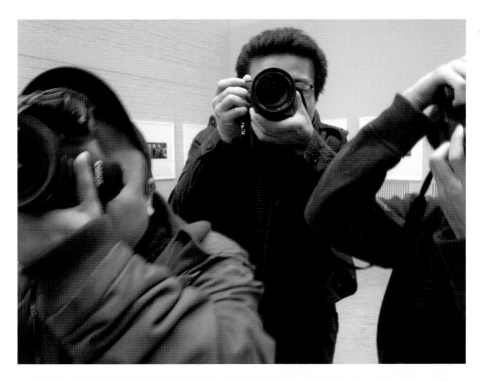

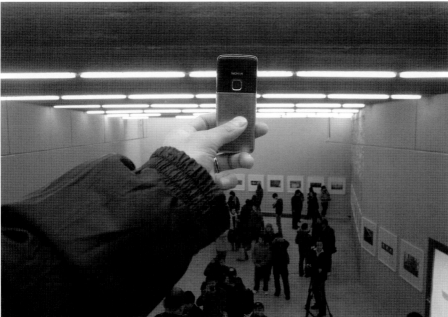

4.1, 4.2 "Ai Weiwei: New York Photographs, 1983–1993," exhibition opening at Three Shadows Photography Art Center, Beijing, January 2, 2009.

Shanzhai Ideals

POSTED ON JANUARY 4, 2009

Generally we say a certain kind of people will have a certain kind of government, that their brand of consciousness will be reflected in their politics. Or we could also say that their ideals will be projected in their national outlook. In that case, China won't have much to be surprised about in 2009.

That publication that "understands China"[1] and used all of its resources just to print timid editorials illustrates the problem perfectly. Veiled thoughts, implicit ideals, lethargic demands, and childish inspirations are types of masturbation exclusive to phony literati and sour academics.

Lines from that document penned on July 4, 1776, can still be used to exorcise demons. One of humanity's universally recognized fundamental values is that viewpoints cannot be glossed over, and likewise one must not yield his or her principles. The tragic reality of today is reflected in the true plight of our spiritual existence: we are spineless, and cannot stand straight.

Let's revisit this passage one more time:

We hold these truths to be self-evident, that all men are created equal, that they are endowed by their Creator with certain unalienable Rights, that among these are Life, Liberty and the pursuit of Happiness. That to secure these rights, Governments are instituted among Men, deriving their just powers from the consent of the governed, that whenever any Form of Government becomes destructive of these ends, it is the Right of the People to alter or to abolish it, and to institute new Government, laying its foundation on such principles and organizing its powers in such form, as to them shall seem most likely to effect their Safety and Happiness.

—The Declaration of Independence

Thirty years of reforms with "special characteristics" are only a *shanzhai*[2] version of phony government ideals that unsympathetically pass the country's political and moral crisis off onto the weak. If we're going to continue tampering with universal values, equality, and justice, all we can do is wait for the next wave of destruction.

Inappropriate Accusations, Excessive Punishments

POSTED ON JANUARY 23, 2009

Midlevel civil courts in Shijiazhuang city have come to a decision on the Sanlu milk powder case.[3] The accused chairman of the Sanlu Corporation, Mr. Tian Wenhua, was convicted of the crime of manufacturing and selling false and inferior products, and sentenced to life in prison.

In my opinion, these are inappropriate accusations, and excessive punishments.

Accusing Sanlu of "manufacturing and selling false and inferior products" reconciles the government's derelict responsibility and disorder in managing the safety of food products, conceals the truth, and disregards threats on the people's lives, but nevertheless must still be seen as an improvement. However, for the past thirty years, the foundation of this powerful country has been precisely the manufacture and sale of false products. Invoking such a charge and declaring someone guilty of violating the law in this regard poses certain difficulties.

As everyone knows, Sanlu Enterprises is one of China's food industry giants. A key enterprise and national focus point, it has been honored with the national "May First" labor certificate of merit, counted as a "national advanced grassroots party organization," included among the nationwide top-ten light industries, is an "advanced quality-control enterprise," a "creative science and technology shooting-star enterprise," and is among two hundred businesses in the Chinese food industry to receive an honorary mention for excellence. As a lauded national trademark, it reflects the wise advice of the party, and with strict management supervision and the attention of local governments, supervised by the news media, and blessed by consumers, the accusation of "manufacturing and selling false and inferior products" seems to be framing an assault on the entire nation.

The "manufacture and sale of false and inferior products" within the dairy industry is not only happening at Sanlu; Mengniu, Yili, and more than twenty other dairies could sign their name to the list—this is the collective shame of the Republic's dairy industry, so why is Sanlu monopolizing the blame?

Furthermore, most of the victims were infants. Their parents objectively facilitated the offenders' ability to commit crimes by declining to rear their children on breast milk, and they were rash to purchase domestic milk powder while their infants were still powerless to make decisions, knowing perfectly well that the market is flooded with false and inferior products. These are both indirect factors contributing to the crime.

Even though thirty thousand infants were harmed by melamine powder, don't forget, China is a great nation of 1.3 billion people, with close to fifteen million babies

born every year and an infant mortality rate of about fifty for every one thousand; every year about seventy thousand infants will die, even if they don't drink milk powder. Only six died as a direct result of melamine powder; this is the same logic as saying the per capita length of the railway in China is as long as a cigarette.

That is why they say you should examine problems from a high altitude, and should stress a political and scientific approach to development.

Bullshit Tax

POSTED ON FEBRUARY 1, 2009

"In order to protect air quality and build a livable city," Beijing will levy an emissions fee on motor vehicles in yet another creative taxing policy with socialist characteristics. With 3.5 million automobiles on the road, and at 300 RMB per car, this will total 1.3 billion RMB per year. This is the first attempt in the Year of the Ox[4] at stimulating domestic demand.

As an urban resident, I am worried for the government, and I'd like to take action for her. I propose that the following industries and professions deliberate the feasibility of the following fees to be collected in regard to Beijing's most critical issues.

Congested Traffic Fee
Owing to Beijing's unique political environment and metropolitan status, nonnative populations are posing increasingly serious pressures on Beijing's traffic. In order to maintain the capital's psychological prospects and tidy appearance, a suggested "Congested Traffic Fee" should be collected from all Beijing nonnatives.

Railway and Highway Occupancy Fee
As a result of Beijing's migrant labor and university student populations' observing the timeless tradition of returning home for the Spring Festival holidays, railways and highways are severely overburdened, and tickets are difficult to obtain. A proposed "Railway and Highway Occupancy Fee" should be collected from travelers to alleviate pressures on these transportation industries.

Party Representatives' Congress and Two Conferences Fee
The annual "Two Meetings"[5] and the various intermittent congresses held by Party Representatives subject the normal lives of Beijing citizens to regular disturbances and excessive security management, and have an extremely negative impact on the city's traffic, appearance, and cultural affairs, ultimately resulting in an inhospitable city.

Fees to be levied from representatives during the Two Meetings are proposed in order to help improve party-state relations.

Eight Honors and Eight Disgraces Fee

In light of the rising overall costs of state propagandizing, the costs of upgrading and optimization strategies for various propagation campaigns, and in light of the increasing importance and obligatory nature of propaganda, an "Eight Honors and Eight Disgraces Fee" is proposed.

Observing Flag Raising in Tiananmen Square Fee

Large numbers of out-of-town floating populations gather in Tiananmen Square to watch the flag-raising ceremony. Their numbers exceed the proscribed amount for unlawful gatherings, and these ceremonies could potentially evolve into a mob scene of antiscientific cults. A fee for entrance onto Tiananmen Square is proposed.

Petitioning Complaints Fee

Owing to long-standing inaction and misconduct on the part of local governments, great numbers of citizens have arrived in the capital to petition complaints. These petitioners have fierce tendencies and are difficult to control; they roam about in the capital, sleep on the streets, and occupy psychiatric hospital beds.[6] They negatively affect the intellectual and civilized atmosphere of Beijing, as well as the international image of the Chinese nation, and it is thus recommended that provincial and local governments be charged a "Petitioning Complaints Fee" based on a head count of their petitioners in Beijing.

Entering the Capital to Present Gifts Fee

As a result of local governments' holiday custom of catering to central government officials and various Beijing institutions by hosting feasts and presenting gifts, shopping centers in the capital have been inundated with inordinate amounts of expensive luxury merchandise. Despite repeated bans, this corruption cannot be stopped. Furthermore, the private cars of provincial government leaders worsen the city's already distressed traffic conditions. A fee should be collected from the automobiles of provincial government officials entering the capital during the holiday seasons to present tribute gifts.

Abalone and Bird's Nest Fee

Although both abalone and bird's nests should already be prohibited items,[7] after a thorough deliberation on cruel national conditions and the urgent need to stimulate domestic demand, a high tax on the sale of such products to individuals is proposed; furthermore, a list of the consumers' names should be disclosed to the public.

Polluted Sauna Water Fee

Saunas, an imported trend, pose self-evident potential sanitation problems. In order to maintain the healthy development of the city's economy, it is recommended that a high tax be collected on the disposal of contaminated sauna water. Taking into account that certain businessmen may potentially repackage the polluted water as drinking water, or sell it back to the city as sanitized water, it is proposed that this fee is to be calculated from the difference in the amount of water pumped into a sauna that has not yet drained off.

First-Time Fee

Considering the facts that mobs protect illicit sexual establishments and that the deflowering of young women has become a scarce commodity on the illegal sex market, the demand for virgins has caused serious mental imbalances in virgins in our society, and a gnawing schizophrenia in many men who will suffer a lifetime without experiencing a "first time." A high fee is proposed, to be collected on the purchase of the "first-time" experience of unmarried women, which will be used for the retirement pensions of women and for research on mental illness in men.

Pornography Elimination Fee

Because the rate of spiritual cultivation of our city's citizens develops so much slower than the rate of overall economic development, the government's annual campaign to "eliminate pornography and illegal publications" must be expanded. Effective methods should be employed to survey the ages of incarcerated prisoners serving sentences for sex-related crimes, and a fee collected from the population of nonimprisoned urban males of a similar age. These funds can be used as retirement pension or medical insurance for people who demonstrate good behavior and pass the at-risk age bracket without committing related criminal offenses. It is suggested that these fees not be employed by the government to invest in the stock market.[8]

Chanting Fee

This tax is directed primarily at spiritual pilgrims, people who burn incense, and those offering prayers. This fee is levied for occupying intangible space.

Amenorrhea Fee

Menstrual irregularities are a primary cause of anxiety disorders in post-married life. This fee should be collected before the arrival of middle or old age in women, and should be used for researching the mental health disorders of the middle-aged and elderly.

Menopause Fee

The reason for this tax is similar to the aforementioned "Amenorrhea Fee," and requires further counsel from a wide range of scholars and experts, or should be collected concurrently with the proposed fee above.

Silencing Newspapers and Periodicals Fee

The news media is similar, although not equivalent to, the pornographic industry, and since reasons for silencing journalists fall outside the scope of the market economy, it is recommended that consideration be given to each unique case and relevant domestic conditions, so that fees will be carefully selected for the appropriate reasons.

Due to time restraints, the sequential prioritization of these fees can be determined at a later time and at our discretion. I've brought up only a few ideas, but omitted so many others. Hopefully my crude attempts can attract some valuable discussion.

The following fees should be considered of equal importance to those mentioned above: parking your body in a public square fee, Olympic public order fee, big footprint and lip-synching fee, migrant workers occupying public space fee, nannies doing the wash fee, security guards hassling citizens fee, crying infants fee, unable to read red poster due to colorblindness fee, Tibetan traitors stationed in Beijing fee, contaminated fruits and vegetable fee, students traversing the road fee, elderly dementia fee, undiagnosable mental illness fee, post-harmonious discord fee. There should also be taxes and fees for not driving, for cadavers unable to discharge waste, for leaving one's house too infrequently, tangling kite strings, polluting with lighters, cellular phone radiation, smoking fake brand-name tobacco, sobriety after drinking fake alcohol, clogging drainage pipes with vomit, and on the reasonable and unreasonable collection of various fees.

It appears that the fees the government could and should be collecting are infinite. This final suggestion is also the most effective: return to the singular fee system from before reform and opening, the "dictatorship of the proletariat" fee. At least you could refrain from collecting a bullshit tax, just this once.

Two Jokes

POSTED ON FEBRUARY 4, 2009

The First:

That ministry furthest removed from culture has begun supervising the art market. Over the past few days in Beijing, Shanghai, and other large cities, they have removed certification plaques from several galleries reading "Reliable Gallery." You are uncultured, yet you forcefully supervise culture. First you launch the idea of "Reliable Gallery" plaques and then you revoke them; the entire affair, from start to finish, is just too far off the mark.

A gallery is a place of business. A painting in a painter's possession is a painting; the same painting in a gallery's possession is merchandise. Selling a painting is not selling culture, and whether a painting is good or bad, expensive or not ought to have nothing to do with the Ministry of Culture. The freshness of your seafood has nothing to do with the Ministry of Oceanic Affairs. The Women's Federation has nothing to do with the strength with which your female masseuse applies pressure. The Ministry of Culture was disorganized enough when it decided to distribute "Reliable Gallery" plaques; it was an initiative that disrupted the market. You fail to understand your own status, yet impose standards on others; this is a common fault of large governments. If you are still unclear, yours is a ministry that should be listed under those to be banned.

The Second:

That ministry most in need of an education believes that the English acronym "CCTV" is illegal, and demands that it be changed to Chinese, or "the statutory transliteration form of Hanyu pinyin."[9] Whether or not "CCTV" is illegal, the television station logo will always remain perfectly legal. Alas, the Ministry of Education, the very department that fails to assume responsibility for any affairs that it actually ought to be managing, has decided to start mulling things over. By the same logic, the Ministry of Education's full name ought to be "CXMZZYRMGHGJYB." Naturally its pet name will still be the "SBJYB."[10]

Assume responsibility for that which you should, such as ensuring that foodstuffs aren't exempt from inspection, ending the manufacture of false medicine, accurately counting the number of students killed, and investigating why schools would collapse. As for the rest, just keep your distance.

Confidence, Face, a Shoe

POSTED ON FEBRUARY 7, 2009

A nation has been shocked, and only because a non-Chinese conveyed his personal opinions in front of the public.[11] Immediately following were curses, and implications arose that this demonstrator's individual viewpoints were somehow intertwined with farfetched ties of national interest. And then came the weeping and wailing apologies, the offender's discharge from his university, and his punishment; they even distorted statements issued by their heads of state.[12]

This is the only way we can redeem the face that we never had, and maintain the friendship that never existed.

Instead, we should rejoice at the courage of the twenty-seven-year-old Cambridge doctoral candidate who dared to risk everything with his great condemnation. He surely doesn't belong to this "harmonious imperial land under heaven." No, he was born into his rights and is protected under the laws of another nation; no one can cause him to sacrifice his will to take a political stance. If he wanted to, he could continue on with his untimely behaviors, and he'd never disappear into a state-run mental hospital simply because he maintained an alternative voice.

Look at the confidence and face that shoe flew with!

4.3, 4.4, 4.5 "Bao Bao, this one's for you!" Ai throws his shoe at the British parliament building, March 5, 2009.

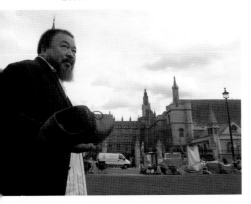

Central Television Is Flaming

POSTED ON FEBRUARY 10, 2009

The northern compound, known as the "Pup Tent," of Central Television's new headquarters, "the Big Underpants,"[13] caught fire at approximately 8:20 last evening. The compound would have served as the cultural center to the motherland's central television station; it also housed a luxury seven-star hotel with more than 60,000 square meters and a combined price tag of over 600 million. The fire was difficult to bring under control, and the entire building was ablaze. Naked flames were still visible at two in the morning.

Friends in the media said that all national media received notification from the authorities before midnight: "Without exception, no one is to cause a commotion over this news story. For the sake of harmony, use wire copy from Xinhua News Agency." Sure enough.

You didn't start the fire, why should you harmonize it?

I couldn't figure it out: Why are you harmonizing news if you didn't start the fire? But nowadays, things are so wicked that anything you say can be turned into truth.

Today, insider information confirmed that, indeed, you ignited this enormous conflagration yourselves: while setting off fireworks as part of a plan to film the explosive excitement during the full moon festival on the fifteenth day of the first lunar month,[14] an accident occurred that ignited the rooftop and the floor just below. Super-large, specially manufactured fireworks—one manufactured to explode in the shape of an enormous cow—would have been filmed from multiple camera locations, but we were treated instead to the consummate incineration of hundreds upon thousands in capital investment. In this instance we can't blame the authorities' hurried need to seal off information and to harmonize; we wouldn't want to drive the common people mad with excitement.

But, as the taxpayers watched their money burning to the ground, why were they really, truly happy? Because Central Television, that giant eunuch, has always been a despicable thing. We always hear that "the unjust are doomed to destruction," and finally, just this once, it was effective.

Although everyone says that the moon on the fifteenth is extraordinarily round, yesterday night was the roundest moon in fifty-two years.[15]

4.6 A guard on duty outside the TVCC building as it burns, February 9, 2009.

Heartless

POSTED ON FEBRUARY 11, 2009

Decades ago, "Dr. Bethunes" fighting on the medical front lines sold human organs for transplant; now China has become the world's most active market for human organs.[16] It's not because the Chinese people are cheap; even though you live cheaply doesn't mean you'll become cheap after you die. As to why a human might be cheap, that is a philosophical question not addressed in this essay.

Here, we will be discussing purely technical issues.

To put it most accurately, harvesting organs from the bodies of executed criminals is stealing. This is a public secret. Even though they want you dead, your remains should naturally be addressed to you, even in death. This includes the bullet you consumed, and this is probably the reason why it is paid for by the family of the executed.[17]

Not too long ago, "counterrevolutionaries" were paraded through the streets and people flocked in throngs to their execution grounds. You would often hear people talking about who "had a lucky fate," because if one bullet didn't do the trick, they would be forced to use leather shoes to finish the job, "saving a bullet" for the nation.

There's not much difference between that era and this one. In this "Spring Tale,"[18] public appreciation of executions is no longer encouraged, and taking into account

the excess value that the deceased will produce, the bullet's point of entry requires a much more exacting skill, so that it kills but does not wound. An ambulance is parked where the executed can plainly see it, and as soon as the gun sounds, the white-clothed angels lunge toward the still-warm corpse with organ transplant coolers in hand.

As a key nation enforcing the death penalty, China executes one-half of the world's population of death row criminals, with a bloodcurdling yearly average of more than four thousand people. All thanks should go to twenty years of "strike hard" and "heavy fist" remediation campaigns.[19] Even before execution, one's fundamental rights and human dignity are forfeited. In the high-profile Yang Jia case,[20] neither he nor his family was notified the day before his execution, and when his mother, who had been secretly incarcerated in a mental hospital, was released to see her son, she had no idea it was to be what we often call their "final moment."

Mr. Wang Jianrong, deputy director of policy and regulations at the Ministry of Health, confirmed that more than 600 hospitals in China are developing the technology for organ transplant, and more than 160 among them already possess the necessary qualifications. That figure doesn't include military hospitals and illegal organizations.

You will discover that, as an average person, once you are disassembled and sold, you will become very expensive. If someone opens you and sells your spare parts once you've departed, you become much more valuable than you were as a complete living and breathing organism. On the Chinese mainland, a single kidney, liver, or heart transplant can cost from RMB 140,000–150,000, often surpassing RMB 400,000. Sales to foreign nationals could be many more times than that.

Looking at the global market, prices for human components in Turkey range around US $5,000, in India US $3,000, in Baghdad, Iraq, costs range from US $700 to 1,000, and the average price in the Philippines is US $1,500. You can see that the price is directly related to the harmoniousness and nonharmoniousness of the nation, and whether or not there was suffering.

In China, the phrase "everyone is born equal" is true mostly after death; there's no difference in price between the innards of Deputy Governor Mr. Hu Changqing and People's Congress Vice Chairman Mr. Cheng Kejie from those of murderers Qiu Xinghua or Ma Jiajue.[21]

When melamine destroyed infant kidneys with stones, sufferers with severe damage were compensated at most 30,000 yuan, and those with mild damage were accorded 2,000—that's an awful lot of stir-fried kidneys. Families of those killed in the Beichuan earthquake have been notified that they ought to "be considerate of the government's difficulty," and 60,000 sent them packing. If they refuse to sign for their compensation, they won't get a single penny and they still face potential detention. Price is such a devil.

The market price for Chinese hearts, livers, and lungs isn't the lowest, so why is there an international market? Because China is a nation of harmony, it has a strong army and the state guarantees stability—the supply is abundant, fresh, and boasts a high potential for a match. Recently, the Japanese Kyodo News Agency reported that seventeen Japanese citizens exchanged kidneys and livers in China, spending a per capita average of 8 million yen, equivalent to 500,000 yuan. Each operation was stimulating national demand.

Ashamed to admit to the sale of human organs, Chinese officials always respond to the Western media's reports by saying these are "vicious accusations," that such reporting is "anti-Chinese" or "reflects ulterior motives." However, people are often caught red-handed. The "Regulations for Human Organ Transplant" were published in 2007, although this document only exists as a printed pamphlet.

That heartless process of reform and opening has sold off basically everything that can, and can't, be sold. Development is hard logic;[22] if you don't sell, that's your own problem.

In the near future the Chinese might wander anywhere, either in our homeland or overseas, and gaze proudly at those people in the distance—it's possible they have a Chinese heart.

Those clever Shanghainese knew they shouldn't sell Yang Jia's organs to the Japanese. If the Japanese were to have even an ounce of his courage, it would take countless warriors to take one of them down.

Central Television Inspired China

POSTED ON FEBRUARY 14, 2009

To inspire the Chinese people,[23] Central Television no longer needs to rack their brains to find gimmicks, and neither does it need to ingratiate itself to the "united Chinese people." The moonlight on the fifteenth night of this first lunar month was the most consummately round and most brilliant in the past fifty-two years; everything else in the world seemed inclined toward perfection as those imperceptible and miraculous forces made their presence known once again, decisively placing the crown of disgrace on the head of CCTV.

Central Television's fate and the evil reality are incessantly normalizing humiliation and repulsion, turning them into everyday experience.

Finally, here was one time when CCTV told the truth with live footage, it was the self-mutilation of the palace eunuch. Even though their motivation didn't stem

from courageousness or persistence, at least this time their version corresponds with actual reality.

The absolute significance of "media is truth" was realized in a moment of absent-mindedness, and accomplished a realistic reality. It sounds awkward, but in practice this is extremely difficult to achieve. To repeat: this is the first time you used light and heat to realize the ultimate ideal and the highest realm of all the media on the planet, and in the process, you unintentionally achieved a realistic reality.

Not long ago, you were still agonizing over live broadcasts of giant footprints and flying shoes, but your fire of humiliation has finally been kindled. This time, all the Chinese people who inspire China were inspired once again by China Central Television, the producers of *Inspiring China*.

The honor belongs to you, it was your magnificent feat that attracted the attention of the entire world to marvel at China's progress, and amid a gradually worsening global economic crisis, to hold their heads high and stare into this fire of hope. It was you who declared to the world that the journey of hope begins not in Europe, and not in Britain, not in Cambridge, but right beside you in China's capital, in a place not too far from Tiananmen Square.

It was you who devoted yourselves entirely to the burning world, bid farewell to hesitation and indecision, and used the remains of the sacred Olympic fire to realize a promise of self-immolation that illuminated the world. Harnessing the great advantages of socialism with special characteristics, for the first time citizens can trust that the future will hold more occasions when, relying on your intelligence and creativity, heroic spirit, and capacity to act consciously, you will realize a scene that goes beyond the tricks and technical skills of any live broadcast.

This is no longer a phony game of production rooms—the production scene is the live scene, reality is on stage. There is no editing, no set, no lighting effects, no adjustments, no director, no supervision, and no censoring. You are not only selfless, but you have completely entered a state of *Anātman*,[24] and although everyone is wild with joy over your disappearance, there are some residual regrets; for example, who will receive the glory? And what a lonely world it will be without you.

You inspired China, and you fully deserve the honor. This is an honor that came too late, but once again won the glory for your comrades and party-state. They were on the brink of extinction, always busying themselves with rockets and guided missiles, but now they are saluting and jumping for joy over their comrades-at-arms. They also feel slightly worried about the precision of the nation that invented gunpowder, but their success has driven out any distracting thoughts, there are many more things they should be worried about.

In the face of your accomplishments, Osama bin Laden looks clumsy. If there were an express mail services for fugitives, you would shortly receive his congratulations,

which would read something like this: "Dear National Leaders: In the central business district of your nation's capital, without any basic training, and without wasting a single bullet, the parties responsible for your media completed an independent operation that successfully attracted the attention of the entire world by obliterating the tiny penis of the 'Big Underpants' created by the capitalist architect Koolhaas. ..." To follow would be a lengthy tirade filled with a zealous clamor difficult to discern, some blathering about how this event embodies the Muslim struggle perfectly. It would be easy to pick out his raving nonsense; we can largely ignore nonsense from someone who can't even identify his own location on a map.

Returning to the topic, the glory and honor of today are related to your years of evildoing, if you can still remember the Olympics, Yang Jia, Tibet, Beichuan, and Sanlu milk powder. In your version of reality, you're so deep in sins you can't even imagine; your misfortune is the great fortune of the masses, a celebration and holiday for all people. With your sensitivity to media you should realize that these live visual effects are much better than any "live broadcast." At the scene where Central Television set itself on fire, the citizens took charge of the live broadcast, immediately inspiring all of China.

One day, mutual falsehoods, swindling, deception, greed, and all the possibilities for your existence will wither away with all related degeneracy. That will be a true holiday. With every day that you exist, that holiday is delayed one more day; only P citizens are stupid enough to peg their happiness on the final day for totalitarian power,[25] and even though that involves a degree of difficulty, it is an inevitable day.

Even though the P citizens are stupid, the joy, pain, grief, and happiness of SBs never needed any excuse. Today, the SBs are happy for you, they are excited about your ignorance because it's enough to inspire their imagination. Your misfortune leads them to think of bigger fires, higher temperatures, and a more thorough collapse, swifter and more violent destruction.

When a long-paralyzed weakling confronts honor, this time, no matter how you look at it, they will be a little embarrassed. But you can relax about one thing: the P citizens will continue to wish you happiness, and every day hereafter you will receive the soft murmurs of congratulations from the P citizens, until your day of judgment arrives.

What Is Central Television, Anyway?

POSTED ON FEBRUARY 17, 2009

It's snowing. Soft snowflakes are tumbling down in the early morning, flake by flake and soundless. The snow arrived late this year, and soon everything before our eyes will be a field of white. Nature always fills us with rich insight and inspiration about reality; one day the world will change, only because this consciousness exists, just like the falling snow.

Central Television burned five billion RMB, right in front of the entire nation; an amount equivalent to two Bird's Nests was razed completely within the space of six hours. The solemn "thrifty Olympics" of last year really was something, but burn other people's money, and no one pays attention. This is the absolute truth.

The sixtieth-anniversary celebration was enormous, if just a little too early. But it was definitely better than nothing.[26]

Over thirty years of reform and opening, we've never heard as much as a fart about Central Television's evil conduct. There has never been an official report informing the public on, for example, who is tuning in, or a single story in the news media mentioning what superior wrote what memo to subordinates saying that they must do this or that. It's unclear if everyone is dead, or if this has touched on a darker shade of corruption. Anyway, this nation is only capable of feigning seriousness. The entire nation and its entire people are feigning seriousness, what kind of production is this? Gangsters have violated the women of your home, and everyone is sitting on their hands like nothing happened.

This time, we need to cultivate memory. Exactly what kind of "national benefit" are you talking about—the people's wealth, the principles of the party? It goes without saying that everyone is making irresponsible remarks, they only assume that no one saw anything, that everyone refused to talk, and everyone played dead.

The patriotic villains are coming forth in droves, and this is certainly a time when plundering thieves are at the reins of government. One enigmatic torch manipulated the entire nation as if it had mystical power; one flying shoe nearly overturned national policy—why are you resting your asses this time?

The Central Television fire was without a doubt ignited by a department head. There are so many departments in Central Television, and their heads never listen to advice, nor do they ask superiors for instructions. They always make their own decisions, they violate the law, violate regulations; every year, hundreds of thousands pass through their hands like firecrackers or money to burn; during vacations they don't go home, on the fifteenth they don't reunite, they just like to hear explosions.

Of course the city government can't be blamed, the reputation of CCTV is too big, and Beijing is too small; they could never manage the affairs of a department

directly subordinate to the state, the Beijing city government can only wait on the sidelines.

The police aren't responsible, they see the people's property going to waste, and even though they say their hearts are in pain, all they can do is swallow their anger and make a tearful plea, unless they chose to turn in their uniforms.

The firefighters actually came, the flames signaled their command, they even offered up a martyr, but no one dares to cry too loud.[27]

You bunch of phonies and whores calling yourselves Central Television, why doesn't anyone dare to keep you in check or to discipline you? Before you beat any dog, you should find out who its master is, but Central Television obviously doesn't imagine itself as any ordinary dog. It nearly became a hot dog, but it's still pretty calm, because it's Central Television's prolonged existence that preserves the sweet dream and status of its master. This is like saying that CCTV is equivalent to the military police. Turn that around: if you want to beat the master, you should check up on their watchdog, and that's one gloomy spotted Tibetan mastiff.

At least in the reality we see before us, humankind is ignorant, most people are desperate, lack potential, and deceive themselves as well as others. There can be no snow that will float down like these white flakes of mercy.

My Regards to Your Mother

POSTED ON FEBRUARY 27, 2009

The recent media hubbub over the rabbit and rat bronzes is just a big deal over nothing.[28] It's as if someone has robbed the grave of a great nation's ancestors, and the patriotic villains are squirming once again.

The nationalists are not only stupid, they're also forgetful: after only a few days of muscle flexing, no one inquired after the Wenchuan tofu-dregs engineering—who knows where those attorneys crawled off to and died. Three hundred thousand infants were poisoned and no one reported on it, the media are deaf and dumb, and the rights lawyers are maidservants. Public security organs are corrupt, and naturally no one is shouting because the lawyers are a part of the corruption. Coal mines collapse on the poor, and of course the lawyers aren't interested, neither are they interested in tens of thousands of AIDS victims. Where were the lawyers when China's ship was sunk by the Russians, during the Yang Jia case, or while they were "doing push-ups" or "eluding the cat"?[29] They wouldn't dare let loose a fart noise, for even that would scare them. They can't even elect the heads of their own Lawyers Association—those kids have lost all their self-respect. Central Television sent more than five billion up in flames, enough to buy Greek, Roman, and Indian cultural relics in droves, enough to buy a sophisticated internationalist culture, enough to buy back so much of our own

and other people's humiliation and dignity, and you don't even make a fart sound. Are your assholes rusty? You were born in the garbage can, and you still can't fart when you ought to, but the places where you shouldn't be flatulent, you've inundated with shit talk. Chinese lawyers truly don't measure up to donkey shit.

The rabbit and rat bronzes from the Old Summer Palace are not Chinese culture, and they have no artistic value. Patriotism is not a love of the Aisin Gioro family name, and twelve playthings manufactured in the West are not the quintessence of Chinese culture.[30] The true robbery today is spending all the P citizens' silver. What kind of slave would love the whip that once thrashed him? The Chinese have been lowly, foolish, rotten, and traitorous for so many generations that they have rotted to their bones. Such a simple truth, it's impossible that either those ignorant and muddled, incompetent dog-fart patriotic lawyers or the penile media could possibly get it right.

What's more, the Old Summer Palace enjoys its current state of decline not merely because of the Western invaders; the contributions of our compatriots cannot be erased. That palace was a row of pigsties until the 1980s, and at that time there wasn't a home in the vicinity that wasn't using its richly ornamented white marble for bricks.

What kind of a plaything is the media? To call them whores would degrade sex workers. To call them beasts of burden would humiliate the animal kingdom. They are only the most disappointing, most uninteresting, most lowly race of people, the most ignorant human beings belonging to the species.

Must overseas Chinese students be ignorant? Are overseas Chinese unquestionably patriotic fiends? Are lawyers all stupid, rotten eggs? The answer is affirmative. At least it always seems to be so.

Even if you wanted to pick up the bill for such a humiliating and criminal culture, how much would your few kilograms, your few grams really be worth?

Over the first few decades of a New China, in the name of the revolution and during the Cultural Revolution, across the entire nation and in Tibet, you destroyed countless cultural relics in the name of the people, the party, in your name. You destroyed infinite numbers of temples, smashed thousands upon thousands of Buddha statues, melted inestimable numbers of wagons filled with gold-plated Buddhas—who will stand up today and tally their worth? At that time you feared you were too late.

Once you understand that lawyers are swindlers, the law is dubious, the media is low-down, and the system is fatuous, then you will know why the Chinese pretend, and what they pretend. This is a nation that disregards fact and shamelessly grandstands itself; enjoy yourself, take your time.

With one hundred, one thousand patriotic lawyers allotted for imperial use, you ought to show more concern for your mother; don't always make us do it for you.

Citizen Investigation

POSTED ON MARCH 20, 2009

Truth. Responsibility. Rights.

Three hundred days ago I traveled to the earthquake zone in Wenchuan county, Sichuan province. There I witnessed infinite suffering and terror.

Today, we still cannot know who left us in the earthquake, why those children left us, and how they were taken. We will never know what they were feeling as they lay under the rubble waiting.

During that disaster, I did not extend my hand. I honestly could not find the strength.

They say the death of the students has nothing to do with them. They say it was inevitable, unavoidable, and that experts have demonstrated this. They close their mouths and do not discuss corruption, they avoid the tofu-dregs engineering. They conceal the facts, and in the name of "stability" they persecute, threaten, and imprison the parents of these deceased children who are demanding to know the truth. They flagrantly violate the constitution and trample on people's fundamental rights.

Those children who perished in the earthquake are not an unknown figure, they are not the result of a "stabilized" nation.

Those children have parents, dreams, and they could smile, they had a name that belonged to them. That name will belong to them three years from now, five years, eighteen or nineteen years later; it is everything about them which may be remembered, it is everything that might be evoked.

Reject the failure to remember, reject lies.

To remember the departed, to show concern for life, to take responsibility, and for the potential happiness of the survivors, we are initiating a "Citizen Investigation." We will seek out the names of each departed child, and we will remember them.

As for those who harbor mistaken illusions about us citizens, please remember: for each day that we won't take our leave, those children will likewise not disappear. This is one portion of the reason for living, and we will not abandon it.

People interested in the Citizen Investigation, please leave your contact information: xuesheng512@gmail.com

Your actions create your world.

Letter from a Beichuan Mother

POSTED ON MARCH 20, 2009

"… lived happily in this world for seven years."

"Today we had a meeting, they talked about maintaining stability. They say there are more than fifteen hundred deceased children. They say that stabilizing our families will stabilize Beichuan. But I just want more people to know about my darling daughter … who once lived happily in this world for seven years."

I hesitate to omit the name of this "darling daughter" here, in deference to the "stability" that the Beichuan government craves. But only in that way will her mother be spared being "stabilized" first.

4.7 *Remembering* (2007), installed on the facade of Munich's Haus der Kunst spells out, "She lived happily in the world for seven years" in brightly colored backpacks, October 2009.

Guests from All Corners of the Earth

POSTED ON MARCH 24, 2009[31]

Question: What is the greatest difficulty you've encountered while working on the list of names?

Ai Weiwei: Once a person is determined to do something, you become your own greatest difficulty. We don't have that problem; we are willing to do this, willing to see this situation manifest some clarity in the end, no matter how difficult. Many people are not willing to reveal their identity when we investigate and interview locally; they are living in fear, and many have been incarcerated or threatened. People don't dare to speak the truth or simple facts, and this is the greatest difficulty we have encountered.

Q: Online searches reveal the headline: "Wenchuan earthquake has disclosed a list of 19,065 names; the death toll is still being investigated." This means that the government is doing similar work. Why do you still want to create a new list of names?

AWW: We saw the same news clip, and started from there, making contact with various government offices in Sichuan. We made more than 150 phone calls, hoping that we could obtain a list of the 19,065 names. All we obtained was procrastination, stalling, and unclear answers. Not a single person knows where this list of names was published or how it was published, and the list has never appeared on any official Web sites. More than three hundred days have passed, and we have yet to see a figure that inspires people's belief. The government should clearly display the names of these people, their ages, and the cause of their deaths, as well as the place they were killed and the area in which they were registered. This kind of basic information, no matter in life or in death, can only be completed under the auspices of the government, and it should be readily available at any moment. We undertook this investigation under the premise of official opacity.

Our reasoning behind this investigation is to achieve the very lowest level of respect for the deceased. The most fundamental worth and civil right of any person is their right to their name; this name is the smallest, most basic unit that helps us attest to an individual's existence. When we die, if all that supplants one's lost life is an Arabic numeral, life is lacking in basic dignity. Under the circumstances, there are no basic facts, and they won't appear in the near future. As citizens, we should shoulder responsibility, ask the questions that should be asked—these are necessary steps in social progress. This was our motivation for launching the Citizen Investigation.

Q: May we ask, Mr. Ai, what are your considerations in demanding the public disclosure of a list of names of the deceased? What is the significance in making this kind of information public?

AWW: The earthquake was a public incident; accounting for the number of dead, compiling a list, and publishing information about public incidents are the responsibility and duty of the government. Names are one of our most fundamental privileges, the names of the dead are attached to the most basic significance and dignity; openly publishing all information related to public incidences will enhance government transparency, and will likewise contribute to greater government credibility and the public right to knowledge. A public with no right to information is a public that won't shoulder any responsibility, and by the same token, a ruling government with no transparency will never realize fairness and justice.

Q: How many people are working on the Citizen Investigation?

AWW: There are more than ten people working on this together. We started working more than two months ago. Earlier on, we went to Sichuan, and I've been concerned with the matter ever since the earthquake. After going public with the Citizen Investigation, there were a few hundred volunteers who applied and sent feedback and who were willing to join in the efforts. This gave us confidence to do the job well, and thoroughly.

Q: How did you obtain this list of names?

AWW: There are three major information channels. One is preexisting: the Internet holds a wealth of statistics, and many civil volunteers did portions of statistical reporting after the earthquake. Another portion was field visits, information that was garnered in visits with the relatives of the deceased, and the third portion was from investigators who had been doing long-term research in the area and who provided statistics after we went public with the Citizen Investigation.

Q: According to your knowledge, what was the ratio of tofu-dregs engineering among the total number of schools?

AWW: At present, we are not discussing the issue of tofu-dregs engineering. This is an issue that needs technical evaluation. I think that the emergence of facts is unequivocal, the number of deceased is unequivocal; it is necessary to first complete the list of names, and this can be used as a base from which to investigate other facts. As this list of names becomes clearer, other issues will gradually become elucidated. This is also the reason why I believe local governments don't disclose these names or procrastinate with their own investigations.

Q: Mr. Ai, in the process of this investigation, what do you personally believe is the real reason that the government doesn't investigate the persons responsible for tofu-dregs engineering? Is it because they are implicated in the crime, and no one can shed responsibility, or some other internal affair? Already, nothing could be stupider than allowing the entire system to pick up the bill for a portion of corruption.

AWW: In the numerous public incidents last year, we all witnessed the reality of an entire system absolving itself from picking up the bill for any portion of the

corruption. This is the enormous cost necessary to realize social change in China today.

Q: In our current circumstances, we are faced with numerous natural and man-made disasters. What should common people like us do? How can we lighten the losses suffered in disasters?

AWW: A new era marked by globalization and information has arrived. This new era will pose new demands on citizens' self-realization and responsibility, because this era has brought with it new possibilities.

Q: Recently there have been preparations to build a temple near Beichuan Middle School, and a call for monks to release the souls of the children and other victims from purgatory. I think that this is extremely unnecessary, and I'd like to know your opinion on the matter. What will the government achieve with this?

AWW: The Beichuan government seems like one that can't tell left from right. Han Han already went with his luxury SUVs;[32] now they're working on more bad ideas, plans to turn the disaster zone into a tourist site, making things seem mystical, and using all kinds of means to seize peasant land. They truly are obsessed to the point of blindness.

Q: Do the pressures placed on the local residents also pressure you and your team?

AWW: The local residents have been treated unfairly, and the families of the deceased children have been treated especially unjustly. Society should not abide this, because the true disaster comes not only from having lost loved ones, but also from society's indifference, the refusal to answer their questions; they have already been forgotten. When we are making inquiries, many government employees say on the phone, "Out of respect for the bereaved families' right to privacy, we will not publicly disclose the list of names." We all know the proletariat has no right to privacy; the families urgently desire that the outside world could understand them, and won't forget them. We have interviewed hundreds of families, and have a large amount of recorded data; if necessary, we are willing to make all this information public. It is a record, a psychological, emotional, and intellectual record of the people living in the place where the earthquake occurred. There are indeed some shocking facts; it's unimaginable.

Q: What were your investigation methods? Aside from mailings and telephone calls, did you have people on the ground visiting families? How can this list of names be verified for authenticity?

AWW: There are various sources of the information. The collection times and their reliability could all potentially have problems. Owing to the fact that this was not a systematic collection, there could always be problems, and if you want to avoid such problems, you must be very strict, and a qualified public organization should actually be in charge. Doing a citizen investigation is extremely difficult, but although

this is true, this is a kind of effort, and we refuse to wait, we reject procrastination and evasion. Hopefully, in the end we will have a more complete list of names, even more detailed information. We hope that the dignity of the deceased can be restored bit by bit.

Q: Confronted with such a bone-chilling list, do you have any regrets?

AWW: The list isn't our ultimate goal. When these children have been forgotten, they will truly be dead, and forgotten children, no matter where they are, can never be happy again. So I believe this is the responsibility of the living toward the dead; if it is not complete, the souls of the living could never be complete. Then, the incompletion of this list explains why the souls of the Chinese people are like tofu-dregs engineering.

Q: What would you most like to say to the parents of the deceased children?

AWW: I would like to tell them that they are a part of society, their pain is the pain of our entire society, and we can hear them. Society has an unshakable responsibility to them, they have already lost too much, and we should not let them wait any longer, or have any more regrets.

Q: Are we memorializing just to memorialize? Shouldn't there be an investigation into deeper causes?

AWW: Memorializing has its specific function, including the promotion of justice and washing away the injustices suffered by the dead.

Q: Mr. Ai, what do you think is the root cause of Chinese people's lying and moral decay, and do you have any hope for China's future?

AWW: When the cost of speaking the truth exceeds that of telling lies, naturally it will be an era where evil money eliminates the good. From today onward, if everyone told the truth, the times would change.

Q: Will you persist in completing this Citizen Investigation to the very end? What are you feeling when during your investigations you are confronted with these [parents of] children who perished for well-known reasons? As you proceed with the investigation, are there powers trying to thwart you? If so, how will you deal with them? Will your investigation achieve the results you are looking for? What are your expected results?

AWW: If I'm still alive on any given day, this investigation will proceed yet another day. If one student is forgotten, humanity will be cast with shame. Clarifying facts, accepting responsibility, this is the reality that no living person can evade. I've never encountered any obvious attempts at thwarting, even though many things have proved disappointing. No one can obstruct the next innocent plan; I refuse to become one of the casualties. My investigation has already had some unanticipated effects: the children are remembered, there is concern for the families, society has demanded basic justice and rights, and there is refusal of the ghastly tofu-dregs engineering.

Q: Is the tension in Chinese interpersonal relations due to a lack of faith? Is China's traditional feudal thinking the root cause of the contempt for the lives of ordinary people?

AWW: The sorest point about a lack of faith is that people lose the ability to act; the most tragic reality about losing one's ability to act is losing the ability to perceive.

Q: We all know that the catastrophic Sichuan earthquake is related at least a little to humans; how can we avoid this? How will we settle scores with certain people? How can we achieve the exposure of misconduct and corruption and ensure that those responsible receive the punishment they deserve?

AWW: Question responsibility. Use all of our efforts to interrogate our government, suspect them, supervise them. Punishment is not the most important; rob them of the potential to misbehave and be corrupt; establish open, fair, and impartial mechanisms, reject lies, reject CCTV.

Q: Mr. Ai, I'd like to ask, are you doing this job because you want to leave something for the next generation?

AWW: We don't have time to think about the next generation, and we can't think about the previous generation. We barely have enough time to take care of ourselves.

Q: Speaking of the list of names, officials were never willing to publicly disclose the names of the dead children, only offering a figure. Every time something happens, it's the same, they don't give specific names, and when we try to collect them, there are obstructions. I want to know what is the meaning behind these official actions.

AWW: Habitual concealment is the result of habitual corruption and degeneracy.

Q: Hello Mr. Ai, you say "people are living in fear, and many have been incarcerated or threatened. People don't dare to speak the truth or simple facts." I want to know, what kind of facts are these, and why have people been incarcerated and threatened?

AWW: The interrogation of suffering families could only be a result of one of the following reasons:

1. There was a problem with the stability of the schools; how the children died and why they died are questions that the local officials have yet to answer clearly.
2. A problem with the efficiency of rescue efforts.
3. A problem with post-earthquake compensation and recompense.
4. Problems of post-earthquake relocation and future living conditions.

All families who have raised questions have been threatened and coerced to varying degrees, some even having been incarcerated or detained.

Q: Mr. Ai, hello, I'm a graphic designer working in Shandong. Is there anything we can help with, do you need volunteers?

AWW: Start now; you can start designing a new national flag!

Q: Why hasn't the so-called mainstream media had any news from the families who lost their children? Don't these families have anything they want to say, to express their grieving and sorrows?

AWW: There is no mainstream media in China, only dead media.

Q: Hello Mr. Ai, I would like to ask why, in the face of natural disaster, governmental departments would want to conceal the number of the dead? Also, is your collection of these names of the departed really just to express your respect for the departed, or do you have some other goal?

AWW: All of my goals are other goals.

Q: Hello Mr. Ai. I would like to express support for the efforts you initiated. But, when choosing between ways to memorialize the dead and giving hope to the living, which one do you think is more important? I'm located in the disaster area, and from what I see, many people in the disaster-hit areas have absolutely no hope! Thank you!

AWW: For the living, memorializing the dead is more important. For the dead, it is more important to give hope to the living.

Q: Sir, the times are changing, the people are awakening, the government is stagnant, or even regressing, and interest groups would never hand over their rights. In an era when citizens' rights and interests and ethnic interests can be sold off at potentially any moment, how do you suppose we can stimulate the government to reflect on itself, assess, and make progress?

AWW: Change could potentially seek a new logical path; let's move forward and see.

Q: While the Americans have elected Obama to office, China claims to have the most advanced social system in the world. Do you think it's the people's fault we are still playing court politics?

AWW: We could say that all mistakes are the people's mistakes, because our government is the People's Government.

Q: Mr. Ai, Hello! I've had a suspicion ever since the earthquake, and want to ask: as per your knowledge, roughly what proportion of the deceased (or missing) in the earthquake do adolescents account for? I've heard that more than 90 percent of the schools collapsed in the areas hardest hit by the earthquake, is this fact? There are also rumors that the entire (or a large majority of the) next generation was lost in certain areas, is this so? According to your data, what is the ratio of the schools that collapsed in the earthquake? And what is the ratio like for other types of buildings that collapsed?

AWW: This is precisely our question; one day we will have a clear answer.

Q: I would like to ask, Mr. Ai, in your understanding, have local government officials greedily stashed the contributions of the people of the entire world?

AWW: If I said there was no corruption, no one would believe it. If I said everyone was corrupt, no one would believe it.

Q: First, I support Mr. Ai Weiwei. Secondly, I'd like to return to matters of monetary donations: could you say something about your personal thoughts on, for example, allotment of funds, etc.?

AWW: Monetary contributions are only one half; who you give them to and how they will use them is the other half.

Q: "Many people are not willing to reveal their identity when we investigate and interview locally, they are living in fear; and many have been incarcerated or threatened. People don't dare to speak the truth or simple facts, and this is the greatest difficulty we have encountered." Why are they living in fear? Why would they be incarcerated and threatened, and who is doing this to them?

AWW: The families of Dujiangyan who have met with disaster tell us that if they discuss any of their suspicions related to the dead or the tofu-dregs engineering, they face the possibility of being laid off and losing their life security. In the hardest-hit areas, many heads of families have experienced being detained or incarcerated. The primary task of public security and stabilizing offices is to prevent the families from talking about deceased relatives.

Q: When we want to do something, we wonder what we can do. There are times when, other than venting our frustration, we just feel that our powers are so miniscule. Mr. Ai, please give us some advice.

AWW: Let's all vent our frustration together.

Q: Please, Mr. Ai, is it worth abandoning everything to pursue life's truths? History is always playing tricks on us; you go in through one door but come out through another. At one time they gave consideration to the common man, but the one-time advocates of the proletariat ultimately leaned toward despotism. Many people who once gave their consideration to the rulers, the advocates of the ruling class, have now actually become endorsers of civil rights. I remember Bertrand Russell once said: "I would never die for my beliefs because I might be wrong." For the moment we won't discuss right or wrong, but I'd like to ask Mr. Ai, if we abandon everything in search of life's truths, can we arrive at the desired harbors?

AWW: When you pursue truth, you have already decided not to abandon everything.

Q: Social contradictions today are acute; some online friends are breeding dissatisfaction with the government, and if they want to grasp onto a minor social problem, they use democracy or freedom of expression to attack and accuse the government.

AWW: The leaders must take responsibility. If they are too tired, or frustrated, then find someone else.

Q: Mr. Ai, how do you view the "small portion" of youth who have lost hope in the nation and society?

AWW: Finding hope in society is an affirmation of life. This is a larger principle.

Q: Thank you for using the power of your influence to speak out. During the earthquake, many parents lost their only child, triggering reconsideration of the compulsory one-child policy. Actually, I was once a supporter of the policy, and have finally realized there are so many kinds of immoral and inhuman activities, such as infanticide, compulsory birth control, and tubal ligations. But it's strange; very few people have voiced their objection to such serious inhuman incidents. What do you think of this?

AWW: Family planning should be the decision of the parents.

Q: I continue to support Mr. Ai, and I would like to ask if you are worried about where the contributions for the relief efforts are going?

AWW: The whereabouts of relief contributions and the whereabouts of funds are like water in the same river.

Q: First, what is the real reason for the delayed release of a list of victims' names? Is the low efficiency of workers only a superficial reason? What is the root reason, and who is afraid of these real reasons on a deeper lever? Second, not even the blood and tears of the disaster can stimulate reflection, self-criticism, or even investigation and punishment; the celebratory voices praising the success in the rescue efforts are drowning out all the others. Why are such wicked flowers always flourishing on our soil?

AWW: When a people reject truth, they have already chosen death.

Day of True National Revitalization

POSTED ON APRIL 13, 2009[33]

You persistently delete, so I'll just repost. Words can be deleted, but the facts won't be deleted along with them. This process will be repeated for a long time, until the day arrives when we evolve, and facts and truth are no longer important to everyday life, so we can forget as we please.

It's not difficult to see that the main similarity in the endless disasters occurring on this plot of land takes the concealing of facts as an important component. The distortion and concealing of basic facts—what happened, how it happened, and why it happened—has become the most sincere, most valuable, and most productive effort this race has ever put forth. The truth is always terrible, unfit for presentation, unspeakable, and difficult for the people to handle; just speaking the truth would be "subversion of the state." Concealing and lying are the foundation ensuring our society's

survival. On the day that truth manifests itself, the sky will brighten; that would be true liberation.[34]

Like an earthquake lake, no matter how great your disaster is, each one is made up of convergent pools of smaller disasters; they are the foundation of this "revitalized nation." Once this foundation has been excavated, there won't be any disasters, and it would be hard to revitalize the nation. We can say that all the concealed facts, altered names, torn out records, erased photographs, destroyed videos, deleted words, sealed mouths, and the "stability" that constrains the truth, all are for a better tomorrow, or in order to gather sufficient energy for an even greater disaster, which will undoubtedly be the true day of the people's long-awaited national revitalization.

These Days I Can't Believe Anything You Say

POSTED ON MAY 7, 2009

The Sichuan government indicated once again that it would not pursue the issue of quality construction in the schools that collapsed during the earthquake. Their reasoning is that, in earthquakes of magnitudes exceeding the earthquake-proofing standards of the collapsed buildings, all losses are natural. The seemingly rational grounds to this argument are enough to allow those behind the tofu-dregs engineering to collectively exhale a sigh of relief—in the name of "scientific development" and "shouldering the power to build a party that serves the interests of the people," more than two thousand Chinese architectural experts wrote down some of their wise assessments in a marvelous document.

If you don't understand, I'll put it this way: if you were on a sinking ship, and someone murdered you, everyone would be guiltless, because you were going to die anyway. Or in another example, rape would naturally be just a form of recreation during the Nanjing massacre. Their verdict is that, owing to the high magnitude of the earthquake, those tofu-dregs schools, which lacked steel supports or acceptable-grade concrete, collapsed as a matter of course. This is not an issue worth investigation. "Not worth investigation" means there is no blame. And that's not criminal logic?

What has never been clearly explained is: of more than one hundred schools scattered around the severe disaster area, only fourteen schools could claim a death toll in excess of one hundred due to collapse. Even though this was an earthquake of magnitude 8, the remaining ninety schools did not topple. Yet, among the fourteen schools that did, there was no unified pattern of destruction: rooms with larger widths collapsed, and while some of the classroom buildings were left unharmed, the dormitory buildings fell. Towers that had fallen into disrepair for many years remained

standing, but newer buildings had collapsed. Identical teaching buildings came down, but not administrative buildings. Surrounding the areas where the most students were killed, at the Beichuan and Juyuan Middle Schools, many buildings were left standing. Thus, interpreting a magnitude 8 earthquake as a "spicy hot pot" (where everything has a different flavor going in, but comes out tasting the same) is evidently a crude explanation.

And then they emphasize the different architectural standards and earthquake defenses in different eras. The dead perished under institutional rules, and no one will take the blame. What they haven't clarified is, among those buildings that toppled, which structures reflect the standards of what era. Is this really that complicated?

4.8 A bereaved mother stands outside the collapsed Juyuan Middle School holding a photograph of her daughter, May 29, 2008.

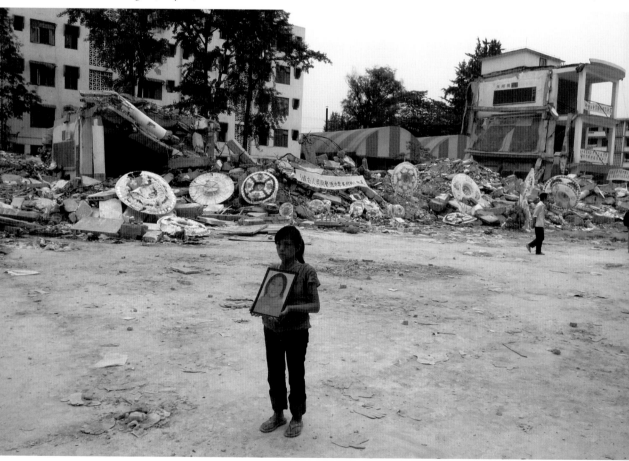

There is another version that says it is impossible to collect evidence because rescue workers disturbed buildings in the collapse zones. This is like saying, if you've been raped, you must lie on the bed without moving, or face a lifetime without retribution.

Once again, the Sichuan government has ruined itself in front of the entire nation. Once again, it has deviated from the sacred meaning of "scientific development." Considering themselves above facts, morality, and justice, and obstinately rejecting the idea of redeeming the public trust or amending their declining honor, they are once again smearing the artificial shades of a fabricated reality onto a heart-breaking natural disaster.

One year later, a reluctantly speculative number of 5,335 disaster-stricken students still remain nameless, there is a lack of information, the facts are insincere, unconvincing. They shirk responsibility, evade discussion, and forgo the public disclosure of information for fragmented facts—what could be lurking behind the obscured portion of truth?

Today, it's not that I would believe what you say. I don't believe anything you say, so go ahead and say it.

When a government's explanation is insufficient to convince even its own people, and those people reject falsehoods and refuse to forget, whose turn is it to grieve?

Paranoid Citizen

POSTED ON MAY 10, 2009

The one-year anniversary of the May 12 Wenchuan earthquake is fast upon us, and the government has repeatedly made it clear the schools that collapsed in the earthquake and the students who were killed have nothing to do with the quality of the buildings' construction, have nothing to do with what people are calling "tofu-dregs engineering."

Organizations representing the wisdom and authority of the government, as well as the media, are attempting to convince the people that because the magnitude of the earthquake was so very high, the schools' collapse was inevitable, and the death of these students unavoidable. As long as this is heaven's will, of course no man should shoulder the responsibility.

Compelled by the will of the state, truth and fact no longer exist; a long string of Arabic numerals has replaced the value of life. So-called scientific research is merely wagers made by pandering technocrats, and in every political deal made in this nation, the first people to come up short on probability are always the common folk. This is because they aren't "people" in the real sense of the word; even as the nation's sixtieth

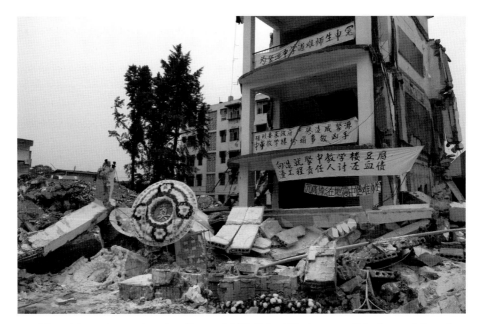

4.9 Memorial wreaths atop the ruins of Juyuan Middle School. The banners call for the search for and reprisal against those responsible for "tofu-dregs" construction, May 29, 2008.

anniversary is approaching, we still lack the right to vote, and have no opportunity to speak. The grievous and indignant sentiments of the masses are continually replaced by tedious amusement and celebrations. Hardly astonishing, the result is the same as with the other great events that occurred in this nation's history: the will of the state has once again brutally supplanted facts and individual suffering, once again sunk the people into an abyss of despair.

Even after the ideology behind a "scientific outlook on development" was proposed at the 17th National People's Congress, these verdicts violate the principles of science. The cause of death for those thousands of wrongly dead students has been determined to be nothing more than their miserable fates; they were in the wrong place at the wrong time, and this is the reason that their adolescent flesh and blood ended up mixed in with the tiled rubble and those concrete reinforcements cut with sand. The official reasoning is clear: in a magnitude 8 earthquake, school buildings will crumble and students will die; anyway, a school education never had any use, and knowledge cannot prevent death; the longer you stay in school, the greater your chances of death, and fate naturally becomes more tragically absurd. As for the majority of buildings that did not collapse in earthquakes of equal magnitude, what was it about those students that kept them from dying? It can only be explained that their ancestors didn't serve in the dynastic courts, thus accumulating good karma for them.

What needs to be asked is, What kind of government ignores the wishes and the feelings of the people, unscrupulously deviating from reality and distorting facts when touching on their lives or the people's property and benefits? And what is the reason for this? Could we deduce the following: the ethics and morals supporting the state are built upon a bogus foundation of lies, and the existence of truth will shake the foundation of society? Their basis of power can only be stabilized by evading or escaping responsibility, and sacrificing social justice and equality.

This is the only explanation for why, before everyone knows the truth, these people choose deceit and treachery. Isn't this foolish? It is foolish, but it arises from helplessness. A society without ideals, a society that departs from humanitarian principles, that abandons fundamental human rights and human dignity, can only exist in a reality that rejects facts, in a space that rejects justice and equality.

Suppression and deception are the attributes that allow for this society's existence; it could not exist without lies. People maintaining illusions in this kind of society will eventually pay a higher price.

This isn't the only such disaster in our memories, and it isn't the most deplorable. We are already accustomed to letting go and forgetting, and all the details of this disaster will similarly be forgotten by the living; just as before, it will be as if nothing ever happened. Ultimately, all of these disasters will converge in one place, composing a landscape of civilization and progress that will boggle the mind.

The rules of this ancient game are clear, they are based on eternal principles: encourage lies, erase memory, those who cause disasters escape, the innocents will be punished.

As for the innocents in this menacing place, there is but one possibility that might relieve them from suffering and bid farewell to abandonment: make zealous pleas for the truth, calmly reject further lapses in memory. Try just this once, for the daughter you will never see again, for she who "lived happily in this world for seven years," Miss Yang Xiaowan, and for her mother and the thousands of unfortunate parents like her. Continue to inquire about the "tofu-dregs engineering," interrogate every hour of every day, until our problems become a part of reality, until every "tofu-dregs" structure is exposed and collapses. Under extremely paranoid rule, being a chronically "paranoid citizen" is today's only possibility for living happily and healthily.

5.12 Memorial Day

POSTED ON MAY 12, 2009

Can these facts be altered? The hearts stopped beating, their limbs decayed, and their shouts disappeared with their breath, can these be returned? Wave upon wave of mighty propaganda from the national state apparatus cannot erase the persistent memories of the survivors. Crushed, the boneless and incompetent collapsed buildings belong to a generation of those unfortunate villagers, and the tofu-dregs engineering has been shielded, absolved by the clamor of desperate attempts at celebration. Those responsible for the offense are attempting to gloss over and distort in order to escape the condemnation.

How foolish and obscene must a person be to lie to the families of the deceased, to bully parents who suffer from the loss of their children and their ruined futures? They cover eyes, stuff throats, wiretap phones, track whereabouts, and threaten, they buy people off, detain, beat, and persecute the common people.

Their happiness was terminated with their lives in the very place where they read books, where the floor under their feet was constructed with concrete of inferior quality and the ceiling above them was stripped of its supports. Those in charge of education disdain to think of it, those responsible for the buildings believe that things are as they ought to be, the people who cry out for scientific development hope this incident will quickly be forgotten.

Those children arrived, and were carelessly sent off, their limbs rashly buried by strangers. Even quicker than their passing was the speed with which some hoped they would be completely and utterly forgotten. The lives of those children were so short, it's as if they never existed.

Just as in other disasters, the rights of young lives and all temporary facts related to them must yield to state, collective, or individualized fictions. Their only value lies in enduring their punishment in this brutal historical process, and in becoming a tiny fraction of a figure that signifies pointless expenditures. Without their existence, this bit of history would pale under evil, ignorance, and barbarism.

Clearly put, they died under the demands and desires of our era; they were born without value or significance, and were just a portion of an even larger void of carelessness, whether or not they came or went is a matter of no importance. This desensitized world was never happy about their existence, and it won't feel lonely after their passing. This place really isn't that great at all.

Their parents lost their anger long ago, and eventually they'll get accustomed to the interruptions in their thoughts, to worrying about disruptions, to disturbing their happiness. They will adapt to a future that won't require anything of them, they

won't have any more troubles or anxieties. Their children will never again disappear into the distance, because on the same day, under those same predestined dangers, more powerful than an attack by any conspiracy, they were forever lost in the ruins behind the mountain ridge. Perhaps what they will talk about will be some of the ambitious investments, the bloodstains that will be pieced into blueprints and will fill officials' hearts with emotion, becoming the miraculous transformations that will be the highlight of someone's career.

Karamay children, Fuyang children, melamine children, Henan AIDS children, Shanxi black-kiln children, murdered children of the earthquake—your misfortune is the most effective curse on the nation, something that the face of the nation can never cast off, a brand of shame that can never be washed away and that tragically dooms the fate of this race.[35]

They are the souls that today's world must burn, drown, betray, and exterminate. But until that day, rest. When that day comes, people's hearts will call out each of your names, the name that belonged to you will be remembered. When it is called out again, you will rise from the dead and be contented spirits.

We will stubbornly refuse this portion of our loss. We won't give up, and you won't be lost. No matter how far you travel, you'll always be in our sights. Thoughts can penetrate time and material, determination will ultimately brush off the decay and corruption like a horsetail duster, trading dignity and honor for your interrupted lives.

We reject pardons, the erasure of your memory, cooperation, and compromise, because your troubles have latched onto us. Life is simple; it simply will not tolerate doubt.

What is truth? It is everything about us, and it is everything about them. In the darkness, the fractured truth will ultimately emerge.

Everything owed must be repaid. That which was altered will be explained; it all remains to be seen. Until each wound from under the rubble has been healed, until each grain of sand has been cleaned from all the hair, and until each name is brilliantly fresh, everything will be remembered as clearly as your departed gaze.

How Could We Have Degenerated to This?

POSTED ON MAY 16, 2009

They are arrogant enough to believe that stolen authority could alter the truth, or alter the will of others. At the same time they are fragile enough to believe that one dissenting voice could bring down their mighty force.[36]

This is because they do not believe that their disreputable names will be written upon any of the ballots once the public truly has the power to cast its own vote.

They have already lost hope in themselves, and they don't want the voice of the people to be heard; but they don't allow people to listen to each other or to discover that like-minded people might exist.

You can think, but you can't speak. No one else knows what you're thinking, and when pain and despair belong exclusively to you, there will be no threats. Of course, you'd be better off without the ability for independent thought; that would be safer, more harmonious.

If you cannot improve on your own reality, then you can only rely on destroying the reality of others to maintain balance. Of course we would be much more peaceful if we never knew about Sanlu milk powder, never heard of Weng'an, Gansu, Tibet, or Beichuan. Supposing we didn't understand the world, it would seem much smaller. If we didn't know the earth was round, we might abandon all hope on the road. We don't understand our rights, and thus believe in emancipators, believe that all manners of death were meant to be, that we should be grateful for life, that Central Television is not base and indecent, and that none of this is evil. If we did know, we would be able to imagine the world another way, or perhaps that being evil is not inevitably a prerequisite to power.

Imagine everything that you don't know; the rest of the world would be whatever others were willing to tell you. They're selling you out, and you don't feel the sting, maybe you're really helping them count their spoils. Your ignorance and your silence are the price you pay for the security of your lifestyle; they have become an important reason for your existence, and have become the very cost of maintaining the status quo in your republic, the grand, benevolent mother. Why not?

If you cannot see or hear, you know absolutely nothing. Even if you know, you are unable to speak out—speak out, and you'll disappear. It doesn't matter if you are suffering, joyous, melancholy, without an imagination, without sympathy, without the desire or potential to change: you are an absolute advocate, you are an outstanding example of a modern slave. You won't inquire into the nature of this world, but isn't that just what you need? You can eat and drink, bear sons and daughters, abide by the law and pay taxes. You are supporting a horde of people who regard you as part of a flatulent mass of citizens, people whose main job is to squander your wealth through corruption while keeping it all a stern secret and misleading you in sustaining your misfortune. Your misfortune becomes the good luck of others. This issue is a little complicated, it's probably best if you didn't know about it.

Without individual voices or the free exchange of information, neither the People nor the proletariat can exist, and there can be no common interests for humanity; you cannot exist. Authentic societal transformation can never be achieved in such a

place, because the first step in social transformation is to regain the power of freedom of speech. A society lacking in freedom of speech is a dark, bottomless pit. When it's this dark, everything begins to look bright.

Domestic Security "Rice Cookers"

POSTED ON MAY 27, 2009

At seven forty this evening, I was emerging from an embassy with the security of at least a three-star prison, after hearing the mumbles of Ms. Nancy "Human Rights" Pelosi. I have finally witnessed the amount of money that could turn a once crafty heroine into an obsequious, culpable old bag. Even more laughable is the fact the United States embassy has inherited the great legacy of the Chinese, vomit.

I left my mobile phone in the car to avoid having it confiscated by the United States Marines. I returned a call from my mother, and she told me nervously that four plainclothes police were waiting for me at home, unremittingly inquiring about my home near the airport expressway. I immediately told her I was on my way home. It has been a while since I saw her.

What followed seemed to be an absurdist novel gone wrong. They were domestic security officers, and although they seemed nice enough, they didn't bring their police identification, and I refuse to talk with someone whose identity is unclear. They said that their colleague had identification, and I told them Bill Clinton was my comrade. When he started to appeal to my emotions, my most hated taboo, I was forced to show them out, and was left with no choice but to call 110.[37] When finally 110 minced their way over, those two pathetic policemen—who had also failed to bring their police identification—tried explaining by saying I was the one who called them over. I informed them I am a taxpayer, and he tried telling me there were identification numbers on their uniforms, and a police car parked outside. I asked him how he could prove that he didn't steal it, and told him that both of them had best return to the station for their identification.

When we arrived at the station together, the other officers were a little startled to see the domestic security officers brought in to make a statement. One officer did both the questioning and the recording, it was too ridiculous, but I still benevolently signed my name. After that, they refused to issue a receipt acknowledging a report, saying that we were just "discussing," and that's not a criminal act. I replied that I didn't dial 110 for fun, and called my lawyer, Hao. The reception where he was in Shanxi province was poor, so instead I called Liu Xiaoyuan,[38] who told me that domestic security officers had kept him company during similar discussions. The officers to whom I was

reporting vanished yet again. I indignantly went to burst out of the police station—no exaggeration at all—yelling that they were wasting taxpayers' money, that they were deceitful, absolutely pathetic, and telling them if they didn't unlock the door immediately, their police station would soon find itself without a door.

First, I went home to pacify my mother, and when I left her, the same security officers were dawdling outside as if they hadn't had enough of their say. I was forced to dial 110 again. This time the officers were effective, and pulled out their police identification. They let the Dongcheng district security officers go, and then shook hands and chatted amicably with the Chaoyang district security officers.

I told them not to forget to bring handcuffs next time they come looking for me, or at least someone capable of speaking in complete sentences. I'm not kidding, this is a different era, and domestic security officers are just like electric rice cookers,[39] they too need to be updated for the times. Who are you trying to scare, all in a day's work?

Don't Harbor Illusions about Me

POSTED ON MAY 28, 2009

It's about that time of year again, and you must be busy these days.[40] Sending one of "your own" people to the public security bureau, that was just another misunderstanding.

Just the day before, I had called 110 twice, and sent two domestic security officers who had forgotten to bring their identification to the PSB.

Today, I called 110 three times to file a report, sending those two plainclothes cops who were trailing me to the PSB.

In short, no matter if it is the aforementioned domestic security officers, public security cops, plainclothes police, 110 on-duty officers, or the cadres in the police station—my actions are not directed at you personally, just as your actions are not directed at me personally. If my blame insulted your dignity, I sincerely apologize. It was a misunderstanding.

You are merely executing official business, no matter what kind of business it is, and as long as it's necessary for survival, I can understand to a certain extent.

What I want to illustrate is: as a human, I feel compelled to uphold my rights. No one should provoke me. I've tolerated your deleting my blog, I've tolerated your wiretapping my phone, I've tolerated your monitoring my residence.

4.10 A friend holds branches in front of one of the surveillance cameras monitoring the front door to Ai's residence, June 6, 2009.

However, I am unable to tolerate your charging into my home and threatening me in front of my seventy-six-year-old mother. I am unable to tolerate plainclothes officers secretly trailing me and threatening my safety. You don't understand human rights, but you ought to have heard of the constitution, right?

What you need to hear clearly is:

1. The world is yours, thus you must act justly and honorably.

2. You must abide by the laws while enforcing the law, and carry your police identification. Five police officers in two days were not carrying their identification; two tried to pass themselves off as "civilians." Respect your profession while you've yet to find anything better.

3. Not all citizens are soft like persimmons. I'm slow to anger today, but that might not be true tomorrow. Don't eat from our table and pretend you don't recognize us the next day.

4. Don't come to me for discussion. All your experience "discussing" with other people won't work for me. You should study up, and get online.

5. Your procedures should be clear, avoid being passive. Your previous experience isn't of any use, and you'd best absorb the weighty lessons learned at the Shanghai Zhabei district station.

6. The 110 police were prompt, polite, and clear on the telephone. They seemed educated. I commend you for this, and I love you all. You have my telephone number, you can get in touch privately.

7. Female officers are all better than their male equivalents. Maybe that's just my old weak spot. I'm biased.

8. Just the same old saying: this is only your job, so don't do things that you really shouldn't. If enforcing the law is inappropriate, losing your job is small stuff; damaging the image of the party would injure the national character.

9. Again, don't harbor illusions about me.

10. To be continued …

I'm Ready

POSTED ON MAY 28, 2009

"Be careful! Are you ready?"

I'm ready. Or rather, there's nothing to get ready for. One person. That is everything that I have, it is all that someone might possibly gain and everything that I can devote. I will not hesitate in the time of need, and I won't be vague.

If there were something to be nostalgic about, that would be the wonders that life brings. These wonders are the same for each and every one of us, a game where everyone is equal, and the illusions and freedom that come with it. I see any manner of threat on any human right as a threat on human dignity and rationality, a threat to life's potential. I want to learn how to confront.

Relax, I learn fast, and I won't let you down. Not long ago, the collective deaths of those children who forfeited their lives helped me to realize the meaning of individual life and society.

Reject cynicism, reject cooperation, reject fear, and reject tea drinking, there is nothing to discuss. It's the same old saying: don't come looking for me again. I won't cooperate. If you must come, bring your instruments of torture with you.

Let Us Forget

POSTED ON JUNE 3, 2009

Let us forget June Fourth, forget that day with no special significance. Life has taught us that every day under totalitarianism is the same day, all totalitarian days are one day, there is no day two, there was no yesterday and is no tomorrow.

Likewise, we no longer need segments of reality, and we no longer need fragmented justice or equality.

People with no freedom of speech, no freedom of the press, and no right to vote aren't human, and they don't need memory. With no right to memory, we choose to forget.

Let us forget every persecution, every humiliation, every massacre, every cover-up, every lie, every collapse, and every death. Forget everything that could be a painful memory and forget every time we forget. Everything is just so they might laugh at us like fair and upstanding gentlemen.

Forget those soldiers firing on civilians, the tank wheels crushing the bodies of students, the bullets whistling down streets and the bloodshed, the city and the square that didn't shed tears. Forget the endless lies, the leaders in power who insist that everyone must forget, forget their weaknesses, wickedness, and ineptitude. You surely will forget, they must be forgotten, they can exist only when they are forgotten. For our own survival, let us forget.

If You Aren't Anti-China, Are You Still Human?

POSTED ON JUNE 14, 2009

The party is infinitely testing the people: your Internet is dammed,[41] education is programmed, and you're duped by the papers, poisoned by milk, and condemned if you're unemployed. Public transport is bombed, you're robbed of your land, your house is razed, your children are sold, miners are crushed, young women are assaulted, and everything else belongs to security guards, city management, the military police, domestic security, gets stabilized, or goes mentally ill.

Demand that rapists be apprehended, and they say it's anti-China; children are crushed by collapsed buildings, but inquire about the quality of the construction and that's anti-China too; exposing contaminated food products is anti-China; civilians who've been beaten and abused attempt to petition the state, and that's also anti-China; trafficking children, selling HIV-infected blood, operating slave labor coal pits, falsifying news, a judiciary that breaks the law, corruption and greed, infringing on

constitutional rights, a "Green Dammed" Internet … anything that highlights your problems is anti-China. If we aren't anti-China, are we still human?

If it's a public incident, then it's an unexpected outburst and mob disturbance; if it's about politics, then it's a crisis of political upheaval; if it's an obvious mistake, then they have ulterior motives; if the irate people are too many, then they are ignorant of the truth, and have been provoked; if the condemnation is international, then it's foreign anti-Chinese forces. Sixty years have passed and we still haven't seen a vote, there is no universal education, no health insurance, no open press, no freedom of speech, no freedom of information, no freedom to relocate, no independent judiciary,

4.11, 4.12 *China Log* (2005), Tieli wood, fragment of a Qing dynasty temple, 337 cm long, 57 cm in diameter.

there are no public watchdogs, no independent labor unions, no national army, no constitutional protection, and everything that's left is a Grass Mud Horse.[42]

Boycott the Internet on July 1, Don't Make Excuses, Don't Calculate Losses or Gains

POSTED ON JUNE 23, 2009[43]

Our plight today was caused by China's having too many smart people, who are always saying: "What's the use in doing that? What will happen afterward?" I suddenly understand that, in any struggle like this, we not only need to confront power and violence, but even more so, we need to confront those smart, sneering people, their ubiquitous expressions from their oily, learned ways, calculating astuteness, and blatantly seeking their own advantage. They are often more honorable and educated, demonstrating sound mind, and full of advice.

They are similar in that none of them is fond of taking action, because they lack imagination and a sense of humor, and behind all their questions they are hiding their low self-esteem and self-renunciation. Low self-esteem, self-renunciation, and self-deception are characteristics of a people living under the tyranny of despots, who, without exception, become victims of self-imposed exile and who are scaring themselves.

These prophets casually drop their warnings: that's stupid, and their reasoning is to condemn it as destined for failure. Before they predict failure, before the arrival of death, they have already proclaimed the necessity of abandoning any kind of effort, resigning before even a modicum of resistance, and muffling any sound before a shout has been made. Failure is inevitable, so why act? This is how their logic runs. China has never had a shortage of this kind of spectator; these people are the true accomplices to violence, their cunning and sordid greed have acquiesced to the arrogance of power. Was there ever any incident of bloodshed in which the kind gaze of these smart people was not turned the other way until the blood dripped dry?

Are the prophets alive? Isn't life the traces of countless struggles to the death? Isn't existence a picture painted from innumerable failures? Everyone hopes to struggle for the right to control his or her own life and death, not for the prophets' obscene interpretations of existence.

Dispel outdated modes with your own language, replace former prejudices with your own attitudes, and cover traditional ways with new expressions. This is a new existence because it is our own methods.

In all crises of survival, crises caused by living in degradation without sincerity or courage, the terrible precursor to death is truly a lack of faith in life's fundamental rights.

The significance of the world is clearly manifested through the processes of disintegration and mutation; there is no predictable meaning. Pies are made of flour; they don't fall from the sky. Democracy and civil rights are the same way.

You can say that this pie doesn't taste good, but if that's the case, you'd best make another one, or go and eat steamed buns.

Today, I'm making a clear appeal: boycott the Internet on July 1, don't make excuses, don't calculate losses or gains.

140 Characters

POSTED ON JULY 9, 2009[44]

The premises for arriving at ethical public judgments are the possibility for people to obtain the truth and the assumption that they are endowed with the potential for self-expression and participation. This is called democracy. Any style of governance lacking these guarantees is a violent one, and political violence is the source of other social violence.

How do both sides understand the form and method? On one side are terrified, panic-stricken Uyghur common folk; on the other are soldiers and fully armed police, dressed head to toe in combat gear, with their tanks, arrogant powers clamoring to repress and attack, monopolizing all the resources and information, including the power to control what you know, to monopolize justice and public opinion. Isn't it perfectly clear what real violence is?

With so many viewpoints, opinions, and methods determining what violence is and how to manage it, this nation is consistently lacking in constitutional awareness and an independent judicial system. There is no appreciation for the constitution, nor is there a legal system independent from political parties; the nation and the government are merely violent groups held hostage. Can this kind of land have prospects for peace?

From the standpoint of a totalitarian state, the ethics and methods used to manage violence merely constitute the reason or purpose for the next violent conflict. Moral and ethical deficiencies and the debate over the legitimacy of power are the latent causes of any violent conflict.

The process becomes more sinister as you describe it. Imagine, after sixty years under the warm, illuminating sunlight that is ethnic policy, thousands of unarmed

ethnic minority civilians take to the streets in protest to confront tens of thousands of military police and soldiers. They kill a few people and burn some cars, but aside from saying that this is foreign-influenced, it's difficult to justify your story.

Whether the incidents in these areas are big or small, they are bound to be the result of cooperation with "hostile overseas forces and domestic thugs." In Chinese revolutionary practice, aren't Marxism and Leninism the quintessential example of successful cooperation with "hostile overseas forces and domestic thugs"?

The death toll has already exceeded our imagination, and the only reliable understanding of this can be from actual weakness and incompetence. Totalitarian violence is everywhere, life is just a number without flesh and blood. The dead students of Sichuan are one example.

The extravagance is finished; cruelty, neglect, decline, and ransacking are all happening before your eyes, you are merely the heir.

When the only truths in the world are all truths in your favor, you become a fake; you are only an excuse for your own existence. The world isn't necessarily what you think it is; everyone's world has a distinct look in his or her own eyes.

Is truth still necessary? It isn't. This government, this kind of political system is the entire, unchanging truth. All other truths are negligible false appearances.

When we are on the boundary of death, there is no ethnicity or viewpoints, death neutralizes all earthly rationality. Causing the death of another is a sin, no matter who it is, or for what purpose. Death is antagonistic to freedom.

Those who die in violence die of a disregard and hatred for life. The unlucky thing is that indifference and hatred are preserving our normal state of existence.

Violence can be divided into the violence we can see and the violence we cannot see; we endure both kinds. If we are not currently on the road to extinction, don't use "extinction" to threaten the people any more.

I lived in Xinjiang for sixteen years and never had the opportunity to come in contact with Uyghurs, so I don't really understand them. This should be enough to illustrate the problem. I've had limitless contact with the Han, and I know how shameless and capable of disappointing some of them can be.

Just like a sick person watching his body waste away, what's different is that this death isn't caused by personal exhaustion, but by external degradation and defeat.

Freedom is limited by the freedom your prisoners enjoy, without freedom for others; you will never have a day of peace.

Political institutions are rules and regulations, they could be a wholesome game. What we should say to the government is: it's fine to be in power, but you don't want to cheat; it's okay to be corrupt, but there's no need to go crazy; you can steal, but don't try to make yourselves sound dignified.

The "three influences" are: violent terrorist influences, ethnic separation influences, extremist religious influences.[45] Aren't you looking in the mirror?

No matter the nature of the incident, they all end the same: seal off information, control public opinion, confuse right and wrong. Isn't it clear what kind of world this is?

Xinjiang, Tibet, Weng'an, Longnan, Shishou,[46] Beichuan … and the people who have dealt with hardships still a small handful? Everyone is paying a price, an ethical and moral price paid for with body and soul, by the young and the old, women and children. What's strange is that no one escapes punishment.

The feeling of helplessness under totalitarianism is the abduction of human morals. Terror doesn't come from ruthless brutality; terror results from submitting to this ruthlessness.

Chairman of the Xinjiang Autonomous Region Nur Bekri described Rebiya Kadeer: "A misbehaved, delinquent evil woman without any shred of national dignity, personal character, or sense of national concern, she has sold out the interests of her nation and people, and is willing to serve as the lackey of anti-Chinese Westerners."[47] Aside from the last part of that last sentence, the rest of his description could be used for Chinese officials.

"Be brave, something big is going to happen." If this is evidence of a foreign-influenced plan, the conclusion can only be that foreign influences aren't nearly as strong as Fanfou's.[48]

I Really Can't Believe It

POSTED ON NOVEMBER 20, 2009

Yesterday, the Ministry of Public Security sent someone who spent the entire afternoon at Bank of China investigating my account information. Their reason for the investigation was that I was involved in "fraud." What are they trying to do?

The Ministry of Public Security investigated very thoroughly, for more than three hours. Such actions prove they have no moral and ethical bottom line. I'm not surprised at all. When I heard that I was involved in "fraud," I laughed—at least they are sharing their honor with me.

My mother and sister both received inquiring calls from the bureau. At first they were worried and thought that anything could happen, but I don't see things that way. I believe that no matter what happens, nothing can prevent the historical process by which society demands freedom and democracy.

This afternoon we had a family meeting, where I gave my family an account of my "work," expressed my views and point of view, and analyzed the situation. Everyone understands that I've already considered the worst of what might happen, and they all feel much more secure.

What can they do to me? Nothing more than to banish, kidnap, or imprison me. Perhaps they could fabricate my disappearance into thin air, but they don't have any creativity or imagination, and they lack both joy and the ability to fly. This kind of political organization is pitiful.

Bury those children, give them kidney stones, and act like it's nothing, exercise violence near and far, but don't dare to face the facts … and this is how you make it in this world? I really can't believe it.

EPILOGUE

Question: What were you feeling when the Sina blog was closed?

Ai Weiwei: It's very difficult to explain my feelings when the Sina blog was shut down. Even though it was a blog, after all, I had spent more than three years on it. I had more than 2,700 posts, and included a great number of images and texts. Even if I was on the road, I posted every day, or had my assistant post for me, and thus I had a high traffic volume, and it became an energetic blog. Even outside of China, I'm sure that few places have such active blogs; every day I would write from two to seven entries. Ever since the Sina blog was closed, I've had a feeling of weightlessness.

Q: The goals of your blog seem to have evolved; do you feel that your personal status has undergone any change?

AWW: When I was writing my blog, I never had writing experience, until I started to write. Of course this was a blog concerned with politics and current affairs, because art doesn't need too much written commentary. My status never changed, and politics have always interfered with my life.

I think that an artist's, or person's, concern with attitudes of existence is always related to politics. The blog provided me with a more dynamic tool, and a place to take full advantage of my expressive potential.

Q: What was your original intent in filming *Laoma tihua*?[1] The events that transpired over the course of that film changed your life. How can people overseas understand the actions of the local governments, and do you have any regrets?

AWW: I brought photo and video-recording devices when I went to Sichuan to testify for Tan Zuoren, because that's how I've done things for a long time; it wasn't with the intention of making a film. Moreover, we often carry cameras to do various kinds of documentation, something I started doing even before *Fairytale*. It was around 2003 that I started filming and documenting.

When we returned from Sichuan it became very difficult to clarify the unexpected events that happened there, and I had the idea of using the recordings to make a film. The events there influenced the course of my life, and it threatened me with a crisis, and it was something that had never occurred to me, something that had a definite influence on my personal and surrounding circumstances.

I think the actions of the local officials—including a lot of things that happen in China—are not necessarily comprehensible to all Westerners. That is because these things lie outside of the parameters of things that can be understood. You're either inside a situation, or you're outside it, understanding is just one part of your surrounding circumstances, and thus there will always be incomprehensible characteristics. Nearly five months have passed since the Tan Zuoren affair—I went to testify for this hard-working intellectual who has always worked for the public interest, and I don't regret my actions. I think that every person must do something for others; that is the only way this world will see change.

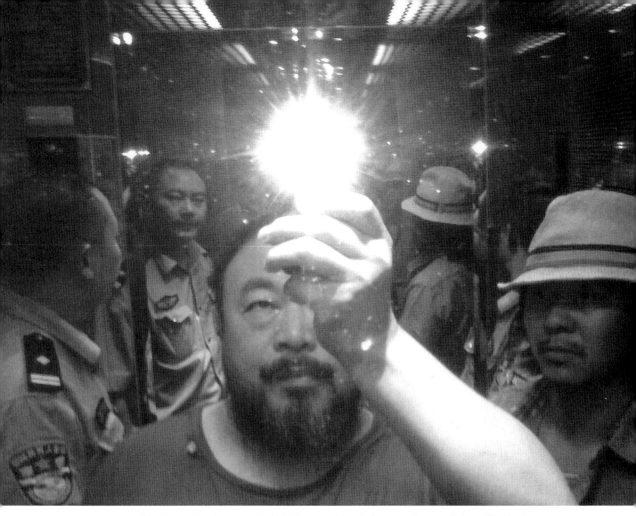

5.1 After being taken into custody, Ai Weiwei uses his cell phone to photograph himself with Zuoxiao Zuzhou and two police officers in Chengdu's Anyi Hotel elevator, at 5 a.m., August 12, 2009.

Q: Are you filming any new films or documentaries lately? Are you looking to develop in that direction?

AWW: We've always been recording, editing, and making documentaries. We've already completed four documentaries; they are all available online.[2] I have no goal or direction, I'm ever moving forward.

Q: You haven't written any longer essays lately. Are we to understand that this is related to the incident in Sichuan?

AWW: The Sichuan incident caused a decrease in my ability to concentrate, and my brain is still recovering. The fortunate thing is that I've learned how to use Twitter, and the events in Sichuan and my surgery in Munich were all posted on the Web

via my cell phone and Twitter. All of this naturally allowed me the possibility to use a new documentation method to narrate my circumstances and expound on events. A new means of expression presented itself, and I discovered that it expresses a dynamic and energetic layer that is easily accepted by the media and the public. At the same time, and most importantly, it surmounts old power structures and outdated possibilities for discourse.

Q: The number of your Twitter followers has already reached twenty thousand. What is it that attracts you most to Twitter? How has it changed your lifestyle? Compared to the blog, which platform suits you most?

AWW: The distinctive nature of Twitter is its promptness and instantaneous turnaround; it's the opposite of the pedantry and deep contemplation involved in literature. I'm often thinking of something Allen Ginsberg told me: "The first thought is the best thought," that kind of thing. I think about how he never had an opportunity to use Twitter. I believe that it will ultimately change the way humans communicate, and will change the way we transmit text and information. Twitter is most suitable for me. In the Chinese language, 140 characters is a novella, it's enough space. Twitter gives people the chance to interact more closely.

Q: Can you speak a bit on the future of human connectivity, or relationships, as facilitated by the digital age?

AWW: We are located in an extremely new era, whose most distinguishing characteristics are manifested in changes to individual expression and influences that change the way that we receive information. When the characteristics of individuals undergo change, the very concept of humankind itself changes. The significance of the effects that the Internet age will have on humankind still hasn't shown itself, but it will become the tool that develops humankind to the greatest degree.

Q: What are the unique effects the Internet has on Chinese society and on Chinese netizens?

AWW: It's difficult to imagine the effects that the Internet has had on Chinese society; this is because China has made its very foundation the blockading of information, surveillance, and the limiting of free expression. The surveillance and limitations are endlessly being augmented. But at the same time, the technical prowess of the netizens and their demands for freedom of expression are growing in resistance to each blockade. This kind of stalemate over the Chinese Internet has cultivated a great new power interested in expressive methods and potential technologies.

Q: In your opinion, what would be the most ideal outcome of an Internet or digital society? Or what kind of social change do you think it will bring about?

AWW: The most ideal outcome of an Internet society would be that people are given the opportunity to make the best choice, which is usually eliminated because of an inequality of knowledge and opportunities or disproportionate information. A

real citizen society could potentially emerge. The social changes that the Internet is giving rise to are moving China even faster toward a liberalized and communalized state of freedom.

Q: Do you have any other thoughts on the digital age or Internet freedom? Is this a cyber Cold War? Will you continue to blog in the future?

AWW: Freedom of speech on the Internet is a new concept, and Hillary Clinton's remarks[3] were a new evaluation of the values of freedom and democracy, and new definitions of these concepts. Everyone could benefit from the protection of these new technologies; upholding these concepts will put authoritarian politicians in a very difficult situation.

I will continue using the Internet, and as an artist, I think that this platform holds incredible potential and expressive features; it's also bestowed on me some quite unimaginable memories.

CHRONOLOGY

1910	March 27, Ai Weiwei's father Ai Qing (born Jiang Haicheng) born to a landowners' family, in Jinhua, Zhejiang province
1957	May 18, Ai Weiwei born in Beijing (August 28 by some accounts) to Ai Qing and his wife Gao Ying
	Ai Qing accused of being a rightist; family relocated to Beidahuang, Heilongjiang
1959	Family relocated to Shihezi, Xinjiang
1976	Ai Qing rehabilitated; family returns to Beijing
1978	Ai Weiwei enrolls at the Beijing Film Academy
1979	Participates in the first Stars exhibition, mounted on a fence outside of the National Art Museum of China
1981	Arrives in New York
1982	Enrolls in Parsons School of Design, Art Students League
	Exhibition at Asia Foundation, San Francisco (solo)
1988	"Old Shoes, Safe Sex," Art Waves Gallery, New York
1989	Joins the group Solidarity for China and participates in eight days of hunger strikes in New York
1993	Returns to China
	"The Stars: 15 Years," Tokyo Gallery, Tokyo (group show)
	Artists begin moving to the East Village on the eastern outskirts of Beijing
1994	Edits and publishes the *Black Cover Book* (*Heipi shu*)
1995	Edits and publishes the *White Cover Book* (*Baipi shu*)
1997	Edits and publishes the *Gray Cover Book* (*Huipi shu*)
1998	Jury member for the first Chinese Contemporary Art Awards
	Co-founds China Art Archives and Warehouse with Hans van Dijk and Frank Uytterhagen

	"Double Kitsch: Painters From China," Max Protetch Gallery, New York (group show)
1999	Completes first architectuaal project, Studio House in Caochangdi, Beijing
	"Innovations I," China Art Archives and Warehouse, Beijing (group show)
	48th Venice Biennale
	"Concepts, Colors, and Passions," China Art Archives and Warehouse, Beijing (group show)
2000	Co-curates "Fuck Off" with Feng Boyi, EastLink Gallery, Shanghai
	China Art Archives and Warehouse (architectural project)
	Concrete, first outdoor project commissioned for Soho China
2002	Edits *Chinese Artists, Texts and Interviews: Chinese Contemporary Art Awards 1998–2002*
2003	Collaborates with Herzog & de Meuron on proposal for Beijing National Stadium, the "Bird's Nest" (architectural project)
	FAKE Design architecture office established
	Jinhua Ai Qing Cultural Park and Yiwu Riverbank, Jinhua, Zhejiang, China (architectural project)
	"Fragments," Galerie Urs Meile, Beijing-Lucerne, Lucerne, Switzerland (solo)
2004	Go Where? restaurant, Beijing (architectural project)
	"Between Past and Future: New Photography and Video from China," New York, Seattle, Chicago, North Carolina, California, Berlin, London (group show)
	9th Venice Biennale of Architecture
	Caermerklooster, Provinciaal Centrum voor Kunst en Cultur, Gent, Belgium (solo)
2005	2nd Guangzhou Triennial
	Courtyard 104 & 105, Beijing (architectural project)

	Galerie Urs Meile, Beijing (architectural project)
	"Mahjong: Chinesische Gegenwartskunst aus der Sammlug Sigg," Kunstmuseum Bern
	October, Ai Weiwei begins blogging on sina.com
2006	"Fragments," Galerie Urs Meile, Beijing (solo)
	"Art in Motion," Shanghai MoCA
	Participant at Davos World Economic Forum Annual Meeting
	"Territorial: Ai Weiwei and Serge Spitzer," Museum für Moderne Kunst, Frankfurt am Main
	15th Biennale of Sydney
	3rd Busan Biennale
2007	June–September, *Fairytale* project realized at Documenta 12, Kassel, Germany
	"Ai Weiwei," Galerie Urs Meile, Lucerne (solo)
	"Traveling Landscapes," AedesLand, Berlin, Germany (solo)
	2nd Moscow Biennale
	"The Real Thing: Contemporary Art from China," Tate Liverpool, Liverpool
	Three Shadows Photography Arts Center, Beijing (architectural project)
	17 Studios, Caochangdi, Beijing (architectural project)
	Museum of Neolithic Pottery, Jinhua, Zhejiang, China (architectural project)
	Treehouse of the Waterville, Lijiang, Yunnan, China (architectural project)
2008	"Ai Weiwei: Illumination," Mary Boone Gallery, New York (solo)
	"Ai Weiwei: Under Construction," Sherman Contemporary Art Foundation and Campbelltown Arts Center, Sydney (solo)

	"Go China! Ai Weiwei," Groninger Museum, Groningen, The Netherlands (solo)
	Gallery Hyundai, Seoul (solo)
	Albion Gallery (solo)
	5th Liverpool Biennale
	11th Venice Biennale of Architecture
	Receives Chinese Contemporary Art Awards lifetime achievement award
2009	"Ai Weiwei: New York Photographs 1983–1993," Three Shadows, Beijing (solo)
	"According to What?," Mori Art Museum, Tokyo (solo)
	March 20, initiates Citizen Investigation
	May 28, Sina blog censored
	June, begins microblogging on Twitter
	August 12, assaulted in Chengdu hotel while attempting to testify at the trial of Tan Zuoren
	September 13, undergoes cranial surgery in Munich
	"So Sorry," Haus der Kunst, Munich (solo)
2010	March 5, Tate Modern announces Ai will fill the Turbine Hall as the 11th commission in the Tate's Unilever series, to be unveiled on October 12, 2010, and run until April 25, 2011
	August 10, while attempting to file a police report for the August 2009 assault, Ai and entourage are attacked by plainclothes officers in front of the Chengdu city police department

Chronology of Important Sociopolitical Events

1911	Republican government established in Beijing
1912	February, the Qing Dynasty ends as the last Manchu emperor abdicates
1919	May 4, student demonstrations in Beijing, May Fourth Movement begins
1927	Civil war between the KMT (Nationalist) and Communist parties
1937	Second Sino-Japanese War begins
1942	Mao Zedong's Yan'an talks on art and literature unify intellectuals and artists under new communist directives
1949	October 1, founding of the People's Republic of China
1950	People's Liberation Army enters Tibet
1956–57	Hundred Flowers campaign encourages intellectual criticism
1957–58	Anti-Rightist Campaign eliminates critical intellectuals
1958	Great Leap Forward begins
1959	Tenth anniversary of the founding of the PRC, Ten Great Constructions under way in Beijing
	March 10, Tibetan uprising, 14th Dalai Lama flees to India
1961	Great Leap Forward ends, famine kills an estimated 14–36 million
1964	First nuclear tests in China
1966	Great Proletarian Cultural Revolution begins
1968	First group of Red Guards are sent down to the countryside for labor and education
1972	Nixon visits China, Sino-American relations begin to normalize
1976	January 8, death of Premier Zhou Enlai
	April 5, mourners for Zhou Enlai gather in Tiananmen Square for Tomb-Sweeping Day and are dispersed by militia force in what became known as the April 5 Tiananmen Incident

	July 6, death of Vice Chairman Zhu De
	July 28, Tangshan earthquake devastates city of Tangshan, Hebei province, killing an estimated 270,000 people
	September 9, death of Chairman Mao Zedong
	October 6, Gang of Four is apprehended in Beijing; the Cultural Revolution winds down
1978	Deng Xiaoping outmaneuvers Mao's chosen successor, Hua Guofeng, and rises to power
	Deng's economic policies of "opening and reform" are first introduced
	December 5, Wei Jingsheng posts "The Fifth Modernization" at the Beijing Democracy Wall
1980	The one-child policy is instated at the national level
	Special economic zones established in Shenzhen, Zhuhai, Shantou, Xiamen, Hainan
1982	Fifth National People's Congress adopts the current constitution
1983	First Strike Hard campaign against crime begins
1985	"Culture fever" and the "'85 New Wave"
1989	April 15, death of General Secretary Hu Yaobang
	May 13, student protesters massing in Tiananmen Square begin a hunger strike
	May 20, martial law declared in Beijing, troops advance on Tiananmen Square but are blocked by civilians
	June 3, troops receive orders to clear Tiananmen Square at all costs by 6 a.m.; on June 4, violence erupts in the square at 4 a.m.
1990	Blood and plasma donors in rural Hebei infected en masse with HIV
	Artists begin moving into the Yuanmingyuan village in Beijing
1992	Deng Xiaoping's Southern Inspection Tour
1993	Beijing's East Village begins to flourish

1994	December 8, Karamay fire in Xinjiang province
	Construction begins on Three Gorges Dam
1996	Beijing West Railway station completed
1997	February 19, death of Deng Xiaoping
	July 1, China gains control over Hong Kong's sovereignty
2000	Jiang Zemin outlines the theory of the "Three Represents" during his Southern Inspection Tour
	Han Han publishes *Third Door*, which becomes the best-selling title in China in over 20 years
	Three Gorges Dam population resettlement begins; an estimated 1.3 million people will be resettled over a period of 17 years
2001	China is awarded the 2008 Olympic Games
2002	Suspected first case of SARS in Guangdong province
	Hu Jintao replaces Jiang Zemin as general secretary of the Communist Party of China
2003	March, Hu Jintao elected president by the National People's Congress
	March 20, Sun Zhigang dies while in police custody; asylum and repatriation policies are reconsidered
	April, Dr. Jiang Yanyong exposes Beijing's cover-up of SARS
	April, Herzog & de Meuron's Bird's Nest proposal for the new National Stadium officially adopted
2004	January, the Shanghai Transrapid maglev train goes into service
	September, "Building a Harmonious Society" is introduced as a primary CPC directive under Hu Jintao's leadership
	September 22, new CCTV tower designed by Rem Koolhaas breaks ground in Beijing
2005	China's Internet users surpass 103 million (per China Internet Network Information Center, CNNIC)
	June, Beijing courts mandate that Suojiacun artists' village be demolished

	September, Yahoo! accused of supplying information leading to the arrest of journalist Shi Tao
2006	January, Google.cn established in accordance to Chinese censorship policy
	March, "Eight Honors, Eight Disgraces" public education program launched
	April 16, Zhang Yimou proclaimed director of the 2008 Olympic Games opening ceremony
	May 10, rock musician Dou Wei trashes the *Beijing News* editorial office in anger over invasion of privacy
	July 1, Qingzang overland railway to Tibet opens
	July 16, Qiu Xinghua kills ten people at the Iron Tile Daoist temple in Shaanxi province
	November, Golden Shield Project (also known as the Great Firewall) begins operations under the Ministry of Public Security
2007	China's Internet users surpass 210 million (per CINNC)
	October 12, Shaanxi forestry officials release "photographic evidence" of the South China Tiger, launching the South China Tiger Scandal
2008	March 14, ethnic protests erupt in Lhasa
	April 1, Wikipedia, Blogger, and YouTube unblocked
	May, Chinese health authorities report major outbreak of EV71 enterovirus in Fuyang city, Anhui province
	May 12, Wenchuan earthquake in Sichuan province
	June 28, riots erupt in Weng'an, Guizhou province
	July 1, Yang Jia storms Shanghai Zhabei police station, killing six officers (also the 87th anniversary of the founding of Chinese Communist Party)
	July 16, first reports linking Sanlu milk formula to kidney ailments in children
	August 8, opening day of the 2008 Olympics Games
	August 27, Yang Jia is tried and sentenced to death in a closed-door hearing
	September 13, Sanlu Corporation halts milk production

	December 10, Charter 08 petition for human rights and political reform in China is published online
2009	February 9, TVCC, adjunct building to Koolhaas's unfinished CCTV headquarters, destroyed by fire
	February 12, Li Qiaoming dies of head injuries sustained in prison; "eluding the cat" scandal erupts online and in Chinese media
	February 25, disputed Qing dynasty rat and rabbit bronzes sell at Christie's for a combined total of EUR 28 million
	March 24, Youtube.com blocked in China indefinitely
	June 4, 20th anniversary of the Tiananmen Incident, microblogging and photosharing sites blocked in anticipation of dissidence
	June 9, Green Dam Youth Escort computer-filtering software is introduced
	June 19, riots in Shishou, Hebei province
	July 5, riots erupt in Ürümqi, Xinjiang province; "Ürümqi" keyword searches are blocked and Internet access in Xinjiang is halted
	October 1, 60th anniversary of the founding of the PRC
	December 25, Liu Xiaobo sentenced to eleven years in prison on charges of "inciting subversion"
	December 28, partial Internet access recovered in Xinjiang; the *People's Daily* online and Xinhuanet.com are the first Web sites to be accessible in Xinjiang
2010	January 10, Google announces it will not continue to censor search results within China, even if this means pulling out of the market
	January 19, China's Internet users reach 384 million
	January 21, U.S. Secretary of State Hillary Clinton's address on Internet freedom and "freedom to connect" makes veiled criticisms of China
	January 22, China Foreign Ministry condemns U.S. criticism, saying it is "harmful to China-U.S. relations"
	February 9, Tan Zuoren sentenced to five years for subversion
	October, Liu Xiaobo awarded the Nobel Peace Prize

NOTES

Introduction

1. Walter Benjamin, "The Task of the Translator" (introduction to a Baudelaire translation, 1923; translation by Harry Zohn, 1968), in *The Translation Studies Reader*, ed. Lawrence Venuti (London: Routledge, 2000).

2. Hans Ulrich Obrist, interview with Mathieu Wellner, "Ai Weiwei," *Mono-Kultur*, no. 22 (Autumn 2009): 5.

3. Ai Weiwei, quoted in Karen Smith, *Ai Weiwei*, Contemporary Artist Series (New York: Phaidon, 2009), 64.

4. Ai Weiwei, interview with the author, January 23, 2009.

5. Ai Weiwei, quoted in Charles Merewether, *Ai Weiwei: Under Construction* (Sydney: University of New South Wales Press, Sherman Contemporary Art Foundation, and Campbelltown Arts Centre, 2009), 24.

6. Sean Simon, "Ai Weiwei's Heart Belongs to Dada," *Artspeak*, New York, March 16, 1988.

7. Quoted in Michael Kaufman, "New Yorkers Try to Defend Students Hunted in China," *New York Times*, June 22, 1989.

8. They appeared in "Ai Weiwei: New York Photographs 1983–1993," exhibited at Beijing's Three Shadows Photography Art Center from January 2 to April 18, 2009. The show included hundreds of images chosen from over 10,000 previously unseen photographs.

9. Ibid.

10. See http://china.blogs.time.com/2009/05/13/ai-weiwei-transcript-for-real-this-time/ (accessed January 23, 2010).

11. See "Letter from a Beichuan Mother" (blog post March 20, 2009, reprinted in this volume).

12. See "Why I Am a Hypocrite" (blog post July 12, 2006, reprinted in this volume).

13. See "Flickering Screens" (blog post February 5, 2008, reprinted in this volume).

14. David Bandurski, "China's Guerrilla War for the Web," *Far Eastern Economic Review*, July 2008 (accessed February 2, 2010).

15. Rebecca MacKinnon, cofounder of Global Voices online, blogs extensively on the subject of the Internet in China, censorship, and democratization.

2006 Texts

1. The term "reform and opening" (*gaige kaifang*) refers to a broad series of economic reforms proposed in 1978 when Deng Xiaoping came to power. After the Cultural Revolution, China was economically on the verge of collapse, with a huge fiscal deficit and a population living in relative poverty and severely lacking in technical knowledge. The Communist Party was also dealing with a crisis of confidence and threats to its powers of governance. Deng Xiaoping's reform plans were meant to transition the planned economy to a market economy, and in 1978, at the third session of the eleventh National People's Congress, a strategy for "internal reforms and opening to the outside" was adopted. "Special Economic Zones" were instated in Shenzhen, Xiamen, Zhuhai, etc., to develop the coastal economy, and began to stimulate the domestic economy. The process of "reform and opening"

is not considered to be over; its current state consists of countless policy and social reforms. This transitional state of economic reforms is frequently referenced throughout Ai Weiwei's writings.

2. May Fourth intellectuals, notably Chen Duxiu, chief editor of the influential journal *New Youth*, urged China to embrace the concepts of "science and democracy," which were seen as antidotes to traditional Confucian society. "Mr. Science" (*sai xiansheng*) and "Mr. Democracy" (*de xiansheng*) were important concepts indicating a general direction for progress that helped inspire China's modern age.

3. The Leninist notion that "art should serve the public" was promoted by Mao Zedong in the seminal "Yan'an talks on art and literature" of 1942, a series of discussions intended to unify art and literature under a common socialist-approved ideology and to set appropriate parameters for their development among the communist artists and intellectuals who were gathering in Yan'an. The rejection of "art for art's sake" was of prime importance: that notion was considered feudal and was replaced by the idea that art and literature should serve as the "nuts and bolts" of revolution, working to inspire the public and proletariat. Despite dramatic changes to the creative landscape in China over the past thirty years, these ideas still shape views on art and literature today among the general populace.

4. Ai Weiwei's first outdoor sculptural work, *Concrete* (2000), was commissioned by the Soho China apartment complex. The work was a cylindrical concrete "barrel" more than five meters high that sat on the top of a low stairway and at the end of a small stream. The wall facing the stream was opened with a narrow slit, causing a negative-positive visual effect with the water. A bird's-eye view would reveal a C shape.

5. The maxim "Du shan qi shen" was first used by Mencius in reference to scholars who must struggle to maintain their purity and integrity even if they failed to pass the imperial examinations and are not serving in office. Today it is often interpreted as describing someone who is self-centered or lacking the collective spirit.

6. A version of "Chinese Contemporary Art in Dilemma and Transition" was first published in Bernard Fibichet, ed., *Mahjong: Contemporary Chinese Art from the Sigg Collection* (Ostfildern-Ruit: Hatje Cantz Verlag, 2005).

7. Excerpted from a dialog with Yin Zhishang, *Trends* magazine (*Shishang Zazhi*), December 2006.

8. "The Longest Road" was originally published in the Red Flag publication *Gray Cover Book*, November 1997, under the title of "Making Choices."

9. "Their city" is the coal manufacturing city of Yuncheng, located on the southern tip of Shanxi province.

10. According to Ai Weiwei, the "ideological weapons" of Marxist-Leninist and Maoist thought were once said to cure certain illnesses.

11. Fake commodities are a serious threat in China. Items sold on the open market include fake medicines, cigarettes, alcohol, even fake eggs. The most devastating case of illegal alcohol sales occurred in 1998, in Shuozhou, Shanxi province. Twenty-seven people died from ingesting the "liquor" brewed with inferior materials, packaged in bottles bearing trade-

marks and shelved in local stores. More than 200 people were hospitalized and countless were blinded as a result.

12. "N Town" is the city of Ningbo in Zhejiang province, which houses multiple projects by the architect Ma Qingyun (b. 1965), including the Tianyi City Plaza, Zhejiang University Library, Ningbo Urban Museum, and the retail complex, Ningbo CCD.

13. Suojia Village, or *Suojiacun*, is an artists' compound on the northeast corner of Beijing's Fifth Ring Road, where an international community of about one hundred artists lives in brick loft-style studios over roughly 9 acres of land. In late 2005 bulldozers appeared and proceeded to demolish the first row of studios. The artists protested, and although Suojiacun was still standing at the time of this writing, its fate is unclear.

14. The sale of official posts, university diplomas, etc., is a widespread phenomenon in China, and is not necessarily new. The classical Chinese term *juanguan* refers specifically to government positions that were obtained through large "tax donations," a practice recorded as early as the Qin dynasty, and which flourished in the Qing dynasty.

15. In March 2006, Italian Prime Minster Silvio Berlusconi made a series of remarks in Italy. "I am accused of having said that the [Chinese] Communists used to eat children," he said, and further, "Read the black book of Communism and you will discover that in the China of Mao, they did not eat children, but had them boiled to fertilize the fields."

16. Han Han (b. 1982) became a best-selling Chinese author with *Triple Door* (2000) when he was only seventeen years old. Despite being a high school dropout, Han Han is now hailed as the representative voice of the "post-80s generation." In addition to his literary success, he is China's most popular blogger and a racecar driver, and has also released an album.

17. Liu Xiaodong (b. 1963) and Yu Hong (b. 1966) are two influential contemporary painters who met while attending preparatory school at Beijing's Central Academy of Fine Arts. Both currently teach in the oil painting department at their alma mater. Chen Danqing (b. 1953), an influential painter trained at the Central Academy, became famous for his paintings of Tibetans in 1980. Chen moved to New York in 1982, and his writings and reflections on his years there have made him a popular intellectual in China, where he now lives and works.

18. *Newly Displaced Population* (2004) is a four-paneled oil painting depicting a motley assortment of supposedly displaced migrants standing precariously on a grassy hillside with the Three Gorges Dam looming in the background. It is part of a series Liu Xiaodong completed on migrants in the Three Gorges region.

19. As the mysterious disease SARS was spreading in late 2002 and into early 2003, Dr. Jiang Yanyong (b. 1931), chief physician at Beijing's 301 Military Hospital, sent an email to Chinese news sources breaking the news that SARS deaths were drastically understated by the government. His warning eventually spread to international news sources, which quickly broke the news, and led to an eventual news panic on the mainland. It is widely believed that Dr. Jiang's exposure prompted the Chinese officials to deal actively with the spread of SARS, preventing it from becoming a pandemic.

20. Nataline Colonnello (b. 1976, Italy) is a curator and art critic. This text was first published as "A Dialogue between Nataline Colonnello and Ai Weiwei about the Exhibition 'Fragments' in the catalog of the exhibition "Fragments" at Galerie Urs Meile, Beijing, April 3–June 17, 2006.

21. On April 16, 2006, internationally famous filmmaker Zhang Yimou (b. 1951, director of *Raise the Red Lantern* and *To Live*) was announced the winner of a competition for the honor of directing the opening ceremony of the 2008 Beijing Olympic games.

22. Tie Guaili is one of the Eight Daoist Immortals. "Iron Crutch" Li holds an iron walking stick, and he is usually accompanied by a magical gourd.

23. The "Red Boy" (*Hong Hai'r*) is a character from the classic Chinese folk tale *Journey to the West*. The boy with fantastical powers has a characteristic feature of two buns on either side of his head and one patch of hair in the middle.

24. Nezha is a popular deity in China, known as a "trickster god"; he is often depicted as a boy, and sometimes rides two wheels of fire. His popular form also shows him with two buns of hair above his ears.

25. In 1957, after being labeled a "rightist," Ai Qing and his family, including the one-year-old Ai Weiwei, were relocated to the bitter cold of Beidahuang in northeastern Heilongjiang province (also known as Manchuria). Two years later they were relocated to Shihezi, Xinjiang province.

26. "A Native of Beijing in New York" (*Beijing ren zai Niuyue*) was a popular television drama in China that first aired in 1993. It was partially filmed in Ai's underground apartment in the East Village, at 52 Seventh Avenue.

27. Construction of the Great Hall of the People, the legislative and ceremonial meeting place of the People's Republic of China, was completed over ten months in 1959. The Great Hall of the People is located on the west side of Tiananmen Square, and was one of the monumental "Ten Great Constructions" built for the tenth anniversary of the founding of the nation. Its architectural style borrows from both Stalinist architecture and the international style, but includes conspicuously Chinese elements, such as gold and green glazed roof tiles.

28. The *hukou* is the contemporary Chinese family registry, a system that can be dated back to ancient China. Originally developed for purposes of taxation, conscription, and social control, in modern society the *hukou* also serves as a means to control and monitor internal migration. Many preferential policies are allotted to those in possession of the highly coveted Beijing (or urban) *hukou*: social welfare, medical insurance, education, and pension benefits; many employers hire only individuals with a Beijing *hukou*, and without it primary students can study only temporarily and are subject to high fees. The difficulty of obtaining an urban *hukou* for rural residents has created a permanent underclass of citizens in Chinese cities.

29. According to Ai, this particular cultural forum was a roundtable discussion that brought together so-called "left-wing scholars" to discuss current trends in culture and literature.

30. Shanghai's Xintiandi, literally "new heaven and earth," is an outdoor shopping, eating, and entertainment district built in a district of refurbished traditional *shikumen* houses (literally "stone gate" houses). Opened to the public in 2003, the area has been billed as one of the first "lifestyle centers" in China, and hailed as a successful example of historical preservation for its adoption of the surrounding *shikumen* neighborhood.

31. Zhu Dake (b. 1957) is a cultural critic, author, and blogger based in Shanghai.

32. Yu Hua (b. 1960) is a Chinese best-selling author. His books include *To Live* (1992), which was later made into a film banned on the mainland and directed by Zhang Yimou, catapulting the author to fame. Yu Hua's other works include *Chronicle of a Blood Merchant* (1995) and, most recently, *Brothers* (2005), a historical satire about the Cultural Revolution.

33. Xu Jinglei (b. 1974) is one of the mainland's most popular actresses and director of three feature films. She also maintains a highly influential blog and a successful lifestyle-fashion online portal. In May 2006, her blog (also hosted by Sina.com) held the number-one spot among Chinese language blogs for a few months.

34. "SB" is Internet usage for *shabi,* a vulgar expression insulting someone as ignorant or dimwitted.

35. Eventually, forum organizers turned off Ai Weiwei's microphone, so he threw it and stormed out, effectively leaving China's cultural elite shocked. This was Ai Weiwei's first and last such "cultural forum."

36. Zuoxiao Zuzhou (b. 1970) was born as Wu Hongjin, and changed his name when he came to Beijing in the early 1990s and formed the early rock group No. Zuoxiao lived in Beijing's East Village, and has become something of a cult rock figure hovering on the fringes of the rock and art scenes ever since. He currently works as a practicing visual artist and has released a dozen studio-recorded albums.

37. *Dakou* cassette tapes and compact discs were "cut" at the edges, making them unfit for sale in North America or Europe. Beginning in the 1990s, they were exported to China and sold there in bulk; they became the primary means through which a generation was introduced to Western music.

38. "A Curse for Zuzhou" was originally published in the now defunct *Rolling Stone China,* April 2006.

39. Urban "floating populations" of migrant labor (many of whom have lived and worked in cities such as Beijing for years) and laws regarding registration and *hukou* (see note 28) have made estimating urban populations an onerous challenge.

40. According to Deng Xiaoping's economic theory, in order for the nation to prosper, the nation should "let a portion of the people get rich first."

41. He Yunchang (b. 1967) is a performance artist born in Yunnan and currently living and working in Beijing. "Ar Chang's Persistence" was first published in the exhibition catalog for "Casting," Beijing-Tokyo Art Projects, April 23–24, 2004: Tang Xin and He Yunchang, eds., *Ar Chang's Perspective: An Exhibition of He Yunchang's Works* (Beijing, 2004).

42. Zhong Nanshan (b. 1936) is a highly celebrated respiratory health specialist. Among other honors, he serves as chairman to the respiratory branch of the Chinese Medical Association and as health consultant to the United Nations World Health Organization.

43. Quotes taken from *Southern Weekly* (*Nanfang Zhoumo*).

44. Asylum and repatriation policies originated in the 1950s, during early stages of nation building, when civil war and turmoil left large populations of social drifters in need of asylum. In 1982, when related laws were instated, the party made it clear that the primary purposes of asylum laws for urban floating populations were to provide poverty relief and education, and to aid resettlement. Because homeless populations and disaster victims were flooding into the cities, the laws were hailed at the time as a public benefit. In 1992, changes were made to the Compulsory Asylum and Repatriation (*shourong qiansong zhidu*) policy, and affected populations were enlarged to include people classified as "three lacks" (*san wu renyuan*): those lacking identification papers, lacking a permanent address, and lacking a fixed income. According to the laws, individuals living unregistered for more than three days in any given urban area had to apply for a temporary residency permit, or risk being considered illegal residents and subjected to compulsory asylum and repatriation.

The legislation gradually transformed into menacing laws for economic migrants, undermining their original purpose as a welfare measure and making them a serious threat to human rights. Asylum stations began collecting various fees from their inhabitants, and other problems such as extortion, illegal detention, and forced labor proliferated. In 2003, Sun Zhigang, a graphic designer only twenty-seven years old, was beaten to death while in custody. His death became a high-profile media case that exposed many similar cases and provoked discussion on the compulsory asylum laws, which were already coming under attack from human rights groups. Only months later, Premier Wen Jiabao repealed the law and abolished related laws.

In May 2006, after Zhong Nanshan's computer was stolen, he proposed the reestablishment of the asylum laws and other severe punishments on migrant populations. His comment triggered heated debates in news media and online forums.

45. The Qingzang railroad to Tibet made railway history when it opened on July 1, 2006, becoming the highest railway in the world. Reaching from Xining, the capital of Qinghai province, to Lhasa, Tibet, the railway is 1,215 miles long, and 596 miles of the track are located more than 13,000 feet above sea level, with a peak at 16,640 feet. A true marvel of engineering, the Qingzang railroad includes 342 miles of track built on permafrost.

46. A *khatag* is a symbolic white scarf. Also known as "scarves of honor," *khatags* are offered as ceremonious or prayerful gestures in the Tibetan tradition.

47. Jingdezhen is a small city located in southern Jiangxi province that became famous during the late Ming and Qing dynasties for its royal kilns. Still an important center for porcelain and pottery manufacturing, Jingdezhen is where Ai Weiwei manufactures his porcelain works.

48. "Why I Am a Hypocrite" was written as a rebuttal to readers' critical response to "The Computer Worth 'Several Hundred Million' and One Worthless Brain." Commentators

accused Ai of exploiting the names and reputations of people more famous than him to make a name for himself, and some online critics called him "shameless."

49. This is an allusion to the March 2006 "Eight Honors, Eight Disgraces" public education program (*barong bachi*) developed by President Hu Jintao and promoted as a "core value system" for Chinese citizens. The honors and disgraces are (1) Love the country; do it no harm, (2) Serve the people; never betray them, (3) Follow science; discard superstition, (4) Be diligent; not indolent, (5) Be united, help each other; make no gains at others' expense, (6) Be honest and trustworthy; do not sacrifice ethics for profit, (7) Be disciplined and law-abiding; not chaotic and lawless, (8) Live plainly, work hard; do not wallow in luxuries and pleasures.

50. These are phrases used during the Cultural Revolution to describe Marxist thinking.

51. The Cultural Revolution was referred to as an "era of heroes" (*yingxiong de shidai*). The reasoning was that heroes were created in the face of trouble, because the people needed heroes to inspire them and lead them out of the "dark ages."

52. Printing unsanctioned or sensitive news comes with harsh penalties: any given media would be forced to stop publishing or broadcasting for a period of at least three months, and responsible editorial departments would be investigated by a special branch of the Ministry of Culture. Of course, this rarely happens, as editors and censors stationed in editorial and news departments strictly monitor content and usually stop any suicidal mistakes before going to print.

53. Zinedine Zidane (b. 1972), legendary French–Algerian footballer, captained the French team in the 2006 World Cup. Zidane was sent off the field for head-butting Italian player Marco Materazzi in the chest during the second period of extra time in the final game of the group stage in Berlin. Zidane later told the press that his actions were provoked by "very hard words" that the Italian had directed at him. He retired from professional football after the 2006 World Cup.

54. Dou Wei (b. 1969) is a figure in Chinese rock famous for his early 1990s metal band Black Panther (*Heibao*). He was also the first husband of pop diva Faye Wong (b. 1969). In May 2006, a journalist from the *Beijing News* (*Xinjing Bao*) visited him on the premise of conducting an interview; the reporter instead printed invasive, gossipy news about him and his current wife which he learned through a visit to the musician's home. On May 10, 2006, Dou Wei stormed the newspaper's editorial office, threatening the journalist (who was out of the office), spilled tea, smashed the computer of the journalist responsible, threatened other staff members, and finally set a car outside the building alight with a fluid that he apparently had prepared for that purpose. Dou Wei was arrested immediately, but was hailed as a hero for defending his right to privacy.

55. In Chinese folklore, the goddess Chang'e lives on the moon in the Moon Palace. She is accompanied by a Jade Rabbit, who can be seen in the moon hunched over his mortar and pestle "making herbal medicines," and a woodcutter named Wu Gang, who was banished there after trying to steal immortal elixirs, and doomed for eternity to cut down an endlessly growing cassia tree.

56. Beijing's CBD, or Central Business District, is the financial, media, and business center in the capital. CBD is located east of the city center, between the Third and Fourth Ring Roads, approximately four kilometers directly east of Tiananmen Square. Beijing's CBD houses the China World Trade Center, a new embassy district, and the new CCTV headquarters, designed by Rem Koolhaas.

57. Ping'an and Liangguang avenues are two parallel arteries cutting horizontally across the city, and located north and south of Beijing's main east-west road Chang'an Avenue, respectively. The development and expansion of these two roads in the late 1990s was part of a new urban planning initiative in Beijing.

58. The concept of "Building a Socialist Harmonious Society" was introduced as a measure to improve party governance, and appeared early on in an address by President Hu Jintao in September 2004 at the fourth plenum of the 16th Communist Party of China Central Committee. The concept of social harmony is the primary rhetoric behind Hu Jintao's leadership, a program aimed at redressing social tensions caused by economic reforms. According to the plan, a harmonious society is dictated by harmony between people, between the Party and the masses, between cadres and the masses, and between neighbors. It was proposed that "Harmony promotes development, and development will promote harmony." The imperative of constructing a socialist and harmonious society is also said to bring about a dynamic and creative, stable and ordered society.

59. The German-built Shanghai Transrapid train is the first commercial high-speed magnetic levitation, or maglev, line in the world. Construction began in March 2001 and public service commenced in January 2004. The train transports passengers 30 kilometers from Longyang Road station in Pudong to Pudong International Airport in 7 minutes 20 seconds, with an average speed of 160 mph. The Shanghai-Hangzhou Maglev Train was a second proposed line from Shanghai to Hangzhou; however, in March 2009 the project was suspended due to protests from the community.

60. After three years of construction, Beijing's West Railway Station was completed in 1996. It currently services 150,000 to 180,000 passengers daily. Despite the enormous cost of completing the station, the inferior construction of the building necessitated its closure on numerous occasions. Among other issues, glass ceilings broke, the floor leaked, and the central air conditioning malfunctioned. Government inspection teams discovered that construction quality was substandard as a result of corruption and the siphoning of construction funds; six officials were eventually arrested. Not only did Beijing residents complain that the building itself was ugly, its construction drained a lot of resources and revealed the high incidence of corruption.

61. Dutch architect Rem Koolhaas's (b. 1944) proposal for a new China Central Television headquarters was selected in December 2002, and ground broke on September 22, 2004. The building is located in Beijing's CBD district and is distinctive for its Moebius strip form.

62. In what is called the "Curse of 1976," national leaders Zhou Enlai, Zhu De, and Mao Zedong passed away in succession that year.

63. Yan Lei (b. 1965) is a painter and conceptual artist born in Hebei province, currently living and working in Beijing. "Super Lights" was a text accompanying the exhibition of the same name at Galerie Urs Meile Beijing-Lucerne, in Lucerne, Switzerland, August 31–October 15, 2005.

64. The Chinese government proposed a gift of two giant pandas to Taiwan in 2005. Significantly, the pandas' names are Tuan Tuan and Yuan Yuan, together implying *tuanyuan*, the Chinese for "reunite." The political nature of the gift was met with strong opposition and debate in Taiwan, although the pandas finally arrived in Taipei in 2008. The incident has since been dubbed "panda diplomacy."

65. One Chinese *mu* is roughly equivalent to a sixth of an acre.

66. The classical saying, "land of etiquette and ceremony" (*liyi zhi bang*), refers to China, a country that traditionally pays special attention to ceremonies and etiquette.

67. "Hypnosis and Fragmented Reality" was first published in the catalog accompanying the exhibition "Li Songsong: 'Hypnogenesis,'" Galerie Urs Meile Beijing-Lucerne (Beijing: November 4, 2006–November 25, 2006; Lucerne: December 16, 2006–January 27, 2007).

68. The *Black*, *White*, and *Gray Cover Books* (*Heipi shu*, *Baipi shu*, *Huipi shu*) are a series of underground publications edited by Ai Weiwei and curator/critic Feng Boyi (b. 1960) in the mid-1990s that documented artists' activities in China and introduced overseas international art to the mainland. Highly influential in their time, the books have been called manifestoes of the Chinese avant-garde and have acquired something of a cult following. The English translation "Cover Book" renders the Chinese title in its most literal form, though a more accurate translation would reflect the intended political pun. The "White Papers" (*bai pishu*) of the Chinese government are official documents that have represented the "official point of view" on matters from development to foreign policy since 1949. However, because the title "Cover Book" has already been in circulation, we use it here for consistency.

69. A version of "Documenting the Unfamiliar Self and the Non-self" was published in *Liu Li Tun: A Catalog of Rongrong & inri's Photography* (Beijing: Three Shadows Photography Art Centre; New York: Chambers Fine Art, 2006).

70. On the evening of July 16, 2006, the "temple slayer" Qiu Xinghua killed ten people at the Iron Tile Daoist temple in Shaanxi province. After spending weeks hiding in the countryside, Qiu was finally apprehended outside of his home on August 19 and sentenced to the death penalty. Because he had previously been suspected of mental illness, lawyers appealed his case, and Qiu's trial became the focus of a public debate on mental health law reform in China. Appeals were subsequently rejected, and Qiu Xinghua was executed on December 28, 2006.

2007 Texts

1. The "Friendlies" (*Fuwa*; literally, "dolls of good fortune") are the five mascots of Beijing's Olympic games. Their names—Bei Bei, Jing Jing, Huan Huan, Ying Ying, Ni Ni—spell out the Hanyu pinyin for "Beijing Welcomes You," *Beijing huanying ni*. Parodies or copyright

infringement of the mascots, whose images were plastered around Beijing ever since their very ceremonious launch in November 2005, were met with severe censorship and legal action.

2. Wang Xingwei (b.1969) is a painter living and working between Shanghai and Beijing. "Rowing on the Bund" was written for Ai's blog on the occasion of Wang Xingwei's exhibition "Large Rowboat" at Galerie Urs Meile Beijing-Lucerne (Beijing: February 3–March 31, 2007; Lucerne: May 12–June 20, 2007).

3. Wang Xingwei's painting *Untitled (Hugging a Mushroom)*, 2006, is representative of one of the artist's visual tropes. In the painting, a man embraces a giant red-and-white-topped mushroom.

4. The Shanghai Bund is perhaps the most renowned symbol of Western occupation in China. Initially a British settlement, the Bund was internationalized during a building boom at the end of the nineteenth century, when it also became China's center of trade and banking. The nearly mile-long strip lies on the western banks of the Huangpu River overlooking the wharves of Shanghai's Pudong district, the city's new symbol of economic strength. Architecture on the Bund includes examples from various styles such as Romanesque, Gothic, Renaissance, baroque, neoclassical, Beaux-Arts, and art deco.

5. Beginning in September 2006, there were three rabies deaths in the village of Gaofeng in the Chongqing region of Sichuan province. On February 17, 2007, another death occurred in neighboring Wanzhou county, making officials nervous that the ratio of rabies deaths was too high in that small, concentrated area. Even though China loses an estimated two thousand people every year to rabies, Wanzhou officials decided to take drastic action to control what they viewed as a rising epidemic. On March 1, local governments designated a district within which all citizens, including those in Wan Chuan county, were given fifteen days to dispose of their own dogs; after that, all dogs would be forcefully eliminated. No official figures were released on exactly how many dogs were killed in this massacre. This was not the first nor the last such elimination and "control" of canine populations in greater China.

6. Fu Xiaodong (b. 1977) is a curator living in Beijing.

7. *Template*, one of Ai's works for the 2007 Documenta, was a 720 x 1200 x 850 cm pinwheel-shaped structure constructed of 1,001 discarded windows and doors from the Ming and Qing dynasties. *Template* was originally installed in Kassel, Germany, for Documenta 12, but shortly after Kassel inspectors had deemed it structurally unsound, a strong gust of wind blew it to the ground (on June 20, 2007). Ai's reaction was contrary to the expectations of the European organizers; he was thrilled with the collapse, declaring the fallen *Template* even better than the original work.

8. "Beijing Welcomes You!" (*Beijing huanying ni*) was a major propaganda slogan during the approach of the 2008 Olympic Games. As a result, the mere word "welcome" had political undertones during that time, when the city was covered with the phrase.

9. This figure was a new estimate, first reported by Xinhua news sources on December 4, 2007, that coincided with a population forum held in Beijing at the same time. A breakdown of the figure indicated there were 12.3 million registered residents of Beijing and 5.4 million transients.

10. In December 1937, Nanjing, the capital of the Republic of China, fell to the Japanese Imperial Army, which subsequently launched a massacre lasting six weeks and ending in the deaths of an estimated 300,000 people, mostly civilians and POWs. In an unforgettable war crime, now known as the Nanjing Massacre or the Rape of Nanjing, the Japanese Imperial Army indiscriminately slaughtered scores of people, and over twenty thousand cases of rape were reported. While many facts (including the death toll) are still widely disputed, the event remains one of the most painful events in China's collective memory.

11. The "Three Represents" are viewed as Jiang Zemin's contribution to Chinese socialist theory. He first formulated the theory in 2000 on a "southern inspection tour" of Guangdong province, saying in a speech in 2002: "In order to enter a new phase of building socialism with Chinese characteristics, the Chinese Communist Party must hold high the great banner of Deng Xiaoping Theory and adhere to the important idea of the Three Represents." According to the three "represents," the Communist Party should represent the development trends of advanced production capacity, the progressive direction of China's advanced culture, and the fundamental interests of the broad majority. The irony here is that the "Three Represents" still remain incredibly ambiguous.

2008 Texts

1. In a dramatic media spectacle, director and photographer Zhang Yuan (b. 1963) was arrested in his Beijing apartment while using drugs in the early morning hours of January 9. Footage of the raid was aired on national television. Zhang's urine tests were positive for methamphetamines; thus he was charged with drug use and possession, and subsequently detained for ten days before being released. The event was widely interpreted as a warning to people in the entertainment industry to curtail drug use.

2. Nanniwan is the name of a narrow gorge near the communist base established at Yan'an, Shaanxi, during the Second Sino-Japanese war. In an effort to boost their economic self-sufficiency, the communists began experimenting with opium production in 1941; by 1943 the program was determined a success, and the revolutionary song "Nanniwan" was commissioned. The song is still a famous revolutionary tune today, even if many people aren't aware that "crops everywhere" and the "fragrant flowers in baskets" are references to opium poppies.

3. On January 19, 2008, Ai Weiwei was one of four individuals to be honored by *Southern Weekly* (*Nanfang zhoumo*) as an important person of the year 2007 for cultural creativity and contributions, due to his work *Fairytale*. "We Have Nothing" is a version of the speech he gave at the awards ceremony, which he delivered after other recipients had praised the developing state of cultural creativity.

4. The "Friendlies" were the five mascots of Beijing's 2008 Olympic games. (See 2007 texts, note 1.) Watching the CCTV Spring Festival Gala on the eve of the Lunar New Year has become a tradition for middle-class Chinese families. Since the first live broadcast of the CCTV gala in 1983, it has evolved into an extravagant variety show including comedy skits, Chinese stand-up comedy known as cross-talk (*xiangsheng*), traditional opera, acrobatics,

magic, choreography, and celebrity appearances. Increasingly since the 1990s, programming has included shades of the upcoming year's political agenda and featured highlights of the previous year's political campaigns. The gala broadcast has an estimated 700 million viewers each year, and is replayed numerous times over the holiday season, inevitably becoming a widely critiqued and discussed topic in Chinese media.

5. Jiang Wen (b. 1963) is a renowned actor and director living in Beijing. He became famous in 1986 playing opposite Gong Li in *Red Sorghum* (dir. Zhang Yimou). He also directed and starred in *Devils at the Doorstep* (2000), which won the Grand Prix at the Festival de Cannes. His most recent film, *The Sun Also Rises* (2007), is a tale with interwoven plots set in a Yunnanese village, the Gobi Desert, and a college campus, but Jiang's experiments with magical realism in the film were met with poor ticket sales and overwhelmingly negative reviews in China.

6. This text was first published in *Southern Weekly*. The "1,001 brave Chinese" were the people who traveled to Kassel for Ai Weiwei's *Fairytale*, a part of Documenta 12 (2007).

7. "Light as a Feather" was first published as a foreword to Christopher Makos, *Andy Warhol in China* (Hong Kong: Timezone 8, 2008).

8. "Daquangou, Zhao Zhao Solo Exhibition" was on display at the China Art Archive & Warehouse from April 5 to May 5, 2008.

9. On March 10, 2008, which was the forty-ninth anniversary of a failed uprising by Tibetans against Chinese rule in 1959, demonstrations in Lhasa began when an estimated three hundred monks gathered peacefully outside of a temple, demanding the release of imprisoned monks who had been detained since the previous autumn. They were dispersed with violence and arrested, triggering more intermittent protests until the city erupted into violence on March 14. Chinese Premier Wen Jiabao accused the Dalai Lama of masterminding the violence, and government officials blamed the unrest on separatist motivations. The Dalai Lama maintains the riots were caused by protracted discontent among ethnic Tibetans, and has said that violence isn't the way to advance the Tibetan cause.

Xinhua reported that "rioters injured 623 people, including 241 police and armed police, and killed 18 others. They also set fire to more than 300 locations, mostly private houses, stores, and schools, smashed vehicles and damaged public facilities." Tibetan rioters appear to have targeted property owned by the Han Chinese and the Muslim minority; mobs of Tibetans were also said to have attacked ethnic Chinese on the streets. The incidents generated deep feelings of nationalism throughout China, fueled by what was seen as "anti-China" sentiments from news sources such as CNN, and conflicting points of view emerged highlighting the difference in perspective in media reports from Chinese and Western sources. While some Western media implied sympathy toward the Tibetans, Chinese media highlighted Tibet's "pre-liberation" feudal history and slave labor policies, condemning the Tibetans' actions as an unappreciative betrayal of a desire to help develop China's west. The response to the riots highlighted the great cultural divide between China and the West over the "Tibet issue."

10. On Monday, May 12, 2008 at 14:28 local time, an earthquake of magnitude 7.9 and lasting about two minutes struck Sichuan province; its epicenter was in Wenchuan county, 80 kilometers northwest of the provincial capital of Chengdu, and thus it is known as the Wenchuan earthquake (*Wenchuan da dizhen*). Official figures (as of this writing) confirmed 69,225 dead, 374,640 injured, and 17,939 missing. The disaster also left an estimated 4.8 million people homeless, although some estimates put the number as high as 11 million. The Wenchuan earthquake was the deadliest earthquake to hit China since the Tangshan earthquake in 1976.

11. "Silent Holiday" was posted on June 1, which is celebrated as Children's Day in China, Russia, and many other formerly communist countries.

12. China's central government acknowledges that 6,898 school buildings collapsed in the Wenchuan earthquake, and many parents attributed their collapse to the substandard construction of the schools. The phrase "tofu-dregs engineering" (*dofuzha gongcheng*) began circulating in the media to describe these shoddy buildings, and soon led to allegations of corruption by the Sichuan Ministry of Education and contractors, who were believed to have been complicit in constructing the school buildings dangerously below government-mandated standards while pocketing the remaining surplus. Grieving parents and journalists pointed out that hundreds of schools collapsed instantly, while buildings nearby were often unscathed. The loss of their children was especially painful because of the PRC's One-Child Policy. Due to the scandal surrounding the schools' inferior construction, many bereaved parents were silenced; in some places parents were forcibly kept away from the ruins, and others were detained or coerced into signing agreements disallowing them to speak to journalists or to petition investigations into the collapsed schools.

13. The anniversary of the Tiananmen Incident, June 4, 1989.

14. Only a few weeks after the devastating Wenchuan earthquake, American actress Sharon Stone commented during a red-carpet interview at the 2008 Cannes Film Festival, "I've been concerned about how we should deal with the Olympics, because they are not being nice to the Dalai Lama, who is a good friend of mine." She continued, "Then all this earthquake stuff happened, and I thought, is that karma? When you're not nice, that bad things happen to you?" Her comments met with furious criticism from the Chinese media and a ban on films featuring the actress in mainland cinemas.

15. Yu Qiuyu (b. 1946) is a prominent Chinese author, intellectual, and cultural commentator. Shortly after the Wenchuan earthquake, he published a controversial article titled "With Tearful Eyes, We Advise the Bereaved Parents of Schoolchildren," in which he suggested that to avoid being tools of the Western media, parents should stop petitioning the government to take responsibility for the tofu-dregs engineering. Yu told the parents to not get excited, lest the "anti-China media," who were looking for excuses to criticize China, use their sorrow against the Chinese people by making their government look bad. Following criticism, his article was later removed from online sources.

16. Fan Meizhong was teaching literature to his class when the earthquake struck, at which point Fan shouted "earthquake," and bolted out of the classroom, leaving his students behind. Pitted against those whose tales of earthquake heroism were praised in the media, the notorious "running teacher Fan" (*Fan paopao*) owned up to his actions in interviews, even though he was met with severe criticism and national condemnation. Fan said, "I ran toward the stairs so fast that I stumbled and fell as I went. When I reached the center of the football pitch, I found I was the first to escape. None of my pupils was with me." His explanation was simple: "I have a very strong sense of self-preservation. ... I have never been a brave man and I'm only really concerned about myself."

17. In the forty-day period before and after the Chinese Spring Festival, migrant workers, students, and others travel to their hometowns to spend the holiday with family; the subsequent strains on the transportation industry is known as *Chunyun*, literally "spring transport." During this internal migration of truly epic proportions, an estimated two billion single journeys are made within the mainland alone, amounting to the movement of one-third of the world's population. In 2008, severe snowstorms in central, eastern, and southern China struck at the height of *Chunyun*. Snowed-in provinces, ill equipped to deal with the storms, were hit hard, and the home-bound travelers were stranded in stations for days. The resulting power outages and rail and road closures caused severe problems in sheltering, feeding, and treating the stranded passengers, who were said to have numbered more than 77 million. On February 2, the Guangzhou Public Security Bureau released news of a tragic accident in which a young woman was trampled to death while trapped inside the Guangzhou train station.

18. The 2008 Olympic torch relay, a 85,000-mile "journey of harmony," was held from March 24 to August 8, along a highly anticipated route which the Chinese media followed with much enthusiasm. After being lit in Athens, the torch made politically symbolic appearances in St. Petersburg, Pyongyang, Taiwan, and Tibet (where it was carried to the top of Mount Everest, known as Mount Qomolangma in China), touching base on each continent. In Chinese cities that hosted the torch, streets along the route were packed for hours in advance, making it nearly impossible for spectators in the crowd to see the flame.

The torch relay became an object of nationalist pride when it came under attack from pro-Tibetan independence and human rights activists protesting along the torch route in Paris and London. In Paris, wheelchair-bound torchbearer Jin Jing was attacked by protesters attempting to extingush and snatch the flame. This incident, like so many others, was a great insult to national pride, another incident that "hurt the feelings" of the Chinese people.

19. "Socialism with Chinese characteristics" or the "socialist market economy" is a concept introduced by Deng Xiaoping which has gradually replaced the centrally planned economy in China. It is also sometimes referred to as "socialism with special characteristics"; according to the *People's Daily*, "Socialism with Chinese characteristics is something that combines the basic principles of scientific socialism with the facts of building socialism unique to China."

20. On March 31, eighteen China Eastern flights flying outbound from their local hub, the

Yunnan provincial capital of Kunming, turned around mid-route and returned to Kunming before arriving at their destinations. Their mid-air strike caused more than a thousand passengers to be detained at the airport. On April 1, more flights returned unexpectedly to their home base in Kunming. China Eastern tried to explain these aborted flights by citing "weather reasons," but a more likely reason was their pilots' long-standing dissatisfaction with low salaries.

21. "Compulsory donations" are required of most Chinese work units in the event of natural disasters; this was also the case in the Wenchuan earthquake. Although there is no limit to one's donation, a mandatory offering of RMB 50 was required from each worker.

22. The head of the Shandong Writers' Association, Wang Taoshan, wrote a poem in which he called the victims of the Wenchuan earthquake "fortunate ghosts." The phrase met with criticism from Chinese netizens.

23. On October 12, 2007, Shaanxi province forestry officials held a news conference to announce "evidence" of an endangered South China Tiger seen in Zhenping county, where the animal was already considered extinct. They released two photographs taken by Zhou Zhenglong, a farmer and former hunter who claimed to have captured the tiger on film after a month-long hunt. However, the authenticity of the photos was immediately called into question by blogger and botanist Fu Dezhi, from the National Academy of Sciences, who claimed they must be fake. The incident sparked a controversy over truth and credibility known as the South China Tiger Scandal. The Zhenping county government was suspected of trying to boost tourism by claiming the rare animal was still found in their forests, and angry netizens demanded more proof. Zhou maintained that the photos were real, going to great lengths to describe his hunt and the location where he took the photos, even saying that the tiger had roared when the flash lit.

After increasing public pressures, on June 29, 2008, county officials finally admitted they had paid RMB 20,000 (US $2,900) to Zhou for the photographs. Thirteen government officials in Shaanxi were fired and Zhou was convicted with fraud in September. The outcome of the South China Tiger Scandal is considered a victory for citizens, accountability, and truth.

24. Meaning that the Public Security Bureau will mete out harsh justice to the little folk and be lenient with the powerful.

25. The Weng'an riots erupted on June 28, 2008, in Weng'an county, southwestern Guizhou province, when thousands of residents smashed government buildings and torched police cars in protest of what they believed to be a police cover-up of a young girl's death. The body of the girl, sixteen-year-old Li Shufen, was pulled from the river in the early morning of June 22. Li was last spotted with two young men with prominent family ties to the Weng'an public security bureau. Family and friends of the victim claim that she was raped and murdered before her corpse was thrown into the river; the government denied the claims and released statements saying the two young men involved were from local farming families. Initial police reports also claimed that the girl drowned after jumping into the river to commit suicide.

Li's family accused the police of shoddy investigation and corruption, and they were accompanied by hundreds of volunteers who helped guard the body for fear police would attempt to tamper with the evidence. On the day after Li's body was found, an estimated five hundred students attempted a protest at the Public Security Bureau, but were turned away with violence. Li Shufen's uncle was also allegedly beaten when he questioned the police, thus creating a series of events that aroused an angry mob who began overturning cars and setting fire to government buildings, including the local Communist party head-quarters, on June 28. The Associated Press reported that "30,000 angry citizens swarmed the streets," and that the riot lasted seven hours, resulting in 150 injured persons, damage to more than 100 government buildings, and the torching of almost 50 police vehicles. News and photographs of the riot were quickly deleted from the Internet, and Li Shufen's family was kept under house arrest to "protect national security." The family was eventually offered RMB 9,000 (US $1,300) from the government, with RMB 3,000 paid by each of the suspects, but the bereaved family refused, calling it an evil deal.

Instead of using the word "riots," Chinese media referred to the Weng'an events with the euphemism "smashing and burning," and repeatedly stated that the people behind the violence were "ignorant of the facts." With an estimated 1,500 riot police called to the scene, the Weng'an riots were one of the biggest such incidents of recent years.

26. Yang Jia (1981–2008) was born into a Beijing working-class family. His parents divorced when he was young and he lived in Beijing with his mother. On a visit to Shanghai in October 2007, Yang Jia was riding an unlicensed bicycle when patrolling Zhabei Public Security Bureau (PSB) officers detained and questioned him for bicycle theft. Because he was uncooperative and refused to show identification or bike papers, Yang Jia was taken into the Zhabei PSB, where according to his later testimony, he was severely beaten before being released. After returning to Beijing, Yang Jia attempted several times to petition the police for the beatings, to no avail.

On July 1, Yang Jia attacked a branch office of the Zhabei PSB, igniting eight petrol bombs outside the gate and then storming inside the building, randomly stabbing nine officers. Six died and four were seriously injured. Yang Jia also carried with him a hammer, particle mask, and tear gas. He was immediately apprehended, and was eventually tried behind closed doors on August 27, when he was found guilty of premeditated murder and sentenced to death. He was executed by lethal injection on November 26, 2008.

Despite Yang Jia's criminal actions, the public was infuriated with media censorship and the suspected cover-up of facts leading up to the event. Yang Jia's sympathizers multiplied, especially in Internet chat rooms and bulletins, where he was increasingly compared to the character Wu Song from the Chinese classic *Water Margin*. Wu Song's brother was eaten by a tiger, and Wu Song avenged him by killing the tiger with his bare hands.

27. The reporters from *Business Week China* (*Shangye zhoukan*) magazine who conducted the interview were Yuan Ying, Wu Jinyong, and Yu Liqi.

28. The "Friendlies" were the five mascots of Beijing's Olympic games; see 2007 texts, note 1.

29. This is a reference to filmmaker Zhang Yimou (b. 1951, dir. *Raise the Red Lantern* and

To Live), who is a Shaanxi native and director of the opening ceremony of the 2008 Beijing Olympics.

30. "One world, one dream" was the motto of the 2008 Beijing Olympics.

31. Three days of unrest began on July 10, 2008, in the coastal town of Yuhuan, Zhejiang province, after a security guard beat up a migrant worker who was trying to obtain a residence permit. When the worker, accompanied by a group of migrants, later attempted to file a complaint about the man who beat him at the local Public Security Bureau, he was detained. The events triggered a protest by hundreds of angry migrant workers who converged outside the PSB, smashing cars and motorcycles. Allegedly, three hundred military police arrived to stabilize the town, and thirty migrant workers were detained. Though scarcely referred to in the media, the incident is known as the "7.10" incident.

32. "Doing push-ups" (*fuwocheng*) became a popular Internet meme after the riots in Weng'an. It originated in one of the official police reports that stated, "the girl [Li Shufen] got into a quarrel with one of her male classmates who was with her at the river bank. Later, she seemed to calm down a little bit, so the boy began doing push-ups next to her. As he finished the third push-up, the girl suddenly jumped into the river." Using the phrase "doing push-ups" quickly became a euphemism for absurd excuses and official irresponsibility.

33. "Do what you must" (*Ni kanzhe ban ba*) was a statement made by Premier Wen Jiabao to army troops who were working in the earthquake rescue zone. The ambiguity of the comment struck Ai Weiwei as something a person with a lack of planning and forethought would say.

34. Zhou Zhenglong, later nicknamed "tiger hunter Zhou," was a key person in the South China Tiger scandal; see note 23 above.

35. Designs inspired by the Bird's Nest—or, more specifically, the appropriation of the characteristically irregular pattern of its steel supports—had already begun to appear all over Beijing in 2008. Similar weblike patterns have been spotted in discos, restaurants, and police stations, as soap containers, in plastic shoes, and elsewhere. Ai Weiwei served as a consultant to Herzog & de Meuron in the design of the National Stadium.

36. This is a specific reference to a quote in the media from a Chinese engineer working on the National Stadium, who (presumably in an effort to show his patriotism) said that he was working so hard that he was losing sleep, and was exhausted to the point of fainting.

37. Naval Marshall General Yamamoto Isoroku (1884–1943) was the commander-in-chief of the Japanese combined fleet during World War II, responsible for major battles such as Pearl Harbor and Midway.

38. SB is Internet usage for *shabi*, a vulgar insult.

39. A reference to the Sanlu milk powder scandal of summer 2008, in which toxic melamine powder caused kidney damage in thousands of infants, bringing great anxiety to milk drinkers and parents alike. See note 43 below.

40. See the blog post "Yang Jia, the Eccentric and Unsociable Type," above. Yang Jia's mother, whose real name is Wang Qingmei, was placed in a mental hospital by the authorities after the arrest of her son. On this practice, see also 2009 texts, note 6.

41. On Sun Zhigang, see 2006 texts, note 44.

42. On November 17, 2008, the Longnan local government, in Gansu province, announced its decision to relocate its administrative offices, and provoked two days of rioting and unrest. The decision was apparently made because Longnan is located on a fault line, and during the Wenchuan earthquake in May more than 300 people were killed in Gansu province, which neighbors Sichuan to the north. Longnan residents were reportedly upset, feeling their government was abandoning them without providing any protective measures for citizens. Others reports said that the disturbances were provoked by economic distress, rampant corruption, and a lack of transparency in the local Longnan Communist Party.

According to a statement issued by the Longnan municipal government, trouble began when more than thirty people whose homes had been demolished in the earthquake gathered at the city's Communist Party office building to petition the move. Officials said the civilians began attacking officials and police with rocks and metal batons, and eventually charged the building, breaking windows and burning whatever they could, including motorcycles and bicycles. Although it is impossible to confirm, eyewitnesses said the riots lasted two full days and involved more than ten thousand people, with seventy-four reported injuries. The reference in Ai's text is to an image he saw of protesters hurling stones at riot police.

43. In the summer of 2008, toxic melamine powder was discovered to be routinely added to infant formula, milk, and other dairy products; products by the Sanlu Corporation were found to have the highest concentration. Melamine powder is used in the making of plastics and fertilizers. When added to food products, it will falsely indicate a higher protein content, but its toxicity causes kidney stones and kidney failure.

Many people believe that news of the poisoned milk powder was hushed up in an attempt to avoid consumer panic during the Olympics. On September 15, nearly a month after convincing knowledge of the harmful effects of the milk powder had surfaced, Sanlu Corporation was finally ordered to halt production and an estimated nine thousand tons of product were recalled. In addition to Sanlu, twenty-one other dairies were found guilty of using the harmful melamine as an additive. At least six children died, and more than 300 thousand other infants fell ill as a result of ingesting melamine, which was later also detected in eggs, chocolates, and milk candies. Dozens of arrests were made, and in January 2009 the Chinese government began sentencing those involved in the scandal, including life imprisonment for former Sanlu executives and execution for two suppliers of the powder.

44. See note 38 above.

45. The universality of "universal values" (*pushi jiazhi*) came under attack by Chinese intellectuals who felt that the values of democracy, freedom, human rights, and equality were forced upon China by the West. Disputing the "objectivist" versus "relativist" nature of these values, they cite incidents in which the Western and Chinese points of view suffer from acute differences of opinion, such as the issues of Tibetan independence or the history of Taiwan.

46. On December 10, 2008, the sixtieth anniversary of the Universal Declaration of Human Rights, the "Charter 08" open letter to the Chinese government was published. Inspired by the "Charter 77" issued by Czechoslovakian dissidents in 1977, Charter 08 (*lingba xianzhang*) was a call for Chinese political reform, democratic reform, religious freedom, and freedom of speech. Three hundred and three Chinese intellectuals and human rights activists, including Ai Weiwei, signed the Charter 08, which led to a series of arrests and questioning for many signatories.

Since the public release of Charter 08, more than 10,000 people inside and outside China have signed, although perhaps the most significant consequence of the document to date has been the severe punishment of one of its authors, Liu Xiaobo (b. 1955), also a prominent activist during the Tiananmen student protests. On Christmas Day 2009, Liu Xiaobo was charged with "inciting to subvert the state" and sentenced to eleven years in prison, one of the harshest such sentences ever. It is believed that the sentencing occurred on Christmas morning as a measure to avoid greater exposure in the Western press.

47. Early on in his political career, Mao Zedong famously said, "Communists need to hold a leaflet in their left hands, and bullets in their right hands if [we] want to defeat the enemy." And throughout his lifetime, Mao consistently attached great importance to the "two shafts, literary and military"—the "military" being the shaft of the gun, and the "literary" being the shaft of the pen.

48. In December 2008, the Nanjing Jiangning District Real Estate Bureau Chief Zhou Jiugeng (b. 1960) made some inappropriate remarks to the media that incited the "human flesh search engine" (a loose group of citizen "net police" who use the Internet to seek out personal information on people) to investigate his background. The "flesh search" discovered that the brand of cigarettes Zhou was smoking were valued at RMB 1,500 a carton (US $220), and his imported wrist watch was valued at no less than RMB 100,000 (US $14,000), discoveries that inspired the great interest of the public. The incident sparked an investigation into Zhou's history, which eventually led to his being sentenced to eleven years in jail on counts of bribery.

2009 Texts

1. *Understanding China* (*Dudong Zhongguo*) is a series of educational readers for primary school children meant to introduce the foundation of Chinese ethics, literature, art, science, and folk arts to readers through ancient poetry, legends, and stories.

2. *Shanzhai* is a Chinese term used to describe imitation, knockoff, or pirated goods. The term was originally a classical reference to mountain stockades of thieves or warlords operating outside of government control; it literally means "mountain fortress." It first became popular in the Cantonese-speaking manufacturing areas of Shenzhen, where it was used primarily to describe pirated cellular phones and electronics (e.g., before it was released on the mainland market, the iPhone was sold in various incarnations as "myPhone" and the "*AiFeng*," which has similar pronunciation; both would be *shanzhai* versions). Later, the label

shanzhai was applied to anything that was adapted and produced for the local Chinese market. In January 2009, the term exploded on the Internet. *Shanzhai* was applied to a variety of do-it-yourself, local things: brand names and chain stores gone *shanzhai* became "KFG," "Haagon-Bozs," "Pizza Huh," "Bucksstar Coffee," and "addidas," "LW," or "Guggi." Not only are *shanzhai* products a fraction of the cost, they are often altered to meet local market demand; for example, cell phones are capable of holding two SIM cards, and portable MP4 players are produced with multiple earphone holes.

3. The Sanlu milk powder scandal of 2008 resulted in thousands of infants being poisoned from melamine powder in milk products produced in China. See 2008 texts, note 43.

4. According to the Chinese zodiac, 2009 was the Year of the Ox.

5. The "Two Meetings" (*lianghui*) are the National People's Congress and the National Committee of the Chinese People's Political Consultative Conference, which meet every March in the Great Hall of the People.

6. The mistreatment of petitioners (*shangfang zhe*), aggrieved or disgruntled citizens from the provinces who have come to Beijing seeking help from the central government, has evolved into a serious social problem and embarrassment for local Communist Party leadership. In late 2008, the media began to expose the illegal detention of petitioners in psychiatric hospitals. The story of Sun Fawu of Shandong province was one such shocking piece of reportage. Sun was incarcerated in a mental hospital for three months, drugged, and forced to sign an agreement that he would no longer petition before he was allowed to leave. If any province shows a rise in petitioners, it is seen as having failed governance. Attempts to reduce the "petition figures" in the national ranking system for provinces and cities have resulted in the hiring of bounty hunters who travel from provincial governments to Beijing to track down petitioners. The bounty hunters use various means, including incarceration in mental hospitals, to prevent them from filing.

7. These two Chinese delicacies, abalone and bird's-nest soup, are prized for their medicinal qualities, but they come with incredibly high price tags due to their rarity. Abalone (*baoyu*) is an edible species of sea snails prized for their meat and preferably eaten fresh on the half shell. "Bird's nest" is the saliva nest of the swift, and is one of the most expensive animal products consumed by humans today. The nests have a gelatinous texture when dissolved in water and made into soup.

8. In the "Shanghai pension scandal" of 2006, pension funds were illegally invested in real estate and public works projects in Shanghai. This corruption case resulted in the dismissal of several government officials, including high-ranking party members.

9. Hanyu pinyin was adopted as the standardized transliteration system for Mandarin Chinese in 2000. If the station call letters of China Central Television (currently "CCTV") were to be adapted to the Hanyu pinyin system, it would read "ZGZYDST."

10. Ai is comparing the Chinese Ministry of Education to that of North Korea (the Democratic People's Republic of Korea), whose Hanyu pinyin transliteration is *chaoxianminzu renmin gongheguo*, to which he adds the pinyin for "Ministry of Education" (*jiaoyu bu*). The "pet name" he refers to would be the same *jiaoyu bu*, with "SB" preceding it. ("SB" is Internet usage for *shabi*, a vulgar insult.)

11. On February 2, 2009, as Premier Wen Jiabao delivered a speech on the global economy at Cambridge University, a student protester interrupted him by blowing a whistle and shouted accusations that the university was "prostituting" itself by allowing a "dictator" to speak. The protester then threw his shoe at Wen Jiabao. The student, Martin Jahnke, a twenty-seven-year-old PhD candidate, stood up and shouted to the crowd: "How can you listen to this unchallenged?"

The Chinese community was outraged, but Wen publicly dismissed the incident, and urged Cambridge authorities to pardon Jahnke, quoting a Chinese proverb, "It is more precious than gold for a young man to turn around and make up for his mistakes." The Cambridge police charged the offender with a public order offense, and on June 3, 2009, Jahnke was found not guilty at Cambridge Magistrates court.

12. The British prime minister had never officially apologized for the Cambridge "shoeing," saying instead that it was a "matter of deep regret."

13. Beijing residents have given Rem Koolhaas's CCTV tower the nickname of the "Big Underpants." Imagining the building's two supporting towers as "legs" helps one to understand this metaphor. Other, more lewd insinuations implied that the structure was a squatting female. Academics and architects vented anger online, accusing Koolhaas of intentionally making this sexual allusion.

14. The traditional Lunar New Year celebration lasts for fifteen days, from the first new moon until the first full moon of the year on the fifteenth day, which is known as the Lantern Festival. The fifteenth day is customarily celebrated with a great display of fireworks. According to Beijing law in 2009, the Lantern Festival was also the last day that fireworks were allowed in the city.

15. According to astronomical interpretations by Chinese astronomers, the February 2009 full moon was to be the largest and closest to the earth in fifty-two years; it was also the deepest penumbral eclipse of 2009.

16. Dr. Henry Norman Bethune was a Canadian physician known for his heroism in the Spanish Civil War and the Second Sino-Japanese War. Bethune made great technical advances in frontline emergency surgery, and developed the first mobile blood transfusion unit. He died on the Chinese front lines in 1939, but lives on in Chinese history and literature as a heroic figure and revolutionary.

17. Capital punishment in China today is primarily carried out by firearms, with a small minority receiving lethal injection. Beginning in the 1950s, the government collected a symbolic fee for the bullet used in the execution (*zidan fei*). Although the fee was apparently still being collected in the early 1980s (online sources cite a bullet fee during the mass executions in the first Strike Hard campaign), relatives are no longer required to pay the nominal bullet fee upon collecting the remains.

18. "Spring Tale" (*Chuntian de gushi*) is a political song extolling Deng Xiaoping's great reforms. Its verses allude to Deng's economic reform policies and their subsequent successes beginning in spring 1978 through his famous southern visit in spring 1992, when the song was composed. Played widely during the 1990s, it is now a familiar tune to most mainland Chinese, and was widely played again following Deng's death in 1996.

19. The Strike Hard campaigns are aggressive crime-fighting measures first proposed by Deng Xiaoping to control crime booms. There have been three Strike Hard campaigns to date: the first was in 1983, followed by another in 1996, and again in 2000, when a "Strike Hard for the New Century" included Internet-aided manhunts. Reportedly, in March 2009 a Strike Hard campaign was carried out in Tibet in anticipation of the fiftieth anniversary of the first Tibetan rebellion, and again in November 2009 throughout Xinjiang province following ethnic unrest. The official rationale behind the Strike Hard programs dictated that China could not copy the "light punishment" systems used in Western countries, and needed more severe, harsher punishment. Sentences are doubled during these campaigns and punishment is meted swiftly. Executions are also increased during Strike Hard campaigns, prompting some human rights groups to call them "execution frenzies."

20. The Yang Jia case erupted in July 2008, after this 27-year-old man massacred several police officers at a local Shanghai police station. See 2008 texts, note 26.

21. Hu Changqing (1948–2000) was a high-ranking Chinese official from Jiangxi province charged with corruption; he was executed on March 8, 2000. At the time he was the highest-ranking official executed in the history of the PRC. Only six months later, Cheng Kejie (1933–2000) from Guangxi province was charged with bribery, becoming the highest-ranking official to be executed (on September 14, 2000).

In a crime that shocked the nation, Ma Jiajue (1981–2004), a college senior at Yunnan University, killed four classmates with a hammer and hid the bodies in their cabinets; he was executed on June 18, 2004. Qiu Xinghua (1959–2006), nicknamed the "temple slayer," and suspected of mental illness (see 2006 texts, note 70), was executed on December 28, 2006.

22. "Development is hard logic" (*fazhan shi yingdaoli*) is one of the key points in speeches Deng Xiaoping delivered during his famous Southern Inspection Tour.

23. *Inspiring China* (*Gandong Zhongguo*) is an annual television program that has been screened during the Spring Festival since 2002. Each year ten outstanding Chinese people are chosen and praised as inspirational figures and model citizens. They range from political figures to sports stars or literary figures, and also include average people doing extraordinary things.

24. The Buddhist term *Anātman* (Sanskrit) is an adjective for the absence of a supposedly permanent and unchanging self or soul, the state of forgetting one's self.

25. "P citizens" (*pi min*) is an Internet term that came into vogue after a misbehaving official was caught on surveillance camera saying that he could do whatever he wanted, and calling others around him "*pi*" citizens. "*Pi* citizens" literally means "flatulent citizens"; the term was shortened to "P *min*" online, and is used ironically. "SB" is the Internet abbreviation for the vulgar expression *shabi*.

26. Extravagant official celebrations were planned for October 1, 2009, the sixtieth anniversary of the founding of the People's Republic of China. Ai's remark here is sarcastic.

27. The CCTV fire claimed the life of one Beijing firefighter and hospitalized seven others, including six firefighters and one construction worker.

28. After the passing of Yves Saint Laurent in June 2008, his partner, Pierre Bergé, announced the auction of the designer's collection of art objects at Christie's in February

2009. The collection contained two bronzes from the Qianlong period, the heads of a rabbit and a rat that originally belonged to a set of twelve Chinese zodiac animals composing a clepsydra, or water clock, at the Old Summer Palace (Yuanmingyuan). The bronze animals were looted by British and French troops during the destruction of the Old Summer Palace in 1860, an incident that still inflames Chinese national pride. Thus, the return of this particular set of bronzes is imbued with patriotic self-esteem and a burning desire for redress. The effort to return this set of bronzes, as well as other art objects looted from China, has been the focal point of much recent media attention.

Initially, various Chinese associations attempted to use legal action to stop the two heads from appearing at auction, but French courts dismissed Chinese claims on the objects, as well as subsequent demands that the bronzes be returned. A team of lawyers unsuccessfully urged Bergé and Christie's to stop the February sale. China didn't want to simply buy the bronzes back, but maintained that the "looted objects" should be returned under the 1995 Unidroit Convention on Stolen or Illegally Exported Cultural Objects, which was signed by both China and France. Further provoking Chinese anger, at one point before the sale Bergé said he would return the heads when "China respects human rights and frees Tibet."

On February 25, Christie's auctioned the Yves Saint Laurent collection, and rabbit and the rat sold to an anonymous bidder over the phone for a total of EUR 28 million. Shortly afterward, the identity of the bidder was revealed as Cai Mingchao, an advisor to China's National Treasures Fund. Cai had no intention (nor the financial resources) to pay for the bronzes, and had intentionally sabotaged the sale, claiming that he acted on moral and patriotic grounds. Bergé later turned down the option to sell the objects to the second-highest bidder, deciding instead to leave them in his possession.

29. The phrase "eluding the cat" (*duo maomao*), the Chinese name for hide-and-seek, became one of China's most explosive Internet memes after twenty-four-year-old Li Qiaoming died of suspicious causes while incarcerated in a prison in Jinning city, Yunnan. After Li Qiaoming died on February 12 as a result of a severe brain injury, local police explained that Li had been injured while playing "eluding the cat," and that he "bumped into a wall after being kicked by another prisoner." The highly unlikely death from "bumping into a wall" prompted an explosive response from netizens, and the term "eluding the cat" joined such catchphrases as "doing push-ups" and "getting the soy sauce" used to criticize official cover-ups and shirking of responsibility.

30. Aisin Gioro was the clan name of the Manchu emperors of the Qing dynasty, the second "foreign" dynasty to rule China (from 1644 to 1911), after the Mongols founded the Yuan dynasty. In the Manchu language the word *aisin* means "gold" and *gioro* means "clan." The twelve heads were designed by an Italian Jesuit artist in Emperor Qianlong's court, Giuseppe Castiglione (1688–1766), who supervised their manufacture in China.

31. "Guests from All Corners of the Earth" was an online interview Ai Weiwei held with the general public on March 23, 2009, to address issues raised by the Citizen Investigation.

32. After the earthquake, the Chinese media took interest in donations made by various celebrity figures. Asked numerous times how much money he had donated, and upset by the way donations were serving as a public measure of patriotism, author/blogger Han Han

rejected the entire system, deciding to travel to the disaster scene to see what donations might be more useful than money. His trip had various sponsors, including car companies that supplied him with SUVs for ground transportation.

33. "Disasters revitalize a nation" (*Duo nan xing bang*) is a patriotic idiom meant to inspire a nation faced with tragedy with the courage to surmount difficulties. The concept can be traced back to the *Chronicles of Zuo* (*Zuozhuan*) from the fourth century BCE, and was famously employed by General Li Hongzhang (1871–1895) in the late Qing period in reference to the invading foreign powers in China. Purposefully, Premier Wen Jiabao invoked the same saying again during a Sichuan classroom visit after the earthquake, where high school students were especially worried because of the approaching *Gaokao* (national-level college entrance exams). They were given a few extra weeks to prepare for the exam, and when Wen visited them, he wrote these four characters on the blackboard in an effort to inspire them.

34. The word "liberation" (*jiefang*) is used to reference the 1949 communist takeover of China, which is simply referred to in Chinese as "liberation." In a similar linguistic idiosyncrasy, Tibet was "liberated" in 1953.

35. The Karamay Fire of 1994 broke out in a theater in Karamay, Xinjiang province. Of the more than one thousand people in the theater, 325 were killed, of whom 288 were school children. It is assumed that so many children died because students and teachers were ordered to remain seated while Communist Party officials exited the theater first.

In the spring of 2008, Fuyang children in Anhui province suffered an unnecessary outbreak of Enterovirus 71, also known as hand, foot, and mouth disease. News blackouts and the spread of misinformation about the disease led to mass infections, with more than three thousand cases in Fuyang alone. The incident became what some people called a "mini-SARS."

Henan province has been devastated by AIDS, which was spread in epidemic proportions in the early 1990s through illegal blood collection vans. According to figures released by the United Nations Children's Fund in 2005, there are 70,000 to 80,000 AIDS orphans across the mainland, including those with only one parent. Many of them are concentrated in Henan province, the hardest-hit area of China.

The name Shanxi "black-kiln children" is given to the estimated hundreds of children who are trafficked into slave labor and forced to work in brick kilns.

36. By the time this post was written, the Citizen Investigation was well under way, with volunteers traveling to and from Sichuan province and calling daily from Ai's Caochangdi office. Lists of student names were posted on the blog, only to be promptly deleted by Sohu, the blog host, under pressure of course from authorities. Deleted posts were all reposted soon after under the heading "deleted contents."

37. 110 is the emergency number, equivalent to 911 in the United States.

38. Liu Xiaoyuan is a human rights lawyer and well-known blogger based in Beijing; in 2007 he attempted to sue his blog host for censoring posts.

39. The title "Domestic Security 'Rice Cookers'" (*dian fanbao*) is a play on the Chinese word for "domestic security officers" (*guobao*). Ai explains that he chose the "rice cooker"

because it is something extremely common and found in every household, an object for household use just as officers are tools of the state, which should be upgraded for the times, just like an appliance.

40. This is a reference to the approaching twentieth anniversary of the massacre in Tiananmen Square on June 4. Crackdowns and increased censorship before such "black anniversaries" are common in China.

41. Green Dam Youth Escort (*luba huaji huhang*) is software developed in China, intended to control Web content and to block sites through its installation on personal computers. In May 2009, the government mandated that every computer sold in China, whether manufactured domestically or overseas, must preinstall the Green Dam software, beginning on July 1. The Green Dam software is programmed to automatically update a list of forbidden Internet sites. Although supposedly developed to block pornography, it could easily be expanded to include politically sensitive Web sites. The law was never enacted, and although schools are required to install the software in all on-site computers, its installation remains a personal decision for computer owners.

42. An entire mythology has developed around the Grass Mud Horse, a fictional animal and Internet meme that was created after a massive 2009 Internet clean-up campaign. Under the guise of an "anti-vulgarity" campaign, censorship became the most severe it had been in years. Not only pornographic sites were targeted; online discussion groups, blogs, BBS boards, and other sites related to politics and current affairs were also closed down. The response from Chinese netizens came in the form of the "Grass Mud Horse," whose Chinese name (*cao ni ma*) has the same pronunciation as, but different tonal inflection from, "XX your mother." According to the tale of the Grass Mud Horse, the endangered mythical beast lives in the "Mahler Gobi Desert" (*ma le ge bi* = "curse your XX") and its very existence is threatened by the ravenous encroachment of the River Crabs (*he xie*), whose name is a similar pun on "harmonization," a euphemistic term for official censoring or deletion of undesirable content from the Internet. The voracious River Crabs compete for the "fertile grass" (*wo cao* = "XX me!") that constitutes the Grass Mud Horse's primary diet.

Songs and videos began circulating on the Internet as the meme gained momentum; stuffed toys and T-shirts were sold with the form of an alpaca representing the Grass Mud Horse. Unfortunately, when authorities caught on, Grass Mud Horses and all related references were deleted, censored, or "harmonized."

43. On July 1, 2009, Ai Weiwei organized a "day without the Internet" boycott to protest the legislation.

44. "140 Characters" is a selection of tweets that were microblogged as violence was erupting in Xinjiang province in July 2009. Relations between the Han Chinese minority and the native Uyghur people of the Xinjiang Autonomous Region have been strained for decades, often resulting in violent ethnic clashes. None, however, has been as serious as the violence that stunned China in July 2009. The immediate cause of the violence was the death of two Uyghur workers in a toy factory in Guangdong province on the evening of June 25. A Uyghur worker relocation program had brought large populations to the

southern, predominantly Han region to deal with labor shortages, and ethnic tensions had mounted in the factory, where workers live in close quarters and share dormitories. Allegations of sexual assault on a Han female employee led to a full-scale riot on the factory premises, which resulted in the death of the two Uyghur employees and injuries to 118 others. Factory officials later released information that a disgruntled worker had spread rumors of rape, and claimed there was no evidence of a sexual assault.

Uyghurs in Xinjiang and abroad were dissatisfied with the way the situation was dealt with, and organized a protest in Ürümqi on July 5. At least one thousand people showed up in the city's People's Square. Eventually violence broke out, with Uyghurs attacking Han, and more than 190 people were killed and 1,700 injured, according to Xinhua sources. Intermittent outbursts of violence lasted until September.

45. Three forces were said to be behind the Xinjiang riots: religious extremism, ethnic separatism, and international terrorism.

46. Riots erupted in Shishou city, Hubei province, after the mysterious death of a twenty-four-year-old hotel employee roused public suspicion. On June 17, 2009, Tu Yuangao's body was found on the ground outside of the hotel where he was employed, after he allegedly jumped from a third-floor window. However, the lack of blood at the scene and reports by some witnesses who had seen several bloody wounds on his head led his family and others to suspect that he had been beaten to death before falling from the window. The owner of the hotel, a relative of Shishou's mayor, was suspected of murder, and subsequent forceful attempts to remove the body from funeral services in order to cremate it were met with resistance from relatives, who wanted to protect the evidence until details of the case were clarified. Sympathetic locals began to gather at the hotel in protest, and crowds amassed over June 19 and 20. Eyewitnesses estimate the crowd at three to ten thousand; the protesters burned the hotel facade and smashed police cars until riot police contained the protests.

47. Rebiya Kadeer (b. 1947) is a prominent Uyghur human-rights advocate and business-woman who was accused of being the chief conspirator behind the Xinjiang riots. Messages she sent on July 5, 2009, were widely circulated in the media as "proof" of her involvement. The messages included the comments "Be brave" and "Something big is going to happen."

48. Fanfou.com was the earliest Twitter imitation in China, opened in May of 2007. One day after the July 5 Ürümqi riots, journalist keyword searches into Fanfou froze the system; just days later it was impossible to log in, and Fanfou and the other popular Chinese micro-blogging site Jiwai.com were simultaneously shut down.

Epilogue

This interview is translated from the Chinese.

1. *Laoma tihua* (75 min., 2009) is a documentary record of Ai's August 2009 trip to Chengdu to testify for Tan Zuoren.

2. The four documentaries are *Hualian ba'r* (78 min., 2009), which documents the process of collecting the names of students killed in the earthquake in Sichuan; *Laoma tihua*; *4851* (87 min.), a list of the names of the student earthquake victims; and finally *Feng Zhenghu hui*

jia (Come Home Feng Zhenghu, 22 min., 2009), which documents the plight of Shanghai-based human rights lawyer Feng Zhenghu, who camped out in the Tokyo Narita Airport after being repeatedly denied entry to China, the country of his citizenship.

3. On January 21, 2009, in an address at the Newseum in Washington, D.C., Secretary of State Hillary Clinton made remarks on Internet freedom which were felt hard in China. She compared digital information barriers to the Berlin Wall, and she called for "Information Freedom," directly invoking China's and other nations' policies and attempts to control information. In January, as China was struggling with Google's decision not to censor search results from behind her "Great Firewall," Clinton's speech was very timely.

CHINESE NAME EQUIVALENTS

Ai Qing 艾青

Ai Weiwei 艾未未

Cai Mingchao 蔡铭超

Chen Danqing 陈丹青

Cheng Kejie 成克杰

Dou Wei 窦唯

Fan Meizhong 范美忠

Feng Boyi 冯博一

Fu Dezhi 傅得志

Fu Xiaodong 付晓东

Gao Ying 高瑛

Han Han 韩寒

He Yunchang (Ar Chang) 何云昌 (阿昌)

Hu Changqing 胡长清

inri 映里

Jiang Haicheng 蒋海澄

Jiang Wen 姜文

Jiang Yanyong 蒋彦永

Li Qiaoming 李荞明

Liu Xiaobo 刘晓波

Liu Xiaodong 刘小东

Liu Xiaoyuan 刘晓原

Longnan 陇南市

Lu Qing 路青

Ma Jiajue 马加爵

Ma Qingyun 马清运

Nanniwan 南泥湾

Rongrong 荣荣

Shihezi 石河子

Shishou 石首市

Sun Fawu 孙法武

Sun Zhigang 孙f志刚

Suojiacun 索家村

Tie Guaili 铁拐李

Tu Yuangao 涂远高

Wan Chuan 万川县

Wang Xingwei 王兴伟

Weng'an 瓮安县

Xu Jinglei 徐静蕾

Yan Lei 颜磊

Yang Jia 杨佳

Yang Xiaowan 杨小丸

Yu Hong 喻红

Yu Hua 余华

Yu Qiuyu 余秋雨

Yuhuan 玉环县

Zhang Yimou 张艺谋

Zhang Yuan 张元

Zhao Zhao 赵赵

Zhong Nanshan 钟南山

Zhou Jiugeng 周久耕

Zhou Zhenglong 周正龙

Zhu Dake 朱大可

Zuoxiao Zuzhou 左小祖咒

INDEX

Note: "*p*" with a page number indicates a photograph.

Mao Zedong, xviii, xxiv, 47, 101, 145, 256n3,
 273n47
Marxism, 235
Materazzi, Marco, 261n53
Materialism, 148
May Fourth intellectuals, 256n2
McDonalds, 145
Media. *See also* China Central Television,
 144, 148, 149, 169, 200, 208
 anti-Chinese, 160
 censorship, 261n52, 270n26, 272n43,
 278n35
 distrust of, xxv–xxvi
 on Enterovirus 71, 278n35
 on SARS epidemic, 257n19
 self-censorship, 261n52
 "Silencing Newspapers and Periodicals Fee"
 (2009), 197
 on Tibetans, 149
 Western views on Tibet issue, 160, 266n9
Melamine poisoning. *See* Sanlu milk powder
 scandal
Memory. *See also* Forgetting
 collective, 88, 98, 149–150
 cultivating, 206
 erasing of, 209, 213, 223
 historical, destruction of, 98
 right to, 231
Menstrual irregularities, 197
Mental health law reform, 263n70
Mentally handicapped, 73
Methamphetamines, 137
Microblogging, xxiv, 234–236, 279n44
Middle class, core beliefs of, 8
Migrants, urban, 3, 31–32, 259n39
 asylum laws and, 68–69, 260n44
 discrimination against, 258n28
 employment, 31
 housing for, 31–32, 53
 monitoring, 258n28
 protest by, 271n31

"Railway and Highway Occupancy Fee,"
 194
 SARS epidemic and, 74
 Spring Festival period, 268n17
 statistics, 3
 violence against, 271n31
 Zhong Nanshan on, 68–69
Milan, 32, 34
Milk powder scandal. *See* Sanlu milk
 powder scandal
Mindfulness, 64
Ministry of Architecture (PRC), 178
Ministry of Culture (PRC)
 attempts to control and monopolize
 market, 157
 culture, understanding of, 140–141
 joke about, 198
 media censorship, 261n52
 standardizing art, 113, 114–115
 theater district plan, 115
Ministry of Education (PRC), 155, 156, 178,
 198, 267n12
Ministry of Health (PRC), 202
Ministry of Public Security (PRC), 236
Mistakes, 62, 83–86
Mob assault, 77
Modernism, 9, 12–13, 25–26
Modernity, 140
Moon, 78
Moon Bear, 96
Morals. *See* Ethics
Mori Art Museum, xxiv
Mourning, 149, 154
Movies, 35, 115
 film industry, 142
 "Flickering Screens" (2008), 141–143
 "Standards and Practical Jokes" (2007),
 113–114
 watching at home, 142–143
Moving house, 52, 78–79
Mr. Democracy (*de xiansheng*), 256n2
Mr. R., 95